ART
FOR THE
MILLIONS

ART
FOR THE
MILLIONS

Essays from the 1930s by
Artists and Administrators
of the WPA Federal Art Project

Edited and with an Introduction by
FRANCIS V. O'CONNOR

NEW YORK GRAPHIC SOCIETY LTD. • Greenwich, Connecticut

International Standard Book Number 0-8212-0439-4
Library of Congress Catalog Card Number 78-181347

First published 1973 by New York Graphic Society Ltd.
140 Greenwich Avenue, Greenwich, Conn. 06830

Manufactured in the United States of America

Designed by Visuality
Graphic Production by Frank De Luca
Composed in 9 on 12 Optima with Optima display
by JD Computer Type Inc.
Printed and bound by Halliday Lithograph Corp.

This book is dedicated to

HOLGER CAHILL

National Director of the WPA Federal Art Project

1935 to 1943

in recognition of his contribution to American art.

Contents

List of Abbreviations 11
Introduction *Francis V. O'Connor* 13
Foreword *Holger Cahill* 33

PART I—THE FINE ARTS

MURALS

Concerning Mural Painting *Philip Evergood* 47
The Development of American Mural Painting *Geoffrey Norman* 50
California Mosaics *Jean Goodwin* 56
The Evolution of Western Civilization *James Michael Newell* 60
Mural Art and the Midwestern Myth *Mitchell Siporin* 64
Mural Education *Karl Knaths* 67
Abstract Murals *Burgoyne Diller* 69
My Murals for the Newark Airport: An
 Interpretation *Arshile Gorky* 72
An Approach to Mural Decoration *Hilaire Hiler* 74
Murals for Use *Lucienne Bloch* 76
On Mural Painting *Walter Quirt* 78

SCULPTURE

Report to the Sculptors of the WPA/FAP *Girolamo Piccoli* 83
The Sculptor's Point of View *Samuel Cashwan* 88
Modern Sculpture and Society *David Smith* 90
Fantasy and Humor in Sculpture *Eugenie Gershoy* 92
Planning a Public Fountain *Waylande Gregory* 94
Concerning Patrocinio Barela *Vernon Hunter* 96
Sculpture in Southern California *Stanton Macdonald-Wright* 100
Symphony in Stone *Donal Hord* 104
For the Present We Are Busy *Beniamino Benvenuto
 Bufano* 107

EASEL PAINTING

After the Locusts *Louis Guglielmi* 113
The People in My Pictures *Julius Bloch* 115
Some Technical Aspects of Easel Painting *Jack Levine* 117
Abstract Painting Today *Stuart Davis* 121
Some of My Working Methods *William Sommer* 128
Golden Colorado *Eugene Trentham* 132
Easel Painting on the WPA/FAP.
 A Statement and a Prophecy *Donald J. Bear* 133

GRAPHIC ART

Graphic Techniques in Progress Hyman Warsager 139
Prints for Mass Production Elizabeth Olds 142
Lithography: Stepchild of the Arts Russell T. Limbach 145
Eulogy on the Woodblock Fritz Eichenberg 148
Satire in Art Mabel Dwight 151
A Graphic Medium Grows Up Anthony Velonis 154
Street of Forgotten Men Eli Jacobi 157

PHOTOGRAPHY

Changing New York Berenice Abbott 158

PART II—THE PRACTICAL ARTS

INDEX OF AMERICAN DESIGN
What is American Design Constance Rourke 165
Recording American Design C. Adolph Glassgold 167
The New York Index Charles Cornelius 170
The Shaker Arts and Crafts Gordon M. Smith 173

POSTERS

Posters Richard Floethe 177
The Poster in Chicago Ralph Graham 179

ARTS AND CRAFTS

The Builders of Timberline Lodge Federal Writers' Project 183

TECHNICAL RESEARCH

The Materials of Art Rutherford J. Gettens 190

PART III—ART EDUCATION

ART TEACHING

The Artist as a Social Worker Irving J. Marantz 197
The New Orleans WPA/FAP Project Lawrence A. Jones 198

Puppetry as a Teacher Hilda Lanier Ogburn 199
The Therapy of Art Alexander R. Stavenitz 201
Art Within Reach Thaddeus Clapp 204

COMMUNITY ART CENTERS

Birth of an Art Center Elzy J. Bird 208
The Negro Artist Today Vertis Hayes 210
The Harlem Community Art Center Gwendolyn Bennett 213
High Noon in Art Harry H. Sutton 216
The Spokane WPA Art Center Carl Morris 218
The Phoenix Art Center Philip C. Curtis 221
Art in Action Daniel S. Defenbacher 223

EXHIBITIONS

The Exhibition Program of the WPA/FAP Mary Morsell 229
Art Comes to the People Eugene Ludins 232

PART IV—ARTISTS' ORGANIZATIONS

ARTISTS' UNION

The Artists' Union of America Chet La More 237
Chicago and the Artists' Union Robert Jay Wolff 239
The Minnesota Artists' Union Einar Heiberg 243

ARTISTS' CONGRESS

American Artists' Congress Stuart Davis 249
The American Artists' Congress Lincoln Rothschild 250

THE PROJECT AND THE ARTISTS' ORGANIZATIONS

The Artists' Coordination Committee Hugo Gellert 255
The Organization of Supervisors of the WPA/FAP E. Herndon Smith 257
The WPA/FAP and the Organized Artist Audrey McMahon 259

PART V—AFTERWORD

Society and the Modern Artist Balcomb Greene 263

PART VI—APPENDICES

A. Who's Who Among the Authors and Artists 268
B. Inventory of the Existing and Missing
 Manuscripts of ART FOR THE MILLIONS 296
C. Physical Accomplishments and Expenditures
 of the WPA/FAP: 1935-43 305
D. List of Community Art Centers 306
E. Selected Bibliography 309

INDEX 311

List of Abbreviations

ABBREVIATIONS THAT APPEAR IN THE TEXT

AAA	American Abstract Artists
AFL	American Federation of Labor
CAA	College Art Association
CCC	Civilian Conservation Corps
CIO	Congress of Industrial Organizations
CWA	Civil Works Administration
ERA	Emergency Relief Administration
FERA	Federal Emergency Relief Administration
MOMA	Museum of Modern Art, New York
NCFA	National Collection of Fine Arts, Smithsonian Institution
NRA	National Recovery Administration
PWA	Public Works·Administration
PWAP	Public Works of Art Project
Section	Treasury Section of Painting and Sculpture (later, Section of Fine Arts)
TERA	Temporary Emergency Relief Administration
TRAP	Treasury Relief Art Project
WPA	Works Progress Administration (after September 1939: Work Projects Administration of the Federal Works Agency; liquidated 1943)
WPA/FAP	Works Progress Administration's Federal Art Project (a composite abbreviation, not current during the 1930s, that is used here to designate the WPA Federal Art Project, which became the WPA Art Program of the Federal Works Agency after September 1939, and the Graphic Section of the War Services Division after March 1942; it was liquidated in July 1943)

ABBREVIATIONS OF PHOTOGRAPH SOURCES

AAA	Archives of American Art, Smithsonian Institution, Washington, D.C.
NA	Record Group 69, Records of the WPA, National Archives, Washington, D.C.
NCFA:CAHILL	Cahill Papers, Files of Federal Support for the Visual Arts: The New Deal and Now, Library, National Collection of Fine Arts, Smithsonian Institution, Washington, D.C.
NCFA:PERRET	Ferdinand Perret Research Library, Library, National Collection of Fine Arts, Smithsonian Institution, Washington, D.C.

A photograph's source appears in parentheses after each caption. If no source is cited, the owner of the work supplied the photograph.

The location of most easel works, works of graphic art, and sculpture is not known. When a work's location is known, it is given either as part of the caption text or after the photograph source. The loss or destruction of murals and architectural sculpture is indicated.

Introduction

FRANCIS V. O'CONNOR

HISTORY[1]

Art for the Millions was first conceived as a national report by the Washington Office of the Works Progress Administration's Federal Art Project (hereafter WPA/FAP) in 1936. At this time the WPA/FAP was anxious to establish a favorable public image in order to counter charges of "boondoggling" leveled at it by Congress and the conservative press ever since its inception in the fall of 1935 as a work-relief program for artists. The Project hoped to make its national report, which would be heavily illustrated, proof to the Congress and to the country of the importance and quality of its activities. To this same end late in 1936, the Project mounted an exhibition of its best productions, called "New Horizons in American Art,"[2] at the Museum of Modern Art in New York.

Emanuel M. Benson[3] was engaged to edit the report and immediately began to solicit essays from Project artists and administrators—to be written on Project time.[4] By the end of December 1936 enough material had been accumulated to permit Holger Cahill,[5] National Director of the WPA/FAP, to write his immediate superior in the WPA administration:

It is our intention to publish the kind of Report that will not only document our accomplishment but do this in a unique and persuasive manner. We came to the conclusion that the most forceful and dramatic way of getting our story across would be to have it come from the lips of those Project workers . . . who have made our achievements possible. This democratic procedure reaped a rich harvest far beyond our wildest expectations. We found that artists, contrary to prevailing opinion, have something vital to say about themselves, about their crafts, about the world they live in, and about the relation of all these things to the Federal Art Project. And they have said this with a clarity of intelligence and warmth of feeling that carries conviction and does honor to the Works Progress Administration. What has resulted is a complete and vivid summary in words and pictures of what the Federal Art Project has achieved during its short existence as well as a record of the greatest importance to art history and to society.[6]

Early in 1937 plans were being made for the Government Printing Office to publish the report. This did not happen. By December 1937, Benson was actively seeking a private publisher. About this time the title of the anthology was changed to "Government in Art." A memo dated July 1938 indicates Benson was still trying to find a publisher and was negotiating with Random House—but nothing happened. The

records are silent until March 1939, when they reveal that Albert Whitman & Co. of Chicago agreed to publish what was then called, for the first time, *Art for the Millions*. Arrangements were made with the private sponsoring committee used by the Federal Writers' Project to legally bypass normal government red tape concerning publishing,[7] and in June 1939 the contract was signed and Albert Whitman & Co. announced *Art for the Millions* in its fall catalog.

The anthology never appeared. By September 1939 the Federal Art Project, along with the entire Works Progress Administration, suffered a severe administrative reorganization. The latter's name was changed to Work Projects Administration, with only the initials remaining the same. It was subsumed into a catchall Federal Works Agency. What were previously autonomous divisions, the Federal Art Project among them (its name was changed to WPA Art Program[8]), were placed under state and local control, severely limiting their freedom and funds.[9]

On June 30, 1940, Emanuel Benson was let go as a consultant to the Project. A month later, in a letter to Stuart Davis, who had inquired about the essay on abstract art he had submitted to Benson earlier in the spring, Holger Cahill wrote: "At the present time this office is undergoing considerable reorganization and so far as I know definite plans for the publication of the book have not been made."[10]

This is the last reference to the ill-fated anthology. With war raging in Europe and our entry soon after, what remained of the art projects declined, and they ended when the WPA as a whole ended early in 1943. The publication of *Art for the Millions* was liquidated with everything else.[11]

Holger Cahill took the manuscript with him into retirement, apparently intending to edit and publish it. Other interests intervened, and his untimely death occurred in 1960. The lack of interest in the 1930s which prevailed through the postwar years and the rise of Abstract Expressionism would have made publication unlikely even if it had been attempted. In 1968, while directing "Federal Support for the Visual Arts: The New Deal and Now," a research proj-

ect investigating the New Deal art programs in New York City and State on a grant from the National Endowment for the Arts, I traced the manuscript to Mrs. Holger Cahill. She turned the entire document over to me with the understanding that the original material would be deposited in the Library of the National Collection of Fine Arts of the Smithsonian Institution in Washington, D.C. This has been done.[12]

EDITING

Art for the Millions was ready for publication in 1939. Benson and his staff prepared an illustrated dummy which was probably used to "sell" the manuscript to publishers. Benson gave this dummy to the Archives of American Art, where I have had the opportunity to study it. I have followed its basic organization in preparing this anthology. Thus the four major Parts follow the original format, which I have departed from in only three places.

Under "The Practical Arts" I have placed an essay on Timberline Lodge at Mount Hood in Oregon. This was not in the original manuscript, having been written by the WPA Federal Writers' Project. It gives, however, unique insight not only into one of the Project's most extensive subventions of handcraft activities, but also into how the whole WPA work-relief program could cooperate in creating a unique recreational facility, one which is still in use today.

Under "Education" I have added a section on exhibitions, to emphasize this important function of the national WPA/FAP.

Finally, one essay—that by the distinguished abstract painter Balcomb Greene—stood out for its trenchant exposition of the artist's responsibility to government, to the millions, and to himself in a time of social and political upheaval. I have made it an "Afterword," to bring this anthology to an appropriate conclusion.

It is clear from the dummy that Holger Cahill intended to write an introduction, yet no draft of it can

be found. There exists, however, a memo dated November 14, 1939, from Cahill to one of his associates, which states:

Here is the speech I made at the John Dewey Eightieth Birthday Celebration. It was given at the Pennsylvania Hotel [New York] on the morning of Saturday, October 28. . . . I have been thinking of holding this talk and publishing parts of it in connection with our Art for the Millions *rather than to publish it in the John Dewey Birthday Volume.*[13]

Mrs. Holger Cahill was able to find the text of this speech, and I have included it here verbatim, since it is a clear and eloquent statement of Cahill's personal philosophy and an apt preamble to what follows.

The dummy indicates that Benson intended to publish 41 essays. I have included 67. Many of the contributions Benson rejected have historical or biographical value today; several he included offer nothing to the present; others are lost. Since considerations of space and the reader's patience forbade preserving for the record every extant page of *Art for the Millions*, I was faced with the difficult task of deciding what to leave out. In general I deleted what seemed dull or repetitious, knowing that the "Inventory of the Existing and Missing Manuscripts" in Appendix B, which lists all the essays written for the original anthology, would be available to ·the curious reader and the full manuscript to the dogged researcher. On the other hand, it is dangerous for an editor to wield Occam's razor too relentlessly when faced with so unique and complex a document. I have therefore left in some tedious essays for the information they contain, or for their point of view, knowing that these pages can be turned quickly or at leisure. In a number of instances I retained an essay because I felt its author should be heard from again—however mutedly. In this regard, permit me to caution the reader not to succumb to the temptation to read only the essays written by familiar names while ignoring the less well known. Our understanding of the 1930s has been distorted by just such

snobbism. Many of the more thoughtful essays here, which probe matters essential for an understanding of the period and its art, are written by individuals long, and unjustly, forgotten—such as Walter Quirt. I hope this anthology will prompt the rehabilitation of many of its artist-authors and expand the conventional wisdom concerning the 1930s—a wisdom unwisely limited to the familiar names of Shahn, Marsh, Gropper, Levine, Benton, the Soyers, et al. To this end I have provided in Appendix A—"Who's Who Among the Authors and Artists"—short biographies of each person whose words or work appear in this anthology.

Similarly, the reproductions have been chosen to provide as wide a range of styles, themes, and artists as possible. I hope the days of getting a "convenience food" photograph from the Whitney or the Museum of Modern Art will soon be over and that the redundant images up to now always associated with the 1930s find rivals in those of the many forgotten, or partially known, masters of the Depression era.

The visual material has been selected also to show the full range of artistic, educational, and sociological activities undertaken or inspired by the Project. Since the dummy was fully illustrated, I have followed its lead wherever feasible. As with the number of essays, however, I found it desirable to broaden the dummy's conception to include other images. The result is a comprehensive visual anthology of the work and activities of the national WPA/FAP.[14]

The individual captions provide, where it is known, basic data concerning each work. Many of these photographs, alas, are all that remain of works of art long lost. Almost all the reproductions were made from original WPA/FAP photographs taken immediately after each work was completed. I hope their publication will lead to the recovery of many lost works.

CONTENT

As Holger Cahill anticipated in 1936, *Art for the Millions* constitutes "a record of the greatest importance to art history and society." I can think of no comparable document in the history of American art—or, for that matter, world art—which so fully articulates, in their own words, the feelings and goals of so large a number of artists engaged in a common enterprise.[15] In our age of "credibility gaps," however, the cynical may suspect that these essays, written by government employees on government time, are merely government propaganda; that these pages give a one-sided view of a mindless art bureaucracy to which its employees gave lip service out of abject economic necessity. Such a suspicion is easily allayed.

First, anyone who knows artists can hear in these pages not only sentiments of gratitude for the patronage of a government program, but expressions of authentic delight in the freedom and opportunity that program afforded: the excitement of being free to experiment with new materials and techniques; the sense of status engendered by working for the people; the discovery of common aesthetic and political purpose with fellow artists in Project workshops and on Artists' Union picket lines.

Second, the research project I directed in 1968, which uncovered the manuscript of *Art for the Millions*, also uncovered some highly positive judgments of that disparaged WPA "boondoggle" by the artists who had worked on it thirty years before. Nearly 90 per cent of the New York artists responding to my questionnaire said the Project was a rich and satisfying experience and felt it permitted them creative freedom. Further, 75 per cent said it fostered a real sense of community among the artists it employed.[16] In short, the recollections of former Project artists correspond to and confirm the enthusiasm of those who wrote these pages.

Art for the Millions is more than a book about art. Its basic concern is the role of art and the artist in society. During the 1930s that role was the subject of everything from the most profound philosophic speculations to fistfights. Today art's social role is seldom discussed—and we are, of course, too "cool" to fight about it. The only exceptions seem to be those critics and artists who have mistaken the "art world" for the real world. But the relationship of art to the millions is not considered, except mockingly by the Pop artists, who make us see the universal kitsch while doing little to eliminate the cause of their inspiration. Everything else is ingrown, solipsistic, asocial and, sadly, increasingly nihilistic. Indeed, where devastating public events prompt gut reactions in the visual arts—events such as Kennedy's murder, or Vietnam, or Mayor Daley—the resulting work is embarrassingly fatuous. This was not the case in the Depression years. Artists then took their social obligations seriously, and each, in his own way, made an attempt to define the scope and relationship of his social and artistic actions. That attempt at definition is the essential subject of *Art for the Millions* and constitutes its cultural importance.

The essays in this anthology, divided as they are into four parts—the fine arts, the practical arts, art education, and artists' organizations—speak eloquently for themselves. There are, however, a number of important themes implicit throughout the text and explicit in its organization which I want to isolate and comment upon.

First of all, I would like to turn to Holger Cahill's foreword and his understanding of the relationship between John Dewey's thought and the goals of the WPA/FAP.

Cahill saw the Project he created and administered as a translation of philosophic ideas into a program of action. He understood Dewey to define art as "a mode of interaction between man and his environment," an idea implicit in the philosopher's attitude toward the deeper social role of art:

The union of men with one another is the source of the rites that from the time of archaic man to the present have commemorated the crises of birth,

death and marriage. *Art is the extension of the power of rites and ceremonies to unite men, through a shared celebration, to all incidents and scenes of life. This office is the reward and seal of art. That art weds man and nature is a familiar fact. Art also renders men aware of their union with one another in origin and destiny.* [17]

Along with seeing art as a symbol of human life and solidarity, Dewey also saw it primarily as a process and only secondarily as a product. [18] Masterpieces are not, therefore, the central goal of the artistic process and formal qualities are subordinate to human utility. Art's timelessness is subordinate to its timeliness. Art exists insofar as there inheres in its manifestations some quality of human experience. Art is social insofar as it reflects the prevailing human condition. [19] Thus Cahill can say in the foreword:

As John Dewey has pointed out, those who contrast eternity with time often are only contrasting present with past time. The emphasis upon the universal and the eternal in art too often has meant that our interest has become attached to aesthetic fragments lost from their contexts in time and in human society.

I do not want to suggest that the WPA/FAP was a planned extension of and experiment with Dewey's ideas. Rather these ideas influenced Cahill not directly but intuitively, providing not a specific agenda but a general permission for original creative enterprise.

When Cahill drew up the initial plans for the WPA/FAP in the summer of 1935, he was faced with a problem national in scope. The country's visual artists were unemployed and in desperate need of economic relief in a form that would foster the preservation of their skills. The Treasury Department's art program under the direction of Edward Bruce had begun little more than a year earlier with the Public Works of Art Project (PWAP), which was designed to dispense relief. It proved inadequate to help all the artists who were unemployed. The

Treasury's Section of Painting and Sculpture, which was organized under Bruce in the fall of 1934, specifically refused to undertake a relief program and concentrated instead on commissioning quality embellishments for Federal buildings. [20] It was up to Cahill, working under Harry Hopkins's freewheeling WPA, to fashion a work-relief program for artists. He saw the opportunity to do that and to create at the same time the context for a cultural revolution.

Cahill did not doubt the need for such a revolution. As he points out in his introduction to the Museum of Modern Art's 1936 exhibition catalog for "New Horizons in American Art," written a year after the WPA/FAP began, the American art patron after the Civil War turned to "aesthetic fragments torn from their social background, but trailing clouds of vanished aristocratic glories," thus engendering a "dislocation of art in this period from its social context." [21] He saw the old "romantic conception" of art as a harmony dependent upon the harmony of nature replaced with Cézanne's notion that art is in harmony parallel to nature. Thus from the close of the nineteenth century until his own time, Cahill felt, art had been "feeding on itself," and artists had been obsessed with "art for art's sake." [22]

Art had become its own subject and an understanding of its self-communicated mysteries was to be limited to a few initiates. On the credit side of this movement must be placed the really profound research which led to the recovery of a usable past. . . . [23]

He goes on to describe the American artist's increasing interest in the art of the past and his exploration of European, Oriental, and primitive traditions in search of new formal vocabularies and modes of abstraction. He points also to a renewed interest in the American scene on the part of the "Ash Can School," and the incipient boom in the market for American art which developed in the late 1920s. But then the Depression came and the stark realities of that disaster prompted communal solutions:

The organization of the Project has proceeded on the principle that it is not the solitary genius but a sound general movement which maintains art as a vital, functioning part of any cultural scheme. Art is not a matter of rare, occasional masterpieces. The emphasis upon masterpieces is a nineteenth century phenomenon. It is primarily a collector's idea and has little relation to an art movement. . . . It is clear that in the best periods of art expression the homely crafts and the fine arts have been closely integrated. . . . The importance of an integration between the fine arts and the practical arts has been recognized from the first by the Federal Art Project, as an objective desirable in itself and as a means of drawing together major aesthetic forces in this country. [24]

Thus the idea of "art for art's sake" was firmly rejected as the basis for the Federal Art Project. This rejection was in keeping · not only with the theoretical tenor of Cahill's thought and the desires of the socialist-orientated artists' organizations, but with the practical necessities of setting up an effective art-relief program, on a national scale, designed to employ all needy artists regardless of skill or aesthetic proclivity. The ideal·was collectivism, not individualism. Cahill's achievement was to create a program open to the artistic "everyman." The highly creative went into the fine arts divisions, those whose enthusiasm perhaps outweighed their skill were assigned to teaching, the commercial artists went into the Index of American Design or the poster divisions, those with only craft skills made dioramas or frames. The pay was the same for all and so was the government's recognition of each individual's contribution. The artist left the im-. pecunious isolation and psychological vacuum of his "ivory tower" to become a salaried worker. If he was lucky, he enjoyed as much as eight years of artistic freedom. I say "if he was lucky" because the WPA/FAP was anything but a bed of roses. To be employed, one had first to endure the humiliating process of home-relief certification. [25] Thereafter

one had to contend with innumerable employment quota cuts and the ministrations of "timekeepers" and other petty bureaucrats obsessed with regulations that had little relationship to the whims and schedules of the creative process. [26] There was also, toward the end, a certain insensitivity on the part of the Project in the allocation of works of art. Many artists never learned the ultimate disposition of their creations. At the final liquidation, large quantities of work were destroyed or auctioned by order of the WPA administration without the knowledge or control of what was left of the Project staff. [27] Yet these objections are minor compared to the opportunities afforded by the Project—a fact to which, as already noted, its veterans and these essays attest.

Let us now turn to the attitudes expressed by the authors of *Art for the Millions* when the Project was flourishing in its peak years of 1936 to 1939. Three basic themes seem to dominate. The first concerns the role of the fine and practical arts as means of social communication and change. The second deals with the dissemination of visual culture to the people. The third reveals the Project artists' tendency to organize in the face of their social and economic environment. These aesthetic, sociological, and political themes, embodied in the structure of the anthology, interweave throughout the essays as the authors define their commitment to art and the millions. In what follows I shall organize my comments on these themes around the author's understanding of the social implications of their expressive and educational media, their subject matter and style, and their organized militancy during the 1930s.

MEDIA OF EXPRESSION AND EDUCATION

Project artists had very definite attitudes toward the social implications of their media of expression.

Muralists, and sculptors engaged in monumental work, were highly conscious of reaching—as Philip Evergood phrases it—a "people's audience." Since

these artists often worked *in situ* in a school library, prison recreation room, or on the facade of a building, they provided the first opportunity many people had ever had to see a professional artist at work. The Chicago muralist Edgar Britton puts this strongly: "I find the constant vigilance of an audience a challenge. . . . By executing his work in public the mural artist is doing a great deal toward dissipating the halo of mystery surrounding works of art." Lucienne Bloch, painting a mural of children at play in the recreation room of the Women's House of Detention in New York City, discovered the same thing:

The matrons, outside of the fact that their conception of an artist was shattered when they saw me work without a smock and without inspired fits, were delighted to witness the creation of a "genuine, hand-painted picture." The inmates had a more natural point of view. . . . The mural was not a foreign thing to them. In fact, in the inmates' make-believe moments, the children in the mural were adopted and named. The scene representing Negro and White children sharing an apple was keenly appreciated and [letters home clearly revealed] to what degree a mural can, aside from its artistic value, act as a healthy tonic on the lives of us all.

The surrealist Louis Guglielmi, whose easel paintings for the Project are among his most famous works, states that private collectors "not only encouraged private ownership of public property but . . . destroyed a potential popular audience and forced the artist into a sterile tower of isolation divorced from society . . . where he created superdeluxe framed wallpaper to decorate the houses of the wealthy."

This theme is naturally strongest among the printmakers, who condemn the practice of limited editions for the luxury trade and demand, in the words of Elizabeth Olds, "prints for mass production." Noting that in the past popular prints were issued in editions of hundreds of thousands, she

suggests that the Government Printing Office distribute original prints to public institutions and directly to the people along with its agricultural manuals and departmental reports.[28]

The idea that art should be democratic is often expressed. Fritz Eichenberg sees his woodblock as "the most democratic medium of art." The colorful San Francisco sculptor Beniamino Bufano declares with Whitmanesque fervor, "Our art must become as democratic as science and the children in the playgrounds of our cities." Bufano goes on to describe his controversial statue of St. Francis designed for Twin Peaks as "a symbol of the city that bears his honored name, big enough to belong to everybody, too big for anyone to put in his pocket and call his own."

This idea—that art should belong to everybody and not just to the affluent—is frequently reiterated in these essays. The Project's policy of allocating easel paintings, pedestal sculptures, and prints to public institutions such as schools, libraries, hospitals, and housing developments was appreciated. For the first time artists saw their work going to the people and not to "stockmarket-minded dealers and collectors," as the printmaker Russel Limbach put it. Even commercial artists such as Ralph Graham, who worked in the Project's poster division in Chicago, were conscious of their social impact:

. . . very gratifying . . . is the public need of and demand for the work of the artist as an integral part of the community. The artist has occupied a place aside, not from his own volition entirely, but because he was thought to be a little different from the throng. Through the efforts of the WPA/FAP the artist and the public have come to know each other and to realize the definite need of one for the other. The poster has been responsible in large part for this phase of common understanding because it has reached so many people.

The arts reached the people even more directly through the efforts of the many artists who worked on the Project as teachers. It is not realized that most

of our urban school systems and settlement houses did not have extensive art programs until the WPA/FAP sent in professional artists like Irving Marantz from the relief rolls to develop them. Similarly, some of the first public-sponsored experiments in the field of art as psychotherapy were undertaken by Project artists in the wards of Bellevue Hospital—as described here by Alexander Stavenitz—and other metropolitan institutions. Such programs in our schools and hospitals are commonplace today—in the 1930s they were daring innovations.

In this same spirit of daring innovation, the WPA/FAP established across this nation over one hundred Community Art Centers. One of the most vivid essays in this anthology is that by Elzy J. Bird describing the establishment of centers in the towns of Helper and Price, Utah. It illustrates the ready acceptance these cultural facilities received from the people.

A typical Community Art Center offered art classes and lectures and housed art galleries which showed numerous traveling exhibitions of Project art. These exhibitions, circulated by the National Office and discussed here by Mary Morsell, ranged from the most conservative work to pure abstraction and often provided the first opportunity for people in a rural community—and sometimes even the local art teachers!—to see original works of art. To man these centers, hundreds of artists from big cities—such as Carl Morris and Philip Curtis—were assigned to areas of the country where professional artists had never been before. In this way, between 1935 and 1943, the WPA/FAP shared the experience of creativity with millions of culturally underdeveloped citizens.

Of these, the blacks were probably the worst off. The testimony of Gwendolyn Bennett, Vertis Hayes, Lawrence A. Jones, and Harry H. Sutton, Jr., provides insight into the Project's effort to spread cultural democracy to even the least regarded citizens, to give them the training and encouragement they needed, and to provide equality with whites insofar as the social conventions of the 1930s permitted. [29]

Similarly, Spanish-American artists such as the sculptor Patrocinio Barela received much-needed support from the Project.

The history of these art education programs and Community Art Centers remains to be written. As an enlightened patron, the Project not only nurtured the creation of art but attempted to create an audience for it. The extent to which it succeeded during the 1930s and what effect that effort had on cultural developments in later decades should be carefully investigated. But one thing is very clear—and it is true of the creative arts as well as the practical: for the first time in our history artists conscious of their ability to do so put art within the reach of all the American people.

SUBJECT MATTER AND STYLE

A glance at the illustrations in this book reveals a great range of subject matter and style, which can be divided into specific, through sometimes related, categories.

First there are scenes and figures from American and world history. These range from the depiction of the origins of a local community in 1840, as in the mural by James Brooks, through monumental portraits of religious and political leaders such as St. Francis, Jane Addams, and Abraham Lincoln by John Palo-Kangas, Beniamino Bufano, Mitchell Siporin, Samuel Cashwan, and others, to grandiose mural cycles such as the one by James Michael Newell surveying the evolution of western civilization.

These historical narratives and portraits reflect the very important retrospective tendencies inherent in the culture of the 1930s. The quest for "a usable past," referred to above by Cahill and first articulated by Van Wyck Brooks at the time of the first World War, was renewed with great energy during the Depression years. [30] The fall from economic grace which so shocked the American people and induced in so many millions of unemployed a profound sense

of self-doubt and inadequacy, engendered a turning back to a past when men presumably did things right. Dos Passos stated the situation this way: "We need to know what kind of firm ground other men, belonging to generations before us, have found to stand on."[31] This renewed interest during the Depression years in the past as foundation for the present is symbolized by the establishment of the National Archives during the 1930s and embodied in the publication of such scholarly series as the *Dictionary·of National Biography* (1928-36) and *The History of American Life* (1928-44).[32] It is also behind many projects undertaken by the cultural programs of the WPA. Thus the Writers' Project preserved and catalogued historic records and buildings and, in its *State Guide* series, located the nation's landmarks in time and space. The Music Project recorded our heritage of folk songs and tunes, and the WPA/FAP created the Index of American Design—discussed here in a number of essays—to preserve our visual legacy of folk art and craft.

In a similar sense the courses in arts and crafts conducted at many Community Art Centers, and decorative projects such as that at Timberline Lodge in Oregon, reflect an interest in returning to the handcraft values of a less industrialized time.

Our muralists, in particular, conscious of their "people's audience" and inspired by the example of the Mexicans, sought to trace a national lineage which inevitably went back to our European origins. In so doing, as Siporin states, they reevaluated "the mural art of the past in the attempt to bring about a new synthesis of form and content, growing out of the artist's own milieu and the new social functions in our society." They rejected the academic allegory so popular at the turn of the century. An historic event was carefully researched and then abstracted to its most visually legible configuration. The symbolic personification gave way to the "concentrated picturization of an idea," to use Newell's phrase.

It should be recognized that much original research into local and national history went into the generalized content of many of the over 2,500 murals painted by WPA/FAP artists.[33] This, along with the patterns of choice made in the generalizing process, constitutes a visual parallel to that quest for "a usable past" so evident in the historical and biographical writing of the time. A careful study of these murals from this point of view would provide valuable insight into our cultural attitudes during the Depression years.

Despite their cultural content, however, it must be admitted that American mural art during that time never reached a peak of human and artistic intensity comparable to that of the Mexican creations which inspired it. This can be attributed, of course, to the relative inexperience of our young muralists, their lack of readily available models, and the serious scarcity of appropriate walls to paint upon. But the reasons go deeper and are rooted in our national youth and European genealogy. I would like to suggest that the general weakness of American mural art during the 1930s, and its virtual disappearance as a viable means of expression after the second World War,[34] is a function of that very rootlessness which prompted the search for "a usable past" in the first place. The Mexicans could draw from the deep wells of their primordial past and their experience of assimilating Spanish conquerors. The great power of their murals lies not only in the fusion of traditional techniques with modern forms and scales, but also in the incorporation of the ancient universal images of *their* "usable past" in the service of their social revolution. They had heroic images for heroic deeds. How tragic, yet how American, that our mural artists ignored the rich, ancient, archetypal lore and icons of our continent's Indian tribes. But then the implications of Dewey's insight, quoted earlier, that "art is the extension of the power of rites and ceremonies to unite men, through a shared celebration, to all the incidents and scenes of life," were not grasped during the 1930s. The culture of the American Indian was not then—and is not today—a part of our usable past, and its absence from popular consciousness (except as a sociological phenomenon to be

emulated, as Cahill proposes) is symptomatic of our continuing humanistic myopia. Our European roots are not sufficient to celebrate our national experience; our indigenous roots are neither recognized nor assimilated.

The second category of subject matter—the American Scene in its contemporary aspects—was a far more familiar and popular side of our national consciousness and is represented here in all its dimensions. Like the openly retrospective art just discussed—but perhaps more subtly—it suggests a longing for a bucolic, or just a plain, peaceful, uncluttered past that is now lost. Whatever its nostalgias, you can find here the everyday scene of bathing beaches in the Long Beach mosaic, the circus in Albert Kelley's hospital murals, and "zoot-suiters" ogling pretty girls in LeRoy Flint's print. The rural scene of farm and pasture is celebrated in the works of Cameron Booth, William Sommer, and Jackson and Charles Pollock—both students of Thomas Hart Benton. The urban scene is caricatured in Agnes Hart's inebriated "el" and captured in the arresting juxtapositions of a city's never-ending architectural growth in Berenice Abbott's photographs. But almost imperceptibly the grimmer realities of the times insinuate themselves. The everyday scene includes Aaron Goodelman's homeless men huddled together; the rural scene Jacob Kainen's vision of drought, dust, and despair; the urban scene Lucienne Bloch's picturesque back yards framing racial tension and bleak environments, Jack Levine's sardonic depiction of the police conspiring with gangsters, and Louis Guglielmi's variations on the theme of the loneliness of poverty.

Related to the category of the American scene is a similar category of subject matter which portrays the worker—but without overt ideological commentary. Employing a tactful understatement, artists such as Elizabeth Olds in her print *Miner Joe*, and Cesare Stea in his frieze of pipe fitters for a sewage-disposal plant, quietly acknowledge the simple dignity and worth of labor and the common man's contribution to building his community.

A more consciously heroic depiction of the worker is found in the murals of Marion Greenwood, Seymour Fogel, and Anton Refregier. Using stylistic devices borrowed from the Mexican muralists—such as montage space planes and the consciously monumental modeling of figures—these artists envision a utopia where the earnest worker and his handsome family live in blissful diligence in well-planned communities. In these works the social realist's frequent resort to semi-abstract stylistic devices elevates the triumph of socialism above the nagging realities of proletarian space and time to an almost visionary level. In this, American social realism is distinguished from the down-to-earth verisimilitude of its European—and especially Russian—counterparts.

It is also characterized by the vibrant *esprit de corps* which existed among the Project muralists. This is vividly portrayed in the following excerpt from Anton Refregier's diary, dated January 1939, in which he describes painting the murals for the WPA building at the New York World's Fair:

The work is going full swing. The workshop is the closest to the Renaissance of anything, I am sure, that has ever happened before in the States. My assistants and I have the central part of the studio. On the left, Philip Guston is working on the full-size drawings for the mural he is going to do for the outdoor wall of the building. In front of us, Seymour Fogel is working on a large canvas. In back, Eric Mose with his assistants. Other artists are working elsewhere. Every person here is dedicated to the Project. Everyone feels and knows that we must do our utmost. We know that there are a bunch of commercial mural painters preparing murals for the different buildings of the Fair—Hildreth Meière and others. They are making at least ten times more money than we are. But they can have it. Theirs will be the usual commercial crap. They are not moved as we are by our content—by our search for creative and contemporary design—by our concern for

people. WE are the mural painters. We hope we are catching up with our great fellow artists of Mexico. We will show what mural painting can be!! [35]

In a contest sponsored by the American Society of Mural Painters, Philip Guston's mural won first prize and Refregier's second. It is tragic that everything these eager young artists created for the Fair was destroyed in 1940; only photographs remain.

Another socially-orientated movement in American art during the 1930s was the small and little-noticed school of "social-surrealists"—represented here by Walter Quirt, Louis Guglielmi, and James Guy—who attempted to utilize the "dreamscape" devices of such artists as Salvador Dali to broaden the scope and impact of their social commentaries.

Implicit in social surrealism and, even more, in the last category of subject matter I wish to discuss, abstraction, is an uneasiness born of a profound suspicion of "art for art's sake." While this uneasiness is latent in Dewey's thinking, it is quite explicit in Marxist theory. [36] A work of art whose content is beyond the comprehension of the people cannot serve the cause of the people. For a true artist, this can raise some difficult problems which, not surprisingly, he seeks to solve in words rather than in his work.

True art, of course, is always for the self's sake, though artists usually choose to rationalize their self-commitment in terms of art's sake or society's sake, depending on the tendencies of the times. Thus the artists of a given period will usually justify their creations on aesthetic or sociological grounds while disparaging or, more often, ignoring the psychological roots of their activity. In general, aesthetic arguments are used by artists who are psychologically elitist, while sociological arguments are adduced by the more egalitarian. In the twentieth century only Surrealism and its derivative styles—such as Abstract Expressionism—acknowledge and exploit the self-concern that is the basis of artistic sensibility. During the 1930s in the United States the quite tragic human situation invested "art for art's sake" or "art for the self's sake" with an aura of profound guilt. Pure abstraction and overt personal expressiveness were out of step with the dominant utilitarian notion that only what is useful can be considered beautiful. Yet few true artists really believed that depicted misery could alleviate actual misery, or that caricaturing a capitalist would hasten the redistribution of private property. Indeed, one has only to survey the pictures in this book, or the art reproduced in the periodicals of the time, to see that it was "American-history-in-costume" or "domestic naturalism"—to use Stuart Davis's disparaging phrases—not abstraction or expressionism or surrealism, that dominated the production of the Depression artists. While the conventional wisdom about the art of the 1930s tends to see it solely in terms of some form of "social consciousness"—with Regionalism's Benton, Wood, and Curry given passing reference—the fact is that few politically-orientated works were produced relative to the whole national output. Social protest is really the province of a very few rather diverse artists, including Ben Shahn, Jack Levine, William Gropper, and Joseph Hirsh, who articulated visually the sociological phenomena that were more powerfully presented by writers such as Dos Passos and Steinbeck. These artists' natural self-concern found authentic expression in subjects meaningful to themselves, which also happened to be congruent with the time's dominant guilt: the crushingly exploitative social reality. Proof of this assertion is perhaps best found in Jack Levine's essay. This artist, more totally committed to social protest art than any other author in this book first chose to discuss the nitty-gritty of his painting techniques (only later was he persuaded to address himself to the social problem). His brethren here, especially the abstractionists and surrealists, true to themselves in their art but quite ambivalent in the face of communal guilts, go to great lengths to establish the social relevance of their art and their actions—thus the contradictions often found between words and images.

With all this in mind, I will now turn to a discussion of how the abstractionists and surrealists writing in *Art for the Millions* justified their behavior, which many saw as anti-social. Or, to put it another way, how those concerned with the problems of art and self articulated their social role.

Stuart Davis is certainly the most verbal abstract artist writing here. As one who participated in the Armory Show, contributed to *The Masses* before the first War, and during the 1930s participated in the Artists' Union, its publication *Art Front*, and the American Artists' Congress (about which he also writes here), he was keenly aware of the social as well as the cultural obligations of the artist—especially the abstract artist.

In his eloquent essay "Abstract Painting Today," Davis compares the spatial and temporal dynamics of abstract art with similar phenomena in the contemporary environment:

Abstract art has been and is now a direct progressive social force. . . . In addition to its effect on the design of clothes, autos, architecture, magazine and advertising layout, five and ten cent store utensils, and all industrial products, abstract art in its mural, easel and graphic forms has given concrete artistic formulation to the new lights, speeds, and spaces which are uniquely real in our time. . . . Radio, for example, is the very essence of abstraction. . . .

Davis rails against Regionalism and social protest art as superficial and a "serious social omen." He concludes by defining the social dimension of abstract art, saying:

Art values are social values, not by reflection of other social values, but by direct social participation. . . . Abstract art is a realistic art, not different in kind from the realistic art of any other time, . . . it is the most vital expression of our time in painting. . . .the trend away from it in American art [indicates] a reactionary social trend and a curtailment of democratic rights.

Thus Davis seems to be saying three things in his defense of abstract art against the charge of social indifference: it revitalizes the design of mass-produced utilitarian objects, symbolizes the new dynamics of modern everyday life, and participates, by virtue of its radical departures from conventional artistic norms, in the social revolution. One wonders. That that amalgam of late Cubism, Constructivism, and De Stijl promoted with such vigor by the American Abstract Artists during the 1930s is decorative (as Hilaire Hiler and Burgoyne Diller freely admit in their essays), no man can gainsay. That it is visually dynamic is an aesthetic judgment occasionally justified—especially in Davis's own work. But that it can lay claim in any political sense to being "a direct progressive social force" is open to question. Indeed, I think it is invalid to make such a claim in defense of geometric abstraction, whose cerebral patternings epitomize that "art-for-art's-sake" the Marxist-orientated 1930s so vehemently, and I think correctly, accused of social irrelevance. But Davis writes a good brief, and his ideas about abstract art reflect the obligation imposed by the times to assign a social role to even the most asocial endeavors.

It is refreshing to see how Arshile Gorky, aware of his obligation, manages to relate his abstract murals to the shapes and colors of an airport while at the same time understanding the artist's role as, in Rimbaud's words, defining "the quantity of the unknown which awakes in his time, the universal soul." This forerunner of Abstract Expressionism, who saw social realism as "poor art for poor people," articulates here the social dimension of self-expression with a poetic faith sorely lacking in much of the art and art thinking of the literal-minded 1930s.[37]

Gorky, of course, was influenced by the Surrealists, whose American followers present a more convincing case than does Davis since they appeal to art's humanity and its relation to the social environment not as a specific ideological commitment but as a natural phenomenon. Though stylistically worlds apart, they, of all the American artists of the

1930s, are the most sensitive to those primordial roots and universal icons which lend their power to great art.

Louis Guglielmi talks in his essay of artists returning to the "life of the people." He does not mean that art can cure social ills. Rather, the artist seeks "the richness, the vitality, and the lusty healthiness inherent in the people." He continues: "The source of inspiration necessarily dictates the creative forms that evolve. Coming from within the people, the resulting art will celebrate the experience of the race."

This sense of the social role of art in relation to "the experience of the race" rather than to some "party line" is beautifully expressed by Walter Quirt. Working in the "social-surrealist" style, Quirt wrote extensively on the social implications of the creative process. His essay on mural painting in this anthology is one of its most profound and prophetic.

In keeping with the attitudes of his time, he sees the role of the mural as ideological, but immediately notes that, as such, the mural must reach people with radically differing social and political outlooks. How can it do this? He firmly rejects representational art as the answer and criticizes those who cannot see its limitations. He especially stresses the gulf between the artist's social concern and the conventions of pictorial narration. The greatest problem, as Quirt sees it, is the demand made by a representational work that the viewer accept its intellectual and formal point of view in order to involve himself in it. He states his solution to this problem as follows:

Art is primarily a language of the emotions and not of the mind. This does not mean a separation of form and content — it means a closer fusion of the two. In our society — highly literate, highly sophisticated — we are apt to become unconsciously insulting to the lay mind by giving it the ABC's of life. The Renaissance had a common ideology in the form of religion; and in Mexico the common ideology of the revolution was expressed simply and clearly in murals for an illiterate populace. We have no similar ideology, though without much consideration for the needs of our culture we took over characteristics of both schools. This resulted in, and could only result in, the making of experiences, common to all of us, ordinary. Our real job, of course, is to take common experiences and make them articulate in emotional terms, not exclusively intellectual ones. . . .

Thus if we have found that literal documentation of life has little or no effect upon a lay audience and yet that audience is capable of being moved, we are led to the belief that there must be some common denominator in all of us that needs but a special type of exterior impulse to set our emotions into play. . . . But our period demands new forms, in fact is developing new forms, and interestingly enough these new forms are such that they can reach people of differing social views.

As human beings we all have essentially the same fantasy life. Our biological needs and impulses, our unconscious worlds with their conflicts and desires, our dreams and symbols are common to all even though individually we may hold opposing political or social views that are not harmonious with those of others.

Thus Quirt sees the real social effectiveness of art residing in its ability to affect and engage our essential humanity rather than our ideological biases. Quirt concludes his essay by saying that the artist, if he is to evoke a meaningful response to his work, must learn:

to release his own fantasies, release them completely and uninhibitedly, free from self-censorship and intellectualization whether they revolve around a factual problem or an imaginary one, for, reiterating the point, art is a language of the emotions.

We see, then, that those who really toiled for the sake of abstract art saw that act as more revolutionary than any literal social protest — as did the

Russian Suprematists and Constructivists—and those who opted for an art of personal self-expression put their faith in the ultimate social efficacy of universal insight—as would the Abstract Expressionists. These were, needless to say, minority opinions throughout the Depression years, for most artists saw themselves, however loosely, as workers in a great struggle against the inequities of the social situation. Indeed, the same Stuart Davis who could so eloquently and forcefully defend abstract art against the charge of social irrelevance could, in his role of Secretary of the American Artists' Congress, make the following statement:

In order to withstand the severe shock of the crisis, artists have had to seek a new grip on reality. Around the pros and cons of "social content," a dominant issue in discussions of present day American art, we are witnessing determined efforts by artists to find a meaningful direction. Increasing expression of social problems of the day in the new American art makes it clear that in times such as we are living in, few artists can honestly remain aloof, wrapt up in studio problems. But the artist has not simply looked out of the window; he has had to step into the street. [38]

That step—onto the picket line—implies a militancy on the part of the American artist—a militancy which was peculiar to the 1930s.

ORGANIZED MILITANCY

Five interrelated factors contributed to the American artist's taking his grievances into the streets. The first, of course, was poverty, induced by the collapse of the art market and intensified by the specialized nature of an artist's skills. The second was the success of the Mexican muralists, whose Syndicate, founded in the 1920s, established a precedent for the artist to see himself as a worker deserving of a just wage. The third was the example set by the growing labor movement in this country of organizing in unions and bargaining collectively. The fourth was

the establishment of the New Deal art projects, which provided American artists with "employee" status—the logical pre-condition for their unionization. The fifth was the influence of socialist ideologues, who exploited the poverty, stressed the example of their Mexican comrades, motivated the labor unions, and supported the government art projects.

Much, of course, has been made of "Communist - domination" of cultural organizations during the 1930s. This accusation was constantly made by conservative observers at the time and was the cause of much suffering and recrimination during the witch hunts of the cold-war years. That such organizations as the Artists' Union and the American Artists' Congress had Communists among their leaders and members cannot be denied; that these persons exercised a sinister or politically subversive influence, however, must be denied. The hysteria of the McCarthy era has led to an almost total "block" when trying to reconstruct exactly what role the Communists did play in cultural organizations during the 1930s. As a result, little research has been undertaken in this important area. [39] Nevertheless, certain facts are clear, and I shall try to present them in the context of the relationship between the artists' organizations and the WPA/FAP.

When seen from the viewpoint of an artist's experience during the 1930s, the period divides itself into three distinct phases, which transcend the precise chronology of the decade. In his essay on the Artists' Congress, Stuart Davis distinguishes the first two phases as "the pre-government project period and the post-government project period." He goes on to characterize them as follows: "In the first period the artist saw his world crumble, he experienced disillusionment and despair, and in the second period he found a new orientation and a new hope and purpose based on a new sense of social responsibility." Thus the first phase can be dated from October 1929 through the six-month PWAP experiment which ended in June 1934 and gave artists a taste of the new orientation and hope Davis refers to. The second

phase began with the fight to continue government support after the end of the PWAP. This resulted first in the state art projects of the Temporary Emergency Relief Administration (TERA) and then in the establishment of the WPA/FAP in the fall of 1935. The second phase continued through the fall of 1939. The third phase, which developed after Davis wrote his essay, began with the decline of the Project under state sponsorship in 1939 and lasted until the liquidation in the spring of 1943.

The first phase starts with the collapse of the art market with the stock market. The artist, unemployed and unemployable, without patrons, with skills threatened with atrophy, was at first as stunned as the rest of the population. He reacted slowly, driven on by his increasingly desperate economic situation. First he participated in hunger marches and outdoor sales exhibitions. Then, as things got worse, he joined goal-orientated organizations. [40] With the coming of the New Deal and the establishment of relief programs, these organizations lobbied for and obtained government assistance. Thus the Artists' Committee of Action and the Artists' Union—both born of the John Reed Clubs founded in 1929—were important factors in the history of the short-lived PWAP. [41] By constant agitation for employment quota increases and democratic procedures, they fought the understandable but unrealistic tendencies of the museum people who ran the PWAP to view the project as a source of "quality" art rather than as a relief program. While they did not always win their points, their constant, vociferous pressure, especially after the PWAP ended in June 1934, led to the continued employment of artists on the TERA programs in the states and ultimately to the establishment of the purely relief-orientated WPA/FAP in the fall of 1935.

This first phase—from the Crash to mid-1934—saw the nation's artists at first tentatively and then successfully obtaining government assistance through collective effort. The Artists' Union succeeded the Artists' Committee of Action in 1935, establishing itself on a national basis as the spokes-

man for America's artists just as they achieved employee status on the WPA/FAP. That the Artists' Union had a Communist Party "fraction" is certain. Such influence was natural since the Party was the only disciplined body capable of galvanizing the disorganized and panic-stricken artists into effective groups. The artists accepted this leadership not because they were willing to accept the at times obtuse Party line and the strict Party discipline, but because they saw no contradiction between the Party's aims and their economic needs. It was purely a pragmatic and essentially an apolitical relationship. In this respect I think the following excerpt from the Artists' Union Constitution can be taken at face value:

The purpose of this organization is to unite all artists engaged in the practice of graphic and plastic art in their struggle for economic security and to encourage a wider distribution and understanding of art. It recognizes that private patronage cannot provide the means to satisfy these needs in this period of grave economic crisis. Therefore, as a non-political, non-sectarian mass organization of artists, it demands that the Government fulfill its responsibilities toward unemployed artists, as part of the Government's responsibility towards providing for all unemployed workers. It demands that the Government fulfill its responsibility towards the maintenance and furtherance of the cultural standards of this country by the proper use of the artists' talents and to set up the machinery necessary for the widest possible distribution of art to the general public. (This organization recognizes the need of linking up the struggle of the artists with that of all cultural, professional and manual workers for a united effort to win economic security and will cooperate with and support any organization of workers for such united action.) [42]

The second phase, which was the realization, for the most part, of the Union's program, dates from the summer of 1934 through 1939 and corresponds to several sets of parallel events. In 1935, with Roose-

velt's labor-orientated NRA killed by the Supreme Court and an election looming in 1936, the New Deal turned to a policy of work-relief with the establishment of the WPA. At the same time the Communist Party inaugurated its "Popular Front against Fascism." This had the result of attracting to organizations such as the Artists' Congress and the Writers' Congress large numbers of liberal intellectuals who were not Party members and who would have balked at submitting to Party discipline.[43] The WPA/FAP came into being just as the Popular Front made organized social involvement more attractive to artists. At the same time the American labor movement in general was entering upon an extremely activist period.[44] It is therefore not surprising to find New York members of the Artists' Union participating in sit-down strikes during 1936 in the Project's offices at the same time similar tactics were being used by the fledgling CIO against U.S. Steel and General Motors. In the same spirit, the Artists' Union always enthusiastically participated in the May Day parades which commemorated the worker's organized struggle for his rights which began in the late nineteenth century. "The stronger the labor movement, the stronger the Artists' Union," was the prevailing attitude.[45]

This identification of the artist with the worker during the 1930s is a fascinating phenomenon which, like so many other aspects of this period, has not yet been fully investigated. Indeed, the Artists' Union's actions seem to reflect the development and strategies of the American labor movement event by event. A thorough study of these parallels is needed. One does note, however, that while the Union included without discrimination artists practicing in all styles, its leadership certainly inclined toward social realism. Yet although its members were seriously demanding their rights as "workers" they did not always work for the workers—with the result that exhibitions of members' art hung in the Union's own hall could be decidedly lacking in social or political viewpoints.[46] Union artists were obviously capable of making clear distinctions between their economic

and aesthetic needs and viewed with skepticism the Stalinist line concerning the utilitarian nature of art. Because of this, most of these artists, or at least the younger of them, were accused of being "Trotskyites" and their attitudes led in the succeeding decade to a re-formulation of "art for art's sake" and "art for the self's sake" which would eclipse the decade when art was, or was held to be, for "society's sake."[47]

In sum, then, if the first phase of the artists' militancy was a purely practical relationship between the Party and the artist based on the artist's economic plight, the second phase was a working relationship between Union and the Project designed to maintain, and hopefully make permanent, the government's unprecedented patronage. The aims of the WPA/FAP and the Artists' Union were essentially identical. The conflict between them was in how to reconcile the demands of the Union with the at times inflexible regulations of the Project. This conflict often came to a head when the Project would be forced to cut employment quotas while the Union could point to thousands of artists still without work. As Audrey McMahon, the director of the New York Project, explains in her essay, many procedures were instituted to weigh demands against realities. This relationship, which was national in scope—as the essays by Robert Jay Wolff and Einar Heiberg indicate—laid the foundation for healthy artist-government cooperation which has, unfortunately, not been built upon since the 1930s.

The third phase—from 1939 through to the end in 1943—was, like the first, one of "disillusion and despair," but of a different order. A conservative coalition of Democrats and Republicans in Congress attacked the cultural programs viciously, making them the scapegoats for a strong reaction to New Deal welfare policies. As a result they were placed under partial state control, resulting in their serious curtailment and their later being subsumed into the defense effort as war approached. While the remaining artists protested, there was little that could be done in the face of war hysteria to maintain creative

art programs. The Popular Front disintegrated with the disillusion induced by the Fascist victory in the Spanish Civil War and the Hitler-Stalin pact.[48] As a result, artists clung to the Project as long as they could and then were absorbed into the booming war economy where they became workers in reality—or were drafted.

CONCLUSION

I have tried in this Introduction to outline the history of *Art for the Millions* and to explain how I have edited it, to isolate and comment upon some of the themes contained in the essays which follow, to give the reader some idea of the dynamic though complex period in which the WPA/FAP operated, and to point to the many areas where further research is needed.

I hope the publication of this anthology, over thirty years after it was written, will stimulate interest in the art of the New Deal projects and also in the situation of art and the artist in society today. Art cannot subsist in the vacuum of the "NOW" any more than the millions can mature culturally without learning from the past.

ACKNOWLEDGMENTS

Mrs. Holger Cahill gave me the manuscript of *Art for the Millions* to publish; I thank her for the opportunity. For many years as a curator at the Museum of Modern Art in New York she was the primary source of information concerning the New Deal art projects for those art historians, critics, and students who thought them important. My own interest was first stirred by her "WPA Alumni" exhibition, which the Museum of Modern Art circulated in 1963-64. She has been of the greatest help to my work since. I am deeply grateful to her.

The illustrations in this book come primarily from three sources. The photograph file of the New York City WPA/FAP is preserved in the Smithsonian's Archives of American Art in Washington, D.C. I am indebted to Mr. Garnett McCoy, its Deputy Director, for giving me free access to these original Project photographs and to the dummy and other documents in the papers of Emanuel M. Benson. I am also indebted to Mr. William Walker, Director of the Library of the Smithsonian's National Collection of Fine Arts, for photographs from the Holger Cahill Papers preserved in the files of my former research project, "Federal Support for the Visual Arts: The New Deal and Now," and from the Ferdinand Perret Research Library. Mr. James Moore, Chief of the Audio-Visual Division of the National Archives in Washington, D.C., has also been generous in facilitating my use of the WPA/FAP photographs in Record Group 69.

I want to thank Dr. Belisario R. Contreras of Washington, D.C., the sculptor Robert Cronbach of New York City, Garnett McCoy, and Dr. Gerald M. Monroe of Glassboro State College, Glassboro, New Jersey, for reading a draft of the Introduction and making valuable suggestions, and Mrs. Mildred Baker for help in revising Appendix D.

I also want to express my appreciation to Dr. Joshua C. Taylor, Director of the National Collection of Fine Arts, and to the staff of the Smithsonian's Office of Academic Studies for a Visiting Postdoctoral Research Associateship at the National Collection, under which this anthology was completed.

Finally, I want to thank my research assistants Mrs. Lucy Leitzell and Mrs. Ellen Eisenberg Dissanayake for their help at various stages of the editorial process.

Washington, D.C.
March, 1972

Francis V. O'Connor, Ph.D.
Research Program
National Collection of Fine Arts
Smithsonian Institution

Notes to the Introduction of ART FOR THE MILLIONS

1. This history of *Art for the Millions* is based on WPA/FAP documents preserved at the National Archives in Washington, D.C., in Record Group 69, Series 651.315, boxes 2105 and 2106, and Series 211.5, boxes 443 and 448 (hereafter cited as RG69 plus Series number), and the papers of Holger Cahill in the files of my research project, Federal Support for the Visual Arts: The New Deal and Now, which are deposited in the Library of the National Collection of Fine Arts, Smithsonian Institution, Washington, D.C. (hereafter cited as Cahill Papers).

2. See Holger Cahill, *New Horizons in American Art*, New York: Museum of Modern Art, 1936. (Hereafter cited as *New Horizons*.) Excerpts from Cahill's introduction have been reprinted in Herschel B. Chipp, editor, *Theories of Modern Art*, Berkeley and Los Angeles: University of California Press, 1969, pp. 471-73.

3. See Benson's biography in Appendix A.

4. For example, on November 27, 1936, Benson wrote to Arshile Gorky over Cahill's signature, asking him to write five hundred words on his Newark Airport mural and stating "We will allow you three days of project time in which to write the article. . . ." RG69:651.315.

5. See Cahill's biography in Appendix A.

6. Memorandum from Holger Cahill to Mrs. Ellen S. Woodward, Assistant Administrator, Women's and Professional Division, WPA, December 30, 1936. Cahill Papers.

7. This was The Guild's Committee for Federal Writers' Publications, Inc., whose secretary was Morris Ernst of the New York City law firm of Greenbaum, Wolff and Ernst. The WPA/FAP had sought the Guild Committee's sponsorship earlier for the publication of Berenice Abbott's photographs in *Changing New York*, New York: E. P. Dutton & Co., 1939. The Project's agent in these negotiations was Samuel J. Wallace, of the book manufacturing firm of J. J. Little & Ives Co. The pertinent correspondence is preserved in RG69:211.5.

8. I have used "WPA/FAP" consistently throughout, even though some essays referred to "WPA Art Program." While the latter seemed at first to date an essay after September 1939, it became clear that many of the essays written earlier had been edited to conform with the new title and had then been re-typed. Where an essay was dated by its author, I have given the date in the Inventory in Appendix B.

9. See my *Federal Support for the Visual Arts: The New Deal and Now*, Greenwich, Connecticut: New York Graphic Society Ltd., 1969 (hereafter *Federal Support*), Section II, for a history of the WPA/FAP.

10. Letter to Stuart Davis from Holger Cahill, July 30, 1940. RG69:211.5.

11. The manuscript and related materials sent to Albert Whitman & Co. were returned to Mr. Wallace at J. J. Little & Ives Co. (letter to Editor from John F. McGonagle, Vice President, Albert Whitman & Co., May 23, 1966), and he returned them to Cahill. The dummy of the book and several essays were retained by Benson when he left the Project. He later deposited them in the Archives of American Art.

12. The manuscript of *Art for the Millions* is available to researchers in the files of Federal Support for the Visual Arts: The New Deal and Now. It should be noted for the record that Garnett McCoy first urged the search for the lost manuscript of *Art for the Millions* in the private *Newsletter* of the Archives of American Art, November 6, 1964. I reiterated the plea in *Federal Art Patronage: 1933 to 1943*, College Park: University of Maryland Art Gallery, 1966, p. 42 (hereafter *Federal Art Patronage*).

13. Memorandum, Holger Cahill to Jay du Von, November 14, 1939. RG69:211.5.

14. For other reproductions of art created on the WPA/FAP see my *Federal Art Patronage*; the October 1970 issue of *American Heritage* and my *The New Deal Art Projects: An Anthology of Memoirs*, Washington, D.C.: Smithsonian Institution Press, 1972 (hereafter as *New Deal Memoirs*), as well as *New Horizons*.

15. Two publications of the 1930s also articulate artists' views: the Artists' Union's magazine *Art Front*, published irregularly between November 1934 and December 1937, and the anthology of artists' speeches, *First American Artists' Congress*, New York: Editorial Committee of the First American Artists' Congress Against War and Fascism, 1936 (hereafter: *Artists' Congress*).

16. *Federal Support*, pp. 95-6.

17. *Art as Experience*, New York: Capricorn Books, 1958, pp. 270-71. This book was first published in 1934.

18. Bertram Morris, "Dewey's Aesthetics: The Tragic Encounter with Nature," *Journal of Aesthetics and Art Criticism*, Vol. XXX, No. 2, Winter, 1971, p. 193.

19. *Ibid.*, pp. 193-94.

20. Edward Bruce had been a lawyer, banker, newspaper owner, art collector, and since 1923 a professional painter. Unlike Holger Cahill, whose conception of the WPA/FAP was shaped in part by his lifelong experience as an art historian and museum curator, Bruce understood art as a product, not a communal process, and strongly felt that the Treasury's art programs, and especially the Section (which was funded by a percentage of construction appropriations) were mandated to acquire masterpieces for the government. For a detailed history of the PWAP, Section, and TRAP, see Belisario R. Contreras, "Treasury Art Programs: The New Deal and the American Artist, 1933 to 1943," unpublished Ph.D. dissertation, American University, 1967. Dr. Contreras is currently working on a study of the influence Cahill and Bruce had on the art support programs they administered.

21. *New Horizons*, pp. 11-12.

22. *Ibid.*, p. 13.

23. *Ibid.*, p. 14.

24. *Ibid.*, pp. 18-19.

25. See "The Artist and the New York City Relief System" in *Federal Support*, Section III, pp. 68-79 for a full discussion of this subject.

26. See, for instance, Jacob Kainen, "The Graphic Arts Division of the WPA Federal Art Project," in my *New Deal Memoirs*, pp. 155-75, for a description of these problems.

27. One wonders to what extent Dewey's notion of art as process rather than product might have influenced the attitude the Project displayed toward the art its employees created. The Project's administrative staff was so intent on maintaining its quota and getting that paycheck to needy artists that the art created became secondary to the creating of it and the means of doing so. The Project was a pragmatic construct, an instrument rather than an

institution, a creature of necessity. See Audrey McMahon's comments on this in the "Dialogue" in *New Deal Memoirs*, p. 322.

28. The printmaker Harry Sternberg, in *Artists Congress*, p. 54, put the matter bluntly: "The social effectiveness of pictures may be said to be directly proportional to the size of the audience reached."

29. Professor Jane DeHart Mathews of the University of North Carolina is presently working on a study entitled "Public Patronage and Black Culture: The Negro and the New Deal Art Projects."

30. An excellent discussion of this can be found in Alfred Haworth Jones, "The Search for a Usable American Past in the New Deal Era," *American Quarterly*, Vol. XXIII, No. 5, December 1971, pp. 710-24.

31. Quoted from *The Ground We Stand On* in *ibid.*, pp. 714-15.

32. *Ibid.*, p. 716.

33. This is also true of the nearly 2,000 murals executed mostly in post offices and courthouses under the Treasury programs. See Contreras, *op. cit.* and Erica Beckh Rubenstein, "Taxpayers' Murals," unpublished Ph.D. dissertation, Harvard University, 1944.

34. Mural-scale paintings were created by the Abstract Expressionists, but not on walls. See my "New Deal Murals in New York," *Artforum*, November 1968, p. 49, note 14. This is another problem which deserves further research.

35. From Anton Refregier's diary notes included in a letter to me dated December 14, 1971. The reference to the Renaissance recalls Augustus Saint-Gaudens' similar remark to Daniel H. Burnham when planning the beaux-arts murals and sculpture for the World's Columbian Exposition which opened in Chicago in 1893, that "this is the greatest meeting of artists since the fifteenth century!" See Charles Moore, *Daniel Burnham*, Boston and New York: Houghton Mifflin Co., 2 vols., 1921, Vol. I, p. 47. The relationship of American mural art to both the spirit and style of the Renaissance ought to be explored.

36. See Donald Drew Egbert, *Socialism and American Art in the Light of European Utopianism, Marxism and Anarchism*, Princeton, New Jersey: Princeton University Press, 1967, for a detailed discussion of Marxist theory and its influence on American art.

37. For the quote, see Irving Sandler, *The Triumph of American Painting: A History of Abstract Expressionism*, New York: Praeger Publishers, 1970, p. 10. Gorky's essay here differs substantially from the version published by Harold Rosenberg in *Arshile Gorky*, New York: Grove Press, 1962, pp. 130-32 on which he bases some rather harsh judgments of Gorky on pp. 90-92. He is making a strong point, however, when he suggests in the same place that the tension between concern for art and concern for society in American artists amounted to "schizophrenia." He states: "Almost to a man they were allured by the social principle, at least to the point of allowing it to rule their public vocabulary."

38. "Why an Artists' Congress?" in *Artists Congress*, p. 3.

39. See Gerald M. Monroe, "The Artists' Union of New York," unpublished Ed.D. dissertation, New York University, 1971, and Lincoln Rothschild, "Artists' Organizations of the Depression Decade," in *New Deal Memoirs*, pp. 198-221. For a wide-ranging discussion from the point of view of the literary world, see Matthew Josephson, *Infidel in the Temple: A Memoir of the Nineteen Thirties*, New York: Alfred A. Knopf, 1967.

40. This pattern emerges first in New York City, where roughly one third of the nation's artists were concentrated. The famous Washington Square outdoor sales exhibitions were begun in May 1932 to help needy artists. About the same time, private relief efforts for artists were undertaken. See "Early Work-Relief Programs for Artists" in *Federal Support*, pp. 30-31. By 1933 the artists began to organize. See *Art Front*, November 1934, p. 6.

41. See Contreras, *op.cit.*, p. 58-9, and Monroe, *op.cit.*, Chapter II.

42. Quoted in *Art Front*, November 1934, p. 8. At this time there were sixteen Artists' Unions in major American cities.

43. See Egbert, *op.cit.*, pp. 72, 89-90; and Josephson, *op.cit.*, Chapter 17, "The Writer and the Popular Front."

44. See Thomas R. Brooks, *Toil and Trouble: A History of American Labor*, New York: Delta Books, 1964, Chapters XIII and XIV, and David Brody, "Labor and the Great Depression: The Interpretative Prospects," *Labor History*, Vol. XIII, No. 2, Spring, 1971, pp. 231-44.

45. "May Day and the Artists," unsigned, *Art Front*, May, 1936, p. 4.

46. "The Union Show," signed B.G., *Art Front*, June 1936, p. 13. This, of course, was a result of the more "liberal" policies of the Popular Front.

47. Trotsky stated that the nature of art precluded the Party's controlling it. Egbert, *ibid.*, p. 64-5, comments:

Trotsky was accused by the Stalinists of the deadly sin of "formalism." He was accused, in short, of encouraging art that is abstract, or that is mechanical or experimental for its own sake, art in which the form or the technique is itself the end rather than a vehicle by which suitable socialist subject matter is given a socialist content. The Stalinists therefore increasingly maintained that Trotsky and his followers, in separating form in art from social content, were divorcing theory from practice and thus had become "idealists" who, in believing that mind, ideas, can exist without matter, were ipso facto not true Marxian realists. To put it another way, the Trotskyists were accused of holding that there are abstract ideal principles of formal design which are good for all time and independent of the Marxian laws of economic and social change. Insofar as Trotsky fostered art that was thus "idealistic" as well as radical, he was regarded as a Leftist. However, confusingly enough, art in which form is separated from social content in this way was also considered by the Stalinists to be characteristic of decadent bourgeois culture, and therefore as Rightist in tendency. Consequently, although usually regarded as a leader of the Left, on several counts Trotsky was eventually accused of both Leftism and Rightism.

Needless to say, the ramifications of all this within the Artists' Union and Congress—as well as for the next decade—remain to be investigated. Indeed, Clement Greenberg's essay "The Late Thirties in New York," in *Art and Culture*, Boston: Beacon Press, 1961, p. 230, contains the following parenthetical remark:

(. . . *some day it will have to be told how "anti-Stalinism," which started out more or less as "Trotskyism," turned into art for art's sake, and thereby cleared the way, heroically, for what was to come.*)

The tale has not yet been told.

48. The tale of the psychological effects of the triumph of Fascism in the late 1930s and the impact of that triumph on the arts also remains to be told.

Holger Cahill, National Director of the WPA/FAP, speaking at dedication of James Michael Newell's murals at Evander Childs High School, Bronx, New York, November, 1938. (AAA)

American Resources in the Arts

HOLGER CAHILL

I recall very clearly the first time I heard John Dewey speak. It was on the opening day of a summer session at Columbia University about twenty-five years ago. I was a few minutes late getting to the lecture and found the room crowded with students. Every seat was taken and there were a few standees near the door. The lecturer had just begun to speak. He was seated on a platform at the end of the room, gazing out the window, speaking slowly and hesitatingly, feeling out his words very carefully. I recall that he was speaking of the fact that philosophic ideas have a way of getting translated into programs of action. The atmosphere of the lecture was one of informality and human friendliness. I was not quite sure I had found the right lecture since I had never seen John Dewey before. So I turned to a student standing beside me, a tall young Chinese, and asked him who the lecturer was. He gave me a long look in which I could read mingled surprise and disapproval. Then he said slowly, as he turned away: "The lecturer is Professor John Dewey."

I am not equipped by training or experience to speak of John Dewey as a philosopher. But I think I might venture to take as my thesis one of the ideas expressed in the first talk I heard John Dewey give; something of the influence of philosophic ideas when they are translated into programs of action; something of how the thought of the philosopher makes its way into the homely experience of every day and the common sense of the man in the street.

It seems to me that the ideas of John Dewey, probably more than those of any other philosopher of our time, have been taken as plans of action in the field of everyday activity, and have been translated rather freely into the common sense of the American people. This is due partly to the fact that they are sound, workable ideas. But is is due also to the fact that they are very much in the American grain, that they have been put forward without pretension, and that their author has been neither detached nor withdrawn but has been an active participant in the life and thought and movement of the human society in which his ideas have been born.

The subject of my talk this morning is "American Resources in the Arts." John Dewey and his pupils and followers have been of the greatest importance

33

in developing American resources in the arts, especially through their influence on the school systems of this country. They have emphasized the importance and pervasiveness of the aesthetic experience, the place of the arts as part of the significant life of an organized community, and the necessary unity of the arts with the activities, the objects, and the scenes of everyday life. They have insisted that the teaching of the arts should not be relegated to the frills and the extras, but that it is central in any system of education. They have shown that art education, like art itself, involves activity, that art appreciation can best be taught through doing. Their thought and activity have been of the greatest significance in the organization of contemporary art programs which are stimulating the development of American art resources and making these resources available to wide publics. Among these is the WPA/FAP, of which I shall speak later.

If art is defined, as John Dewey defines it, as a mode of interaction between man and his environment, then we may say that our art resources will fall into three categories: the resources in man himself, the resources in the environment, and the resources which come about through the methods and techniques developed in this particular type of interaction between man and his environment. There is some overlapping in these three divisions, but since no very rigorous classification is here intended, we may keep them.

The first and richest of these resources is in man himself. People are both the producers and consumers of art, and so in a double sense our resources will depend on their activity as creators and participants. Our resources in the environment will consist not only in what artists call "nature" which includes the elemental environments of earth and sea and sky and the visual and spatial aspects of the environments which have been created by human society. It will include also the stored-up environment of the past, the tradition of art which is the result of prolonged and cumulative interaction between man as artist and his environment, and

which, in the form of works of art has become part of our aesthetic environment today. Our resources in the methods and techniques of art will include the conservative ways which accompany the stored-up environment of the past, and the new ways developed by the creative activity of our own time; new methods of handling material, new techniques, new attitudes and points of view toward form and subject. It is in this last division that most of the critical battles of the past generations have been fought. And our generation seems destined to continue along somewhat similar lines. Up to the close of the 1920s the main battles were about technique and form. In the past five years the center has shifted toward subject matter. One hopes that these battles will continue. They serve to enliven critical discussion. In a very genuine sense they can be creative. And they can take place only in a society like ours. Democracies alone can afford to permit differences of opinion, even in aesthetic matters.

What may be said of the art resources we now have in America? We have today a greater degree of creative activity of a high order than we have had at any other time—certainly at any other time with which I am familiar. Hardly a season passes that we do not have a dozen first-rate talents exhibiting work in the metropolitan art galleries. Large national exhibitions such as those at the New York World's Fair and at the San Francisco Fair this year, in their level of technical competence and craftsmanship, and in their catholicity of point of view could not be surpassed by any other country in the world today. Every region of the country sent in work to these exhibitions in painting, in sculpture, and in graphic art, which met the highest standards of professional performance, and which showed sound technical accomplishment, good construction, and spirited expression. There was not a state that did not send in meritorious work to one or the other of these large exhibitions.

I do not know whether these exhibitions discovered any geniuses, nor can I say whether there were any masterpieces shown. Such judgments need

longer perspectives of time. But I do know that the level of performance was high. It seems to me that this is the important thing, not whether masterpieces were discovered. Art is not a matter of rare occasional masterpieces. The emphasis on masterpieces is primarily a collectors' idea and is related to a whole series of commercial magnifications which have very little to do with the needs of society as creator or as participant in the experience of art. Though we cannot tell whether our day has produced masters, or masterpieces, I think we can say that we have a situation in this country which makes it possible for both to appear. One of the things which the history of art indicates is that great art arises only in situations where there is a great deal of art activity, and where the general level of art expression is high. When one goes through European art museums which preserve, in spite of all the destructive forces of time, an extraordinary quantity of works from the past, one is struck by the amount of work produced in the great periods. During the early part of the twentieth century it is said that there were some forty thousand artists at work in Paris. Probably art history will not remember many of these artists. Probably too, if these great numbers had not been working, very few of those who will be remembered would have been stimulated to creative endeavor. And even those who will be forgotten were doing useful work in their own generation.

The creative activity in American art today is enormous. What of the public as appreciator and participant? The history of art seems to indicate that where the general level of art production is high the artist is reaching publics whose standards of taste are equal to his performance. Great traditions of art must have great audiences. As Walt Whitman said, there is a close relationship always between the creative artist and the group for which he creates. In the past the artist usually has produced for minority groups within the community. The standards of his art have been the standards of these groups. This situation has existed throughout the modern period, but in any long view it becomes clear that whole

nations, as much as the individuals and the groups which compose them, may develop standards of taste in the arts. That a large section of the American people is developing standards is indicated in the wealth and the general high level of our art production today. Certainly the American public shows great liberality and catholicity of taste. So far as technique and point of view are concerned the artist should not be held in any conventional channel. He should be free to range from the most conservative academicism to surrealism, abstraction and non-objectivism, and while he may not find a large following everywhere, he is sure of some following, and of a friendly and sympathetic interest.

The American public as participant in the experience of art has developed a wide tolerance and a deep interest. I believe that we have today greater resources of popular interest in the visual arts than at any other time in our history. Several portfolios of fairly good color reproductions of American art of the past and present are now being circulated through our museums, libraries, and schools. In the past month, three or four large books on American art, handsomely printed and profusely illustrated in color, have been published. [1] Hundreds of exhibitions devoted to American art are at this moment being shown in every section of the country. In the past week probably tens of thousands of classes in the arts and art appreciation have met in these United States. It is true that very little of this widespread interest translates itself into patronage, except for the interest of the United States Government—our greatest art patron. But in any event we now have a sweeping renaissance of democratic interest in American art which runs through every economic level of our society, from the richest to the poorest.

This wide interest in the arts, this democratic sharing of the art experience, is a comparatively recent development in American life. It is the devoted work of people who, like John Dewey, believe that democracy should be the name of a life of "free and enriching communion" in which everyone may have

a part. Certainly this broad, democratic community participation in the creative experience is not implicit in the very form of our society, nor in the European societies from which it developed. In the modern period, up to our time, the opportunities provided for the people as a whole to share in the experience of art have been very few. Even today many persons in the art field in Europe and America cannot go the whole democratic way in the arts. They cannot bring themselves to admit, somehow, that art, the highest level of creative experience, should belong to everybody. Many American artists, many American museum directors and teachers of art, people who would lay down their lives for political democracy, would scarcely raise a finger for democracy in the arts. They say that art, after all, is an aristocratic thing, that you cannot get away from aristocracy in matters of aesthetic selection. They have a feeling that art is a little too good, a little too rare and fine, to be shared with the masses.

It is a very human reaction—an illustration of what habits of thinking do to human nature. In most of the experience of our people, art activity has not been carried on as a community enterprise, except by primitive people like the Indians of our Southwest. Among the peoples which have kept alive the European tradition of art since the Middle Ages, the activities of the artist have been related to the ideas and the sensibilities of small groups. Art has, in fact, during the past three hundred years, depended far more upon individual talent than upon tradition or group activity. In the contemporary period, there has been an increasing emphasis upon individual talent, an inclination toward extreme subjectivism and over-personalized expression. The postwar period, both in Europe and America, saw the high point of this tendency. In the past few years there has been a turn toward a more democratic point of view. However, not since the Middle Ages have we had an art that everyone could share.

Our society today does not yet afford a life in which art is intimately connected with everyday vocations. Our democracy has not yet become the life of "free and enriching communion" of which John Dewey speaks. But we hold to that idea as the pattern of a program for our society, and we are beginning to translate it into action. And as a test that our program is possible of fulfillment, we look to those periods in the past which have achieved a degree of community participation in the arts. We look to the Middle Ages, when art was devoted to a subject matter which was of the deepest concern to everyone, when its symbols and allegories had profound meaning for the whole community. We look to the era of handicrafts when the techniques of art were understood by the average man, since in an era of manual production the average artisan and craftsman, through his daily activity, could find a path to the work of the masters. In a society of artisans and craftsmen—among whom the painter and the sculptor moved—the carpenter, the cabinetmaker, the carver of decorations, the painter of houses and furniture, the carriage and wagon maker, all had an understanding of craftsmanship and a feeling for the good joinery and solid construction which are the fundamentals of art. Up to the close of the 18th century, the man who wanted to be an artist could fall back upon the shop tradition of these craftsmen, beginning say, as a chair gilder—an occupation which started a distinguished artist like Chester Harding towards his career as a portrait painter.

I do not think that we have weighed sufficiently the meaning of the change from a handicraft to a machine method of production, probably the most revolutionary change in the history of human society. Its effect upon the arts has been catastrophic. It has divorced the artist from the usual vocations of the community and has practically shut off the average man from the arts.

In our modern industrial civilization, with its lack of unity, its tendency to divide the various activities of life into separate grooves, the arts have been more isolated than ever before. They have been tied to narrow interests and have shown a shifting and broken pattern which reflects the disunity of our age. It is this discrete, gritty, broken experience of our in-

dustrial age to which the upholders of aristocratic detachment in the arts really refer when they think they are referring to the aristocratic ages of the past.

Very few nations of our industrial world have achieved much in the way of community participation in the arts. For contemporary examples of community sharing in the art experience we must turn to societies such as those of the Pueblo Indians of our Southwest. In these coherent societies, art tradition is rooted firmly in community experience, and is kept alive through participation by the whole people. Here official art and folk art are united. If anyone wishes to see what art expression at the level of a whole community can be, let him visit one of the dance ceremonials at Santo Domingo, or Zia, or Cochiti in New Mexico. Here the entire resources of a community, resources of design and color, of rhythm and movement in dance and song and chant, have been poured into a ceremony in which everyone participates. Here is undoubtedly the most moving and impressive example of community expression and community sharing in the arts which our contemporary world affords.

There is nothing like this in the experience of our European stock in America, save possibly in communities of craftsmen like the Shakers, where craftsmanship was almost a form of worship. There has been, however, in various periods of our past an honest search for an art that mirrors the everyday experience, the sense and the sentiment of the American people. We can look back to the seventeenth and eighteenth centuries when homespun American talent, working with homespun materials, and with little more than local handicraft traditions to guide it, produced work which clearly indicates the emergence of native American traits in the arts—works which are still worth our loving study. We have the major development out of that local tradition in our eighteenth century school, which in such paintings as Ralph Earl's awkward and powerful "Portrait of Roger Sherman"[2] reflects the spirit of a people and of a time. Our provincial and genre painting of the nineteenth century, and the whole

tradition of popular and folk art, are related to this earlier tradition and to the interests and the vocations of the common man.

But from the middle of the nineteenth century up to very recent times art has tended to become an activity sharply segregated from the everyday vocations of society. The art object has become more and more a minor luxury product. Our art patrons have sought their art objects, their ideas about art and art patronage in other countries and other times. It has been a period of extraordinary exoticism, an exoticism of time and space, which has ranged through all the countries and ages of the world for the rare, the costly, the ancient. The only country and the only time which were neglected were our own country and our own time. This has become so fixed a social habit that it has been considered a part of our essential human nature. It is as if man as art patron in America were incapable of reacting to his environment and could react only to the stored-up environment of the past. I believe that our art pundits have admired the exoticism of the American collector as an expression of an interest in the universal and the eternal in art rather than in the secular and the merely local. As John Dewey has pointed out, those who contrast eternity with time often are only contrasting present with past time. The emphasis upon the universal and the eternal in art too often has meant that our interest has become attached to aesthetic fragments lost from their contexts in time and in human society.

This exoticism has had serious results for the American artist. During the past seventy-five years there developed in this country a tremendous traffic in aesthetic fragments torn from their social background, but trailing clouds of vanished aristocratic glories. Fully four-fifths of our art patronage has been devoted to it. Now I would be the last person to disparage the work of the masters of past time, but it seems to me that it is a very strange affair when a country neglects its living artists and gives most of its support to artists long dead. Suppose the economic affairs of the nation were conducted in that way.

Suppose most of the national income were spent for goods and services produced in Europe or Asia. National bankruptcy would be a matter of hours. This is a crude example, but it helps to explain the desperate position of the American artist when the United States Government art program was organized a few years ago.

Because, during the past seventy-five years, the arts in America have had to follow a path remote from the common experience, our country has suffered a cultural erosion far more serious than the erosion of the Dust Bowl. This erosion has affected nearly every section of the country and every sphere of its social life. There has been little opportunity for artists except in two or three metropolitan centers. With the exception of these centers, the country has been left practically barren of art and art interest. The ideas and the techniques of art have become a closed book to whole populations which have had no opportunity to share in the art experience, and which, in our industrial age, have become divorced from creative craftsmanship.

During the late 1920s many artists, museum directors, educators, and critics became deeply concerned over this situation. They have helped to stimulate currents toward an art of native social meaning which would relate art to the ideas and vocations of everyday life and help to bridge the gap between the American artist and the American public. Some of these currents may have flowed a bit too strongly in the direction of chauvinism, but on the whole the direction has been good. Museums devoted to American art have been founded, and there have been some really splendid new developments in art education. There has been a great effort to conserve and develop America's resources in the arts and to make these resources available to the public. The effort has been directed both toward the producer of art and the public which consumes it. No other group has been more effective in this effort than the progressive educators who have been influenced by the thinking of John Dewey.

In the past six years the groups working for an art program which would release the creative forces of our country and make art participation possible for the whole people have found a powerful ally in the United States Government as art patron. A government art program is hardly a new phenomenon. Governments in every age and in every part of the world have employed artists. Egypt, Greece, Rome, many of the governments of medieval and modern Europe, governments in China, and other Oriental countries, as well as the governments of our ancient American civilizations, all employed artists. The Acropolis at Athens was a government art project. Since the seventeenth century most of the governments of Europe have inaugurated art programs. The French government has long had a liberal policy of encouraging art and public education in art, as have Italy, Germany, Russia, and other European countries. In Sweden a finely planned program has long been established, leading to an outstanding development of the industrial arts in that country. Government support of art was undertaken in a striking fashion in the 1920s by the Republic of Mexico. A group of Mexican painters was commissioned to paint murals for public buildings under the direction of the Ministry of Education. From the work of that group came an art movement which spread through the country and far across its borders, carrying the fame of Mexico to every part of the world.

During this century, government support of art has become well-nigh universal. The United States Government's effort however, has differed considerably from other art programs, both in extent and significance. At its very beginning it received the impetus of two powerful forces which helped to establish its character. One of these is the Mexican mural program of which we have spoken. The other is the philosophy of John Dewey. The Mexican mural program revealed to us the spirit of a nation, gave us a more profound understanding of the people of our sister republic, and at the same time enriched the creative life of our own land by giving us a living example of an art of native social meaning. Here is a dramatic illustration of John Dewey's saying that art

is the most civilized form of communication and the best means for entering sympathetically into the deepest life experience of other peoples.

An art program, like the creative activity of the artist, must find a medium and move in an environment. In this case medium and environment are to be found in the people themselves, the actions, habits, thoughts, and feelings of men and women. If this medium and environment proves unsympathetic the program will fail. If channels have not been prepared for it, or may not be prepared without excessive effort, it cannot become a useful stream, but will run into the sands of indifference and neglect. The United States Government art program was fortunate in finding a sympathetic environment. The activity of the artists, museum directors and progressive educators had prepared the way. The ideas of John Dewey had influenced teachers in every section of the country, and had become part of the thought-pattern of hundreds of American artists and millions of the American people. Channels had been opened everywhere. What happened when the government inaugurated the WPA/FAP has been beautifully stated by Archibald MacLeish, in an article in *Fortune*. I quote:

What the government's experiments . . . actually did, was to work a sort of cultural revolution in America. They brought the American audience and the American artist face to face for the first time in their respective lives. And the result was an astonishment needled with excitement such as neither the American audience nor the American artist had ever felt before. Down to the beginning of these experiments neither the American audience nor the American artist had ever guessed that the American audience existed. The American audience as the American artist saw it was a small group of American millionaires who bought pictures not because they liked pictures but because the possession of certain pictures was the surest and most cheaply acquired sign of culture. Since all pictures, to qualify, must necessarily have been sold first for a high price at

Christie's in London, this audience did not do much for American painters. . . . From one end of the range to the other, American artists, with the partial exception of the popular novelists and the successful Broadway playwrights, wrote and painted and composed in a kind of vacuum, despising the audience they had, ignoring the existence of any other.

It was this vacuum which the Federal Arts Projects exploded. In less than a year from the time the program first got under way the totally unexpected pressure of popular interest had crushed the shell which had always isolated painters and musicians from the rest of their countrymen and the American artist was brought face to face with the true American audience. . . .[3]

And this American audience has demanded the Project artists' work in extraordinary quantities. Since the very beginning of the WPA/FAP, every project has had to have local sponsorship to the extent that the community has contributed materials, tools, supplies, working space, etc., so that the production which has been stimulated has represented a genuine demand as expressed not only in terms of interest and appreciation, but also in terms of cash. This fact gives special emphasis to the production figures of the Project.

These include, in the purely creative field, over 1,400 murals installed in buildings throughout the country; some 50,000 oil paintings and watercolors and 90,000 prints on permanent loan to schools, libraries, hospitals, community centers, and other public agencies; and some 3,700 sculptures designed for public buildings. Project artists have produced in the allied arts 975 large dioramas and models to be used in schools, 39,125 map drawings and diagrams, 15,300 lantern slides, 52,100 arts and crafts objects, 495,620 documentary photographs, and 850,000 reproductions of posters from 28,000 original designs. The WPA Community Art Center program has given six million people in every section of the country some understanding of the significance of art in the life of the community.[4]

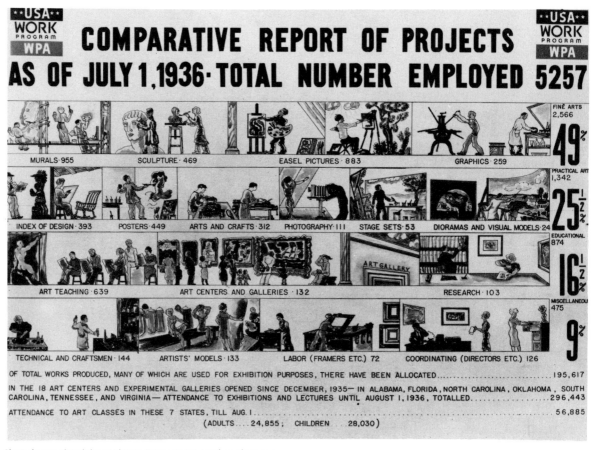

Chart showing breakdown of WPA/FAP activities and employment
at their peak in 1936. (NCFA:Cahill)

These are large figures. I mention them only to show that there has been an active and consistent demand for Project work and Project services. But figures alone cannot give even a hint of the vitality and creative drive of the Project. The rise and abundance of artistic talent in every section of the country has been heartening to all those who have the welfare of the Project at heart. This creative drive has been stimulated and maintained because the Project has held to the idea of the unity of art with the common experience, the continuity between "the refined and intensified forms of experience that are works of art and the everyday events, doings, sufferings, that are universally recognized to constitute experience"; because the Project has encouraged the closest possible collaboration between the artist and the public for which he works; and because it has held firmly to the idea of the greatest degree of freedom for the artist.

On this subject of freedom I should like to read to you what a distinguished American painter, George Biddle, says about the Project in his *An American Artist's Story:*

It is the first time in history that many thousands of artists are working completely without censorship, without even the indirect censorship of the art dealer or the collector. I believe this is the most quickening impulse in painting alive in the world today. I believe that it will form a record of the deepest value. . . .[5]

In its program of encouraging collaboration between artist and public, the Project has discovered that such a simple matter as finding employment for the artist in his hometown has been of the greatest importance. It has, for one thing, helped to stem the cultural erosion which in the past generation has drawn most of America's art talent to a few large cities. It has brought the artist closer to the interests of a public which needs him, and which is now learning to understand him. And it has made the artist more responsive to the inspiration of the country, and through this the artist is bringing every aspect of American life into the currency of art. The direct response of the artist to his environment is a thing to be encouraged, it seems to me, for it is the artist, as John Dewey says, who keeps alive our ability to experience the common world in its fullness.

Let me read you what two Project artists have written about their reactions to the world of their everyday experience. One of these artists, William Sommer, is a man over seventy. He writes:

I live in Northfield, Ohio, twenty miles from Cleveland, in a state that gives all it has to the artist — ever-rolling hills, miniature valleys, old farm houses, cattle grazing around immense barns with small towers, towers which do away with the straight lines on the roof, towers that simply must be put into the general scheme, beautiful in form and eternal in simplicity. The farm folk never disturb me as an artist in my work, but welcome and instinctively respect what I represent. This, then, is my background.[6]

I think I have seen every painting this artist has produced for the Project, and in my opinion they are

beautiful and sensitive records of the Ohio farming country, as clear and honest and straightforward as the statement which I have just quoted.

The other statement is that of a brilliant young Boston artist in his early twenties named Jack Levine. He has painted a number of powerful and searching scenes of city life for the Project. He says:

Essentially a city dweller, I find that the aspects of man and his environment in a large city are all I need to work with. I find my approach to painting inseparable from my approach to the world. Justice is more important than good looks. The artist must sit in judgment and intelligently evaluate the case for any aspect of the world he deals with. The validity of his work will rest on the humanity of his decision. A painting is good for the very same reason that anything in this world is good.

I feel the sordid neglect of a slum section strongly enough to wish to be a steward of its contents, to enumerate its increment — newspaper, cigarette butts, torn posters, empty match cards, broken bottles, orange rinds, overflowing garbage cans, flies, boarded houses, gas lights, and so on — to present this picture in the very places where the escapist plans his flight.[7]

These statements express very clearly the differing attitudes of an artist interested in the American scene and an artist interested in social comment. But both, in their differing points of view, relate their art directly to their immediate environment. The mural painter, who is engaged in creating a monumental art for America, will have still another point of view. Let me read you something written by Mitchell Siporin, of Chicago, one of the most brilliant young muralists the Project has developed. He says:

The midwestern painter and sculptor of the immediate past attached himself at first to the Greeks and to the artists of the Renaissance. Then there were the English portraitists, and later the dainty swish of a Bouguereau nude, descending from the bath, rustled

through the art salons on the shores of Lake Michigan. And much later, the 'isms' of a modern world: impressionism, expressionism, futurism, and even dadaism. Today, we young midwestern artists are at work on a native epic in fresco

Ours is the story of Labor and Progressivism, of Jane Addams and Mary McDowell, of Eugene Debs and Robert LaFollette, Sr., of Vachel Lindsay and Theodore Dreiser, of Haymarket and Hull House.

We are only now seeking out our myth and with our growing maturity as painters, we will develop towards a formal pattern for the things we say that will bind us closer to those to whom we speak. [8]

Here is the odyssey of the American artist in our time.

Artists such as these have contributed immeasurably to the aesthetic resources of our country. I wish I might tell you more fully of their work in painting, and sculpture and printmaking and teaching, of the thousand and one activities in which they have engaged in creating a great popular art program. But there is not time. The WPA/FAP has a great variety of projects, gauged to the skills and the talents of the artists it employs, and the needs of the public which it serves. I should like, however, to mention two of these activities—the Index of American Design and the Community Art Center program, for both of these have been affected by the thinking of John Dewey, and have been assisted by progressive educators who have come under John Dewey's influence.

A nation's resources in the visual arts are not confined to painting and sculpture and printmaking. They include all the arts of design which express the daily life of a people and which bring order, design, and harmony into an environment which their society creates. These will include the whole range of the decorative and useful arts, from the shaping of a teacup to the building of a city. This view of American art has given direction to the activities of the Index of American Design. The Index, started in the fall of 1935, is recording, by means of carefully documented drawings, our design heritage from the earliest days of the colonization to the close of the nineteenth century. Ten thousand of these drawings have been completed. Thousands of photographs have been made and extensive bibliographies on American design have been compiled. Some three hundred and fifty artists in every section of the country are carrying on this work. The WPA/FAP will make this material accessible through libraries, museums, and schools to give the student, the teacher, the research worker, and the general public opportunities to become familiar with this important phase of the American culture pattern.

The Index of American Design represents an endeavor to recover a usable past in the decorative, folk, and popular arts of our country. This record of the arts of our people is an accompaniment to the widespread movement that has been going forward in literature and in music to awaken a realistic and vivid appreciation of the American past. The Index is rediscovering a rich native design heritage which we had all but forgotten in our frantic and fashionable search for aesthetic fragments of European and Asiatic civilizations. The Index is a record of objects which reveal a native and spontaneous culture. It gives us a broad view of this American cultural heritage embraced between the linear purity and almost magical proportion of Shaker craftsmanship and the Latin gaiety and color of Southwestern design; between the bold strength of the ship's carver and the delicate perfection of embroidery. In its drawings of the work of hundreds of unknown and humble artisans, the Index of American Design shows the continuity of the aesthetic experience with the daily vocations of the American people. The enthusiasm and surprise which has greeted exhibitions of Index material throughout the country reveals that our people have a deep affection for these arts of the common man. They seem to recognize that these arts fit very closely into the context of our democratic life, as, for instance, the thought of Thomas Jefferson fits into the context of our democratic ideas. [9]

In a pamphlet entitled "Education and the Worker Student," by Jean Carter and Hilda W. Smith, there is a comment of a worker student on education. He says: "I have never had much use for education. I thought it couldn't be worth very much if those who had it didn't care enough to pass it along."[10]

In no field of education has this lack of "caring to pass it along" been more evident than in the field of art. This in spite of the fact that our universities probably do more about art teaching, especially the teaching of art history, than any others in the world, and that our schools have done a great deal about art education, particularly the schools where the influence of John Dewey has been felt. But by and large American communities have had little opportunity to share in the art experience. This is particularly true of the poorer sections of our large cities and of almost every community outside the orbit of a few favored metropolitan centers. But the eagerness to share in the experience of art is not confined to the large cities, to any one section of the country, or to any special group in the community. This has been proved by the response in seventy American communities from Key West, Florida, to Spokane, Washington, to the Community Art Center program of the WPA/FAP.

The core of the community art center idea is active participation, doing and sharing, and not merely passive seeing. If genuine learning in any field can be achieved only by doing then this is certainly true of the visual arts, whose techniques demand a coordination of brain and hand and eye. The WPA Community Art Centers emphasize learning through doing. As inherently American as a New England "town meeting," every art center is a part of the life of the community. It acts as a center for community life where the amateur may share with the professional in the rich experience of creative expression. It provides a friendly meeting place, with workshops, galleries and lecture rooms where the unity of the arts with the activities and the objects of everyday life may be realized. There are exhibitions both local and national in scope, lectures on art,

demonstrations in art media, hobby club activities, participation of various age groups in painting, sculpture, and the arts and crafts according to individual temperament and skill. There is also an active interest in community problems such as housing, landscape gardening, and town planning, and the decoration and furnishing of the home.

Every effort has been made to adapt the community centers to regional needs and interest, ranging from the native handicraft skills in the Southern mountain sections and in states like New Mexico, to the technical problems and hobby interests of industrial communities. This adaptation to community needs is important, but most important of all is the spirit of cooperative learning and sharing which has characterized the art center movement throughout. The seventy communities in which art centers have been organized have expressed their approval of the program by contributing nearly half a million dollars in the past three and a half years. During that time more than six million persons have attended art classes, art demonstrations and lectures, exhibitions, discussions, and various forms of group activity in the centers. This program as it continues will serve to naturalize art in many American communities hitherto barren of art and art interest. It should serve to stimulate American creative workers and provide greater resources in art for the American people.

The resources for art in America depend upon the creative experience stored up in its art traditions, upon the knowledge and talent of its living artists and the opportunities provided for them, but most of all upon opportunities provided for the people as a whole to participate in the experience of art. American art has a tradition that has endured through many changes, a usable past that is a powerful link in establishing the continuity of our culture. We must look to American scholarship to study and evaluate that tradition. American art today is searching for methods which will guide the American people in bringing order, design, and harmony into

the environments created by our society, and it is searching for forms and symbols and allegories which will reveal the character of American life and the American people.

Certainly American life and American character can never be expressed once and for all, but will be relearned and expressed again and again with fresh vitality and revelation. It is to the creative talent of our own day that we look to provide us with the fresh and unfolding revelation of our country and our people, for the expression of those qualitative unities which make the pattern of American culture. And it is our hope that the philosophers and educators of America, men like John Dewey and the progressive educators who have done so much to release our art resources, will help with their ideas, their example, their strength to provide a better environment for the American artist, to provide wider opportunities for the American people to participate in the experience of art. For it is our conviction that along that path we will move toward the life "of free and enriching communion," envisioned by John Dewey as an ideal for American democracy.

Editor's Notes to Cahill Foreword:

1. Cahill is referring here to Peyton Boswell, Jr.'s *Modern American Painting*, New York: Dodd, Mead & Co.; Forbes Watson's *American Painting Today*, Washington, D.C.: American Federation of Arts; and *American Art Today* and *Frontiers of American Art*—the last two the respective catalogs of exhibitions at the New York and San Francisco World's Fairs. All were published in 1939.
2. This painting is in the Yale University Art Gallery.
3. "Unemployed Arts: WPA's Four Arts Projects: Their Origins, Their Operation," unsigned, *Fortune*, May, 1937, pp. 108-17ff.
4. These figures are for the period 1935 to 1939. See Appendix C for final WPA/FAP production figures through 1943.
5. Boston: Little, Brown & Co., 1939, p. 279. Biddle italicizes these sentences in his book and ends the last sentence with the words "to the psychologist or art critic of future generations."
6. See complete essay below, p. 128.
7. See complete text below, p. 120.
8. See complete essay below, p. 64.
9. See Erwin O. Christensen, *The Index of American Design*, New York: Macmillan, 1950, which has an extensive introduction by Cahill.
10. *Education and the worker-student: a book about workers' education based upon the experience of teachers and students*, New York: Affiliated Schools for Workers, Inc., c. 1934.

PART I
THE FINE ARTS

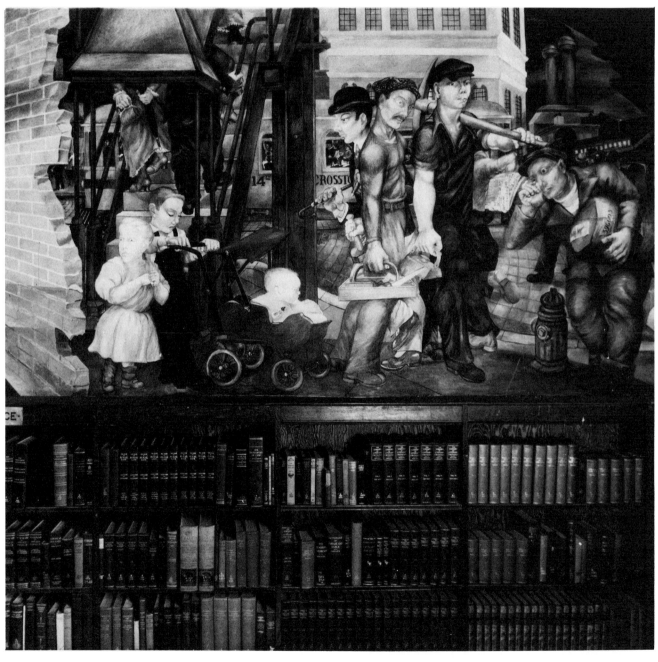

Philip Evergood. *The Story of Richmond Hill*. Detail of mural, oil on canvas, Richmond Hill Public Library, Queens, New York, c. 1936. (AAA)

Concerning Mural Painting

PHILIP EVERGOOD

In thinking about mural painting and its development from the earliest prehistoric beginnings in the caves of Southern France, through the early Florentine period when such great hands as those of Fra Angelico, Lippo Lippi and Masaccio wielded the brush, to Eugène Delacroix, the last great nineteenth-century European exponent of mural art, one can't help being impressed, and not a little shocked, by the fact that with all our exciting past, with all our crammed history books, brave deeds, and great accomplishments, we Americans had managed to exist without a real mural art for so many generations.

One marvels also, that such innocuous mural illustrations as Edwin Abbey's for the Boston Library, and those of the modish-mannered Sargent on a nearby wall, could captivate the imagination of such a young and virile nation as ours. It is safe to say that no monumental mural painting had been executed in the western world before the recent great and sweeping movement in this field took place in Mexico twenty years ago under the leadership of men like Orozco, Rivera, Siqueiros.

An interesting fact to be observed in comparing the development of painting in this country with that in Europe, is that in Europe the embellishment of walls was the first and most elementary concern of the artist. His first exciting pictorial adventures in color and design were made on the walls of dwellings. Easel painting in Europe developed from the mural. In this country easel painting had reached a comparatively high standard of quality before the humble wall seemed worthy of the painter's art. Perhaps this was the result, in part, of the lack of a true, uninfluenced native architecture in this country until the invention of the skyscraper. It is possible that the present interest in the art of the mural derives from the important part modern architecture plays in our everyday life.

A more logical reason for the slow development of interest in mural painting in the United States may be outlined as follows: Our early art consisted of a folk art which was the natural free expression of the spare-time worker who carved a beautiful chair, beat a weathervane out of copper, or painted a crude but expressive portrait. These amateur artisans were

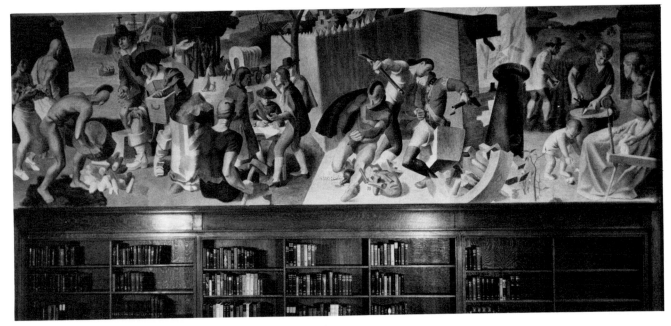

James Brooks. *Acquisition of Long Island*. Mural (destroyed),
tempera on gesso, Woodside Public Library, Queens, New York,
c. 1936. (AAA)

farmers, fishermen, etc.—their houses, churches, and community buildings were of rough-hewn wood (not of brick and stone like those of the earlier and older civilizations) and were therefore unsuitable for murals. The professional artist, at this time, was a carryover from the genre painters of Flanders, France, and Germany, who painted familiar scenes of everyday life and sold them to the merchant, the farmer, and the peasant. He was a "speculative" painter.

As industry and the machine developed in this country, the factory and sweatshop gradually claimed the folk artists, and the professional painter found himself catering to a rich and select audience—he became a "precious" painter—concentrating on exquisite quality in small scale—and because he got closer to preciosity and farther away from the public as a whole, he got farther away from the mural, both in scale and in aim. The mural, by virtue of its physical characteristics (being of large scale on a wall where it is on permanent public display), belongs to a people's audience.

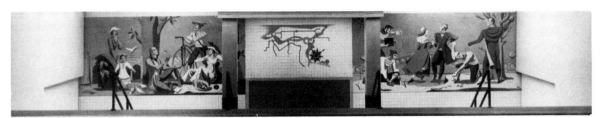

Anton Refregier, Sketch for a subway mural. New York City Project, c. 1939. (AAA)

Whether our country's growing interest in the mural is predominantly the result of Mexican pollen which has been wafted northward on the breeze or due to an inner compulsion of our own artists to extend their appeal to a larger audience is a disputable point, but two things are certain: First, that our artists are unquestionably indebted to the Mexican artists who have brought to life the sound and permanent techniques of the ancients; second, that the economic depression and the consequent birth of the WPA/FAP has done more in five years for mural painting, and more for the closer understanding between the American artist and his public through the medium of the mural than any individual efforts could have accomplished during a much longer period.

Today throughout the length and breadth of our country we see new and virile mural talents coming to the fore. Our young artists never would have had the opportunity, on such a large scale, to embellish the walls of public buildings had not the government supplied a living wage to them and the public institutions supplied the bare walls and the cost of materials.

Also, the artist living in this highly mechanized and technically advanced country of ours has become aware of new and necessary fields for the mural—take the subway for example. A group of Project mural painters has been experimenting in the past year or two with three processes which will resist the dampness, vibration, and modern cleaning methods used in the subways. An important exhibition of this work, in glazed tiles, enamel fired on sheet iron, and silicon ester paint applied to concrete, was exhibited at the Museum of Modern Art last year.* The completion of experiments in these techniques and the ensuing process of perfecting these new methods has definitely established the practicability of murals for subways.

For the final blossoming of a distinct and great American mural tradition, we need time. Time and the assurance that our government art projects will continue on a permanent basis. Great strides have been made toward establishing this American mural tradition as a result of this encouragement. Let us hope that the American artist will be given the chance to complete the experiment and to build mural monuments which will rival the great works of the past.

*This exhibition, called "Subway Art," was held at the Museum of Modern Art, New York, from February 8 to March 7, 1938.

The Development of American Mural Painting

GEOFFREY NORMAN

Except as a popular and provincial art of no pretensions, mural painting was not generally practiced in the United States before the close of the nineteenth century. It is true that certain European painters were employed to decorate the National Capitol and several other public buildings, and there were, here and there, local artists who decorated the walls of private homes. But to no appreciable extent was mural painting used or considered for wide use in public buildings.

In the 1890s a small group of American artists who had spent much of their lives abroad decided to promote mural painting in this country. They noted the local acclaim accorded by Bostonians to the murals of the Frenchman Puvis de Chavannes, the Englishman Edwin Austin Abbey, and John Singer Sargent, the expatriate American. So in 1895 Charles Lamb, William Hunt, Frederic Crowninshield, and others founded the National Society of Mural Painters, in order to "establish and advance the standards of mural decoration in America; to promote cooperation among mural painters; to represent the interests of mural painters in major public issues; and to hold exhibitions and encourage sound education in mural decoration." The Society has functioned continuously ever since, maintaining a close association with the Architectural League and membership in the Fine Arts Federation of New York, which dates from the same year. Among its past presidents we find John LaFarge, Edwin Blashfield, John W. Alexander, Kenyon Cox, and in more recent years, Ernest Peixotto, George Biddle, and Hildreth Meière.

It was indeed a small band of artists who first assembled to promote and advance the standards of mural painting, and their task was difficult. Mural art was devoted to the classics, and the romantics wandered over the face of the walls. Monumental allegory was the established theme, and as such lent itself to the dignified ornamentation of public buildings. The Church was the principal source of patronage. The use of murals in public buildings was still an innovation. In the '90s Puvis de Chavannes captured the mind of the American architect who admired the mild and delicate tones that adorned the walls so quietly. The gentle, the innocuous, became the accepted style for allegory—the decorative illustration (after Abbey) became the recognized style for historical subjects suitable for libraries. For nearly a generation, American mural painting was tied to these two conceptions and lacked the impulse to break away from the convention.

During this period an artist found few opportunities to decorate walls unless he had the background of a Prix de Rome scholarship and he could look forward at best to years of work as assistant to one of the few well-known established muralists. The architects dominated the American Academy at Rome, they controlled the mural-painting field in this country, and they directed the development of the student of mural painting through the atelier maintained by the Society of Beaux Arts Architects. The painter was brought in to do a job under instruction, and very few architects had the vision to let him experiment with new styles. The public generally was apathetic.

In the 1920s a revival of interest in the arts was

manifest, paralleling an unprecedented increase in national income. The World War caused a gap that severed many ties, traditions, and conventions, and artists began to look at the problems of wall painting differently. Ezra Winter, after his return from Rome, startled New York with his decorative ceiling for the Cunard Building and won instant recognition. Hildreth Meière decorated the dome of the Nebraska State Capitol with mosaic designs, and Eugene Savage's stylized murals for Detroit showed that mural painters were beginning to think along different lines.

Then in the early 1930s a brief incursion into the United States was made by the Mexicans who had rejuvenated mural painting in their own country. They opened our eyes to the possibilities of mural painting by demonstrating a simple return to the methods of the old Renaissance masters, that of

Marion Greenwood. *Blueprint for Living*. Mural (destroyed), fresco, in lobby of Community Center Building, Red Hook Housing Project, Brooklyn, New York, 1940. (Courtesy of the artist)

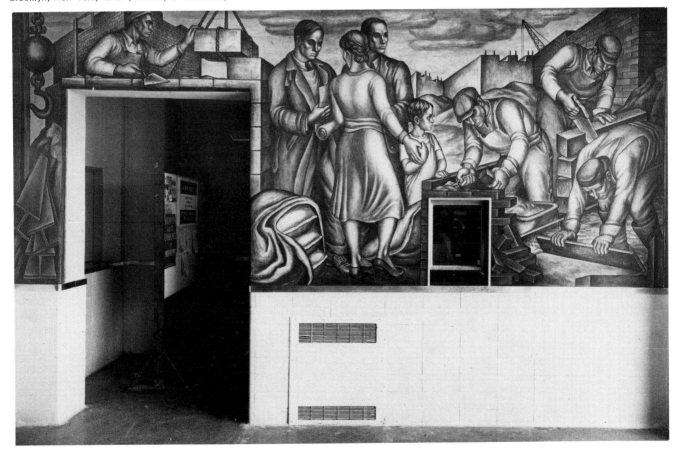

painting in strong but simple terms a simple message of universal interest. Public imagination was caught and held.

Olin Downes, speaking of the tone poem "Finlandia" by Sibelius, once remarked that most composers today write for an audience of music critics, but that only a great man can write music that will be loved and understood by all the people. Orozco, Rivera, and Siqueiros demonstrated how truly this applies to the art of mural painting.

Imagine then the sensation caused by the WPA/FAP. Artists were given walls to decorate not in imposing banks or state capitols, but in schools, hospitals, libraries, prisons, in every part of the country, and they responded with enthusiasm. With this a new realization came to the artist; he was no longer painting for an architect, or for a board of directors, but for the United States Government, which asked him to talk to the people in a language they could readily understand, and about everyday subjects with which they were familiar. This basic policy established by the Government, of painting for the people, actually founded a movement in this country that has done more to awaken an art interest in the masses than could possibly have been calculated. It placed painting on a level with the millions of passersby who had never thought about it before, but now began to pay attention, because it was there for them to see. Today a new type of artist has developed who thinks and paints naturally in terms of this new public.

Through continued employment at their own profession good painters are developing so rapidly that the impact of their work is being felt from coast to coast. The younger men are benefiting by close association or group effort and technical skill and knowledge of different media has become widespread.

The tendency is growing for artists to leave the big cities where they have always congregated, and to settle (or remain) in the West or Middle West, where the public is becoming more and more receptive to their profession. This decentralizing of artists, if it continues, will be one of the greatest forces for public education in the arts; and coupled with the scores of art centers operated by the WPA/FAP all over the country for the benefit of local communities learning to participate, bids fair to root the contemporary art movement deeply in the lives of the people. It has achieved remarkable results during its comparatively short existence, and its success can be directly attributed to this basic policy of painting for the people, by the people. Its public has been "the man in the street," and it has reached out into this vast section of humanity with programs designed to awaken interest and to encourage participation in the arts as a means of enjoyment and relaxation. The Section has also contributed to the movement by employing artists, directly or through competition, to paint murals for post offices and other federal buildings.

A public that is conscious of and susceptible to art is a potential patron, and there lies the economic significance of this great movement now in process of evolution. For it is true that art cannot be imposed on any people but must evolve as an expression of its own life and work. The artist will become an important influence in his community and will receive the support and respect for his ability that he deserves, so long as he paints in terms that will stir the imagination of his public. That the mural as an art form is here to stay is evident from the general approval expressed by countless communities.

And so we pause to survey the future of mural painting. It lies in a continued government art program, public and private housing, and industry.

Public housing, or what George Howe* calls the "expanded dwelling," with outdoor community play areas and indoor halls and auditoriums, offers a splendid chance to utilize the mural as a functioning

*The distinguished architect George Howe (1886-1955) designed the first air-conditioned skyscraper with William Lescaze in 1932 for the Philadelphia Savings Fund Society. He later worked for the U.S. Public Buildings Administration and was chairman of Yale University's Department of Architecture.

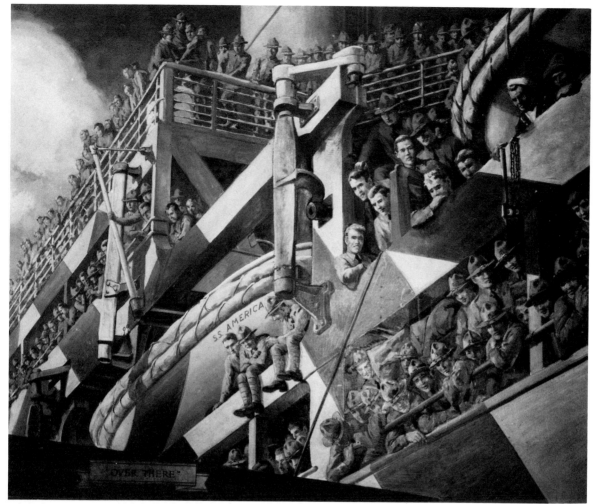

Earl Lonsbury. *Over There*. One mural panel (lost?), oil on canvas, from series titled "History of the 165th Regiment in American Wars," in the 165th Regiment Armory, New York City, c. 1936. (AAA)

factor in the architectural plan.

Unfortunately, the architect, as a general rule, dislikes the use of mural decoration in his modern house and appears to feel the lily is better ungilded. Both he and the mural painter have yet to collaborate sincerely and effectively. The architect must be convinced that his beautiful wall areas are not sufficient in themselves aesthetically and the mural painter must learn to relate his work completely to its environment. The decoration cannot be separated from the Greek vase without injury to the aesthetic whole. The little box-like rooms of Pompeii could ill afford to lose their wall paintings. The ceilings of Pintoricchio bring joy to the cold stones of Rome and Siena.

Most modern homes are well furnished with low comfortable furniture and functional kitchens and plumbing. Adequate thought has been given to the beauty of texture and surface treatment—but no one seems to know what to do with the walls. Ask any modern home owner and he will agree. No painting with a frame around it can be brought in and hung satisfactorily on the wall area that was not planned proportionally to receive it.

Architecture becomes more functional and the style more and more unsuited to the pictorial appliqué mural. It is possible to foresee the mural medium eventually restricted to the materials of building—paint, plaster, terra cotta, enamel on sheet iron, metal, wood, glass, and light. More thought could well be given by the architect to the enhancement of the wall with color and form exquisitely considered and planned for incorporation in the wall surface at the time of the wall's construction.

The so-called "abstract" wall painting, so often slandered, has not been given a fair trial. This type of

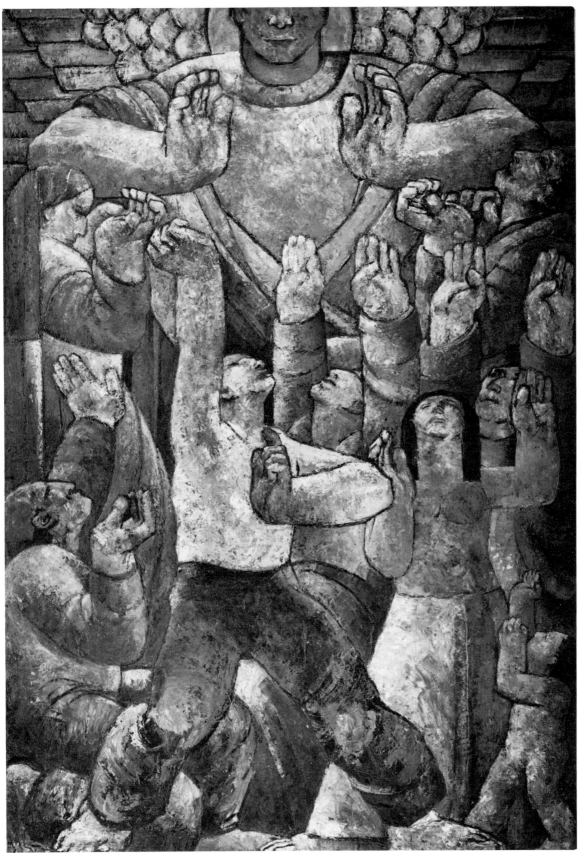

Darrel Austin. One of four mural panels (lost), oil on canvas,
symbolizing "The Evolution of Education" in the Medical School of
the University of Oregon, Portland, c. 1937 (NCFA:Cahill).

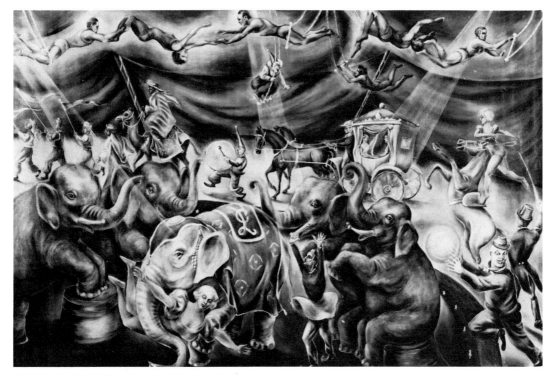

Albert Sumter Kelley. *Circus Parade*. One of a series of mural panels (lost), oil on canvas, in the children's ward of Lincoln Hospital, New York City, c. 1940. (AAA)

work might better be defined as a pattern of carefully planned and related two-dimensional areas of color, form, rhythm, so proportionally arranged and balanced as to complement and enhance the three-dimensional area they decorate. Painting of this type is usually nonrepresentational, although the forms are frequently reminiscent and convey a mood through suggestive form patterns. In this country a large group of young painters are ready for the opportunity to collaborate with architects in such a demonstration.

Indicative of the presently narrowing gap between the sculptor and the painter where wall surfaces are concerned is a talk I had recently with a well-known ceramic sculptor who told me that he had been commissioned to decorate an exterior wall some 70 feet in length by 10 feet in height. He intended to carry it out in very low relief and intaglio, some sections being flush with the wall surface. The terra cotta was to be highly colored in places with glazes, and he found himself faced with a real mural problem, many elements of which were new to him as a sculptor used to working in the round. There are plenty of capable young mural painters today who are branching out into mosaics and colored cements and are aware of the limitations of metal and other new media they may wish to incorporate in their designs.

There is a challenge here for the architect with vision.

But the great potential patron of the mural profession is industry. Industry makes a business of understanding public taste and basing its consumer appeal thereon. Industry is already taking note of the general growth of art interest and sooner or later will capitalize on it by the expenditure of large sums of money for the finest work that artists of the country can produce. Just as it now spends millions each year for talent on the radio to dramatize its products, so it may come to employ the mural painter to fulfill a similar function by decorating the exteriors of its plants, warehouses, and office buildings.

It may be argued that this will debase the art, but I have sufficient confidence in the younger generation of mural painters to feel that it may be the means of developing a great new school of muralists, working not in allegory but in facts closely affecting the daily life of the people. So mural painting would seem to stand on the threshold of a great future and will realize its possibilities so long as it continues to relate itself simply and sincerely with the common culture of the country. Its language is universal and it can therefore speak with authority. That it speak also with beauty and strength must be the ambition of the artists in whose hands this great responsibility rests.

California Mosaics

JEAN GOODWIN

Designs and pictures made from many pieces of stone or ceramic material, held together in a cement, have been used to decorate floors and walls since the most distant times. Each culture which used the art of mosaic employed only those materials which were available and which lent themselves to an art expression that was typical of the time. Some influences in style and technique originating in one nation spread to other nations of the same period; and some were still evident in cultures of later periods. Many times the craft died down, only to be revived centuries later on some rising tide of human feeling. Today we are witnessing just such a revival— and in California there is an unusual activity which is writing a new chapter in the history of this age-old medium.

This ancient craft is the heritage of the contemporary artist. In the twentieth century, artists exploring for a means of expressing the spirit of their age, and being concerned with the creative elements beneath representation that live in all great art, rediscovered the richness and strength latent in the mosaic medium. In California—so like the Mediterranean lands where rich glowing decoration seems to fit the brilliant skies—many artists, in their search to find the media best suited for walls, simultaneously rediscovered the potentialities in mosaic.

Ray Boynton introduced mosaic ten years ago in a manner which met contemporary aesthetic criteria. His mural in a Los Gatos patio was done in glazed tile and marble. Then, in 1934, under the PWAP, Helen and Esther Bruton executed two gracious figure-and-animal panels, in irregularly cut pieces of glazed tile, for the Fleishhacker Zoo in San Francisco.

When the WPA/FAP was established in 1935, Joseph Danysh, regional director for the western states, encouraged a number of artists who were interested in mosaic to carry out decorations in that medium with material that was at hand. One of the most original types of mosaic technique that has been developed is that of textured surfaces. Its inspiration was due to Stanton Macdonald-Wright, formerly supervisor of the Los Angeles area, and now state director for Southern California. Something of the effect of Persian geometric tile work has been incorporated in this mosaic technique. Certain simple geometrically shaped cuts of tile are so assembled as to form ingenious textural patterns giving a varied and rich surface to a flat-patterned mosaic. The method has been applied in both glazed and unglazed body-colored tiles. The range of color on the glazed tile is wide, and with this medium the most brilliantly colored mosaics have been made.

These texture patterns are developed for the purpose of creating a pleasing surface variety, as in the

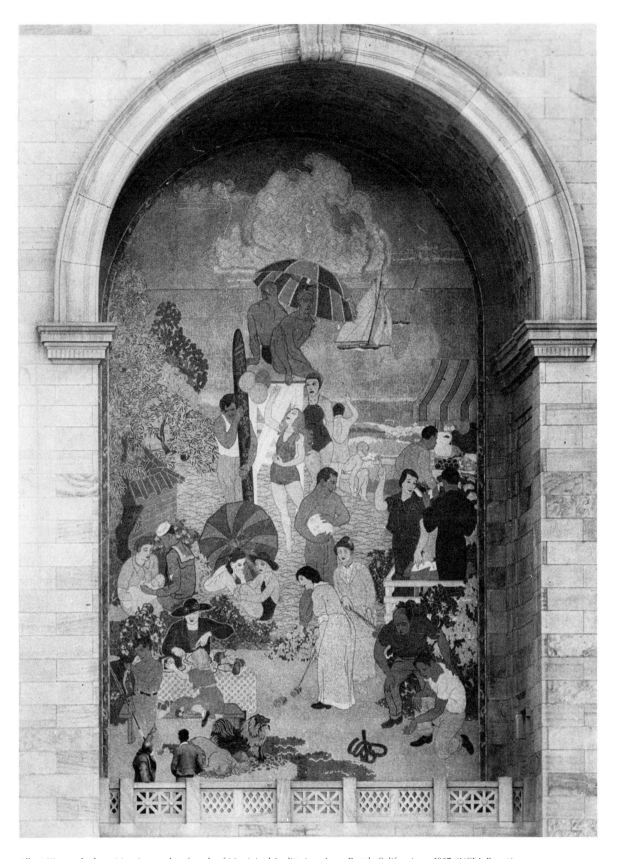

Albert King and others. Mosaic mural on facade of Municipal Auditorium, Long Beach, California, c. 1937. (NCFA: Perret)

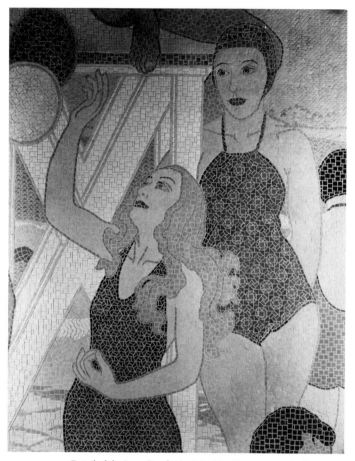

Detail of the Long Beach Municipal Auditorium mosaic, showing the arrangement of the glazed tile tesserae. (NCFA:Perret)

crew to work on a single mosaic once the design has been laid out.

Other mosaics in California have followed traditional methods to some extent in the manner in which the pieces of material, or tesserae, are cut and laid, but the designs are expressive of our contemporary art.

Many beautiful marble mosaics have been executed in San Francisco under the supervision of William Gaskin. From a vast store of mosaic marble left over from the 1915 Fair, and with the help of an expert marble mosaicist and of artist designers, some significant contributions have been made. Notable among these is the facade of the San Francisco State Teachers' College, designed by Maxine Albro. It is a rich pattern interpretive of California life. The design, on a background of creamy white, is reminiscent of the patterned marble pavements of Syria, but in spirit it is purely western.

Helen Bruton and Florence Swift have combined glazed and unglazed tile tesserae advantageously in their murals depicting the arts for the art gallery facade at the University of California.

Arthur Ames and the writer have developed a technique for the unglazed semi-vitreous tile in a variety of low-intensity colors. The tesserae, generally cut in squares about the same size as those of the Byzantine glass mosaics, were so placed as to accent the linear rhythms. Two panels of "Youth" and "Sea" are in the patio of Newport Harbor Union High School.

The contributions the California artists under the Project have made in mosaic through the new use of materials have benefited many other western mural artists who have been looking for a beautiful material which is at the same time permanent, inexpensive, easily obtained, and practical for outdoor use, and above all has an inherent material integrity for architectural decoration. In the mosaic medium, the California artists have met new demands to create a noble form of decoration, expressive, not in the ancient manner, but in terms of moving line, form, and color that interpret modern life.

design in the lobby of the Santa Monica High School, and also for imitative significance, as in the large glazed-tile mosaic of the facade of the Long Beach Municipal Auditorium. In this mosaic, which pictures activities of Long Beach, the water, grass, leaves, clothing, and other details have been simulated in tile texture. The mural is probably the largest single unbroken surface of mosaic in the world.

A special feature of the texture pattern method is that its regular treatment makes it possible for a large

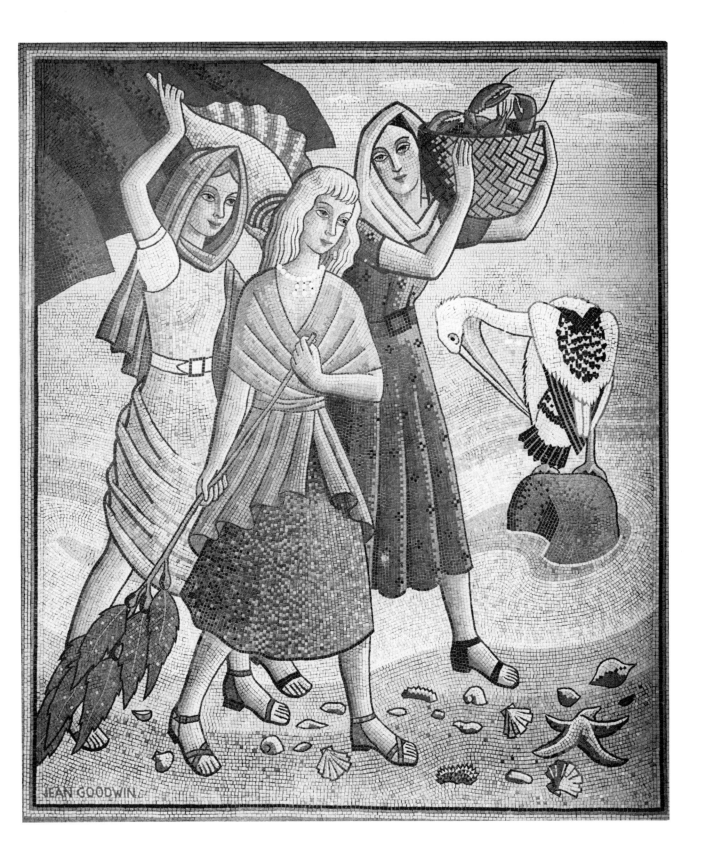

Jean Goodwin Ames. Mosaic mural panel for Newport Harbor Union High School, Costa Mesa, California, 1937. (Courtesy of the artist)

The Evolution of Western Civilization*

JAMES MICHAEL NEWELL

My first consideration in approaching the work of decorating the library of the Evander Childs High School in New York City was its physical dimensions, which are approximately one hundred by sixty feet. The space to be decorated, except for pilasters dividing the long wall, presented a continuous stretch about eight feet high around three sides of the room above the wood paneling and bookshelves. Murals for a room of such proportions must be planned to an over-life-size scale and must be bold in design if their meaning is to reach the students seated in different parts of the room.

I offered these first impressions to the principal and art director of the school and suggested for a subject an interpretation of a progression of events, perhaps the story of mankind. They felt that since the high school is located in the Bronx, a series of panels depicting the history of that section of the city would be more appropriate. The Bronx history was gone into thoroughly, and at the same time rough sketches were drawn for a series of murals describing the growth of western civilization. The latter plan was no more than tolerated until the color sketches were completed. Then they were approved with real enthusiasm.

As the painting progressed, the students and faculty of the school showed more and more enthusiasm for the work. In fresco painting, the artist scales up his sketches to a full-size drawing·or car-

toon as a preliminary to the actual work on the wall. This he judges in place, and makes any necessary corrections in drawing, scale, position and relation of objects, or volumes on the cartoon. The mason meanwhile is preparing the wall for the paint.

Satisfied with his drawing, the artist selects a portion from it that can be painted in one day and the corresponding section of wall is covered with the thin finish coat of mortar (a mixture of marble dust and lime), which is troweled to a smooth finish.

The outline of the drawing is then transferred to the fresh wet mortar and the artist begins to paint. Each day a new section is patched to the previous day's work. The students on their way in and out of the library stopped to ask questions and inform each other about the art process and the meaning of each section. They recognized events, criticized the knot in the cowboy's scarf and the proportion of the mechanic's hand. They were seriously interested in the work and studied carefully an exhibit I arranged in a case in the library to show the process of fresco, its history, and photographs of Italian, Mexican, and American murals. Representatives of the school paper interviewed me and took photographs of the work in progress.

The faculty of the science and chemistry departments were most helpful in technical suggestions and instruction in locating and lending apparatus for models. Wherever possible I have used as models people from the school—the engineer, the man pouring glass, the gentlemen of the jury—are all connected with the school, so that a great variety of people have contributed to and are enjoying sharing in the work.

*This essay incorporates two separate draft texts by James Michael Newell for Art for the Millions entitled "The Evolution of Western Civilization" and "The Use of Symbols in Mural Painting."

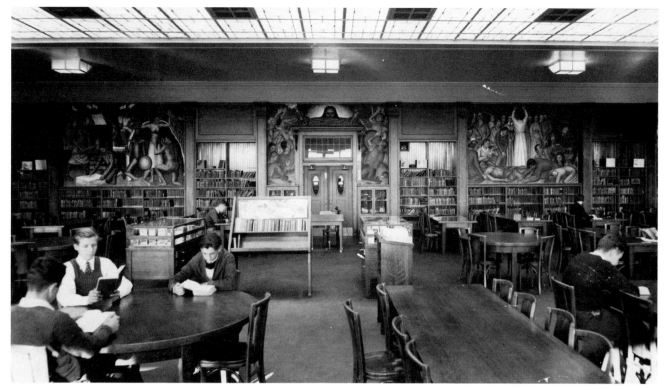

James Michael Newell. *Evolution of Western Civilization.* Overview of fresco mural panels in the library of Evander Childs High School, Bronx, New York, 1938. (NCFA:Cahill)

In time, of course, these resemblances will be forgotten and my mural will stand on its essential meaning. This leads me to some thoughts on the use of symbols in mural painting.

The desire to put into concrete form reactions to events, human behavior, the particular beauty of the color and arrangement of a spot in nature is the common urge of artistically creative people. In choosing a vehicle of expression, each artist is guided by his keener sensitivity to the beauty and force of music or words or color and form. And again the musician, the writer, or the painter chooses to express himself, according to his personality and way of thinking, in straight recording or picturization, or in symbols interpreting the significance of a form or an event.

In the first instance we think of the painting of a portrait of a racehorse. Exact to a hair in color, height, length, head and body structure, it is a record of the outward appearance of that horse. The death scene of a general, the coronation of a king are other examples in which the portraiture, the clothes worn, and the attending personages are pictured as they appear to the eye. Because of this fidelity to nature, the exactness in the copying of detail, the picture

mirrors the event. Similarly, the landscape that matches blade for blade, leaf for leaf, nature's arrangement stands as a record of the outward appearance of a scene.

In a symbolic painting, the artist utilizes the pictorial record as a dictionary. Out of his experience and knowledge he creates a new and personal form through which to interpret events and feelings. He exaggerates and reserves arbitrarily. There is no attempt to record events exactly. Rather, he tries to recreate the sense of significance of a generalized event.

Mural painting, most often placed in public buildings, is seen by a very great many passing people, who represent a variety of ideas and are engaged in different callings. It is therefore by nature not intimate, but general or universal in thought and appeal. Through its monumental approach it goes beyond the recording of outward appearance to include also the inner significance of the society and time in which it is painted. In expressing himself through the portrayal of his ideas on a limited wall space the artist has a very real need for a universal language in order that his work may be easily read. He therefore invents symbols—a shorthand or

phonetic language—through which to convey his thought.

A symbol can be conceived as an arrangement of objects or lines or forms whose presence and relationship stand for a meaning. Its power is felt through its concentrated picturization of an idea. Its significance is manifested by its representation of the peaks, the mores, the supremes of human possibilities, of physical properties, of beliefs.

Symbols used in painting have gone through a very academic period. Recognizable objects held in the hand of the stately figure of a woman have sufficed for symbolic reference. Many of the objects can be traced through centuries of painting. The scales of justice are obvious. The triangle and T-square and the mortar and pestle are often-used symbols of the architect's and chemist's professions. Here the material object designates the meaning of the figure, which is, in itself, without expression. It might be said to be negative. On the other hand an inanimate object used alone may have great power and significance. Bread or wheat, which is abundant in life-sustaining food value, becomes a symbol of life itself. Embodied in two pieces of wood in the form of a cross is the supreme sacrifice of Christ and all his moral and ethical beliefs. Through usage, objects become the symbols of qualities or conditions, as the olive branch does for peace. In more formal settings emblems and seals and also flags are the symbols of schools and organizations and countries as they picture what each collective body stands for.

The mural painter today prefers to use for his symbol not the mortar and pestle but the figure of the chemist himself, suggesting his work and its social relationship. Without meaningless gadgets and endowed with human and understandable life, the symbol becomes a real and vital force. Again the figure of the American pioneer might be used, and it will stand not alone for the man but for the physical endurance, the courage, the adventurous, inquisitive spirit that founded a new and free country. As the way of living and the social problem change, new symbols become universally accepted as significant

of new ways, new standards. The use of electricity, a new force and necessity in the present-day world, has revolutionized living, comfort, and health. Its tremendous powers out of control work immediately for man's destruction. Mechanized transportation and quick communication of various sorts envelop the world, changing time and space. They draw people and countries closer together and also, by eliminating borders, involve people and countries in each other's affairs. These influences are universally incorporated into living so that man's use or conquest of them becomes significant in the world of today.

This wide and varied activity is so highly involved and its reactions and repercussions so far-reaching that it must be simplified by the artist who is attempting, through pictures, to interpret his world. Through the use of such symbols he can throw together with great freedom a variety of situations and point up his belief and emotion through their arbitrary juxtaposition. With economy of line and simplicity of mass he produces a strong clear picture of an idea, recognizable and interesting to consider.

Thus, to return to my work at Evander Childs High School, the murals in progression around the library show primitive man building his society, youth migrating from it to new lands, the meeting and mingling of tribes, the clashing of eastern culture and scientific knowledge with western force, building knowledge and ideas of law and democracy.

The dark ages of plague are shown next, with the church alone perpetuating knowledge. Then come the beginnings of scientific experiment and the awakening of the people to nature, the force of which destroys their bondage and leads to the great flowering of the Renaissance. The exploration which follows founded a new country to which all nations and all time have contributed, and which has developed into a varied, dynamic, and powerful civilization. In this way I have tried to interpret in pictorial symbols the important historical forces that determined the evolution of western civilization.

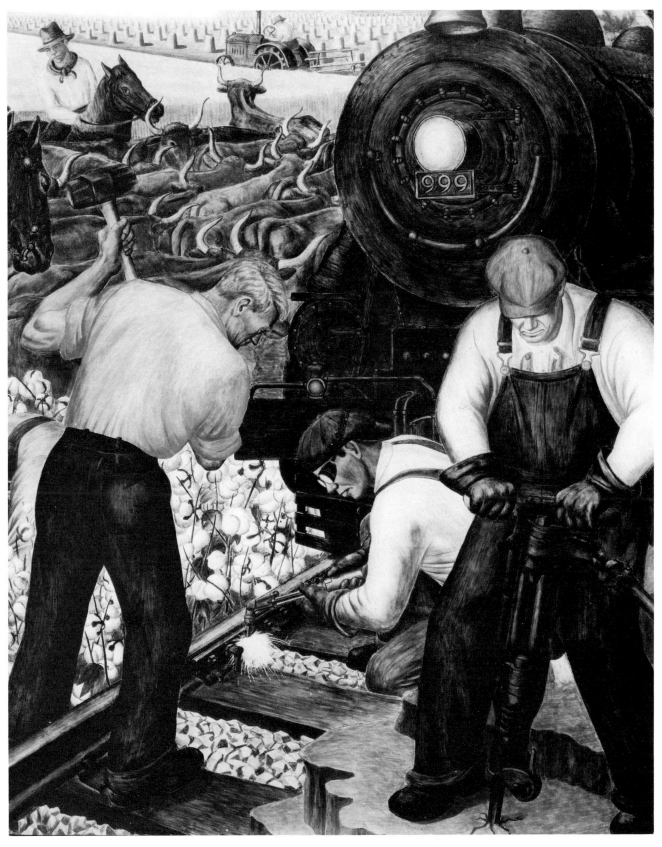

James Michael Newell. Detail of mural panel in library of Evander Childs High School, Bronx, New York, 1938. (NCFA:Cahill)

Mural Art and The Midwestern Myth

MITCHELL SIPORIN

Vachel Lindsay, in his poem "On the Building of Springfield," calls to the "native genius":

Record it for the grandson of your son
A city is not builded in a day:
Our little town cannot complete her soul
Till countless generations pass away.

And the Midwest, laid out flat around Lindsay's Springfield, is still in the process of "completing her soul."

Our poets, our writers, have revealed the existence of great cities with "broad shoulders," and endless prairie countryside, and a history of great leaders of the people. There is a potential painting in every poem of Sandburg, Lindsay, and Masters, and our novels and short stories are entire sequences of genre painting of the common man in his brooding environment.

The Midwest in the visual arts is only now bringing forth the artists who will reveal the physiognomy and meaning of their place. The artist has always in the past been conditioned by his life here, and yet there has always been present the feeling of being lost in a cultureless world of tremendous bustle, noise, and violence (this from Chicago—and from the country around an eating loneliness)—an abundance of life everywhere, and yet no culture.

The midwestern painter and sculptor of the immediate past attached himself at first to the Greeks and to the artists of the Renaissance. Then there were the English portraitists, and later the dainty swish of a Bouguereau nude descending from the bath rustled through the art salons on the shores of Lake Michigan. And much later, the "isms" of a modern world: impressionism, expressionism, futurism, and even dadaism. Today, we young midwestern artists at work on a native epic in fresco return to Giotto, Masaccio, Orozco, and a lesser number, perhaps to the surrealists.

The mural artist in America is earnestly reevaluating the mural art of the past in the attempt to bring about a new synthesis of form and content growing out of the artist's own milieu and the new social functions in our society. In the work of the mural artists on the WPA/FAP in the Middle West, this new synthesis is the beginning of a search to discover and to establish the tendency of a mural art in our own times, commensurate with the rich life of our locale.

Contemporary artists everywhere have witnessed the amazing spectacle of the modern renaissance of mural painting in Mexico, and they have been deeply moved by its profound artistry and meaning. Through the lessons of our Mexican teachers, we have been made aware of the scope and fullness of the "soul" of our own environment. We have been made aware of the application of modernism toward a socially moving epic art of our time and place. We have discovered for ourselves a richer feeling in the fabric of the history of our place. There is the "big parade" for us now of the past melting into the present, a parade in which each event begs the artistic transformation into a moving sociocultural critique, and the spirit of each historic personality begs of us nothing less than epic portrayal.

Mitchell Siporin. Mural panels, tempera on gesso, in auditorium lobby of Lane Technical High School, Chicago, Illinois, c. 1938. (NCFA:Cahill)

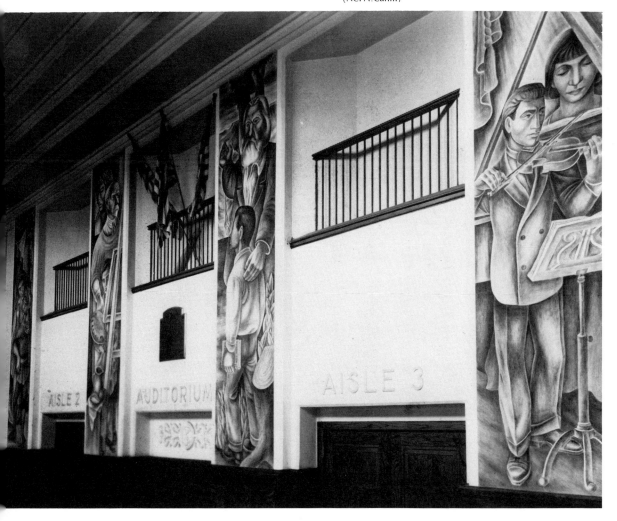

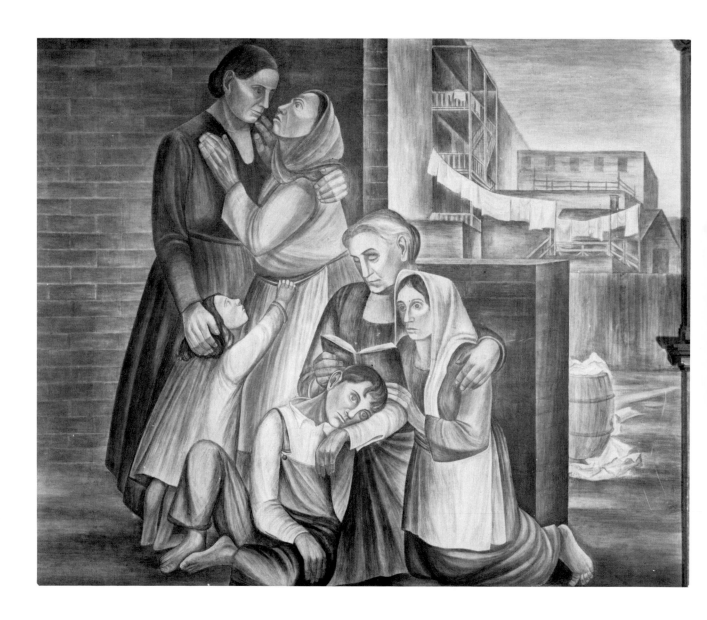

Edward Millman. *Jane Addams*. Mural panel, fresco, from a series
entitled "Woman's Contribution to American Progress" in the Lucy
Flower Technical High School, Chicago, Illinois, c. 1940.
(NCFA:Cahill)

For us there are Lincoln and Altgeld (you were wrong, Vachel Lindsay, when you said, "Sleep softly . . . eagle forgotten . . . under the stone") and the lessons of these leaders of the people will be fused into fresco, as a permanent reminder of the rights and heritages of our people.

For us there is the story of the reaper of Cyrus McCormick, of its profound influence on the life of our cities and countryside. There is the story of our constantly smoking "Pittsburgh Plus," of our industries of steel and hog, and of our agriculture of corn and wheat.

Ours is the story of Labor and Progressivism, of Jane Addams and Mary McDowell, of Eugene Debs and Robert La Follette, Sr., of Vachel Lindsay and Theodore Dreiser, of Haymarket and Hull House.

We are only now seeking out our myth, and with our growing maturity as painters, we will develop towards a formal pattern for the things we say that will bind us closer to those to whom we speak.*

*Two other Chicago muralists also wrote for *Art for the Millions.* Edgar Britton, in his essay "A Muralist Speaks His Mind," states:

I must frankly admit that we muralists are probably thinking too much about the literary significance of our subject matter. We must feel our subject as an idea expressed in terms of the people we know. If it is necessary to interpret historical events, costuming and appurtenances should be secondary considerations. It should be the artist's privilege to interpret any subject without the necessity of too strict chronological sequence or development, or adherence to authentic environment, as long as he is true to the organic flavor of his subject matter.

I also feel that the mural painter, for many reasons, should work directly on the wall in whatever medium. Aside from the fact that he is thus able to relate his work to the architecture, he is also becoming acquainted with the people for whom he is painting. I find the constant vigilance of an audience, as for instance, the students of a high school, offers a challenge which makes it practically impossible, at least very uncomfortable, to fall down on the job.

By executing his work in public the mural artist is doing a great deal toward dissipating the halo of mystery surrounding works of art. This accomplishment alone is of great value to the future of American art.

Edward Millman, in his "Symbolism in Wall Painting," says:

For a mural painter, the employment of valid symbolism in itself is not enough. He must give these symbols plastic meaning; the forms of a mural must be abstracted through substance, texture, color, tone. To obtain this greater artistic reality, the essence of the realistic form must be carefully selected in order to create the particular mood and spirit which itself then becomes the ultimate symbol. . . . An example is the concern felt by the midwestern mural painter to express the "squint" in the eye of the prairie farmer, for generations accustomed to gazing beyond the prairies. These squinting eyes, a weatherbeaten face resigned to the constant struggle with the soil, gnarled, knotty hands ready to seize the plough for an assault on the earth—these are the elements which truly symbolize agriculture, and not . . . the prop symbol of the Greek goddess with cornucopia. . . .

Mural Education

KARL KNATHS

So far I have completed panels for the Science Hall and the Music Room of the Falmouth, Massachusetts, High School. At present I have in mind a decoration for a school cafeteria which would utilize the material made available to guide consumers— such as balanced diet, calories, vitamins, quality of goods, etc. To offset the technical content of such a mural I plan to treat it somewhat in the spirit of Pieter Bruegel's famous painting "Slumberland." It is my firm belief that in time this type of utilitarian decoration will be highly developed and become an instructive as well as stimulating addition to every classroom.

The value of the pictorial image as an effective educator has been widely recognized but, unfortunately, seldom properly utilized. School walls,

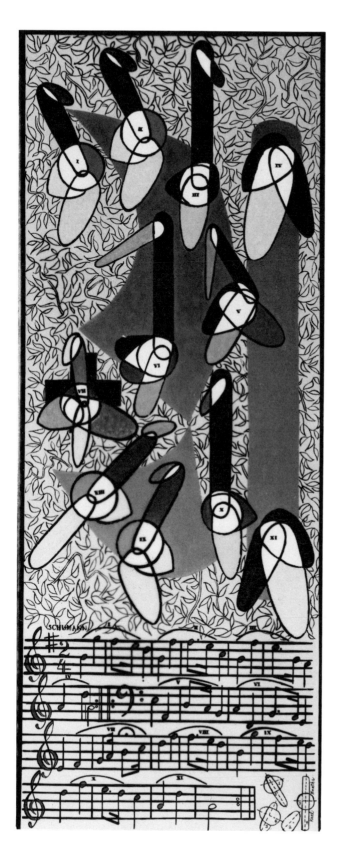

for example, are usually left unadorned, bare and remote from the activity of the classroom. Here is an opportunity which would hardly have presented itself to the artist without the intervention of an enlightened government agency. Here were splendid walls which in the past had served to chill rather than to stimulate activity. At least that is the way they affected me when I was first given the chance to do something with them at the Falmouth High School.

To bring the bare walls into vital relation with the teaching program and at the same time to create a pleasant working environment, I felt that the subject should be essentially instructive, that it should be scientifically accurate, and be easily intelligible to students untrained in the fine arts—all this to be done without any sacrifice of artistic form.

This seemed to be the problem, and the pedagogic mural the solution. The educational material, instead of serving as an obstacle, conformed nicely to the formal relations. The fear that this would give rise to an unmanageable contradiction was based largely on the illusion, a hangover from the age of individualism for its own sake, that the artist should be free in every sense—economically as well as artistically. There is no need any longer to discover new ways to be "startling" and "original."

As I proceeded with my work, it became more and more absorbing. An abundance of material whose artistic value had scarcely been tapped made its appearance. I found myself making use of every kind and manner of depiction: symbols, diagrams, formulae, lettering, illustrative devices, and imagery. All these pictorial devices were used for their decorative effect as well as for the value a striking image has of making a fresh impact upon the mind.

Karl Knaths. *Music*. Mural panel (lost?), oil on canvas, in the music room of Falmouth High School, Falmouth, Massachusetts, c. 1936. (AAA)

Abstract Murals

BURGOYNE DILLER

The Williamsburg Housing Project consists of twenty buildings which are being erected under the supervision of the PWA and the New York Housing Authority. The architectural design is functional. These buildings contain social rooms which were open to the WPA/FAP for decoration. The decision to place abstract murals in these rooms was made because these areas were intended to provide a place of relaxation and entertainment for the tenants. The more arbitrary color, possible when not determined by the description of objects, enables the artist to place an emphasis on its psychological potential to stimulate relaxation. The arbitrary use of shapes provides an opportunity to create colorful patterns clearly related to the interior architecture and complementing the architect's intentions.

The twelve artists selected for this project include several who are recognized as being among the country's leading abstract painters, notably Stuart Davis, Jan Matulka, Francis Criss, and Paul Kelpe.

Stuart Davis. *Swing Landscape*. Tempera sketch for mural in Williamsburg Housing Project, New York City, 1938. (AAA; National Collection of Fine Arts, Smithsonian Institution, Washington, D.C.)

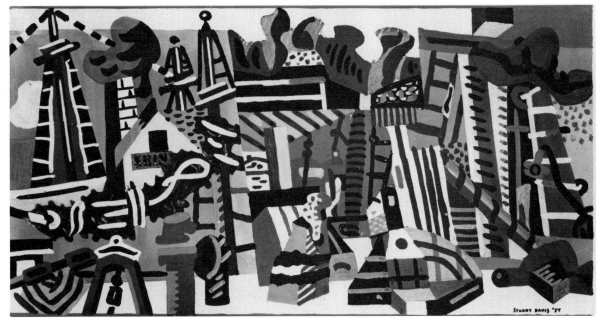

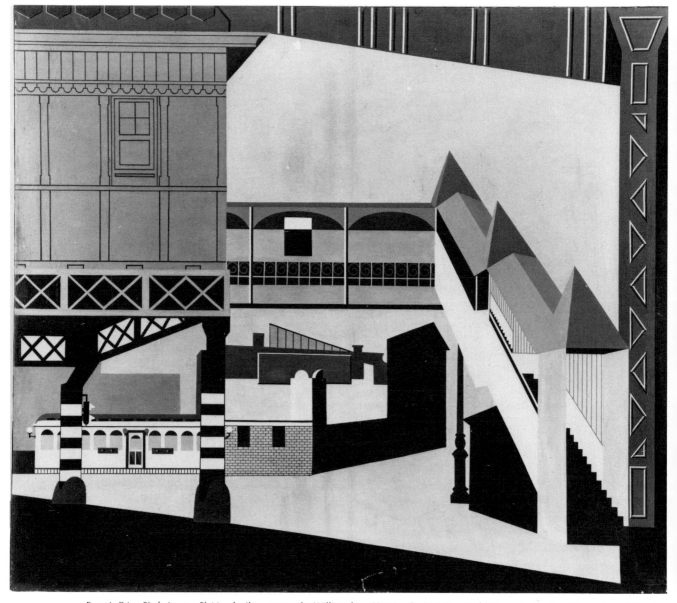

Francis Criss. *Sixth Avenue El*. Mural, oil on canvas, for Williamsburg Housing Project, New York City, 1938. (National Collection of Fine Arts, Smithsonian Institution, Washington, D.C.)

These men have exhibited widely and are represented in many private collections. The balance of the group is composed of younger artists, namely: Byron Browne, George McNeil, Willem de Kooning, Balcomb Greene, Ilya Bolotowsky, Harry Bowden, Eugene Morley, and Albert Swinden. These painters are comparatively little known, but their work on this project has received special commendation from critics. Because of common limitations, this group will have the unique opportunity to collaborate in solving technical problems, to experiment with new

media, and to redefine their approach to painting. Centering activity in this manner can easily lead to establishing a clearer direction to be taken by young American painters interested in abstraction.

Abstract murals are also being designed for the Newark Airport by Arshile Gorky, a Project artist whose work is well known and represented in many collections. These murals will be placed in the second floor foyer of the airport administration building which is to be used as a lounge for visitors. Gorky's interest in the forms that have evolved under

aero-dynamic limitations and his clarity in relating these forms on a two-dimensional plane has resulted in a mural admirably suited to its location. Its exciting color patterns lend themselves to the stimulating experience of a visitor to this center of contemporary activities.

These murals, as well as many others, symbolize the effort that is being made by the WPA/FAP to stimulate rather than to restrict the direction of painting, which, in the last analysis, should be the artists' prerogative.

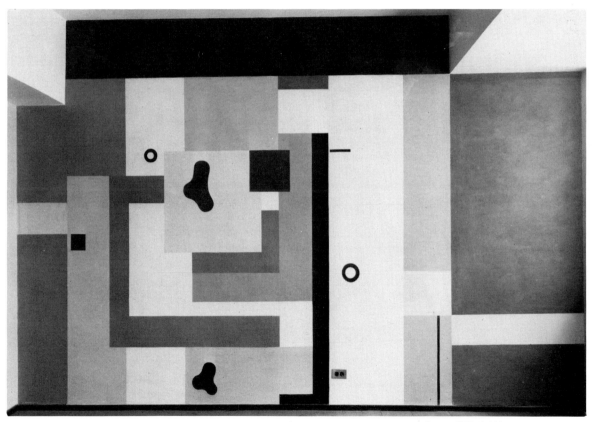

Albert Swinden. *Abstraction*. Mural (lost), oil on canvas, for Williamsburg Housing Project, New York City, c. 1939. (AAA)

My Murals for The Newark Airport: An Interpretation

ARSHILE GORKY

The walls of the house in .Russia where I was born and spent my childhood were made of clay blocks, deprived of all detail, with a roof of rude timber.

It was here that I first experienced the poetic elevation of the object. This took the form of a structural substitute for a calendar.

In this culture, where seasonal changes are forcefully abrupt, there was no need, with the exception of the Lenten period, for a formal calendar. The people, with the imagery of their extravagantly tender, almost innocently direct concept of Space and Time, conceived of the following:

In the ceiling was a round aperture to permit the emission of smoke. Over it was placed a wooden cross from which was suspended by a string an onion into which seven feathers had been plunged. As each Sunday elapsed, a feather was removed, thus denoting passage of Time.

As I have mentioned above, through these elevated objects—floating feather and onion—was revealed to me, for the first time, the marvel of making from the common—the uncommon!

This accidental disorder became the modern miracle. Through the denial of reality, by the removal of the object from its habitual surrounding, a new reality was pronounced.

The same sense of poetic operations manifested itself in the handiwork of the ancient Egyptian undertaker. Knowing that the living could not live forever, with the spiritual support of the priest he operated upon the dead so that the dead might live forever—never to die! To ensure the perpetuation of Life, portraits, glassy-eyed and enigmatic, were painted upon the mummies.

This operation has transferred itself to the clinical image of our Time. To operate upon the object! To oppose the photographic image, which was the weakness of the old masters. Their painting was complete when the outline of the object was correct. The realism of modern painting is diametrically opposed to this concept, since the painter of today operates on the given space of the canvas, breaking up the surface until he arrives at the realization of the entirety.

I am definitely opposed to the interior decorator's taste in mural painting, which seems to be that everything must "match." Mural painting should not become part of the wall, because the moment this occurs the painting loses its identity.

In these times, it is of sociological importance that everything should stand on its own merit, always keeping its individuality. I much prefer that the mural fall out of the wall than harmonize with it.

Mural painting should not become architecture. Naturally, it has its own architecture and limits of space, but should never be confused with walls, windows, doors, or any other anatomical blueprints.

In the popular idea of art, an airplane is painted as it might look in a photograph. But such a slavish concept has no architectural unity in the space that it is to occupy, nor does it truthfully represent an airplane with all its relationships.* A plastic operation is imperative, and that is why in the first panel of my Newark Airport mural, "Activities on the Field," I

dissected an airplane into its constituent parts. An airplane is composed of a variety of shapes and forms, and I have used such elemental forms as a rudder, a wing, a wheel, and a searchlight to create not only numerical interest but also to invent within a given wallspace plastic symbols of aviation.

These symbols are the permanent elements of airplanes that will not change with the change of design. These symbols, these forms, I have used in paralyzing disproportions in order to impress upon the spectator the miraculous new vision of our time. To add to the aggressiveness of these shapes, I have used such local colors as are to be seen on the aviation field—red, blue, yellow, black, grey, brown—because these colors were used originally to sharpen the objects so that they could be seen clearly and quickly.

The second panel of the same wall contains objects commonly used around a hangar, such as a ladder, a fire extinguisher, a gasoline truck, and scales. These objects I have dissected and reorganized in a homogeneous organization comparable to the previous panel.

In the panel "Early Aviation," I sought to bring into elemental terms the sensation of the passengers in the first balloon to the wonder of the sky around them and the earth beneath. From the first balloon of Montgolfier, aviation developed until the wings of the modern airplane, figuratively speaking, stretch across the United States. The sky is still green, and the map of the United States takes on a new geographical outline because of the illusion of change brought about by the change in speed.

The first three panels of "Modern Aviation" contain the anatomical parts of autogyros in the process of soaring into space, and yet with the immobility of suspension. The fourth panel is a modern airplane simplified to its essential shape and so spaced as to give a sense of flight.

In the other three panels, I have used arbitrary colors and shapes; the wing is black, the rudder yellow, so as to convey the sense that these modern gigantic implements of man are decorated with the same fanciful yet utilitarian sense of play that children use in coloring their kites. In the same spirit the engine becomes in one place like the wings of a dragon, and in another, the wheels, propeller, and motor take on the demonic speed of a meteor cleaving the atmosphere.

In "Mechanics of Flying," I used morphic shapes: a thermometer, hygrometer, anemometer, an airplane map of the United States—all objects which have definitely important uses in aviation. To emphasize this, I have given them importance by detaching them from their environment.

Mural painting does not serve only in a decorative capacity, but an educational one as well. By education, I do not mean in a descriptive sense, portraying, cinema-like, the suffering or progress of humanity, but rather the plastic forms, attitudes, and methods that have become the heritage of the art of painting. Since many workers, schoolchildren, or patients in hospitals (as the case may be) have little or no opportunity to visit museums, mural painting could and would open up new vistas to their neglected knowledge of a far-too-little-popularized art.

Rimbaud has epitomized for me the true function of the artist when he wrote: "The poet should define the quantity of the unknown which awakes in his time, in the universal soul. He should give more than the formula of his thought, than the annotation of his march toward progress. The enormous becoming the normal, when absorbed by everyone, he would really be a multiplication of progress."**

*This essay incorporates the foregoing two sentences from an abridged version in the manuscript of *Art for the Millions* and differs in this respect from the text published in Brooks Joyner, *The Drawings of Arshile Gorky* (College Park: The University of Maryland Art Gallery, 1969) p. 12.

**Arthur Rimbaud to Paul Demeny, May 15, 1871. The original reads, *"Le poète définirait la quantité d'inconnu s'éveillant en son temps dans l'âme universelle: il donnerait plus—que la formule de sa pensée, que l'annotation de sa marche au Progrès! Enormité devenant norme, absorbée par tous, il serait vraiment un multiplicateur de progrès!"*

An Approach to Mural Decoration

HILAIRE HILER

The Aquatic Park building stands modern and boat-like by the Yacht Harbor in San Francisco. Ferro-concrete, glass, and stainless steel. Its curved ends enclose two perfectly circular rooms, the form of which influenced my ideas as to how it might be adequately decorated. White as a tropical cruise liner, long aluminum railings accentuate its nautical character. The streamlined two hundred and fifty feet of its length is visible above the eight-hundred-foot bathhouse which is partially underground. Its modernity reassured me. Architecturally it would provide a framework into which modern painting and principles of decoration would naturally fit.

The situation was fortunate also in that I was privileged to meet and talk with the architects at a very early stage in the building's construction and could thus have a finger in every part of the pie: to design floors, wainscotings, electric fixtures, sculptured low-relief carvings, tile mosaics, color harmonies for the ceilings as well as the ceilings themselves. Such a situation is all too rare in the life of the contemporary artist. The opportunity carried considerable responsibility with it; but the sort of responsibility which is gladly shouldered. There would be no aesthetic quarrel in style between the architectural setting and the mural decoration as far as I was concerned.

My background was, at the same time, both a help and a hindrance. I had had considerable experience in designing and executing mural decorations, chiefly of a commercial nature. Some fifteen years of residence abroad had made me, for better or worse, quite thoroughly expatriate. I was a member of that lost generation whose roots were torn from the mother soil. My understanding of the life and ideals of my own country was far too vague to be of use.

With such a background I did not feel that I could do a "mural with a message" in some more or less literal fashion. Historical subjects or social ones, whether they are called "Cuirassiers at Waterloo," "Don't Wake Grandma," "Japanese Artillery in Action," "Sharecroppers," "The Mail Arrives at Porto Rico," fail to give me a thrill. Tons of news pulp, the movies, and the radio convinced me that mural painting as a means of special pleading could be absurdly feeble.

Even when the style purports to be contemporary, I do not feel that a mural must function as an enlarged illustration, no matter how noble its "message" may be. I am well aware that this attitude is in disagreement with that of practically all the mural painters now practicing in America.

A mural painting, I believe, should primarily be a decoration functioning as form and color, archi-

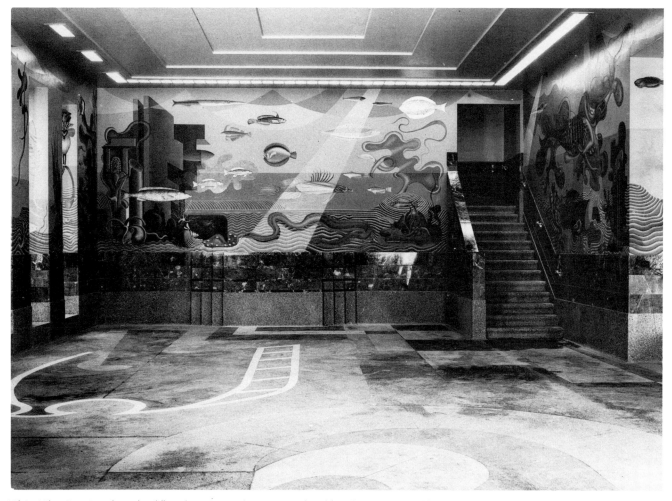

Hilaire Hiler. Overview of mural and floor decoration in the Aquatic Park Building, San Francisco, California, 1938. (NA)

tecturally connected with the room in which it stands as part of the building which shelters it. That the painting must form a unified and continuously flowing series of arabesques was happily simplified by the nature of the Aquatic building in which I worked.

The main lounge, because of its size and function, made possible a decoration which contains as incidental motifs ethnological and psychological symbols drawn from Pacific and American mythology. They are there for those who care to read consciously, or sense their implications. But they are strictly subordinated to the sensory side of the murals as plastic painting.

A round room suggested a prismatarium, with a large color circle as ceiling decoration—a room purporting to show the world of color as a planetarium shows the heavens. A second round room suggested a spiral ceiling, with this form repeated in rope inlaid in low relief into the walls. Yacht club flags of the

Pacific Coast provided color and abstract design for this room to be used as a seafood restaurant. A banquet hall on another floor, because of its severity in shape and the fact that its construction was left evident in the great uncovered steel beams which make a gridiron of the ceiling, suggested motifs taken from naval architecture. A correspondingly severe constructivist technique seemed fitting. This has been carried out in low relief and executed in many different materials such as sheet aluminum, balsa and other woods, seine twine, composition wallboard, lacquer, etc.

This work, with the labor available, which is not in all cases either expert or experienced, has progressed satisfactorily. Cooperation from the architects has been intelligently helpful. Criticism, unsolicited and unabashed, from house painters, carpenters, electricians, plumbers, masons, terrazzo men, stone cutters, plasterers, etc., has in general been understanding and surprisingly gratifying.

Murals For Use

LUCIENNE BLOCH

At my first visit to the Women's House of Detention in New York, where I was assigned to paint a mural, I was made sadly aware of the monotonous regularity of the clinic tiles and vertical bars used throughout the building. In considering an appropriate mural, there was, it seemed to me, a crying need for bright colors and bold curves to offset this drabness and cold austerity. The problem that confronted me was not an easy one.

Discussion with the psychiatrist in attendance and many conversations with the inmates revealed with what sarcasm and suspicion the latter treated the mention of Art—as something "highbrow," indicating to what extent art had in the past been severed from the people and placed upon a pedestal for the privilege of museum students, art patrons, and art dealers.

To combat this antagonism it seemed essential to bring art to the inmates by relating it closely to their own lives. Since they were women and for the most part products of poverty and slums, I chose the only subject which would not be foreign to them—children—framed in a New York landscape of the most ordinary kind. It could be Uptown, Downtown, East Side or West Side—any place they chose. The tenements, the trees, the common dandelions were theirs.

Persons not acquainted with an artist's method of making preliminary rough sketches would naturally find them hard to understand. This was found to be the case by many artists whose sketches had to pass through the hands of directors of various public institutions. The superintendent of the House of Detention was no exception. She did not, at the time, feel that New York and ragged children were suitable subjects to be painted in permanent form on the prison walls. She then believed that "nature scenes" of a fantastic kind "would be more inspiring" and would not remind the inmates of unpleasant associations. Only when I had fully developed my sketches

and had made the gas tanks glitter in the distant blue, had drawn out each pert braid on the pickaninnies, did she appreciate that my approach to the subject was intended to relate what I was doing to the intimacy of the lives of the inmates. Craftsmanship won her over. As the work progressed, her interest grew, and she often stood by the scaffold and eagerly discussed my problems with me.

As for the matrons, outside of the fact that their conception of an artist was shattered when they saw me work without a smock and without inspired fits, they were delighted to witness a creation of a "genuine hand-painted picture."

The inmates had a more natural point of view; they wholeheartedly enjoyed watching me paint. The mural was not a foreign thing to them. In fact, in the inmates' make-believe moments, the children in the mural were adopted and named. The scene representing Negro and White children sharing an apple was keenly appreciated, and some of the more articulate girls even used this and other themes from the mural as subjects of letters* to their friends and relatives in the outside world. Such response clearly reveals to what degree a mural can, aside from its artistic value, act as a healthy tonic on the lives of all of us.

*Two of these letters are attached to the original manuscript.

Lucienne Bloch. *Cycle of a Woman's Life*. Mural (lost), fresco, in recreation room of the Women's House of Detention, New York City, 1936. (NCFA:Cahill)

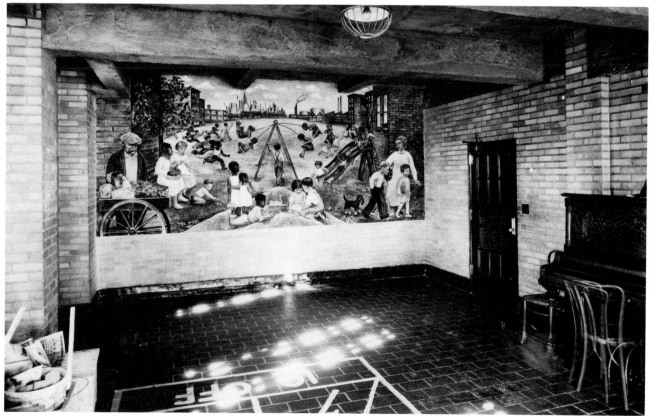

On Mural Painting

WALTER QUIRT

The difficulty in writing about problems concerning mural painting is that little if any theoretical work has been done. Peculiarly, or perhaps not so peculiarly, a tremendous amount of mural work has been executed in the past few years unpresaged by theoretical considerations other than discussions of technical questions. Discussion of conceptual painting, and mural painting in particular, has never been the major concern of artists. It is from this basic weakness that the writer believes most of our difficulties arise.

The first task of a mural is ideological: it must reach many people of various views, differing social concepts, and political outlooks. How to reach these people has been a question answered by our artists more by "doing" than by "thinking." Some artists have retreated from the question by doing the obvious and innocuous thing; other, more socially conscious artists, have assumed that what concerned them would necessarily concern the spectator.

The artist who deals in social content would be correct in assuming that what he does interests the spectator, if he could and would put into his mural all his doubts and conflicts, his philosophy and fantasy, all the release that the subject originally gave him. But between the original feeling stimulated by the subject and its final execution there is a tremendous gap, and it is this gap that really contains the vital content. The artist usually consciously censors his work and carefully gives a cut and dried version of a given theme so that there is no possibility of mistaking the content and what the artist personally thought of that content. What he fails to put in are his feeling and doubts. Thus the finished work has clearly written across it the dictum, "Accept me and my sociological views completely, or not at all." This can result in only one thing, blocking the audience from participating in the mural.

Perhaps the reason there has been no theoretical ground-covering in mural work might be the general predisposition toward a definite style, for strangely enough there is little dissimilarity of approach among mural painters. It apparently was assumed at the beginning that representationalism was the one and only form. This may be due to several factors, such as American tradition, the Mexican School, and the natural attraction mural work would have for representational artists.

But is this assumption entirely correct? The result-

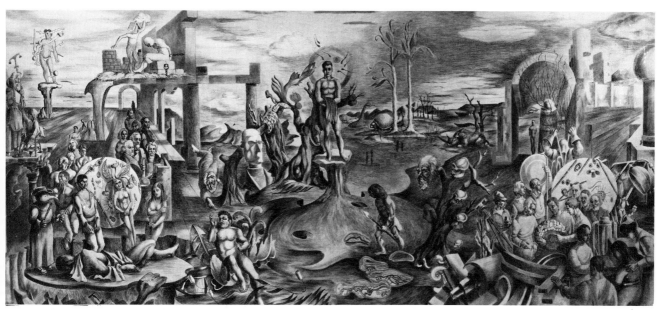

Walter Quirt. *The Growth of Medicine from Primitive Times.* One of two mural panels (destroyed?), tempera on gesso, in the psychiatry lecture room, Bellevue Hospital, New York City, 1937. (NCFA:Cahill)

ing murals lead one to believe it contains an inherent weakness in presuming that art is of an intellectual nature—or descriptive. Art is primarily a language of the emotions and not of the mind. This does not mean a separation of form and content—it means a closer fusion of the two. In our society—highly literate, highly sophisticated—we are apt to become unconsciously insulting to the lay mind by giving it the ABCs of life. The Renaissance had a common ideology in the form of religion, and in Mexico the common ideology of the revolution was expressed simply and clearly in murals for an illiterate populace. We have no similar ideology, though without much consideration for the needs of our culture we took over characteristics of both schools. This resulted in, and could only result in, the making of experiences, common to all of us, ordinary. Our real job, of course, is to take common experiences and make them articulate in emotional terms, not exclusively intellectual ones.

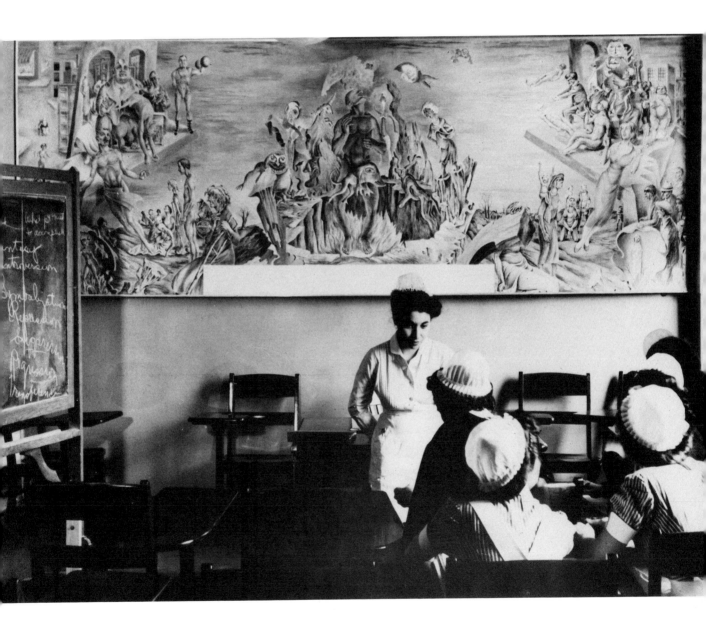

Walter Quirt. Overview of psychiatry lecture room in Bellevue
Hospital, New York City, showing second of two mural panels
depicting *The Growth of Medicine from Primitive Times*. (NA)

If this is so, then purely representational art already has a couple of strikes on it before going up to bat. How can we expect to take a dynamic scene or situation and make it more real than the real? Man in watching a given scene has a constantly shifting view that carries his fantasies in many different directions. The same scene put into a mural in representational form becomes static, lifeless, and dull, because the primary interest of the spectator was not of an intellectual nature—it wasn't an interest in the scene per se—that was only the medium for a bit of day-dreaming.

Thus if we have found that literal documentation of life has little or no effect upon a lay audience and yet that audience is capable of being moved, we are led to the belief that there must be some common denominator in all of us that needs but a special type of exterior impulse to set our emotions into play. This is a difficult problem to see, let alone solve. For one peculiarity of art is that once it is contained within a painting it lives eternally, so that we today can respond pleasantly without diminished vigor to masterpieces of the past as well as to contemporary painting. This often confuses us into thinking that any style or method of expression is appropriate today. But our period demands new forms, in fact is developing new forms, and interestingly enough these new forms are such that they can reach people of differing social views.

As human beings we all have essentially the same fantasy life. Our biological needs and impulses, our unconscious worlds with their conflicts and desires, our dreams and symbols are common to all even though individually we may hold opposing political or social views that are not harmonious with those of others.

The fact that people generally do have a fantasy life, that this fantasy life constantly demands release, and that our fantasy worlds are all pretty similar offers us the key with which to unlock the emotional responses of people. It is the common denominator of this period in history. Its scope is as wide as Man and Man's world, embracing all aspects of life: political, social, economic; the concrete and the abstract. What the artist must learn to do to evoke this response is to learn to release his own fantasies, release them completely and uninhibitedly, free from self-censorship and intellectualization whether they revolve around a factual problem or an imaginary one, for, reiterating the point, art is a language of the emotions.*

*In a brief contribution to *Art for the Millions* entitled "Murals For Use," which I have deleted, the muralist Lou Block (not to be confused with Lucienne Bloch) states the following concerning Walter Quirt's Bellevue murals which illustrate this essay: "In Bellevue Hospital in the City of New York it has been possible to combine in one building the functional mural and the mural which serves a decorative purpose only. In the lobby of the building the embellishments are an adjunct to the architecture. In the rooms devoted to occupational therapy a definite attempt is being made to install a series of coordinated murals based on the use of various types of therapy as aids to the rehabilitation of the patients. A more directly functional mural is being painted by Walter Quirt for a classroom in the psychopathic pavilion, where lectures on psychiatry and the kindred subjects which have to do with the treatment of mentally disturbed individuals are given. Mr. Quirt is painting directly for an audience whose interests are of a scientific order and his theme is entirely bound in with the functions of the room. The officials of the hospital find the subject matter of the mural accurately documented with a definite educational value and an aid to the work which is carried on in this room."

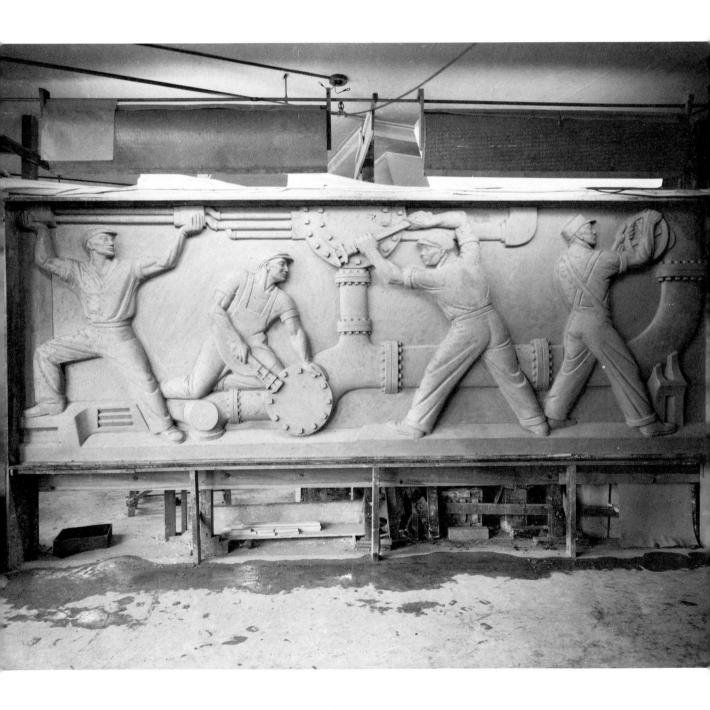

Cesare Stea. Relief for Bowery Bay Sewage Disposal Plant, New
York City Project. (AAA)

Report to The Sculptors of the WPA/FAP*

GIROLAMO PICCOLI

We meet to take stock of what we have already done, in order that we may look ahead. On the basis of this report, we must see how we can improve our work, and plan to make even greater contributions than we already have.

Since the inception of the Project, we have had to make adjustments and meet new problems. The very establishment of the division presented problems that had never before received consideration. Because such opportunity for creative work is unprecedented, our problems must be faced and solved as they arise.

Inasmuch as the Depression period greatly curtailed funds for public building, both the public and sculptors tended to lose sight of the possibilities inherent in the social use of sculpture. The type of buildings that have been erected has restricted sculpture to very minor decoration. Furthermore, the current use of functionalism as practiced in buildings deprived the community of this art. We have had to re-awaken and develop an understanding of this aspect of sculpture and its application among the people, as well as among the sculptors. With years of isolation in their studios, sculptors began to lose sight of the traditional role of their art.

Traditionally, sculpture has been a mass art. Few could pay the heavy expense of a sculptor's career. Today, a lifetime is needed to create a reputation that can attract the money and the patronage of the rich. Sculpture was practically an unknown art, as far

Martin Craig. *Abstraction*. Plaster, New York City Project, c. 1939. (AAA)

as the American people were concerned, until the formation of the WPA/FAP. Now the art of the sculptor is emerging and is creating a record of achievement. Within the two years before November 1, 1937, 918 works have been completed and 138 more are now in progress.

Sculpture in America is now being given a definite

*The manuscript of this essay is headed "Department of Information, WPA Federal Art Project, 235 East 42nd Street, NYC. . . ." indicating it may have been used for publicity purposes before being included in *Art for the Millions*.

direction. Our Project has made a strenuous effort to unite the distinct but related arts of sculpture and architecture. The greater part of Project sculpture has therefore been designed to harmonize with architectural plans, and to stimulate a larger demand for sculpture in public buildings. Many friezes, pediments, plaques, and figures have been installed in schools, colleges, libraries, government housing units, and other public buildings. A good deal of the free sculpture of the Project has been designed to fit specific locations in public parks, botanical gardens, and courtyards of buildings. Many casts have been distributed to schools and libraries throughout the city and the state.

Through the facilities of our architectural section, we have been able to work out, together with the designing architects, proper settings for sculpture in relation to the buildings and grounds.

Two comprehensive sculpture shows were presented in the Federal Art Gallery, through which 110 allocations were made.

The James Madison High School selected pieces in a wide range of styles, techniques, and materials: "Abstraction," a plaster composition in geometric form, "Ground Hog," carved in limestone, "Children Playing," a three-figure group, and "Alice in Wonderland."

A series of eight cement animals and fifteen plaques was designed for the children's playground of First Houses, the Federal Housing Project at 3rd Street, Manhattan. Here, the sculptors were able to design animal compositions for a community in the lower income brackets. Heretofore, these communities had no way of getting such sculpture, and their response to this sculpture has been most gratifying.

In the main cadet dining room of the Military Academy at West Point, four Project sculptors have designed figures intended to symbolize the size of the entire student body of the Academy. These figures are now being carved in limestone. Two figures are being designed for the campus at Queens College, which are intended also to symbolize the student body.

A large pediment is being executed for the gymnasium building of Brooklyn College, on the theme of "Sports." Sketches are being prepared for two additional figures, directly related to the function of the gym and its place in the college.

In collaboration with the directors of the Brooklyn Museum, the Sculpture Division is designing two heroic animal figures to be placed in front of the entrance of the building.

The Project has also undertaken to enrich the decoration of Grant's tomb with the addition of several heroic busts of General Grant's military colleagues.

For Alexander Hamilton High School, we are designing large reliefs for the auditorium and a number of groups in stone for the various parts of the building.

This review of what we have done is only an indication of what we are now creating for some forty other institutions not mentioned here.*

The community gains by the creation of this type of sculpture, for without the assistance of the Sculpture Division of the Project, architects engaged in designing public buildings might have had to eliminate sculptural decorations altogether. Limited appropriations for public buildings prevent the undertaking of such large-scale work as is now made possible through our facilities.

The scope of our work and what we plan for the future make it necessary to consider here the various technical problems of the sculptor.

Experimentation has, of course, great value. The tradition of experimentation in form has been carried

*While it is possible to trace references to most of these sculpture projects in the monthly reports of the New York City WPA/FAP, it is only with the May 1, 1936, report that the names of the artists working on them are indicated. The animals and plaques at First Houses were done by N. De Brennecke, Fortunato Duci, Gino Ficini, George Girolami, Edna Guck, Hugo Robus, John Rosalie, Bernard Walsh, and A. Wolff. Robert Cronbach designed the pediment at Brooklyn College, and Saverio Sulmonetti and Joseph Walters worked at Alexander Hamilton High School.

on by the sculptors of our generation. Therefore these problems are not new to us. However, the field that the Project has opened up raises the problem of how we can best use these experiments for the period in which we live, and how we can make our own contribution.

We on the Project no longer work blindly; nor are we isolated from society. We have a client. Our client is the American People. But does this mean that we must pander to the most undeveloped tastes of our society? Obviously not. Does this mean we cannot use the most developed form of art expression? Again, we must say no!

We have a twofold task: We must develop ourselves as sculptors, and in doing so, we must give the American people the highest form of expression of which we are capable. To those of you who take creative assignments of a non-architectural nature, I say: your task is not a simple one. It is this work in the main that is available for our exhibitions. You have the opportunity to give sculptural expression to society as it is reflected through you.

We must approach this problem, not from the standpoint of the materials we will use, or of what art forms, but rather from the point of view of what we have to say. When we have answered the questions this problem raises, we shall then be able to find the art form and material best fitted to our expression. If our work has emotional intensity, we must find the forms that will give it fullest expression, because all art forms are an outgrowth of what the artist wishes to say and what he feels.

Some of you wish to approach your work from a decorative point of view. In this case, naturally, the type of material you use will play an important role. You will select your material for its decorative value. In other words, let us remove the discussion of the type of material we are to use from the theoretical realm of experimentation in new materials, but only because I believe such experimentation must be brought into its proper relationship to our work. Some of you are of a mind which naturally leads you to experimentation with new materials. That is good.

All of us will benefit from your experiments. However, as artists our essential problem still remains one of giving form to our expression.

The success or failure of our work depends in a measure on how closely we can approximate our intentions, and also how closely our expression is related to those for whom our work is designated. It is necessary, therefore, to clear up here many of the misconceptions that have surrounded the whole question of allocations in relation to the work of the creative artists. I welcome this opportunity to make clear our view on allocation. All work that we do on the Project is creative and allocatable to tax-supported institutions. This does not mean, however, that we take a narrow view on the question of allocations. The one thing the Project requires is that you do your best work. We are aware that some of the work which you create is not immediately allocated. But we know, too, that if the work is true and creative, it will find its place. If you do your best work for the Project, the standards of the Project are thereby raised. Do not create "pot boilers," and *stop worrying about allocations*: This is an administrative problem with which we can well cope. To date we have had no difficulty in allocating your works. It is up to you to do your stuff.

Our policy is to consider each artist's work in relation to his proved abilities, and not to set up a standard and expect all artists to conform to it. Nothing would be more deadening to the Project than to require all works to fit in a set groove, but our policy must not lessen your responsibilities to the Project in giving it your best work.

I have noted instances where sculptors created work which they considered too good to give the Project, and have submitted instead a lesser piece. In all these cases I have called the artists to task. It is up to you now individually and collectively to stamp out this attitude, which can only do injury to you personally and to the Project as a whole. We, on our part, shall take whatever administrative action is necessary to correct this condition, and your discussion on this point will be in order.

Anonymous. Bronze group in library of Evander Childs
High School, Bronx, New York. (Courtesy of Robert Hunter)

The technical section of the Sculpture Division includes plaster-casting, model making, wood and stone carving, bronze-casting, and cement-casting. The Sculpture Division is proud of the personnel engaged in these activities. They have made and are still making great contributions to the division, sometimes under very trying conditions. All of you are familiar with the work they are doing and know its quality. Its main weakness is the lack of forces and equipment.

The foundry is on a production basis and is beginning to pay dividends, because it makes possible allocation in permanent materials. As a consequence, greater interest is being shown in our work by co-sponsors.

The Project has been greatly handicapped by lack of permanent materials. Due to the lack of funds and the need of using as much of the funds as are available for employment, this phase of our work has suffered. We are solving this by contributions from co-sponsors as allocations increase. What progress has been made in getting needed equipment is due in a large measure to Mrs. Audrey McMahon's special interest in our work.

Eventually we hope to have on hand a variety of permanent materials, such as marble, wood, and stone. Then a sculptor will know before he begins an assignment what material is available for his particular design.

A brief discussion of the so-called new materials is in place here.

Unfortunately, and notwithstanding the loose talk that has been floating around the Project, these new materials have not reached the point where they can be extensively utilized by us. First of all, the use of bakelite composition is not practical because it requires a high temperature treatment and the use of expensive steel dies. This medium is practical only for mass production—a field that we are not yet exploiting.

Glass can be blown and also cast, but both of these methods require considerable equipment. Many of the disadvantages in the use of the material have been overcome by modern methods and developments. The excessive shrinkage that was formerly a handicap has been successfully overcome. But glass is still more expensive than metal.

The Project is already making extensive use of dextrine composition, the main virtue of which is that a lighter and stronger cast can be made than in plaster.

The new metals, such as chromium steel and aluminum, offer no new technical problem, for these metals can be handled only in the usual accepted methods such as casting, cutting, and welding—methods which have been long employed by

sculptors. The virtue of these materials is in the new effects that can be achieved by their use.

We have made much use of cast stone as a medium, but it has its limitations. Cast stone has neither the permanency nor the beauty of the natural stones and marbles; but its relative inexpensiveness has made it feasible when more than one cast was needed of a given design.

Repoussé materials, such as sheet brass, copper, and other metals, can, of course, be used, but again they allow for only a special and limited expression.

We must relate our attitude toward the use of new materials to our general approach to sculpture. If we have a plastic conception that requires the use of aluminum or chromium or even glass, then we should, if possible, use these materials. What can be said in glass or aluminum differs from what can be expressed in the more usual materials. We are opposed to the torturing of materials. Again, it is a question of what we are trying to express. I think it is necessary for the sculptor to give greater thought to form and tensions of the masses, placing special emphasis on their relationship to the emotional and aesthetic content of the work. This can be done only if the sculptor knows clearly what he wants to achieve.

In conclusion, I want to point out that we have only begun to touch the possibilities inherent in the work of the Project. The community is making greater demands upon us, and I expect that this meeting and the discussion that will follow will lay the foundation for a better understanding of our problems. Our standards, as you know, are constantly being raised, and the public has every right to expect that we take our responsibility seriously.

Ahead of us is work directly related to the community, in designs for outdoor sculpture suitable for the municipal airport at North Beach, Long Island, and sculpture for the new Contagious Disease Hospital and Convalescent Home now under construction on Welfare Island. This work is being held in abeyance, because everyone is now engaged on other work.

Louise Nevelson. *Cat*. Painted plaster, New York City Project, c. 1940. (AAA)

Faced with many more requests for work than we are able to produce with our present personnel, we find it necessary to be more selective in the work we undertake to do. It becomes possible, therefore, for the sculptor to have an opportunity to create work more closely allied to his own ability and expression.

Our work is showing marked improvement in direct ratio to the development of our sculpture. The younger ones, given the opportunity to work, are showing their increased abilities to meet and fulfill the demands made of them by the community.

Now that you have heard my report, if this meeting is to succeed in its purpose, you will discuss openly and frankly what we can do to correct and improve our work, both as artists and administratively, and how you as artists can be given greater assistance in fulfilling your tasks.

The Sculptor's Point of View

SAMUEL CASHWAN

Conditions prevailing before the advent of the Project were disheartening to most American sculptors. The popularization among architects of "simplification" in construction closed the sculptor's last outlet. I found this to be true not only for myself and other sculptors in Michigan, but also for my friends in other states. Nothing remained but the infrequent encouragement of a prize in a museum show.

These conditions nurtured a tendency among sculptors to despair of their future as well as for the general development of art in America.

The picture brightened suddenly for us in Michigan. In 1935 the Project was organized. Some time later I was asked to head the group of sculptors as supervisor. During my first acquaintance with the Project, I was deeply impressed with the many possibilities for development and the good that could be derived by the public from its activities. After two years of creative work in the sculpture division I still feel equally enthusiastic, despite the many unavoidable limitations, inadequate facilities, and especially the constant threat of stoppage and lay-offs.

It was a revelation and a pleasure to be given a free hand in the creation of sculpture without the sterilizing control of committees or of limitations as to personal style. When the only criterion is quality, a work of art never suffers. The greatest good a sculptor can perform is to create, not for a museum or a private collection, but for the common meeting-places of men, to enhance and ennoble everyday life. Here was the sought-for, unexpected opportunity presented to us to do this greatest good.

From this starting point we have progressed steadily. From the certified relief lists of the WPA we enrolled modelers, carvers, plasterers, and stone cutters—men who for years had not had the opportunity to practice their crafts. Their rehabilitation, for such it seemed, was a peculiar joy to me. This in itself seemed a complete justification for the sculpture project. They were again active in the kind of work for which they had been trained and which they had despaired of finding.

With me on the project were two other sculptors and a ceramicist. Typical of these was the latter, an artist of unusual talent, living from hand to mouth by modeling chandelier parts during the day and teaching in her spare time. I soon realized the extent of her capacities for creative growth. Sponsors were quick to call for her ceramic work. We enlarged the kiln and gave her several assistants. Her fountains, glazed outdoor figures, and wall decorations are now cheerful spots in schools, on the college campus, in public lobbies and libraries.

Thus from a nucleus of four sculptors we have

gradually welded together a creative group of twenty-four artists and craftsmen working together and prepared to tackle the most difficult sculptural assignments. Though highly creative, with a complete knowledge of their craft, these artists for the first time have been given the opportunity to develop, and to embark on man-sized works. It was a challenge to their capacities, and they grew in experience with each new problem.

Practicing architects in Michigan were slow at first to take advantage of the potentialities of the Project's sculptors. Soon, however, we were busy designing ornamentation, decorative figures, symbolic reliefs, etc., in collaboration with these men. Public buildings which might otherwise have gone bare or carried shopworn designs blossomed with fresh contemporary sculpture which not only gratified the architect, but delighted the sponsor.

Our more ambitious undertakings have been fairly recent. A thirty-two-foot relief in monolithic concrete on the facade of the Lansing water-conditioning plant; a ceramic and terrazzo fountain for its lobby; a heroic granite figure of Michigan's famous pioneer, Father Gabriel Richard, to be placed in a public park; a memorial to a great scientist, Dr. Miller, for the University of Michigan; and a monumental sculptured window in glass for the Dentistry Building of this university; thirty-three stone reliefs for the Health and Music Buildings of Michigan State College and a marker for its entrance.

The public's appreciation of the work we have done has created in us an almost unbelievable change. Our function in the social scheme of things, hitherto restricted to sparse and select groups, has suddenly begun to widen and embrace a whole society, to improve its surroundings, to broaden its imaginative scope, and to stir latent artistic impulses in its children. That this is satisfying a real need is beyond question. That it may be permitted to do so in the future is our earnest hope.

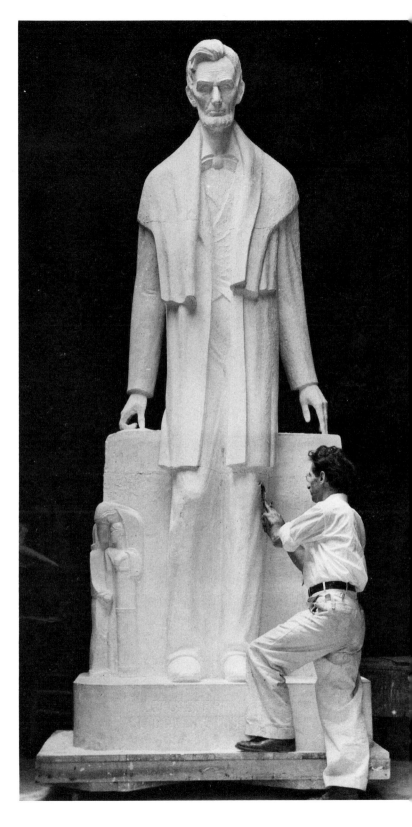

Samuel Cashwan. *Abraham Lincoln.* Plaster model for sculpture at Lincoln Consolidated Training School, Ypsilanti, Michigan. (NCFA:Cahill)

Modern Sculpture and Society*

DAVID SMITH

Culture and science are international. The beginning of American culture was foreign, so were her people, her religion, her science and customs. Europe's culture was foreign. The basis of both cultures came from the East twenty centuries or more ago.

Culture is not a discovery, an authoritative or a premeditated act. It is cumulative, built on the past, contributed to by creative forces indigenous to the people, the age. It progresses with free men. It degenerates with dictation. Art is born of freedom and liberty, and dies of constraint.

The function of sculpture in our democratic society depends primarily on its relation to architecture. Not because it is a lesser art, but by the nature of its function and sponsorship. Its purpose here is usually to lend aesthetic identity to the building's function, either with the mechanics carried on inside, or to complement the atmosphere created by its exterior. Sculpture not dependent on architecture proper, but relegated to a setting as in a park or for a memorial, still serves an architectural function. A secondary use of sculpture may be designated as free-creative. Here the sculpture is conceived independently, for purely aesthetic reasons.

Creative sculpture has always had a definite rela-tionship to the architecture of its period. It has reflected the complexity or simplicity of the forms of its architectural era, and, conversely, architecture has derived a definite influence from sculpture. The parallel of Phidias, Michelangelo, and Lubetkin** represents sculptor and architect each to varying degrees. There is also a parallel between architecture and sculpture in the use of materials. This is evident in early mud building, through stone and bronze periods to modern times, with the contemporary use of alloys, aluminum, and stainless steel. The kind of tools used in the making of architecture and sculp-ture have left the same imprint on both. They have both reflected the existing social growth, decadence, science, and cultural pursuits of their time.

The first architecture of man was represented by the cave, in which incised sculptured adornment was included. Throughout man's great periods, archi-

*This is a shortened version of a longer essay which will be published by Garnett McCoy in his forthcoming anthology of Smith's writings in Praeger's "Documentary Monographs in Modern Art" series.

**Berthold Lubetkin (1901-) is an English architect, a member of the Tecton group. During the 1930s he designed London's Highgate Apartments and the Penguin Pool at London Zoo.

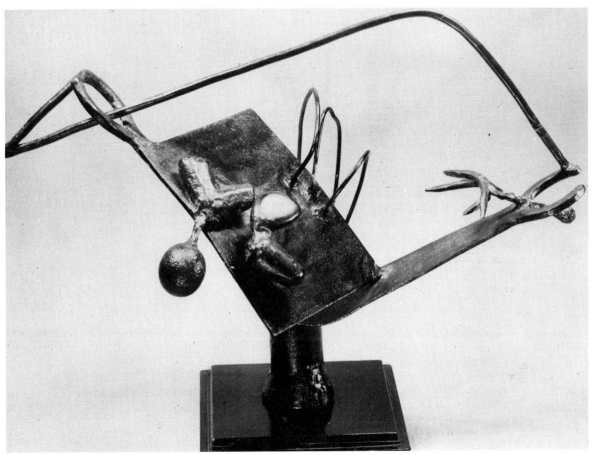

David Smith. *Abstraction*. Painted iron, New York City Project, c. 1938. (NA)

tectural concepts have changed, according to its needs, aesthetic dictates, and scientific advances. Sculptural concepts have also changed.

The composition of lines, space, textures forming the structure of a modern building appeals to the eye because of an aesthetic principle which most people accept without knowing the creator's theories relating to composition, or the experiences on which his associations have been formed. This is no less true of the layman's response to sculpture. Like any progressive attitude in art or science, of men of good will, serious and unbiased consideration of sculpture

will further the appreciation of it. A typical tory attitude is to oppose modern sculpture on anti-intellectual grounds. The tory class is using an anti-intellectual eye to view not only art, but other social-cultural forces as well. Even its notion of realism is limited to a few basic emotional reactions of sentiment and heroics. It accepts only the most superficial attitudes of realism. It is interested in one aspect of pictorial representation, and that in its most elementary form. This point of view is not one which will stimulate or enrich a growing culture.

Engineering expresses itself in mathematical

language. Abstract sculpture expresses itself in optical aesthetic language. Both languages are subject to evolution and cultural change. Both science and art are basic forces in that coordination called architecture. Mathematics is creative. Even mathematics, like sculpture, changes with time and social concepts.

Modern building cannot disregard sculpture any more than it can disregard mechanics. The sculptural point of view popularly known as abstract is progressive and definitely one of this age. It is closely related to modern building and designing, and is reflected in virtually every present-day object. It is the art of today and an important contemporary force. Neolithic, Egyptian, Greek, Roman, and medieval architecture all utilized the arts of their time. Vital modern architects will find it necessary to maintain this same cultural concept. Commercial disregard of culture has usually obliged the architect to build on the real-estate manipulator's theory of short life. For this reason sculpture which has been included in the architect's original specifications has often been eliminated.

There is no need for government building, whether federal, state, or municipal, to build on the theory of scarcity. To use the nation's talent and maintain its culture creates a fiscal asset as great as or greater than the building itself.

Fantasy and Humor in Sculpture

EUGENIE GERSHOY

Generally, it may be said that all art forms are of two kinds: One is concerned with a more or less factual interpretation of things seen, the other with a highly personal conception made up of lyrical, mystical, and religious experiences. From these two art forms arises still another which combines these elements, and extends them into a realm beyond the purely objective or purely subjective—the world of fantasy, humor, and satire.

All three traditions have always existed side by side. During certain periods one form or another has assumed preeminence. Among primitive peoples exaggeration was always a necessary part of their vocabulary. Since the meaning of their art was not obscured by method, the resultant form, though grotesque and distorted, was an intensification of life.

In classical antiquity, in Greek sculpture for example, idealized external forms express the harmonized inner life. The ideal is no individual fancy, but a rational intelligence, recreating perfection from that which can be actually seen. In contrast to this art which defines concrete objects, there developed in Gothic sculpture an art transcending

Eugenie Gershoy sculpture, and mural panel
(lost?) by Max Spivak, for the Astoria Public
Library, Queens, New York, c. 1936. (AAA)

reality: the Christian ideal of spiritual purity which
removed man from the contemplation of the ma-
terial and persuaded him of unseen realities.

With the loss of faith and religious fervor, there
was a corresponding loss of collective effort in art—a
loss of the united effort coming from a popular
religious movement—and a more individualized
approach took shape. And as industrial development
advanced, with the growth of invention, we mark a
more intellectual attitude toward art, a more and
more critical record of human action in social
conditions.

Before the sixteenth century, caricature as a form
of art was still bound up with religion, confined to
the pictorialization of good and evil. After the
Reformation it became the weapon of warring
political sects. Since then, its main function has been
the expression of revolt against subjection to
authority in every walk of life, by reducing might and
power to absurdity.

Out of the urge to destroy the sham grandiose and
the soft sentimental, both aspects of mid-nineteenth-
century degenerate traditionalism, arose new art
forms. The influence of modern psychology led the
artist to depart even further from realistic and tra-

ditional forms. Likewise the chaos in the economic
and social world in which we live has emphasized in
art the fantastic, the satirical, and the humorous.

Today the artist's revolt against conditions of life
at once prosaic and sordid, jaded and over-so-
phisticated, serves to free his art from rigid canons.
The effect is to release the imagination toward more
meaningful values. In sculpture particularly, a fan-
tastic conception can use a sculptural form that is
pure, not needing to describe organic structure. A
form released from such restrictions creates dynamic
effects. The idea that fancies, vagaries, and impres-
sions are not suitable to the sculptor's medium is
fallacious. On the contrary, lightness and gaiety are
as much in his realm as in the most capricious
imaginings of the dadaists and surrealists. Color, too,
in sculpture, serves as a delightful and important
means to intensify the individual and the typical.
Finally, then, the function of fantasy and humor in
sculpture, as in all other forms, is of prime impor-
tance today, as an echo, varied and universal, of our
changing fantastic world. It takes the role of com-
mentator: as satire it becomes propaganda; as humor
and fantasy it laughs with or at human beings—a
salvo against boredom and deceit.

Planning a Public Fountain

WAYLANDE GREGORY

The functionalist movement in architecture, aided by the recent economic crisis, called a halt to the gingerbread embellishment which had become the stock-in-trade of the ceramic industry. But before this came about the quality standards of the crafts-men who earned their livelihood in this work had reached a deplorably low level. When these in-adequate commercial outlets vanished, the artisans were left to shift for themselves. It was at this point that the WPA/FAP stepped into the picture. Its prob-lem was not only to provide a minimum of economic security, but to salvage these workers as creative artists.

I considered it an unusual opportunity when I learned that part of my work was to be the creation of a fountain to be located in the heart of the ceramic district of New Jersey. I was given a free hand in the planning of the fountain. The theme I chose, "Light Destroying Darkness," is one that has

held my interest for many years. With Roosevelt Park, the location of this fountain, only a stone's throw from the spot where Edison invented the incandescent lamp, there was a perfect setting for a creative conception of this kind. It seemed to me that this would be a fitting commemorative tribute to Thomas Edison. I wanted to interpret this theme, not only in its scientific meaning, but in the broader sense of "Enlightenment Destroying Ignorance."

At this point a number of practical considerations entered into the planning of the fountain. One of the main objectives I kept in mind was that this work should not only be fitting as to theme and location, but socially significant for the members of the com-munity. This aim could be realized by the use of the materials and facilities of the local ceramic industry and by the employment of men who lived in the community.

I found that the nucleus of men on the sculpture

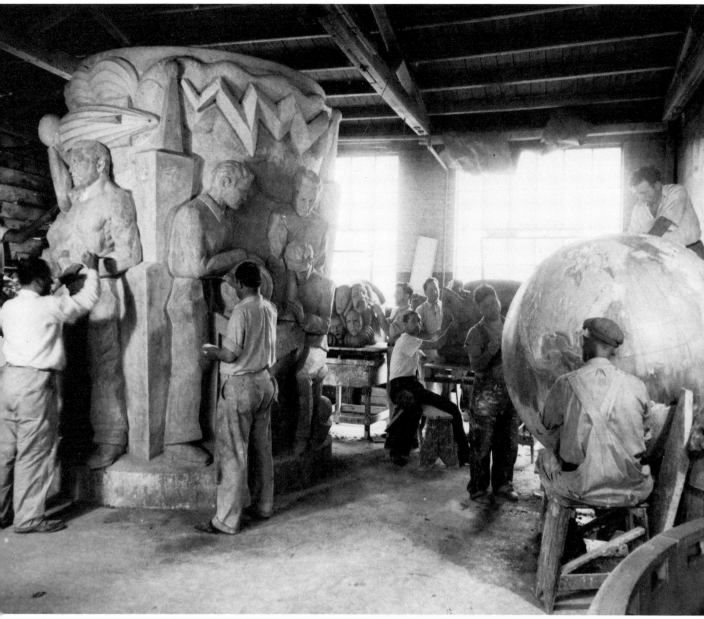

Waylande Gregory. Elements of fountain group (lost?), *Light Dispelling Darkness*, for the grounds of Roosevelt Hospital, New Brunswick, New Jersey, nearing completion in the New York WPA/FAP's sculpture studio, c. 1937. (AAA)

project in New Jersey consisted of ornamental modelers and plaster molders all formerly employed by the terra-cotta industry. I therefore decided to use terra cotta and molded concrete aggregate in this fountain. Although these men had no experience executing sculptures directly in terra-cotta clay, they were quick to learn the important lesson of adhering to true sculptural forms as related to the purpose of the work and the nature and function of the material. If the ceramic industry as well as its workers can be made to take this lesson to heart, this in itself will make our sculpture project worthwhile. What is even more significant is that the WPA/FAP is helping to pave the way for a more vital relationship between the craftsman-sculptor and industry.

Concerning Patrocinio Barela

VERNON HUNTER

The work of Patrocinio Barela, wood-carver of Taos, is so intimately an expression of the ideas and feelings aroused by his experience of every day that it forms a sort of allegorized autobiography of the artist. Patrocinio's work and thought are closely related to the simple patterns of his daily life, but there is in them always a search for the universal.

Carving bultos and thinking about them has been the most vital necessity of life to Patrocinio ever since, some years ago, he visited the home of a friend who was repairing one of the old church sculptures of New Mexico. Patrocinio became deeply interested in the powerful, crudely carved figure. That night he went home and carved a head from a block of cedar wood and hung it on the wall, telling the children that it was a policeman who would watch over their behavior. Once having begun to carve, he knew he had found a medium of expression for which he had long been seeking, for he says that he has always seen faces and figures that come to him in reveries and which he desires to realize in some enduring material. Patrocinio says:

Man lives four different kinds of life in his life—when he is boy and when he is young man, and then middle man and then old man. And those have been my ideas to carve a bulto to show the life of man in these carvings.

Man is born and created by laws of nature and so he born all by himself and then he hope for the hope he has been waiting. Then comes number two which means it is a son which has been reproduced by him and it only half the man he should be, but then after, he grown to be a man and that means number three. Number two and three make a complete man and he grow like the tree that is by his side—large and strong in life, full of happiness and full of hope. But then comes number four—that man is growing older and he has gone through life. He has work and struggle and now he is old, tiresome, and weak.

Same way with the tree by his side. He older, his branches and leaves have fallen, his beauty gone. So tree only appears to be a pole or a bare post. The trees have grown in the same way of man. When the tree that is carved near the bulto number four there is no more hope so the life of the tree died and there was no more beauty. Nothing left but bare branches. That was my idea. So under those way I carved the following bulto to show the four different parts of a man's life.

At first Patrocinio carved traditional figures of saints, evidently feeling that the more conventional type of work would be more acceptable, although his manner of making his carvings has always been far from the conventional. Had he lived in colonial New

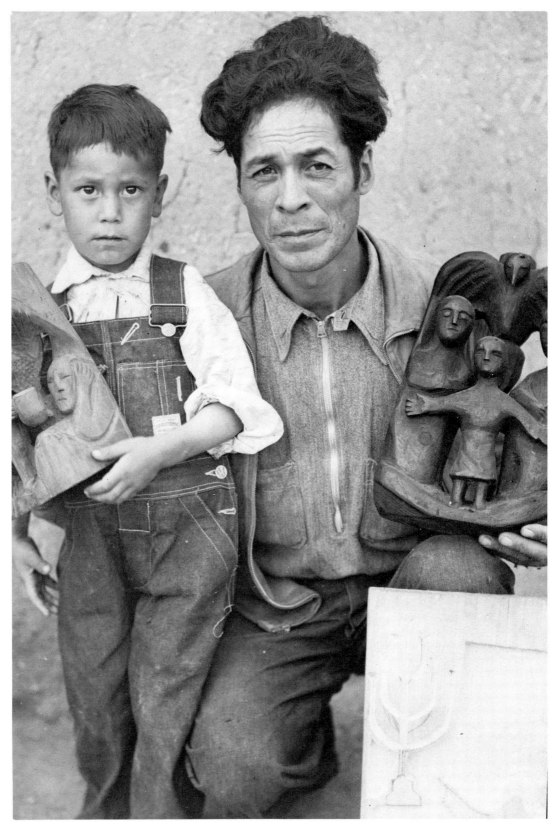

Patrocinio Barela with his son and wood-
carvings. New Mexico Project. (AAA)

Mexico, he probably would have dramatized his carvings within canonical conventions in order to find patronage among the faithful. But Patrocinio's expression has not been influenced by any tutoring in doctrinal presentation of religious subjects inasmuch as his father, the strongest influence of his childhood, was an herb healer who at times indulged in occult practices.

Patrocinio Barela's childhood was by no means molded in orthodoxy. He was born in Bisbee, Arizona, twenty-nine years ago. His mother died in his infancy and his earliest recollections are of a variety of boarding houses, and of lumber and sheep camps and farms where his father worked. Patrocinio and his father moved to New Mexico when Pat was a small boy, and there the father married a woman who had no love for his wide-eyed, curly-haired son. At the age of eleven Pat ran away from home to face the world on his own.

The father had not thought it necessary to send the boy to school since he was only going to be a laborer, and since his family had had no relations with English-speaking people Patrocinio knew no English when he left home. In beating his way on a train he injured his arm and hand, and a kindly policeman who picked him up in Denver took him to the Juvenile Detention Home. Here he was given medical care and later was sent to board with a Negro family. In this family he learned the English language and "American ways." As soon as he was able he went to work as a ranch hand and for a number of years wandered through Colorado, Wyoming, and New Mexico, picking up a meager living as an itinerant laborer.

Since 1930, when he returned to New Mexico to visit his father, he has lived in a small village in Taos Canyon. Here he married and tried to make a place for himself in the little village world as an occasional laborer and carver of bultos. But work was scarce and the demand for Patrocinio's carvings almost non-existent.

"My friends they say, those work of yours, those carving, they no good. Can't eat, can't sit on, can't use. Why not you make things to use. They laugh at me. But they no use their head, just make boxes. Before this government work come I must find food for five mouth. Sometime I make maybe twenty-five cent a week. A week! If I have good luck."

When the ERA opened its office in New Mexico, Patrocinio, who had for a long time been without employment, was given a job as a teamster. At night, when he was not too tired, he worked on his carvings. When the WPA/FAP was organized in 1935, Patrocinio's work was brought to the attention of the Project by an ERA social worker who had become greatly interested in Pat and his carvings. Since then Pat has been employed on the Project and has been able to carry on his chosen vocation.

He continuously demonstrates profoundly his devotion to his work and his appreciation of the opportunities which the Project has brought him. His work is such an intimate expression of his psyche that it might easily be a trial for him to see it leave his workroom. He repeatedly refuses to sell to tourists, retaining everything, far beyond Project production requirements, saying, "This belong now to Art Project. When project he is finish, then I will find way to make living."

This sense of responsibility carries over to his family—a wife, three stepchildren, and two of his own—a four-year-old son and a daughter aged five months. To his own, Pat expresses his first obligations: "I got just three in world I can depend on; they depend on me. Old man, I come from him; owe him more than I can ever pay. My kids, they come from me; I owe them food, fire, life."

He says of his carving "Heavy Thinker" that he there portrayed himself weighed down by the responsibilities of his family life and the problems of his art, struggling to be himself, and supported only by the friends who believe in him. "My head, he is often felt to be in three or four pieces, although he looks to be only one."

The physical forms of the work of Patrocinio Barela might seem eclectic to some. But certainly the meaning and intent of this work could never be

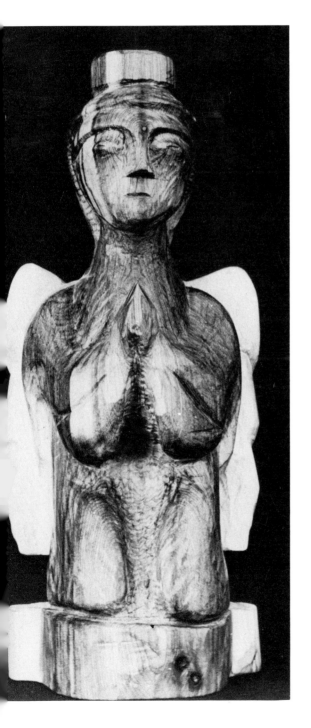

construed as anything other than Patrocinio's own—call him a natural, a primitive, a true original, or what you will, with the power to philosophize the experience which life has brought him.

A recent carving explains him: Man is crouching painfully under a dying tree, with depressed thoughts in a depression-ridden world. "Before idea come, I got my head, but no use; just sitting, dreaming all time." On the second side of the carving thought comes to the depressed one. "When I find my head, a notion comes from the air. Persons without head got only heavy work, hard times." In the third part of his carving: "Is where I planted the future for me, which has been the art I discover. I put my right hand to my head, surprised. I stand on my own feet. I didn't know I had those brain to develop such things as I have discovered for my future, so I planted that tree which you know is straight and full of life."

To his workroom he has brought a stump gnawed by beavers. Of it he remarked: "They are better carvers than man. If God send beavers to school, they beat us all." To Pat, school means an unlimited observation of natural phenomena. A pine knot, weather-gnawed into filigree, strikes deep humility into his mind as he compares it with his own work.

With the inherent adaptability of his realistic race, he takes things as they are with a fatalism not less than oriental, but he meets them with unconquerable idealism and fortitude. Knowing little of life's tangible complications beyond the need for enough food, enough fuel, a room in which to work, and a house to keep out the cold, he is free from our national passion for accumulating things. But of natural philosophy, of timeless wisdom, he knows more than most persons gain through formal degrees, for to Patrocinio Barela faith is axiomatic, and life has reason.

Patrocinio Barela. Woodcarving of angel. New Mexico Project. (NCFA:Cahill)

Sculpture in Southern California

STANTON MACDONALD-WRIGHT

Perhaps the most significant contribution of the WPA/FAP in Southern California has been the creation of objects by groups of artists—public monuments like the mosaic at Long Beach or the recently completed sculpture by Donal Hord at San Diego—on which anywhere from ten to one hundred artists have been employed. The individuality of the artist was compelled by circumstance to adjust itself to a group conception. This healthy subordination of the individual's creative will to the wishes of the many has brought about the realization that art is essentially a group activity, and that artists can work together toward a common goal in the cause of culture and humanity.

The Project in Southern California has tried to avoid, as much as possible, the creation of works in perishable materials, or the erection of monuments in cast concrete, and to concentrate the efforts of the sculptors on the cutting of natural stone. With this in view, and at the same time realizing the difficulties of developing the talents of sculptors to include stone cutting, we have encouraged the cutting from stone of even small models to be submitted to sponsors' committees. This has developed a very real interest in what one might call a "feel" for the material of stone itself. And living in a country where the material is highly diversified, there has been little difficulty in obtaining practically any type of rock, from hard to soft, with which the artist may experiment.

Another contributing factor in this trend of sculpture in Southern California has been the enormous amount of building during the last few years and the planning of cities which is going on continually through the efforts of our park boards and city engineers. Such planning has often included plazas or squares in front of the new edifices that have really cried out for the placement of monuments. With the advent of the Project, municipalities and institutions of learning have realized the possibility of finishing their plans by taking advantage not only of the talents supplied by the Project, but also of the vastly lesser sums of money necessary under this arrangement than if these commissions had been given as private commissions.

The Project was fortunate also in having men who had already experimented with rock cutting, such as Gordon Newell and Donal Hord of San Diego, and it required little effort on their part to inspire the other men and women to attempt this much more satisfactory (both to the artist and the onlooker) type of work. The supervisors themselves, well versed in the art history of the older races and cultures, gave lectures on the developments of stone cutting throughout the ages and exhibitions were given on cultural developments, most of the examples of which were reproductions of sculpture pieces.

It was pointed out how various was the approach to the cutting of different types of stone and how very important the artist's approach to his material,

in relation to the ultimate form taken by the material. With such an idea underlying the instruction of the workers, a rationalistic basis of types of material was made by pointing out how, for instance, in the Egyptian tradition, green stone, granite, wood, lime, and sandstone produced over a period of thousands of years certain radically disparate types of techniques.

These studies have not only aroused a very much greater and more intense interest in the sculptors for sculpture, but they have given all those who work directly in these materials a greater feeling for the possibilities of sculpture itself.

Needless to say, most of the sculpture done on this Project has been of figures and figure groups, due to the fact that most municipalities wish to memorialize pioneers of their particular communities or to symbolize events in their history. For instance, in San Diego we have Donal Hord's statue, locally called "Guardian of Water." This project represents eighteen months' work by a crew of three artists and two blacksmiths, and the entire cost to the City of San Diego, including even the hydraulic machinery, amounts to the extremely low outlay of six thousand dollars.

Besides this magnificent work of art, Mr. Hord has carved, in the most intractable material conceivable, a life-size Aztec Indian now placed in the San Diego State College. The difficulties encountered in cutting this black diorite figure were almost insurmountable by means of hand tools, and it was only when this was discovered that air pressure was brought in to help the crew.

It must be realized that all hard stones such as granite, serpentine, or diorite cannot be cut; they must be abraded, and the old method of abrasion was to make a sort of double-bitted ax, each blade of which was composed of twelve sharpened and tempered steel blades bolted together. This was then used almost as one would use a common ax, the stone crumbling slightly when struck with great force. Modern machinery has made this unnecessary by the utilization of tools which work much in the

manner of Burley drills, producing abrasion by means of rapidly striking the surface of the stone. A clear idea of the old processes can be gathered, by those who are interested, from reading Benvenuto Cellini's essay, "Stone Cutting During the Renaissance," in which he speaks of a single artist who was attempting to cut hard stone. It is perhaps due to the unflagging effort necessary to work in this adamantine material that the great artists of the Renaissance made use of marble almost exclusively, for marble can actually be cut by sharpened chisels when struck with a hammer.

Mr. Hord, we believe, is one of the first men in this country to attempt any large piece of monumental work in diorite, and he is no less successful in his work in obsidian. At the present time, there is a black obsidian head, over-life-size, abraded by Mr. Hord, at the New York World's Fair which, aside from its undeniably artistic qualities, represents the acme of craftsmanship, not to speak of the acme of patience. This head required three years to complete, as no tool of any kind can be used in its cutting. Carborundum stone, or a similar abrasive, was placed in the end crotch of a small, manageable piece of bamboo, and this volcanic glass was rubbed until its surface was eaten away. An electric tool, revolving or vibrating, could only cause too great a heat or deep fractures where no fractures were wanted. The result of technical experimentation brought Mr. Hord to the conclusion that the ancients, both in Central America and Egypt, had found the ultimate process for the working of obsidian.

The type of work most in demand in this area is that which Mr. Uno Palo-Kangas carved for Bakersfield, California. We are told that this piece of limestone was the largest single block ever brought out of Indiana. It weighed approximately twenty-four tons and was cut down about fifty per cent in the carving of the figure. This figure is that of Father Garces, the first white man to open up the territory which is now a thriving agricultural district one hundred and fifty miles north of Los Angeles. It is a simple figure of this priest, sixteen feet four inches high, set on a base of

Uno John Palo-Kangas.
Fra Junipera Serra. Cast concrete.
Ventura, California, 1936.
(NCFA:Cahill)

purple carnelian granite on which are incised scenes depicting the life of Father Garces. The whole monument stands twenty-two feet five and one-half inches high and the circle in which it has been placed has been renamed Father Garces Circle by an enthusiastic group of townspeople.

Mr. Palo-Kangas achieved some fame when he was first taken on in the Project by carving from a piece of red sandstone a father, mother, and child. Since then, he has produced a heroic-size Fra Junipero Serra which stands in front of the Ventura Court House. He is now working on a design for a relief carving depicting the migrations of peoples; it is to be erected in Los Angeles.

Another figure fifteen feet high, carved in Lucerne granite, is being done by Sherry Peticolas and represents De Anza, the Spanish conquistador who made the famous trip from Tubac to Riverside. Needless to say, Riverside will be the home of this magnificent work. It is to be placed in the public square in the center of the city and from it will extend a wall, forty feet long and seven feet high, which will have cut in low relief the procession depicting De Anza's entourage in his famous travels. The wall is being designed by Miss Dorr Bothwell. This monument gives promise of being one of the Project's greatest achievements.

Perhaps the largest monument being done in the Project anywhere in the United States is now nearing completion at the entrance to the Hollywood Bowl. There are three figures: the central figure, depicting the Muse of Music, a conventionalized female figure kneeling and holding a lyre, is cut from four pieces of Lucerne granite and rises over fifteen feet from its base. The base itself is twenty-five feet above sidewalk level. There is one figure of the Dance and one of the Drama, each ten feet high. Aside from the figures themselves, the entire monument is an engineering feat undertaken by the WPA/FAP according to the designs made by the artist, George

Stanley, and sponsored by the County of Los Angeles. The entire hillside of this famous shrine is made into a monument, in which are eleven hundred and eighty-eight tons of concrete, the forms of which are delineated by slabs of the same granite to the amount of two hundred and forty-five tons.

Besides these pieces, which represent the largest undertaking, there are numerous other works that are but slightly smaller in range, some in cast stone, placed in prominent places throughout the Southland, others decorating fountains and architecture. At the present time we have orders for a number of other very large pieces. Balboa Beach wishes to have a fifteen-foot statue of the Spanish discoverer after whom the city is named. This will make a sister piece to the large statue of Cabrillo made by Henry Lion and erected in the last-named city. This design was also made by Archie Garner, who has done creditable work here on the old PWAP He has designed a figure of Santa Barbara over forty feet high for Santa Barbara which was to be constructed of metal in an artificial lake. He has also designed two groups, to be cut in granite, for Glendale, both of which depict figures over life size.

A greater range of materials would be used were the cost less prohibitive to cooperating sponsors, but within the range possible to the budgets of our tax-supported institutions we have diversified our media as much as could be expected. Our program has, up to the present, comprised limestone, sandstone, diorite, two kinds of granite, three kinds of marble, wood, concrete, and terrazzo. But like all projects, we are hoping some day to find the sponsors who can afford to let us choose our own material and give us time to work it without haste and without fear of financial consequences. At such a time perhaps a great figure in black jasper or in that magnificent stone, colored like lapis lazuli and almost as hard as a diamond, called dumortierite, will engage our attention.

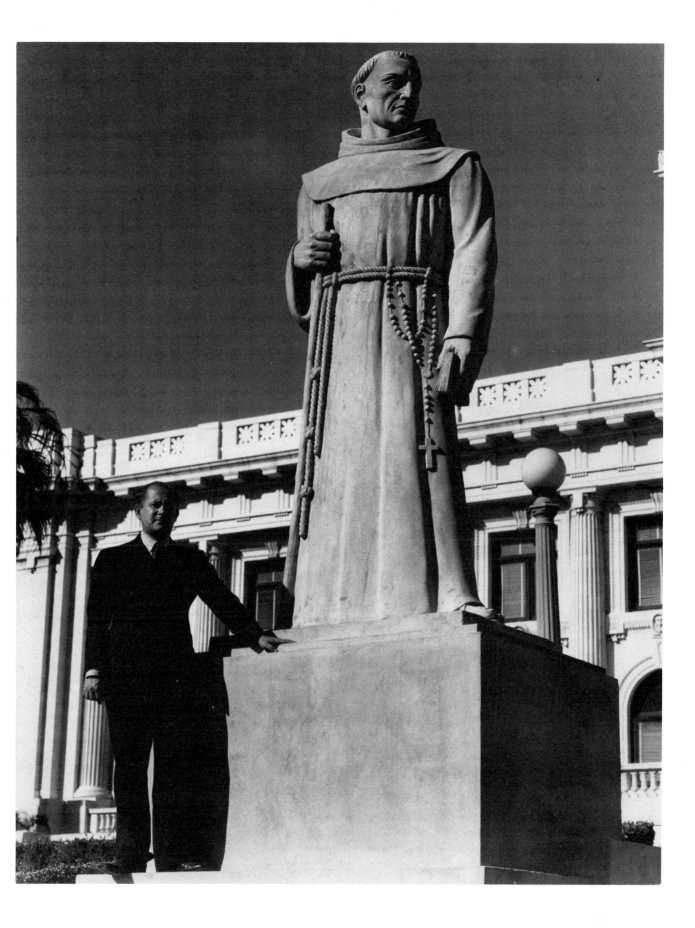

Symphony in Stone

DONAL HORD

The artist in this, the extreme southwestern corner of the United States, faces an element that is concerned less with people and an industrialized landscape than with the strong light beating on ancient granite and sparsely watered hills. Each year the question of seasonal rains affects the land. Will the dams overflow, or will it be necessary to graze cattle on the little patches of green in the reservoir basins? Will there be enough water? That is in essence the background of this region which runs diagonally north through Nevada and east through and beyond Arizona—and south into Mexico. For this is on the border of what botanists call the Sonora Zone. If an artist lives here long enough and knows the dry boulder-studded reaches of the American deserts, he becomes affected by that same symbolism of forces, rather than an impact of personalities, that affected the ancient Asiatics who passed through here on their way south to develop art in Mexico.

I have lived in the southwest most of my life. I learned to model and carve here in Southern California, where sunlight is intense and shadows are harsh. I once spent fourteen months in Mexico, and thereafter eight months in New York and Philadelphia. Both these cities seemed, and still seem, more foreign to me than the Mexican states south of our border. Feeling this, I came home.

Very few western sculptors, south of San Francisco, were carving at that time. I learned and broke the maxim: "Never use anything but a chisel on wood." I have riffled wood, I have sanded and polished wood, and polychromed and laid metal leaf over it. From many mistakes one learns many things. I learned direct carving.

Fine quality granite is available here, black diorite, green diorite, obsidian, and felsite. Granite is a tough stone to crush into forms. Our diorite rings like an anvil, and gives tactile pleasure after its dark crystals

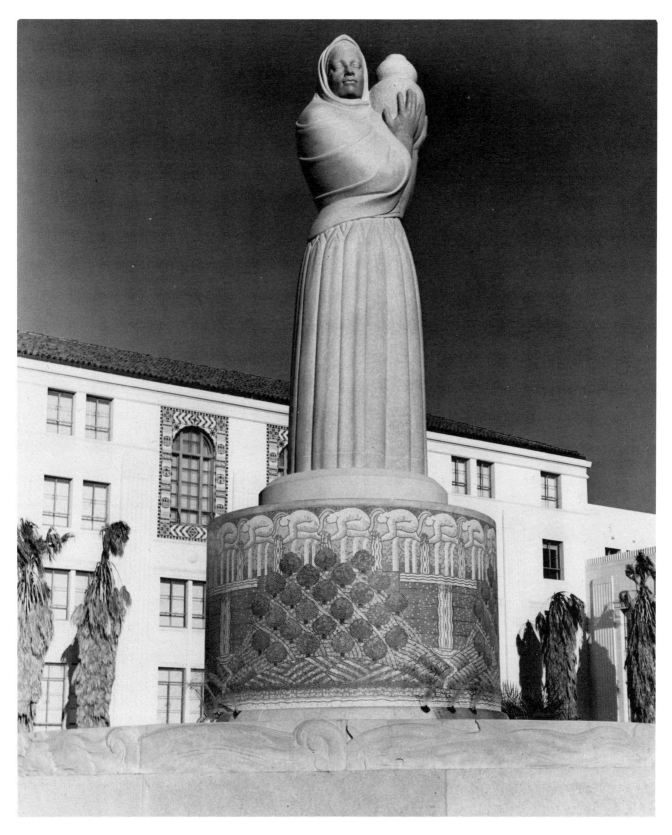

Donal Hord. *Guardian of Water.*
Granite. San Diego, California.
(NCFA:Perret)

have been rubbed smooth. My second stone figure was beaten from this material. It was shaped in the open under all lights and conditions, and after seven months of struggle with peen and bouchard hammers, modern air tools and diamond points were brought into use. This diorite sculpture was begun, finished, and dedicated under the auspices of the WPA/FAP.

Shortly after the conclusion of this work, funds were set up by the Fine Arts Society of San Diego for a memorial to Helen M. Towle. This work, a public fountain, was also sponsored by the WPA/FAP. The subject material was not specified. The only official demand made was a natural one: the sketch must be seen and approved by various committees. This was freedom indeed in an area where historical personages are dear to the hearts of most citizens. Alta California began here. Juan Rodrigues Cabrillo, Portola, Father Junipero Serra, glamor figures of exploration and secularization of the territory, knew this spot. They knew our harbor—and they found water enough here to support a population.

A sketch was made in clay, a woman's figure, based on the fluted water-storing column of a spiky native cactus. The figure bore a jar shaped like the water gourds once used on desert trails—a natural container from which the Yuma Indians evolved a pottery form. The woman was compact, designed for a twelve-foot monolith of silver-gray granite. We called her the "Guardian of Water." Someone named her "Pioneer Woman." Some society objected to her, saying, "The pioneer woman looks like a Mexican." A battle was on. We won.

The fountain base and supporting basin designs were founded on the idea of concentric ripples caused by water falling, drop by drop, into a still pool. On the rim of the outer circle a mosaic ripple design with salt-water snails was the symbolic shore of the sea. Across a strip of water an inner pool encircled by bas-relief, carved and cast, portrayed the ocean churned by porpoise, swordfish, skipjack, and squid. Again there is an area of water. From this, a drum eight feet in diameter rises to support the gran-

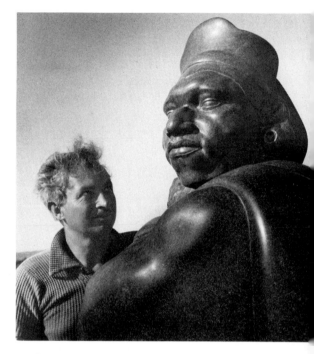

Donal Hord with his sculpture, *Aztec*. Diorite, San Diego State College, San Diego, California, c. 1937. (NCFA:Cahill)

ite transitional base under the figure. The textural effect of mosaic is repeated on the drum to stress the theme of the importance of water. Symbolic clouds pour water into dams and onto citrus groves.

The surmounting figure of the "Guardian of Water" was carved in the open, facing the west as it was intended to face when in position, and after the first proportional blocking all small models were stored away and ignored. Pointing was not used. The carving was direct. As I have written before, our light is too bright, our shadows too deep to permit the use of angles. Continual observation of the granite under varied lights enabled us to minimize the harsh effect of sharp turns in fold or form.

As to methods, I have no formula. I was once reproached by a fine sculptor who said, "Don't treat your clay like a navvy with a bucket of swash. Handle it as if it were precious and you'll get a precious result."

There are many who argue against this. I agree with it. It applies to stone and wood and wrought bronze. Respect your material. It will probably outlast you, so don't betray it.

For the Present We Are Busy

BENIAMINO BENVENUTO BUFANO

Let us work in the most modern media in the world: stainless steel, Duraluminum, and the noncorrosive alloys. Let us work in the hardest media in the world: granite and porphyry. Let us work directly in our material, for the things we have to say are unevasive and unsentimental. Let us commemorate the great men of our time and the great cities: Pasteur, Einstein, Sun Yat-sen, Steinmetz, and St. Francis.

Our art must become as democratic as science and the children in the playgrounds of our cities. That is why I have sculptured Pasteur for one of our high schools, Sun Yat-sen for our Chinese quarter, granite frogs, bears, and seals for our recreational parks, and St. Francis for Twin Peaks—a symbol of the city that bears his honored name, big enough to belong to everybody, too big for anyone to put in his pocket and call his own.

We ask no more than this, but if we are to do these things we must have help. We must have money for our granite, we must have tools for our metals. We must have men who have schooled themselves in the crafts to help us produce. Art, to have power, must have these things. If we are to create a living art for a living world, we must have help.

Long before the WPA/FAP came into existence, I offered my services to several communities at day-labor wages if they would supply the materials and let me work. There must have been many artists with this same spirit, enough so that their voices could be heard beyond the provincialism of their own towns. Movements like a government art project are not an accident; they come from great needs, the need of the artist to give something to the world as much as from his need to survive.

An artist today must, in order to be classed with the living, play a part in the contemporary scene. This does not mean that he cannot experiment in abstractions and other testing grounds of creative work. But he must not fail to recognize that both a need and an opportunity exist today in which it is incumbent upon him to make his contribution.

We have only just begun to glimpse a vision of the

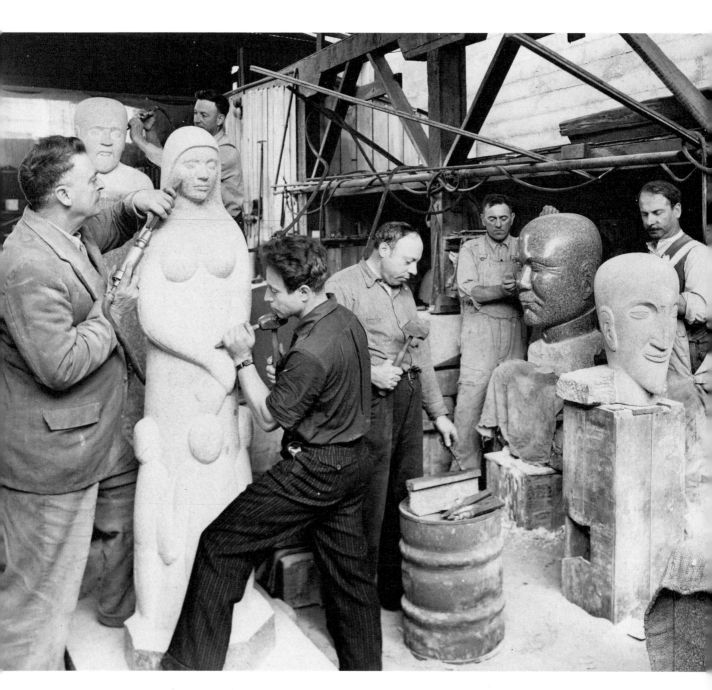

Beniamino Bufano (in striped trousers) at work in the WPA/FAP sculpture studio, San Francisco, California, with statues of (l. to r.) *Louis Pasteur, Mother of Races,* a red granite head of *Dr. Sun Yat-sen,* and a model for his head of *St. Francis.* (NCFA:Cahill)

great genius of the American people. Their desire for a fuller abundance and their eagerness to acquire education relating to the arts, the sciences, and most important, human relations—all these add up to an exciting fact. It is a demonstration that we have within ourselves the opportunity to create a greater civilization and a greater culture, a culture that might well guide the future course of world destiny to a better way of living. And on our scientists, architects, statesmen, painters, musicians, writers, and sculptors is the responsibility of leadership fixed. Theirs is the powerful medium for the dissemination of true universal principles.

The vastness of our country inclines our engineers to think in broad terms. Witness our dams and our bridges. They have pointed the way toward our American culture. Their very designs reflect public service and functional objectives. That is why they are remarkably beautiful. And that is why our great American public make pilgrimages to these public monuments as Europeans do to shrines.

Industry too has inadvertently contributed to the raising of our aesthetic standards. Our airplanes, our automobiles, our streamlined trains—all embody in their designs that economy of line that is true art. But herein lies a paradox.

Too many of the same public who would object to a 1908 Ford as a modern means of transportation will object to a sculptor using pure forms in interpreting his message. Yet this same group readily accepts the sculptural forms of ancient Egypt, because they have been authoritatively told that these forms are good.

Apparently there has been a lack of education in aesthetic appreciation. Johnny and Mary have been taught Salesmanship and how to punch a cash register. They have not received as yet the fuller measure of knowledge embodying less transient values and more permanent happiness. Those engaged in the arts can supply that.

Many who call themselves "American artists" have borrowed some decadent European form and have pursued it in true merchant fashion. If sales were being made in the "Barbizon School" technique, these "artists" would supply them. In New York they would adapt the "Barbizon" palette for scenes of the Catskills. In California the locale would be Monterey. What the hell! Mix the paint by the gallon. Get a mess of picture postcards and enlarge them to overmantel size. Hand-painted, by God! Roll them out of the studios like belt-line production, and our children laugh at these chromos as they laugh at the clothes mother wore when she was a girl.

We need artists who are interested in creating a universal culture. In being alive. In having something to say. And in saying it—ready to consider no sacrifice too great in making themselves heard. Artists who are concerned with universal truths. Artists whose natural instincts are to grow, to move forward. Artists who will be the ambassadors of time into Time. Men who will ultimately be favorably judged on what they have created for the benefit of their fellowmen.

WPA/FAP has laid the foundation of a renaissance of art in America. It is the open sesame to a freer art and a more democratic use of the creations of the artist's hand and brain. It has freed American art. No longer must the artist be forced into social associations where the only claim to attention is the individual's financial means. Means that meant material with which to work—stodgy dinners where the humiliation of being lionized was the price of the meal. Meals where artists were assembled to "sing for their supper"—portraits of overstuffed children and lazy women the only means of an artist's expression and survival.

One couldn't expect these "patrons" to like the Project. It interfered with their opportunity to buy things of enduring beauty for pittances, under the guise of "helping struggling artists."

I have before me now a letter of whining complaint and recrimination from an "ex-patron" of mine. He was incensed at the idea of my engaging in work which could not adequately fit over a fireplace or decorate a room. The idea of a monumental St. Francis horrified him. To quote: "Your earlier instinct used to be for the small; babies with wobbly heads

and no seeing in their eyes, the little lapis-lazuli-blue-glaze fountain in our court, two children clinging together playfully under the shower of water, and that marble group of puppies which I delivered to Mrs. S. by your order, young rabbits, and such small deer without character or intelligence. You did these beautifully, as so you did any subject with its own compelling lines."

Referring to St. Francis, he says: "The creation of such a statue would require a truly great sculptor—a truly great artist. You did not want that. You wanted a figure of rustless steel boilerplate, so high no one could see or care what face it wore. I think, Benvenuto, that is what you want. I think that is what San Francisco will get, with the help of the WPA/FAP—a rustless steel mechanical stunt."

How can such a man understand the Sun Yat-sen or the Statue of Peace? I sculptured "Peace" in the form of a projectile, to express the idea that if peace is to be preserved today it must be enforced peace—enforced by the democracies against Fascist barbarism. Modern warfare, which involves the bombing of women and children, has no counterpart in a peace interpreted by the conventional motif of olive branches and doves.

How can cultural tastes be developed in a people? How can their lives be made fuller if they have no opportunity to play a part in creating things of beauty?

How can a cultural pattern be developed for America if art and the artists are subjugated to the whims and idiosyncrasies of a few overfed decadent merchant princes, carryovers from the days of feudalism?

WPA/FAP has been the hope of the greatest cultural renaissance in recent times. For the present we have steel, stone, and tools. We have the spirit of great men and great cities to move us. *We are busy.*

Beniamino Bufano. Dr. Sun Yat-sen. Aluminum and red granite. San Francisco Project, c. 1938. (Photo: F. V. O'Connor)

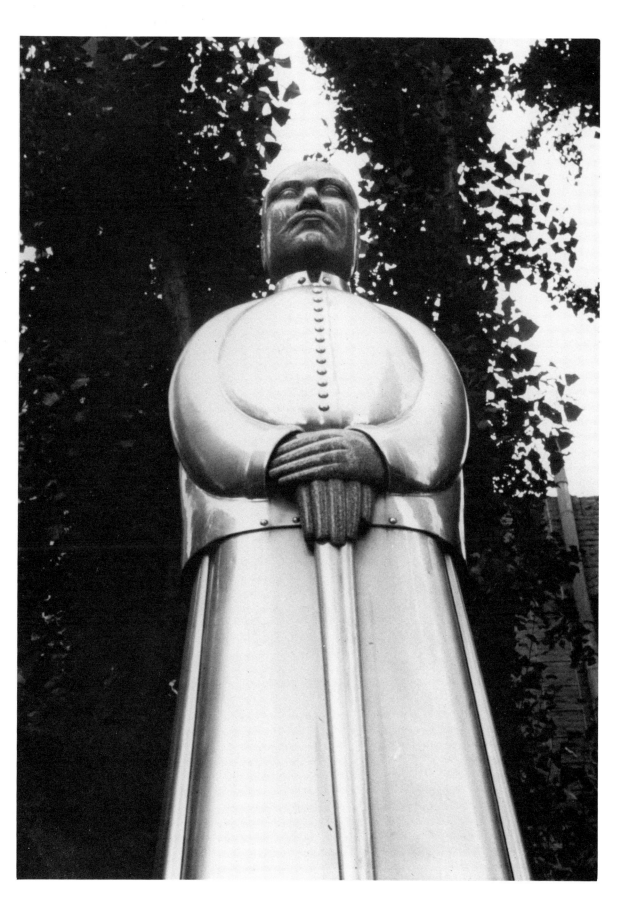

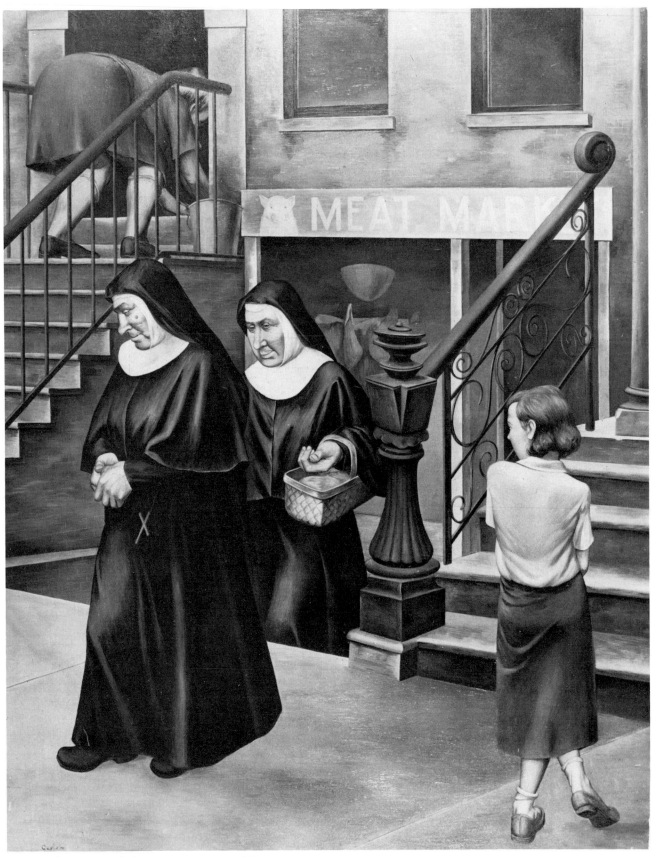

Louis Guglielmi. *Sisters of Charity*. Oil on canvas, New York City Project. (AAA)

After the Locusts

LOUIS GUGLIELMI

It was a charming, decadently gay period before the locusts came to lay waste a world madly preoccupied with the enjoyable pastime of forgetting its spiritual and moral bankruptcy.

The early 1930s were coldly sobering years. The artist, a highly sensitive person, found himself helplessly a part of a devastated world. Faced with the terror of the realities of the day, he could no longer justify the shaky theory of individualism and the role of spectator. As with many other creative workers, I reached out for a more positive and objective basis of thought to displace the inadequate destructive negativism that so deeply pervaded all thought and aesthetic production at the time.

From an honest translation of the French painters and in particular the Surrealists (to whom I was later to return because they expressed our decaying society), my work gradually changed to a more literal and objective representation of life about me. Summers spent in New Hampshire further developed this tendency and awakened a latent interest in the New England tradition and the American scene.

The paintings I produced for the WPA/FAP form still another phase of my development and are products of observation of everyday life in the poorer sections of New York. My own childhood was spent in a tenement neighborhood on the upper East Side. As is commonly the case, there was the motivation to escape this environment and its frustrated existence into what appeared sunnier—the middle-class world. It was also logical that more recently I should seek to regain the roots of earlier years and repudiate the upper crust of society. My two pictures "Hague Street" and "Wedding in South Street" illustrate this attempt to recapture the past in terms of the present. The social content of these pictures is not only common experience, but is essentially autobiographical. The picture of the boy carrying a flowerpot in a classically lovely painting is the sublimation of an emotion, the suggestion of escape from the horror of living in a mean street under the arched approach of Brooklyn Bridge. The other canvas, "Wedding in South Street," is almost literal reporting of the marriage custom among the poor, with the amusing

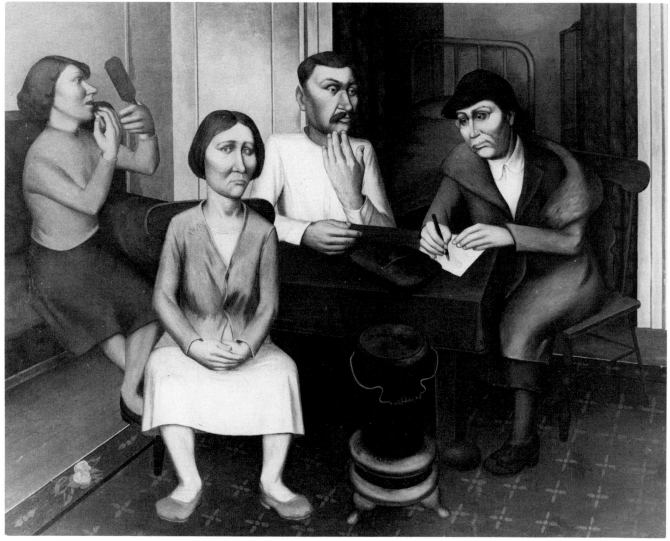

Louis Guglielmi. *The Relief Blues.* Oil on canvas, New York City Project. 1938. (National Collection of Fine Arts, Smithsonian Institution, Washington, D.C.)

anachronism derived from imitation of the rich. This accounts for the hired wedding gown, the hired dress clothes and automobile, against the background of the overpowering warehouse and bridge and the showy Victorian stoop.

I have tried to indicate in this history of my growth as an artist and as a member of society why I feel it is necessary to create a significant art and not merely some super-deluxe framed wallpaper to decorate the homes of the wealthy. The time has come when painters are returning to the life of the people once

again and by so doing are absorbing the richness, the vitality, and the lusty healthiness inherent in the people. This source of inspiration necessarily dictates the creative forms that evolve. Coming from within the people, the resulting art will celebrate the experiences of the race.

This is only possible through government patronage, with its facilities for employing artists in great numbers and for creating a huge audience. The private gallery is an obsolete and withered institution. It not only encouraged private ownership of

public property, but it destroyed a potential popular audience and forced the artist into a sterile tower of isolation divorced from society. The Project has cleared the path toward a sounder and brighter future. Speaking for myself, I can say that without the financial benefit of the Project, it would have been impossible for me to have continued to work and grow in stature. The collective output of the past year has clearly revealed the enormous amount of young talent that, under less fortunate circumstances, would have been crushed on the wheels of poverty. It is of the greatest importance to the culture of our nation that the Project be maintained on a permanent basis, free from the offensive stigma of relief.

The People in My Pictures

JULIUS BLOCH

Most of my work deals with Negroes and their lives. For more than fifteen years I have been observing the Negro population of Philadelphia, attracted by the rich color, rhythmic movement, laughter, and religious fervor so characteristic of the race. Hundreds of notes, made from life in districts where Negroes predominate, fill many of my sketchbooks. These I have frequently used in making compositions for paintings and lithographs. Most of my people have been humble workers, ditch-diggers, hodcarriers, bootblacks, ragpickers, washerwomen, household workers, parkbenchers, preachers, and an occasional tapdancer, boxer, or saxophone player. Each one I selected because I found him or her not only typical of the race, but also revealing in character and bearing the complex problems which are the by-product of life in a large, densely populated city.

It has been my good fortune to have my work shown in formal exhibitions throughout the country, but it has always been my hope that my pictures would be seen and enjoyed by the people who inspired them. This wish was recently granted at a WPA/FAP exhibition held in Philadelphia's subway concourse. Thousands of people streamed by from early morning until midnight, and it was gratifying and inspiring to see how closely they examined the works displayed. "This," remarked a friend of mine, "is truly the People's Museum."

Great numbers of Negroes came to the exhibition, and they manifested an eager and sincere interest in everything on display. There were constantly small groups of them, gazing intently at the pictures, discussing them, and expressing their reactions and preferences. I saw groups standing before "Marble Champ," a small portrait of a bootblack aged fifteen, which I painted during the past summer. Judging by the remarks I overheard, I believe the spectators for the most part approved. A woman said, "Right out of

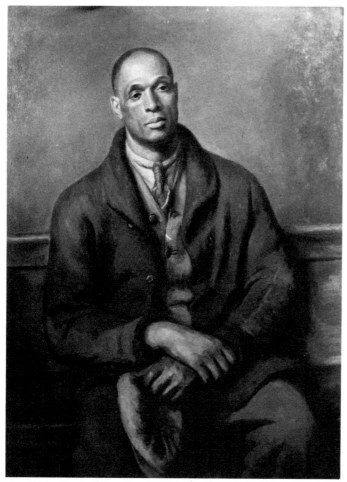

Julius Bloch. *Thomas*. Oil on canvas, Philadelphia Project. (NCFA:Cahill)

South Street, you see them just like that every day in the week. My, it even shows the dirt on his neck. I love it."

Many of my drawings are of workers, men and women of both the White and Negro races. A charcoal drawing and a tempera watercolor represent a gangster who has apparently been put on the spot. "Dead Soldier" is a lithograph made from the vivid and lasting impression made on my mind when, during the first day of the Meuse-Argonne Drive, I came upon the first dead soldier I had ever seen, lying by a thicket near the road to Montfaucon. He was a fair-haired, blue-eyed American lad whose first name was Dennis, according to the tag fastened to the lapel of his jacket. These are the subjects and feelings I have attempted to communicate honestly and persuasively.

Some Technical Aspects of Easel Painting

JACK LEVINE

Today many painters are trying to find more satis-factory methods of painting than the prevalent "straight oil" technique. *The Materials of the Artist and Their Use in Painting*, by Max Doerner,* has stimulated great interest in the procedures of paint-ing, especially in regard to the methods of the old masters. This book, although obscure at times, is ex-tremely valuable as a painter's guide. Books of this category have hitherto been directed to museum technicians.

Having consulted the book for several years in experiments, I find it wanting in two particulars. First, in the lack of consideration given to a low-keyed underpainting, for which I have found ample prece-dent. Second, on the nature of the tempera emulsion in old master paintings.

In the painting "Agony in the Garden" by El Greco, at the Fogg Museum, Cambridge, Massachusetts, the small group of three figures is painted in grays in a value somewhat lower in key than the flesh tints of the Christ or the angel. These figures are doubtless painted in tempera, and except for a glaze to make the background recede past a head, or a few high-lights for saliency, this area in the picture has been otherwise unqualified by an overpainting. It is reasonable to suppose that the entire picture has been underpainted in grays, somewhat lower in key than the finished painting. The warmer flesh tones

were translucently applied in oil color.

Doerner's version of the old master underpainting is the heightening with *white* tempera over an im-primatura (lean varnish or oil varnish glaze over priming). It is true that Doerner occasionally sug-gests the addition of a little ochre so that the under-painting is not too cold, and recommends, here and there in the book, a tinted (white) underpainting. This would establish two categories of under-painting. For practical purposes it might be well to call them, respectively, the "dead-color" under-painting, and the "white, or off-white" underpainting. Over the white or off-white underpainting, Doerner recommends a frottie, or glaze, and onto that an overpainting in opaque colors. This underpainting has just taken care of the modeling, and is neither warm nor cool. The luminous white underpainting will make any color over it look dirty. If sufficiently overpainted, it will cease to have any luminous effect. If one paints opaquely over this under-painting, one has to paint both warm and cool tones. The underpainting will be obliterated in a few minutes. A pure color glaze will look like a cheap stain and a neutral glaze will look dirty.

The painter may go on experimenting, and drawing conclusions, but in the last analysis it's all a matter of taste. I have seen many modern American paintings done in this manner, finished, framed and no doubt a satisfaction to the artists who painted them. To me they ably show the failure of this method and the dissimilarity of their painting to the precedent they

The Materials of the Artist and Their Use in Painting with Notes on the Techniques of the Old Masters. Translated by Eugen Neuhaus. New York: Harcourt, Brace, 1934.

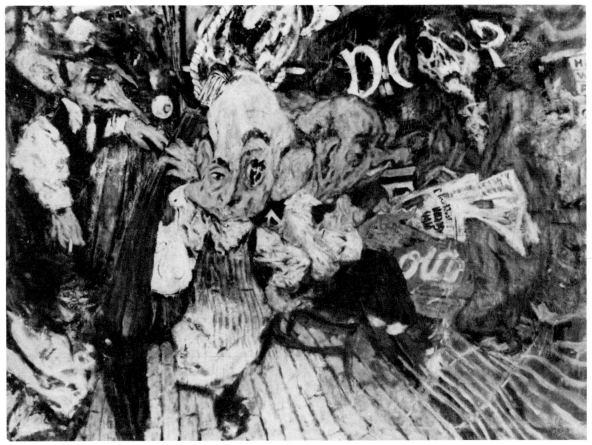

Jack Levine. *The Street*. Oil on canvas, Boston Project, 1938. (NA, Museum of Modern Art, New York)

claim to follow.

With the "dead-color" underpainting, it is possible to paint with oil color opaquely at and above the value of the underpainting, still retaining luminosity. Intermediate neutrals may be achieved with the fingers to heighten the underpainting. Then again, if this dead color is cool in tone, it is merely necessary to overpaint with warm colors. Every Titian and El Greco I have seen has been painted with this dead-color underpainting. I am sure the Van Eycks also used a low-keyed underpainting. The "Madonna of Ypres," on loan to the Museum of Fine Arts, Boston, an unfinished painting and consequently easily analyzed, is underpainted in pink below the value of the finished pink of the flesh. Indeed, I have yet to see such a white underpainting in the old masters.

Now, for the matter of tempera emulsions. Doerner is insistent on the "lean airy beauty" of the emulsion. As a consequence I have spent months using a tempera that cracked, separated from any oil surface, held so little pigment that on varnishing the undertone would "strike through." Obviously such an emulsion is too lean for painting in a mixed technique. If the painter is to paint "fat over lean," he must find richer tempera or not use it in advanced stages of painting.

Doerner's formula is as follows:

One measure—the contents of the whole egg.
Equal measure of oil, thickened oil or resin varnish, stand oil, or coach varnish, etc.
Up to two measures of water.

Put one after the other into the flask, being shaken well each time. The order of the ingredients is important, first oil, then water, otherwise the emulsion will not be a success.

A. P. Laurie's book *The Painter's Methods and Materials** contains formulas which I believe to be more practicable. Laurie believes that the Van Eycks used

*Arthur Pillans Laurie. *The Painter's Methods and Materials*. New York: Lippincott, 1926.

an emulsion that could *not* be diluted with water. He contends that Dutch stand oil or any other highly concentrated oil cannot be diluted with water by an equal addition of egg. I have found the same holds true for sun-thickened oil.

Here is Laurie's formula: an emulsion of one part yolk of egg by volume to one part Dutch stand oil and a little turpentine. In my experiments I substituted sun-thickened oil for Dutch stand oil. This emulsion ground with dry colors was a complete success. Curiously enough, this tempera, although its oil content is greater, dries faster and harder.

The hairline which Doerner promises with his emulsion can be achieved by this tempera, and with the difference that such a line will have sufficient body to remain luminous under several glazes and varnishings.

I have been using a tempera obtained in the following way:

Contents of one egg.
Equal volume of diluted sun-thickened oil and turpentine, 1 to 1.
Equal volume of water.

Place in bottle in that order, shaking well between additions.

Grind Titanium White loosely with this emulsion, then stir in tube oil Zinc White, the quantity to be determined by the desired working consistency. To dilute such a tempera with water, it is advisable to do so previous to the addition of tube oil white. This white tempera may be toned with dry color or tube oil color.

Because of the bulk of such a tempera, it is possible to use an impasto with greater safety. The highlights in a painting by Magnasco would be recklessness with Doerner's tempera. Only because of the richness of such a tempera is it possible to paint over oil. When this underpainting is varnished, it will hardly change at all. The painting may then be further heightened with oil color. There will be no apparent difference between the oil color and the varnished tempera.

In my most recent painting I began by sizing the panel, then toning it with dry color (light red), ground in mastic varnish. I had decided to do without a white priming, reasoning that the gray underpainting would act as a priming—the light red imprimatura would benefit by being over the natural color of the panel, and would be less apt to change in the course of time.

The underpainting was done, of course, in tempera, in tones of gray, the halftones in the flesh being achieved by playing an intermediate tone of gray against the warm, red-brown imprimatura; the lights—a lighter tone of gray more thickly applied. This underpainting was applied almost entirely with the fingers, being rubbed vigorously over the dark ground for the halftones.

In this manner the problem of warm and cool tones in the halftones and shadows had been nearly solved. The cool tones in the lights had already been established by the gray underpainting, leaving the warm tones in the lights, and the more intense and deeper warm tones for the cheeks, lips, ears, etc., still to be established by the overpainting, along with highlights and accents in the shadows.

In a previous Project painting on a canvas, "The Street," I used an imprimatura of Mars Black with a little white, ground in mastic. The underpainting of Titanium White with Mars Black, gray, was applied in the same manner as the painting described above. This tempera, being leaner, didn't work so well. The underpainting completed and dry, it was glazed here and there with Raw Sienna, in resin-oil, setting up a relativity of green and blue, the unglazed portions of the underpainting seeming blue by juxtaposition.

The overpainting was for the most part English Vermilion with Zinc White and Yellow Ochre in varying mixtures ground in resin-oil (mastic to linseed 1 to 1). This was glazed with Raw Sienna, qualifying the overpainting from pink to orange. Highlights were added in resin-oil. Shadows were strengthened with a resin-oil mixture of Mars Black, Cadmium Red Light and Mars Black, or Prussian

Blue. Highlights were glazed with intense prismatic colors such as Hansa Yellow, Orange Lake, Artificial Rose Madder, and Minastral Blue. Where lights appeared lacking in salience and variety, they were repainted as follows: glaze of a dark tone in resin-oil; drawing of object with thick tempera Mars Black or Prussian Blue; application of strong reds, oranges, yellows, greens, and blues in thick blobs of tempera; a much diluted off-white tempera is then quickly brushed over the area and the whole swiped down with the palette knife. Brilliant colors now break to the surface of the dull white. Modeling in shadows may be done by rubbing through the white to the underlying black or blue which is still wet. Colors may be blended with the fingers. The off-white may be added further or scraped off further. Highlights may then be added. This is a very good way, incidentally, to paint a white shirt.

In another case, over a dark gray tempera tone, the underpainting was carried out in tempera, Cadmium Red Light, and mixtures of the same Cadmium Red and White. Relative orange tones were obtained by a glaze of Barium Yellow. The Barium Yellow, being lighter than the pink underpainting, had its effect, although practically invisible as a glaze. I recall that the highlights were added in resin-oil white, and the drawing and shadows strengthened by an emulsion mixture of Mars Black with a tube oil addition of Cadmium Red Light; then, since it was a night scene, the whole was glazed with Cobalt Blue.*

*In a letter to Levine dated September 23, 1939, Emanuel M. Benson rejected the preceding essay, saying, "There are many people who would like to know why you paint as you do, what your subject matter means to you." On October 13, Levine submitted an essay which is reproduced in full below. (I am indebted to Mr. Henry Freedman, who is writing his doctoral dissertation on Jack Levine, for this information.)

STREET SCENE

Essentially a city-dweller, I find that the aspects of man and his environment in a large city are all I need to work with. I find my approach to painting inseparable from my approach to the world. Justice is more important than good looks. The artist must sit in judgment and intelligently evaluate the case for any aspect of the world he deals with. The validity of his work will rest on the humanity of his decision. A painting is good for the very same reason that anything in this world is good.

I feel the sordid neglect of a slum section strongly enough to wish to be a steward of its contents, to enumerate its increment—newspapers, cigarette butts, torn posters, empty match cards, broken bottles, orange rinds, overflowing garbage cans, flies, boarded houses, gas-lights, and so on—to present this picture in the very places where the escapist plans his flight.

It has been an idiosyncrasy of mine to argue that a man so overtaxed in working for another man that he defeats his own cause, is not his own man. This I accept for myself as the reason why, to me, the symbol of work can never express the working man. The picture I persist in painting is an evening scene, designed to catch the man *not* at work, tired and overwhelmed but still, for the time, a free man. The consciousness that may be projected by the limpidness of an eye, or a gentle decrepitude of gesture, are as far as I go in putting my characters into action, because of some logic of the psychological approach. Movement in my canvases embraces every object as well as atmosphere. Dramatic action on the part of the characters is latent. I distort images in an attempt to weld the drama of man and his environment.

That part of my work which is satirical is based on observations gathered in countless hours, hanging around street corners and cafeterias. There I often hear from urbane and case-hardened cronies about crooked contractors, ward-heelers, racketeers, minions of the law and the like. It is my privilege as an artist to put these gentlemen on trial, to give them every ingratiating characteristic they might normally have, and then present them, smiles, benevolence, and all, in my own terms.

If my frosty old gentleman in evening clothes beams with his right eye and has a cold fishy stare in his left, that is not an accident. If a policeman reposefully examines a hangnail, that is not necessarily the sum total of his activity. In this case it is an enforced genre, to familiarize the spectator with the officer, to point out that he, too, has his cares and woes.

The mechanism is one of playing a counter-aspect against the original thesis, leaving it up to the spectator to judge the merits of the case. My experience is that generally the thesis is readily understood.

I paint the poor and the rich, in different pictures, and give them different treatment. I think this is as it should be.

Abstract Painting Today*

STUART DAVIS

The most discussed and vital painting of the last thirty years has been abstract, and from its origin in France it has spread its influence throughout the world in many fields in addition to the art of painting. The word "abstract" is certainly not the best term to describe the many and diverse forms of modern painting to which it has been applied, but since it has achieved such general acceptance it would be confusing to attempt to substitute another at this time.

The first comprehensive showing of abstract art in the United States was held in the 69th Infantry Armory in New York City in February, 1913. The Association of American Painters and Sculptors, Inc., which promoted it, did so for the single purpose of bringing the most advanced European art into the cultural environment of the American artists and public. The preface to the catalogue of the Armory Show warns American artists not to pride themselves on freedom from European influence, because such purity may mean nothing more than isolation from the most progressive forces in art. The spirit which prompted this epochal exhibition was courageously daring, intelligent, and free from false patriotism and provincial complacency. The catalogue specifically calls attention to the fact that the Association "is against cowardice even when it takes the form of amiable self-satisfaction." But the powerful propa-ganda carried on by some critics and artists today for the cultural isolation of the American artist proves that the battle of the Armory Show has not yet been won, and that there are many who are willing to exploit cultural prejudices at the expense of progress.

This huge exhibition received enormous public interest and attendance, and was later successfully shown in Chicago and Boston. America had seen real contemporary art and they knew it, whether it was accepted by everybody or not. American artists were profoundly moved and showed it in their work. It was clearly evident that a genuine effort was being made to comprehend and incorporate these new forms and their meanings. But as time went by, the intensity of this effort decreased, and although a lasting imprint had been left on American painting,

*This essay is the second of three extant drafts. The first, entitled "Abstract Art Today—Democracy—and Reaction," is dated August 11, 1939. The third, "Abstract Painting Today," is dated April 20, 1940, and was found among the papers of Emanuel Benson in the Archives of American Art. It has been published in Diane Kelder, editor, *Stuart Davis*, New York: Praeger, "Documentary Monographs in Modern Art" series, 1971, pp. 116-21. The draft published here is dated November 14, 1939. The text suggests a certain editorial softening of the artist's outspoken style. The earlier drafts are purer Davis and the second seems, in my judgment, the most trenchant formulation. I have added, as a note, two excerpts from the first draft which expand a point concerning cultural monopoly that he merely alludes to here. See the Inventory in Appendix B for a complete list of Davis's essays that are part of the original manuscript of *Art for the Millions*.

the progressive spirit increasingly waned and some of that "cowardice" in the form of "amiable self-satisfaction" began to creep back into the cultural picture. Domestic naturalism, the chicken yard, the pussy cat, the farmer's wife, the artist's model, Route 16A, natural beauties of the home town, etc., became the order of the day in painting. And on the reverse side of the popular trend toward domestic naturalism were found the more trying aspects of man's struggle with nature and society, such as the picket line, the Dust Bowl, the home-relief office, the evicted family, etc. In mural painting it was the same thing; on the one hand, American history-in-costume, cowboys and Indians, frontier days, picturesque industrial landscape, etc.; and on the other hand, Mexican muralism, the allegorical worker of bulging muscle and Greco-Roman profile, the fetish of fresco, etc. American art was, and, I wish to add, still is, right back with the Rogers Groups and J. G. Brown's ragged little shoeshine boys.* What happened to the Armory Show and modern or abstract art? My answer to this question properly belongs to another article which would have the title, "Is there a monopoly in culture in the United States?"**

The above is all highly relevant to any discussion of the position of abstract painting today, but I am

*John Rogers (1829-1904) was an American sculptor noted for plaster genre groups depicting popular historical or literary themes which were mass produced in large editions. J. G. Brown (1831-1913) was a popular genre painter noted for his pictures of shoeshine boys and newsboys.

**In his first draft of this essay, dated August 11, 1939, Davis expounds at length on cultural monopoly in the United States, and what can be done about it. Two excerpts follow: "Culture in the fine arts is a monopoly in the United States just as banking and industry are monopolies. This monopoly in culture, as it refers to art, has its existence in trustees and museums, with their directors, the critics, the dealers who live by their wits from the museum-collector patronage, and the publications which are subsidized directly and indirectly by the trustee-museum unit. This constitutes the monopoly which sets the standards and styles of art in America. The artist has no voice in its policies, unless it is the submissive "company-union" voice of jury service at some annual show. If he speaks contrary to monopoly policy he is certain not to be invited to serve again.

"What is the general character of the personnel of this monopoly . . . and what are their interests? Their interests in art are the same as their interests in life: to play safe. Behind the barricade of their properties they are well content to leave things as they are. New ideas, economic, social, or cultural, do not concern them. On the contrary, from their well-entrenched position they strike out without mercy at new ideas. Their social outlook is as unrealistic as their artistic outlook; they welcome fairy stories and romance. When realism big enough to threaten, in the form of the New Deal, comes along, they present a united front of opposition. The New Deal builds an art project; they smash it because it threatens their monopoly of culture.

"Take the Metropolitan Museum in New York, for example, with its heavyweight board of trustees. A few years ago they sent out press releases announcing their capture of an easel painting by Titian at the cost of $1,000,000. They regarded this as a worthy feat and a culturally important event. That million would have given security to 250 American artists for two years to work at $2000 a year. If anyone had proposed the idea to them they would have had the man locked up as dangerous. The collection of contemporary art at the Metropolitan is painfully unrepresentative and one-sided. To look at its displays one would never know that modern art existed. Since the trustees of art are not going any place, their collections reflect their own lack of orientation.

"This monopoly of culture threatened to smash abstract art in America long ago. Abstract art was too progressive, too objective, too realistic, too prophetic of a different world than the one they control. Their method of suppressing it is to refuse patronage and put their propaganda department of critics to work spreading lies and confusion about it. But they buy French abstract art, you say. True, but only sparingly, and then because circumstances beyond their control gave French abstract art an established market value. They buy it without offending their sense of security.

"This is the way the essential reactionary conservatism of the self-appointed trustees of art who constitute the cultural monopoly in America debases the standards of art. The artist must conform or starve, sometimes both, and all his spontaneous joy in response to the social and natural environment, which includes art, is stifled. . . ."

"The artists of America . . . can win . . . the fight against monopoly in culture by united action on a program for a democratic art. This means artists' participation in museum policy and educational institutions, and in commercial policy as it relates to art. It means Federal guarantee of the right of citizens to participate in art just as they are guaranteed the right to an education in reading and writing. It means a permanent Bureau of Fine Arts in the government. It means that the artists of America will have direct voice in the management of art production, and that such bans by tory reaction as that on abstract art will have no existence. It means that the policy of the Section will be broadened to include modern realism, abstract art, and social comment, as well as the prevailing history-in-costume illustration mural now in favor there. It means that art critics and professors of art theory will have to be more careful to have their ideas relate to practice than is the case at present.

"Abstract art is here to stay because the progressive spirit it represents is here to stay. A free art cannot be destroyed without destroying the social freedoms it expresses."

extremely anxious not to be misunderstood on my estimate of American art in general. My purpose in this paper is certainly not to insult American artists, but rather to find the most expressive words and images which will make my ideas clear. When I characterize American art today as similar to the Rogers Groups and J. G. Brown in basic expressive intention, I believe the estimate is generally true. It is certainly not completely true of any individual contemporary American artist, because I have already said that the Armory Show did leave an imprint on our painting. The Federal support of art has also left

an imprint on our painting, and because of these two factors in the cultural environment I believe that American painting has potentialities of the highest quality. The large exhibition of contemporary American art at the New York World's Fair, 1939, proved these potentialities. This cross section of our national art production showed a high level of competence in craftsmanship, a quantitatively vast production, and a slight recognition of the form and content of modern or abstract art. But it is undeniable that the dominant expressive content of this representative exhibition as a whole consisted of

an "amiable self-satisfaction" with the most elementary aspects of the physical and cultural environment. The spirit of discovery, of new possibilities, of the dynamism of contemporary life, of the uniqueness of our time—these things are not found in the general content of this show. Instead we find extreme formal and tonal conservatism as a general characteristic which corresponds to the complacent and uneventful outlook of a very tame house cat. I have no hesitancy in saying that one oil painting by Henri Matisse done thirty years ago has more con-

temporary meaning, more expressiveness of the cultural environment in the United States today, than was expressed by the whole exhibit.

Before leaving the discussion of the general picture of American art today I want to note two things which I consider significant. The first is that under the policy of freedom of expression which has been followed on the WPA/FAP, a number of young artists chose to work in abstract styles. The second is that the Contemporary American Art Exhibition at the New York World's Fair, 1939, was organized and

Emmet Edwards. *Abstraction*. Oil on canvas, New York City Project, c. 1936. (NCFA:Cahill)

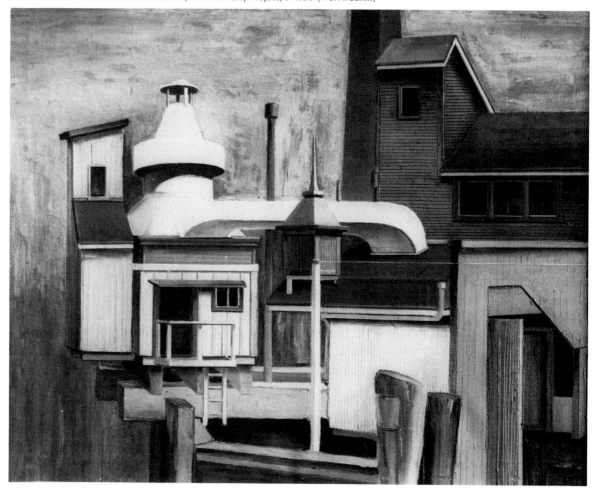

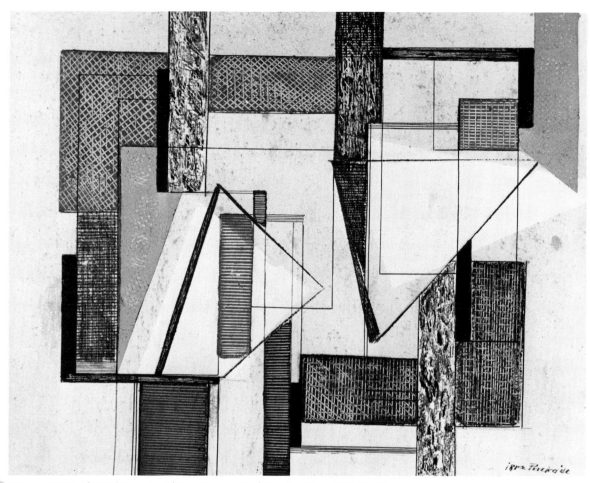

Irene Rice Pereira. *Abstraction No. 10.* Oil on canvas, New York City Project, c. 1941. (AAA)

selected by artists in the most democratic way possible. Both of these phenomena were made possible by the same historical factor, namely, the Federal support of art. This observation involves the topic previously referred to, "Is there a monopoly in culture in the United States," and therefore will not be amplified here, but it is worth noting that the ideas of "democracy in art," "abstract styles," and "Federal support of art" seem to have a certain incidence. American painting unquestionably has the potentialities of a great future, but that too is definitely tied in with Federal support of art.

What is abstract painting and what does it express? Abstract art is not a method, a technique, or a style, but it is a point of view, an attitude toward reality. This point of view is manifested in painting in various styles and techniques which are subsumed in the term "abstract." It is characteristic of abstract painting in general that its sentiment is contemporary, which sets it apart from all painting of the domestic naturalism type, whether of the home-town booster or proletarian variety. The attitude of domestic naturalism toward reality is always idealistic and subjective, whereas the attitude of abstract painting is realistic and objective. Domestic naturalism always affirms a static world in which every color, shape, and perspective is familiar, and which conveys the sentiment that they will always be just like

that. That is why I call the expression of domestic naturalism static. The expression remains static even in the class-struggle variety of domestic naturalism, because although the ideological theme affirms a changing society, the ideographic presentation proves a complete inability to visualize the reality of change. Domestic naturalism seeks to reflect reality in terms of the known and the possible. It fails to understand that the known and the familiar are in reality the unknown and the impossible in a particular time position. This hypermetropia makes it impossible for domestic naturalism to participate in the changing contemporary reality or events which are really near to us.

As a genuine contemporary expression, abstract art has not simply reflected a familiar reality, the remoteness of whose origin makes it seem unmoving, but it has created a new reality. Abstract art is an integral part of the changing contemporary reality, and it is an active agent in that objective process. The brains, arms, materials, and democratic purpose of abstract artists have literally changed the face of our physical world in the last thirty years. And it must be noted that the changes they have made were constructive and progressive, which puts abstract painting in direct opposition to the destructive forces of totalitarianism and reaction. Abstract art has been and is now a direct progressive social force, not simply a theory about progress. In addition to its effect on the design of clothes, autos, architecture, magazine and advertising layout, five-and-ten-cent-store utensils, and all industrial products, abstract painting in its mural, easel, and graphic forms has given concrete artistic formulation to the new lights, speeds, and spaces which are uniquely real in our time. That is why I say that abstract art is a progressive social force.

Radio, for example, is the very essence of abstraction. There is nothing of the amiable self-satisfaction of domestic naturalism about the realistic process of which radio is a concrete example. From the standpoint of domestic naturalism radio is unreal and impossible because it is not a part of that remote reality which is the subject matter of domestic naturalism. But we know that radio is real and that the abstract relations which are its material forms were the product of creative brains of various nationalities, and were completed by everybody, as Kettering* says. Strictly speaking then, the radio is an un-American abstraction and should not be considered as an authentic part of the American Scene or environment if the logic of domestic naturalism is to be followed.

The best painting of the last half century has been done in France, and this development has been characterized as a whole by a spirit of democratic freedom of individual action which resulted in a series of real discoveries in the field of painting. Abstract painting is a part of this development. When it is said that real discoveries were made it is important to remember that painting is one of the forms of social expression and that a real discovery in painting is a positive social value. If it be granted that French painting, or rather painting done in France (because all the best painters were not Frenchmen), is the best of the last half century, then, in view of what has been said above, its social content must be the most important in the field of painting.

What is the dominant social expression of modern painting in France, of which abstract painting is the latest form? In my opinion it is affirmation of the modern view that the world is real, that it is in constant motion, that it can be manipulated in the interests of man by knowledge of the real character of the objective relations, and that through such control of the environment man can develop his standard of life to higher and higher levels. This theory of reality is the basis of modern industrial society, which has given more scope of living to more people than any previous form.

How is this contemporary reality expressed in

*Charles F. Kettering (1876-1958) was a leading automotive engineer and inventor who directed research at General Motors between 1917 and 1947.

modern art and in abstract painting? It is expressed by the choice of spatial fields as defined by Tone-Direction-Size-Story-Shape units which have reference to some aspect of the contemporary environment. By the contemporary environment I mean, of course, the mental as well as the ordinary material environment. For example, modern French art is a part of the real environment of artists of all nationalities as a material object and as a directive theory. It is just as real a part of the environment of American artists as Route 16A, or the obverse and reverse aspects of the American Scene in general. The spatial fields of modern and abstract art are characterized by great color range, severe directional definition, and positive positional statement, with the resultant autonomy of parts corresponding to the freedom of the individual under a democratic government. These characteristics can be observed in the work of the Impressionists, of Seurat, of Cézanne, of Van Gogh, of Matisse, of Picasso, and of Léger. These spatial configurations are not replicas of some already existing systems, they are new spatial systems which are unique and absolute but are at the same time in harmony with, referable, and relative to the contemporary environment. Modern art is not a spectator, it is a participant. In other words, it not only reflects contemporary life but is an active agent in the direction of it.

Scientific analysis of color, development of synthetic chemistry, development of photography, electric light, development of oil industry and new speeds, electronic physics, etc., have all been powerful factors in shaping the environment which lives in modern and abstract art. For reasons which must be analyzed elsewhere, painters in France were the first to give formal reality in paint to these new marvels. They had the courage and the wit to see clearly the contemporary dimensions with the mind as well as the eye, as the great artists of all times have done. The democratic dots of Seurat, and the democratic dashes of Van Gogh, oriented in extensive spatial fields of equality, are examples of modern art in a form corresponding to the political and scientific en-

vironment. This fact is especially easy to see if the modern works are contrasted with works of previous centuries, where the formal conception is hierarchically concentric with a center corresponding to monarchical authority and to a science of eternal categories.

The painting of today, if it is alive, must be as different from that of previous epochs as our time is different, because art is one of the forms of social expression and must change as society changes. From this it follows that if my characterization of the painting of the United States today as a whole as "domestic naturalism" is true, and if my estimate of the social content of domestic naturalism is correct, then this current vogue for the superficial in art may be a serious social omen.

I have tried to express my conception of the meaning of abstract art in its basic social meaning. And I have tried to point out that art values are social values, not by reflection of other social values, but by direct social participation. I have tried to demonstrate that abstract art is a realistic art, not different in kind from the realistic art of any other time, and that it is the most vital expression of our time in painting. I have pointed out the trend away from it in American art and have indicated that this fact might indicate a reactionary social trend and a progressive curtailment of democratic rights. I have pointed out that the unique orders of abstract painting are real social values which are part of the cultural heritage of artists of all countries and that artists who fail to use them, either through intimidation or indifference, are neglecting a valuable resource.

American artists have the greatest potentialities of any artists in the world at the present time because of their relative political freedom and economic level. The important question of Federal support of art can still be discussed and worked for here. If the art of painting is worth preserving and developing in the United States, then I believe our artists should insist on the right to develop it along the lines of the best and most expressive contemporary styles, which are subsumed under the term "abstract."

Some of My Working Methods

WILLIAM SOMMER

I live in Northfield, Ohio, twenty miles from Cleveland, in a state that gives all it has to the artist—ever-rolling hills, miniature valleys, old farmhouses, cattle grazing around immense barns with small towers, towers which do away with the straight lines on the roof, towers that simply must be put into the general scheme, beautiful in form and eternal in simplicity. The farm folk never disturb me as an artist in my work, but welcome and instinctively respect what I represent. This then, is my background.

The honor has been allowed me to write moderately so that any willing reader can share my method of working. This is no attempt to talk down .from pontifical heights. In an unstudied way I plan to point to those roadmarks which have served me well in the vast spiritual expanses of the beautiful.

First and above all, I do not ball-and-chain myself with a lot of detailed rules. In the world of fancy, you can do anything you want. There is no policeman there to club you for a mistake. Great artists have often been redundant with academic blunders in their work; but they were great withal. Be free, because only then will you be individual. Make it a point not to stop for mistakes. Only that way will you keep out of a rut. In art as well as in music you sight read, and pass over mistakes so that the whole rendi-

tion continues and is complete in spite of forgotten flaws here and there. It is for this reason that for many years I have done all sketches with pen and ink. This disallows erasure, and has gained me recognition in freehand to boot. Try that, gradually.

Let us set out then, to do some painting. Shall we wait for some inspiration to strike us down, as a brain hemorrhage does? When I feel like sketching I go out, knowing that inspiration grows upon one gradually. Experience has taught me never again to attempt intensity. I see something that impresses me favorably, though not overwhelmingly. I may pass by such a motive on the roadside, or in a home, but more often than not it continues its call to start creation. I may pass it again and again, but at last I feel forced to obey its gentle command. Or, I may do it to begin with, even when at first I myself wonder just what it is that impresses. I do it, because an idea is at work, and that idea grows as the picture grows. To be sure, I deliberately fortify myself with the strains of musical masters—Schubert, Bach, and the rest. That helps a lot. And away from my art I read good literature. This bolsters inspiration. Under these influences my vision takes on a different, an improved slant. So then, here we are in Nature, and with fountain pen I start with the long lines, curves us-

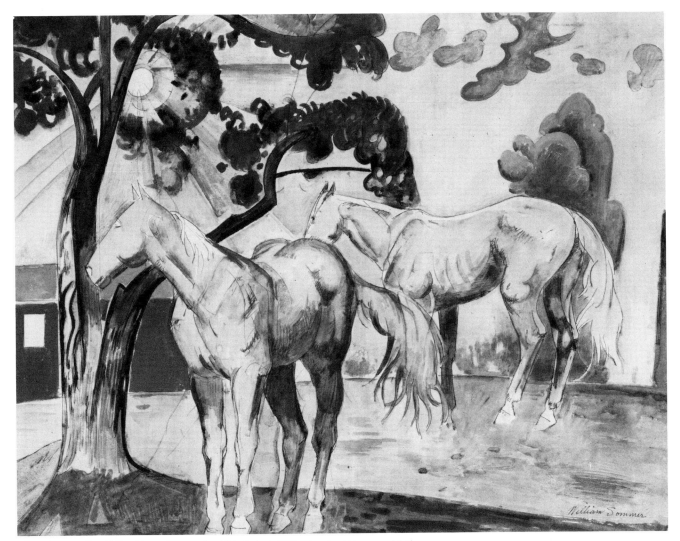

William Sommer. *Two Yellow Horses*. Watercolor, Ohio Project, 1940. (Cleveland Museum of Art)

ually, beginning almost anywhere; and after the first line, the others just beg to follow quickly.

Sometimes I feel sure that lines are underestimated in art. They are values, big values, and I rate them that way from the start. Without calculation I keep going in this way, as disinterested as possible; never stopping to note just what lines or forms are doing, until I must stop because the space

of my picture is covered. I then take my pen-drawing home, and at leisure now or later, I start with color, in the quiet studio, day or night.

It has become second nature with me—and I recommend it—that before I apply color, I reconsider the lines. Lines are forms, and make other forms—triangles, squares, circles, cubes, cylinders, and spheres. Read this in capitals: Forms must be the

artist's religion. When drawing a portrait, for example, I disregard the histology and anatomy of hair; I do not think of it as hair. To me it may be a rolling cylinder, like the rolling surf at sea, or like the implied cylinders in a field of waving wheat. This is form, and into the bargain I get life, by expressing motion. In one of the old masters—a man wearing a red cap and long hair encircling the face down to the shoulders—you will observe that you see really nothing more than a bent cylinder filled in with detail. Of course this presupposes some changes from visible Nature; of course it does. Forms must be changed and torn out of Nature, because you have to gather the important things with which to build unity on your canvas. You, as it were, bake your native clay into bricks. For this reason I avoid imitating Nature

Cameron Booth. *Horse Family*. Oil on canvas, Minneapolis Project, c. 1936. (NCFA:Cahill)

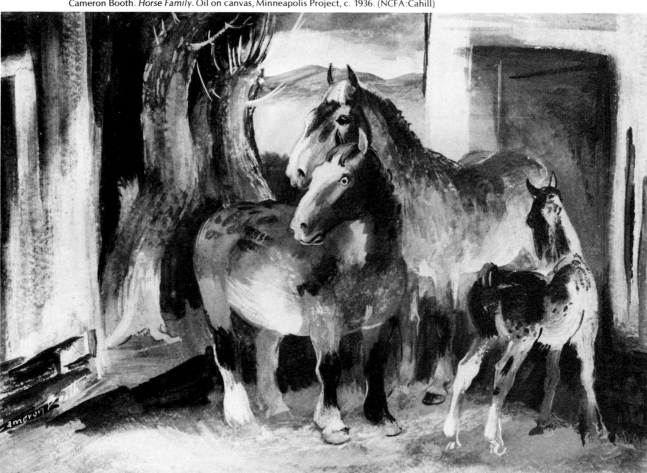

deliberately; I feel free to change or even destroy forms, just so in my drawing I have a unit which holds together. Be the master of the subject which you are drawing; not its servant. Make the subject your object—tear away from Nature if necessary—or you will lose the road to real expression in art. Correctly it has been said that it is one of the functions of art to snatch things from the security of their normal existence and put them where they have never been before. When I view a landscape in Nature, I read into it cubes of different sizes, because that way in my drawing I can better arrange the various parts in their proper place in space.

After thus substantiating my lines and forms, I carefully view the object in terms of planes. Almost all drawings have in them three planes: near, intermediate, and distant. This plan of planes is greatly enhanced by forms, and by colors. Recently I was privileged to view a watercolor by a young man. He showed a dark tree against a dark barn, just as it appeared in Nature. I submit that both barn and tree would have become more significant if the tree had been painted very light, Nature aside. His obedience to Nature choked for the moment the artist's creative instinct, killed his sense of space, and irreparably harmed his creation.

You are not only entitled to liberties with natural forms and natural colors, but even, if you are to create, you must be free. Make your drawing hold together at any cost; make of it a complete unit irrespective of academics, and give each drawing its own dress. One painting may be established upon a greenish scheme; or a red or blue unit; and in doing this, the local color may be ignored entirely. In fact, one is forced to do this to avoid a hodge-podge in color. The use of unnatural colors to express planes is legitimate. Your foreground of hay may be red, your mid-ground of valley purple, and the horizon pink; but make these planes distinct of each other at all costs, each holding its own. Then establish a relationship of color planes by keeping out shadows (not shading); by prolonging forms that run together or touch. In this way you build up a oneness that can

be felt throughout the picture, a harmony without a beginning or an end, an accidental, disinterested rightness which becomes a very pleasing final result.

Now read once more in capitals: Repetition, the mother of studies, is the grandmother of art. Repetition, both of color and of form, links components into a whole, and first catches and then holds the eye.

Such are my methods of working. Of human forms I make very careful drawings in a small book with pen. If the result is worth enlarging, I do so and finish with color. "Ordering Lunch" was done this way at the local Moreman's restaurant. I was careful about content. I avoided showing the group in the act of eating. That would cheapen the conception. I prefer to keep them static—just using figures as simple forms. I keep simplifying continuously, so that if a detail is not an important addition to the general scheme, I take it out. In this way the picture expands.

In "Arrangement," the watercolor, I just filled a glad-bowl with peaches and set it down among some weeds and started drawing very fast. It seemed like a dance; but coloring in the design was very slow. I would leave and come back to it. In this way suggestions came, and I put them in as I went along until nothing more could be done.

And at this stage of this highly-felt but unstudied essay, the suggestion comes that nothing more can be done today.

For me, unused to professional teaching, this has been a rare pleasure. Having lived through several periods of art, and having read through all of them, I confidently submit that here and now, in America, there is a surge forward of artistic development so powerful and so evident, that perhaps even I shall see new Masters, and a new period, fit to overshadow the greatest of the past. I shall be happy indeed if in ever so trivial a manner—there is so very much—it becomes my privilege to share feelings with some of them. After all, I am seventy-three, though satisfied, and happy, and proud of what I see for art in the offing.

Golden Colorado

EUGENE TRENTHAM

When I see an interesting subject such as a face, a landscape, or a still life, I try to interpret the visual impression it makes on me by painting a picture. Whereas the "candid" camera merely retains the photographic likeness of a subject, I attempt in my painting to translate my particular reaction to a subject. If my eye seems less accurate than that of the camera, it is because my mind places greater emphasis on certain aspects of the picture and fails to take note of others.

Also, I have an impulse to make the picture into a pleasing construction of color and design which will be good to look at as well as being a record of the subject. This is natural to most of us. When we build a house, make a chair, or sew a quilt, we usually try to make it beautiful as well as useful.

My painting, of course, has been influenced by the environment in which I live. Here in Colorado we are still essentially western in character. Denver is a city that offers many cultural advantages and at the same time preserves the freshness of a "Saturday-Night" town. We are constantly exposed to the different routines of living and the people who keep them going—farmers, stockmen, factory workers, and business people. All of which is very helpful toward keeping an artist in a sound frame of mind.

It is not difficult to understand why landscape should be the dominant note in Colorado painting, because the greatest range of mountains in the country is always to be seen in a never-ending display of various moods. The mountains nearby naturally offer great inspiration to landscape ideas, but they forever hold a mighty majesty that reminds man of his smallness.

In my two pictures of Golden Colorado I attempted to set down an impression that has often fascinated me—namely, the vision of color one gets on a hot summer day when the sun's rays are beating down on different colored surfaces and textures. I have found that the intensity of the color often destroys the feeling of form and solidity when I try to put such a scene on canvas. Therefore, I have always tried to keep the colors in my pictures pitched slightly below those which I actually see in nature. Although both paintings ultimately developed into summer subjects, the original impulse to do them was received on crisp sunny days in mid-winter.

For the opportunity to develop these and other ideas, I have the WPA/FAP to thank. Without any gushing testimonial regarding my personal liberation, I can say that whatever progress I have made during the past few years is directly traceable to the

economic security and understanding which the Project has offered me. It has become increasingly clear to me and to all artists that while talent may flower in an Ivory Tower of isolation and poverty, it flowers considerably faster in the soil of Government patronage. At last the artist knows that he is not working for himself or a small coterie of admirers but for the people of America.

Heretofore in America, art, one of the noblest ex- pressions of civilization, has received little nourish- ment. On a comparative basis, it has been at the bottom of the remunerative professions, many of which do less good in both a practical and aesthetic sense. By giving art nourishment, we are breaking ground on an aesthetic frontier which will enlarge our intellectual relationship with life as well as our pleasure in living it.

Easel Painting in the WPA/FAP:
A Statement and a Prophecy

DONALD J. BEAR

That provincialism is the effect of a state of mind and not of geographical location is evident in reviewing the easel painting of the WPA/FAP. One sees each locality in the United States honestly represented without readily observable imitation or influence from the large cities. Whether in the national "New Horizons in American Art" exhibition held at the Museum of Modern Art or in the shows circulated in the Federal Art Galleries and Art Centers throughout the country, there can be noted a fresh spirit and positive attack in the work of this great variety of artists. The security of an audience has given them the courage for emotional expression.

For the first time in history American artists as a group, like the Dutch and the Venetians before them, have turned their eyes on themselves and on their own country. The results are both surprising and gratifying. There is only one standard; that is of sin- cerity and an honest relationship, and in some cases a love for the multiple environments of America.

Somehow the questions of technique and influences do not enter here. Each artist seems sufficiently articulate to communicate his particular attitude without straining after virtuosity or imitating a special school.

Systems of thought fluctuate in the field of eco- nomics; that they should do so in the practical field of the plastic arts is proved by the oils and water- colors done under the Project. There have never been enough pictures painted to fill the ever- increasing demand of schools and other public insti- tutions, a demand that comes not alone from com- munities where the need for beauty is a crying one and not an afterthought of luxury, but equally from the great metropolitan centers.

During the past fifteen years it has been conceded that the American artist has learned how to paint, this even by the most indifferent spectator and by those who believed that only European painting had something to offer. Perhaps the most important con-

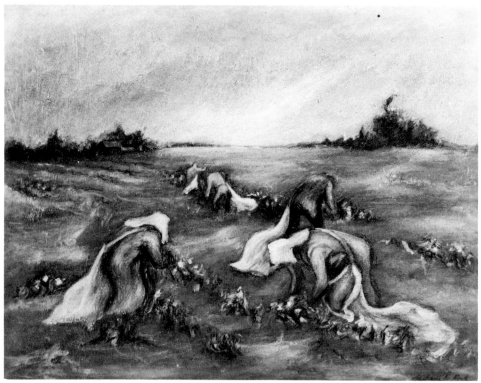

Jackson Pollock. *Cotton Pickers*. Oil on canvas, New York City
Project, c. 1937. (AAA) Martha Jackson Gallery, New York)

Charles Pollock. *The Tipple*. Oil on canvas, Michigan Project,
c. 1940. (AAA)

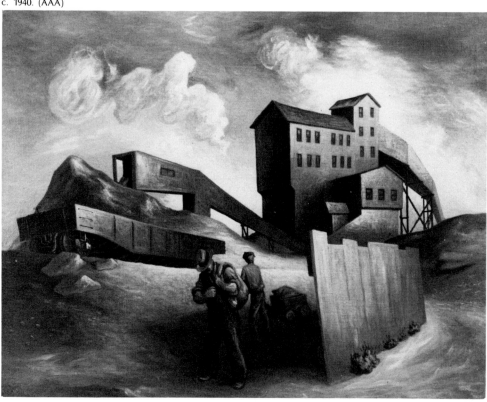

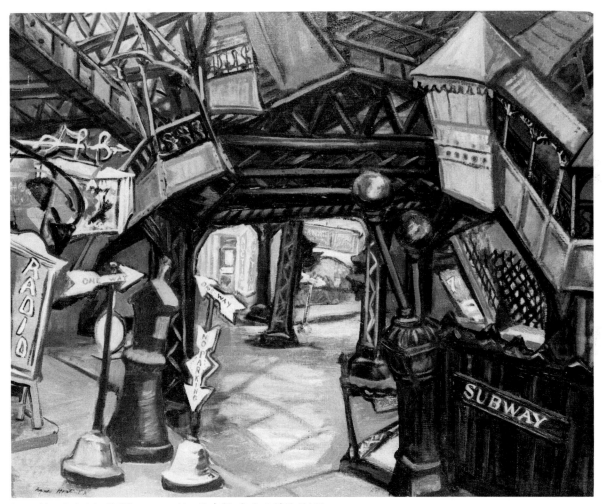

Agnes Hart. *End of the El*. Oil on canvas, New York City Project, 1941. (AAA)

tribution of the Project for both the American artist and his audience is something that no school, no museum, and no amount of art appreciation courses could have done.

To the younger artist it has brought maturity and objective results, developing in him a practical and professional point of view where art for art's sake qualities are rapidly disappearing. Both younger and older artists have reached a directness of expression which is based upon a direct emotional relationship to their environment.

On the other hand, the pictures painted are not in any obvious degree socially conscious, nor do they suffer from elements of preciousness, nor mirror any conventional subject matter or state of mind. They show something as rich and complex as the reality of that life which goes to compose the American spirit—a spirit that has not been forced by any at-

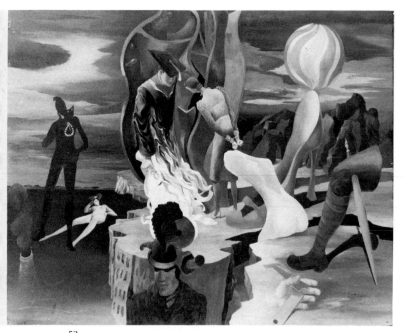

52.
James Guy. *The Graduates*. Oil on canvas, New York City Project, c. 1939. (AAA)

tempt to press the artist into doing work with an artificial stamp of national character. For, with few exceptions, supervision from artists and suggestion by cooperating sponsors has been sympathetic and given only with the idea of extending technical help. The happy effect is that the artists themselves, being thus put on their own mettle, have become their severest critics and disciplinarians, with a resulting disinterestedness that exceeds the best that could have been hoped for.

Again the Project has succeeded not only in bringing out new personalities but it has added to the artistic stature of professional artists in every community where it has flourished. Not only has it brought about an interesting and surprising exchange of ideas among artists themselves but it also has familiarized the nation as a whole with variations of its own civilization and environment that had long been ignored.

To have infused all these varying personalities with a common aim and purpose and to have proved to the American people that their country has something within itself decidedly worthy of record and expression is perhaps the most important contribution of the Project. What may seem more surprising is that the artists have shown that they can grasp this national consciousness without at the same time suffering from the least element of standardization or chauvinism.

Through the painting done on this Project there has begun the development of a tradition which, together with the rest of American art, should lead to a school of painting that in the near future is likely to be the most vital and energetic in the world.

Rufino Tamayo. *Waiting Woman*. Watercolor, New York City Project, c. 1936. (NCFA:Cahill; Museum of Modern Art, New York)

Hyman Warsager. *Boating*. Color woodcut, New York City Project, c. 1939. (AAA)

Graphic Techniques in Progress

HYMAN WARSAGER

Prints have been described by Rockwell Kent as multiple originals. The graphic artists, the creators of these multiple originals, collectively were destitute in the spring of 1935. All had suffered the severe pummeling of an acute Depression for several years. All were hopelessly separated from an audience, for there was no market for prints. The multiple originals, the prints, suffered no less themselves during this period. They no longer reached the hands of the people, but an isolated one or two became rare collectors' items. The original purpose of the print, the production of many originals for wide distribution among the people, had been lost. With the loss of purpose came the resulting constriction in technique. The ivory-tower approach of "preciousness" settled heavily upon the print. Its vitality was low.

The establishment of the graphic division of the WPA/FAP in that memorable fall of 1935 injected new hope into the artist and new life into the print. It gave the artist an income, though meager; it placed him in direct contact with an audience, and, more important, by providing facilities it enabled him to experiment freely in his search for a more adequate technique. Prior to this, prohibitive costs of equipment and printing made it impossible for the graphic artist to work in color lithography or color woodblock.

The New York project established a workshop. Three printers worked in close association with the artists to produce color lithographs. Another printer worked on black and white lithographs only. In etching, Frank Nankivell and an assistant pulled the proofs. Wood engravings and color woodcuts on plank wood of cherry, maple, and gumwood were ably printed by Isaac Sanger, working patiently in cooperation with the individual artists. In color woodcut printing, the artist mixed his own colors, noting carefully the effect of overprinting one color on another. This experience alone was invaluable.

Staff meetings were held. Leading artists in the various print media lectured on their particular crafts. Project artists contributed their own additional research. Thus a constant exchange of information resulted.

In lithography, Project artists did not confine their efforts to crayon work on the stone. They struck out boldly with washes of tusche or opaque tusche and scraped with razor blades, sandpaper, or carborundum. Thus the lithograph no longer was a colored drawing alone, but achieved a plastic expression somewhat akin to oil painting.

Few color woodcuts had been attempted in this country, and in general they were marked by a banal imitation of early Japanese prints. Project artists took to this medium with rare enthusiasm. Large blocks

Eugene Morley. *Structure*. Color lithograph, New York City Project, c. 1939. (National Collection of Fine Arts, Smithsonian Institution, Washington, D.C.)

from plank wood were introduced, usually white-wood, poplar, gumwood, cherry, and in some instances redwood, for it presented a very sympathetic and useful grain. The large blocks permitted bold work, color was used in large simple areas, but subtle uses of overprinting colors were employed. The quality of the grain of the wood itself gave the print a unique character. Raising the printing surface of the wood with cement and lowering it slightly with sandpaper varied the color intensity, adding desired textures. A very rich print often resulted by engraving one block on end grain and adding color from plank wood cuts.

The most startling contribution to color printing was added by the use of the silk screen. Here for the first time silk screen was used as a creative print medium. Thanks to the tireless efforts of Anthony Velonis, who realized and developed the possibilities of this medium, the WPA/FAP has added this new creative process to the graphic division. This technique is ably described in a booklet by Mr. Velonis printed by the WPA/FAP. The economy and ease of this process enables the artist to employ sixteen to twenty colors to a print, whereas color lithography and woodblock are limited to far fewer by both expense and labor. It is the one graphic medium that gives the artist free use of color, since the drawing is always visible through the screen. The color surface can be mat or gloss, thick and opaque, or transparent. The artist is enabled to work in large sizes and editions. The possibilities of the silk screen process are so diverse that it has attracted the attention of artists nationally.

Significant prints were also produced by the color monotype process. The monotype is a single print produced by painting on zinc or copper plate directly with oil colors or printers' inks and printed on an etching press. One print is produced by this method, though a faint impression remains on the plate following the first printing and may be partly recaptured for additional prints, which do vary upon application of more color. These prints, though single, have a wide color range.

In etching, aquatints, mezzotints, soft ground, and dry points were used with astonishing flexibility.

Augustus Peck. *Blue Clown*. Mixed media print, New York City Project, c. 1938. (AAA)

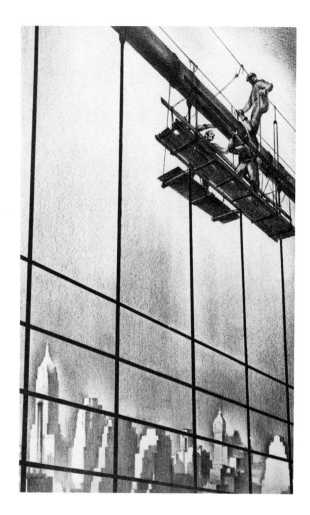

Louis Lozowick. *Bridge Repairs*. Lithograph, New York City Project, c. 1941. (AAA)

Often the artists created a tone over the plate with carborundum and worked toward the light areas with a burnisher. No acid was used in this procedure.

As the Project was established nationally, new life flowed into prints all over the country. In Philadelphia color lithographs and woodcuts were used in posters and are now being preserved for their aesthetic merit as prints. In Chicago the artists printed their own color lithographs, and excellent prints resulted. California artists worked out an important

Joseph Vogel. *Solicitations*. Lithograph, New York City Project, c. 1937. (AAA)

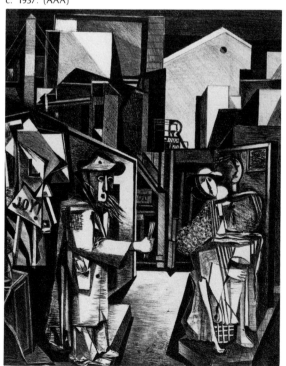

technical innovation in lithography. They produced a new type of transfer paper that has the actual grain of the stone. Thus drawings made on this paper in Carmel, Sacramento, and outlying districts were sent to San Francisco, where they were transferred to the stone and editions pulled. Throughout the country local difficulties were solved by artists in the same fashion.

The original Currier and Ives prints, contrary to popular belief, were really black and white lithographs that were hand colored. The tradition of American color prints is actually being created today. The varied approach of the Project artists to color lithography is indicating its limitless scope as a print medium.

The artists are showing a keener interest in techniques suitable for mass production of fine prints. In affording the artist the means of experiment and providing him contact with a part of his vast audience, the WPA/FAP has not only revitalized the techniques of graphic art, but has placed both the print and the artist a step forward toward their ultimate goal of providing fine prints for all the people.

Prints for Mass Production

ELIZABETH OLDS

From the artist's point of view, the phrase "Prints for mass production" has a complex meaning. First of all, it implies that etchings or woodcuts or lithographs possessing genuine artistic merit have been printed in thousands or hundreds of thousands without loss of their basic significance or intent. By virtue of the fact that prints can be created as multiple originals in an edition numbering thousands rather than tens, their price is low enough so that they can be bought by the average citizen, not just the wealthy collector. After this condition has been fulfilled, there is still the problem of putting these low-priced, mass-produced prints before the people who can afford to buy them and of interesting these people in such an art. These average citizens are an audience for the artist new to our time. New methods of reaching them have to be devised. When all these factors have been reconciled, then art will at last flourish on a democratic scale.

In making it possible for every man, woman, and child in America to enjoy art on a wide popular basis, the WPA/FAP has played a major role. One of its most constructive services has been to conserve and encourage the crafts of graphic art: lithography, etching, wood engraving, and the recently developed method of silk screen. In hundreds of master printmakers America has a sound technical foundation for the revival of a popular graphic art.

A second requirement is that graphic artists who hope to interest the millions in art must work in terms of what is vital and real to people generally. Early prints were purposeful; they did not exist solely for art's sake; they communicated knowledge and heightened emotion about the current world and its history; they spoke of war and of eternity, of secular life and of religion. The whole wide world of America today is the subject matter of the printmakers of mass production prints.

The WPA/FAP has done more than any agency in the past to enable graphic artists to ply their crafts and to achieve that almost instinctive mastery of the medium that comes from years of systematic practice. The workshops have provided that setup for externalization which a graphic artist was not always able to buy for himself; his lithographs, etchings, and woodcuts have been printed, when previously he might not have been able to pay the cost of printing.

With freedom to choose his subjects, he did not need to restrict himself to gamboling kittens and succulent nymphs beside a lake (sure-fire sales), but he could use any subject matter which seemed real and significant. Thus American printmakers have come of age.

Illiteracy in the United States counts among its victims only about five per cent of the population. By tradition and law, every American is entitled to

read and write. He can pick up a newspaper or magazine and know what is going on in his world. Theoretically, he should be able to pick up a lithograph, etching, or woodcut and know what it is about. Actually, he is culturally illiterate, because the language of art is a closed book to him, a speech which he has not been taught and of which he has been deprived, as the chained Bibles of the Middle Ages were withheld from the peoples of that era. To put art on a basis comparable to our free public school system is to make prints by mass production.

At present, there are two main channels for distributing the work of graphic artists. Those employed in the graphic division of the WPA/FAP see their prints take a normal course, as they are printed and allocated to tax-supported institutions. Artists not in the Project make their prints, get them printed, and leave the distribution (sales) to the art dealers.

All these prints are made by hand processes, laboriously and painfully, usually in editions limited to twenty-five or fifty copies, the block, stone, or plate then being destroyed so that no more can be printed. We thus produce prints by tens when we could produce them by thousands. In the market, if a limited edition is sold quickly and there is further demand for the print, prices rise. This system works to the benefit of the dealer and the detriment of the artist; for the living artist gets no royalty on resale of his work nor do wives and relatives of the deceased artist. A speculator's fiesta! The artificial scarcity of the print makes impossible a large circulation of these works of art.

There is a cultural contradiction in the existing situation, in which a few hand-pulled prints are bought at high prices and the most perfect printing machinery whirs merrily along turning out rubbish. The finest contemporary printmakers are thus isolated by lack of opportunity to apply their knowledge to making prints which may be insured a wide and cheap circulation by the use of these machines. Comparative costs, by hand and by machine, are revealing. A lithograph printer's usual charge is thirty cents a hand-pulled print, which includes the paper

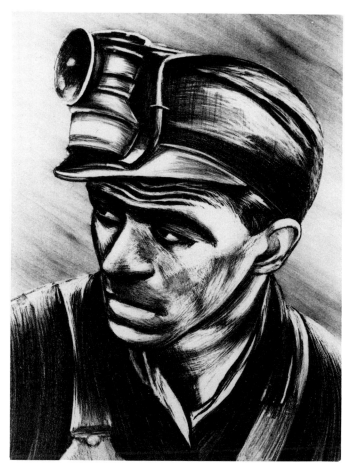

Elizabeth Olds. *Miner Joe.* Lithograph, New York City Project, c. 1938. (AAA)

and his labor. The price remains the same whether there are twelve or fifty prints taken. On the other hand, a machine print costs from two and one half cents to ten cents depending on the quantity produced. The cost per print grows lower as the number of prints increases. An edition of two thousand can be turned out in less than an hour by machine.

The present situation has not always been in effect. In 1766 a woodcut, "Notre Dame de Bonne Délivrance," was printed in an edition of five hundred thousand; and editions of two thousand prints were no novelty in the early centuries of printmaking. Quite a contrast with present-day editions of twenty-five or fifty!

The answer to this is "Prints for mass production." By conceiving lithographs and woodcuts in broad stylistic terms capable of being printed on power presses, or by working in new media like silk screen color prints, the printmaker can see his visual idea flower in thousands of multiple originals. By printing the picture by thousands instead of tens, we can produce it at prices millions can afford—prices comparable to the nineteenth-century democratic, popular prices of Currier & Ives prints. The question remains: How can the cheap, popular-priced, mass-produced print and the public be brought together?

The first and most immediate channel is the WPA/FAP, which has already done so much to bridge the gap between the American public and the American artist. Exhibitions in schools, libraries, hospitals, municipal airports, have taught many Americans that art is no rare, esoteric commodity but something they can sincerely and spontaneously enjoy. To widen the usefulness of art for the American millions, the Project can develop new applications of art, especially of graphic art. If the level of cultural literacy is to be raised, new uses should be explored. The "picture textbook" is such a use. There is no reason why artists cannot work together to turn out pictorial records or histories of varied aspects of life in their communities, whether city or country. Through such integrated visual images the student would gain a fresh sense of how he lives, how he gets his water, gas, electricity, food. Improvements in city planning, construction, playgrounds, and parks, change in controlled urban and rural environments, all should be recorded so that both adults and students could become more keenly aware of the world in which they live. Groups of artists working cooperatively on one theme, such as building a bridge or digging a tunnel, could turn out thrilling picture histories of changing civilization, techniques, and construction.

Coordinated with explanatory text, these picture stories (based on a scenario, as a movie is) could easily be assimilated into the educational fabric. Other immediate and practical uses for greater quantities of art, for thousands of prints (instead of tens), would result from a wider definition of the conditions under which exhibition and allocation are permitted. For a number of years public libraries, an organic part of the free public school system of the nation, have operated circulating picture collections. Why should not prints be on deposit in such public institutions for circulation to the public, which is generally too poor to buy books and by the same token too poor to buy works of art, pending a drastic reconstitution of the economics of the art market bringing about a radical change in prices and methods of selling? Publicly financed housing projects are logical depositories for publicly produced prints, and more liberal terms of loan might well be formulated for such purposes.

There is also precedent for a further revision of the conditions under which government financed works of art could be allocated to private citizens. For years a major service to knowledge in the United States has been performed through the publications of the Government Printing Office, whereby the results of research by myriad government offices, bureaus, and agencies have been made available to the public at no charge or for nominal fees. Here is a tremendous body of social wealth, still waiting to be mined. Already the government has set about producing another body of cultural wealth in the activities of the WPA/FAP. An easy, quick, popular way of disseminating this new knowledge is through the mass production of prints. Essentially, there is no conflict here with private industry, as the markets do not overlap. Researchers, scholars, and students generally have welcomed the government publications. Would not the great lay public welcome a similar expansion of art?

Lithography: Stepchild of the Arts

RUSSELL T. LIMBACH

A few short years ago an article such as this would not have been written. Lithography in this country had no connection with fine art and meant only one thing, the flashy poster or the "chromo" reproduction of tenth-rate paintings. In spite of the fact that European artists had produced superb examples of work from stone, both in black and white and in color, art dealers, museums, and collectors for the most part turned up their noses at the suggestion that lithography could be a vehicle for the production of great art. Etching and engraving alone were regarded as legitimate media for the artist to employ in printmaking.

Why, one may ask, did the invention of lithography, a new graphic medium, become the sole property of the commercial world, while American artists continued to use the older and less facile methods of printmaking? A large share of the blame can be traced to the fictitious values created by the artificial scarcity of the signed, numbered, and greatly limited editions of prints. The artist himself has always turned to the most convenient and expressive forms of printmaking in order to obtain the widest possible circulation for his work. The speculator's attitude toward "fine" arts has its origin in stockmarket-minded dealers and collectors. This attitude inevitably fostered a snobbishness toward lithography as a creative art, and is responsible for retarding the development of this important graphic medium of expression.

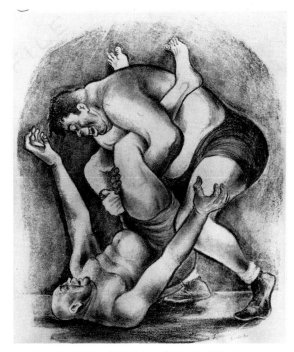

Russell Limbach. *Wrestlers*. Lithograph, New York City Project, c. 1936. (AAA)

Engraving, the earliest form of printmaking, meant long hours of tedious work cutting a design in wood, steel, or copper, and the artist was usually glad to turn over this technical task to an apprentice or assistant so that he himself could be free for more creative effort. Later, with the discovery that lines and tones could be bitten into a metal plate with acid, the art of etching in the hands of masters

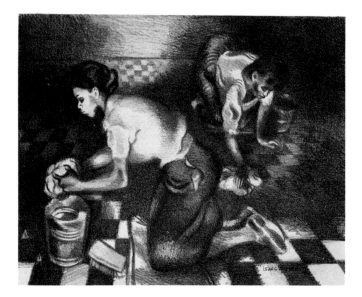

Isaac Soyer. *Scrubwomen*. Lithograph, New York City Project, c. 1937. (AAA)

reached great heights because of its comparative flexibility and ease of control. But lithography, the most flexible of all the autographic processes, was only invented at the close of the eighteenth century, and the ease with which a drawing could be made and reproduced by this process became, paradoxically, a handicap from which the creative artist is still suffering.

Alois Senefelder, an impoverished German actor, composer, and music publisher, accidentally discovered that a pen and ink drawing made on a polished slab of limestone could be chemically treated to make the undrawn portions of the stone impervious to an ink roller passed over it and yet allow the ink to stick to the portions that were intended to be black, so that a proof could be obtained from it. Elimination of the necessity of cutting away with a tool, as is done in relief processes, or scratching or etching beneath the surface of resistant metal, as in intaglio printing, was a boon to the creative artist, and quickly recognized as a great labor-saving device by those who exploited it commercially.

In this new process of surface printing, the artist needed only to draw on the stone with crayon in exactly the same manner in which he drew on a sheet of paper, and thousands of facsimiles could be made without the slightest alteration in tone, texture, or color. Newspaper, book, and music publishers, advertisers, manufacturers, in fact everyone interested in the commercial aspects of printing, were quick to realize the advantages of this new process which eliminated the slower and costlier methods.

For a hundred years lithography flourished in industry and created an abundance of pictorial matter, the like of which, from the standpoint of quantity, had never before been possible. Illustrations could now be made so cheaply and so easily that pictures moved out of the luxury class and seeped down from the highest strata of society to the very lowest. The humblest of weekly periodicals could now afford cartoons, and it was a poor cigar box indeed that did not sport a multicolored label. But this widespread use of the process seemed to lower rather than raise the artistic level of the medium, because there was no thought of making good art but only of embellishing a commercial commodity. However, some pictures thoughtfully designed to sell merchandise or ideas went beyond these commercial limits and became art in the best sense of the word.

Art descended on the country with a resounding crash in the form of gaudy reproductions of bad paintings, too many of which are still found in homes today, to say nothing of the countless numbers of labels, posters, and postcards for every occasion. In fact, until the perfection of photo-engraving eliminated hand work on plates, practically everything printed in color was reproduced by lithography.

The sudden eruption of so much "art" was appalling, and it is no wonder that the United States Customs still determines duty on importations of artists' lithographs by the pound, whereas etchings and engravings are taxed on the basis of their declared value as works of art. People who should have known better coupled lithography in their minds with the cheap and gaudy chromos, forgetting the few fine prints produced by Goya within the lifetime of Senefelder, and the superb examples of the possibilities of the medium by later artists abroad, such as Daumier, Delacroix, Manet, Lautrec, Renoir, Signac, Cézanne, and many others of the top rank. As a result, artists were discouraged from attempting to produce lithographs and stuck to the more ancient and respected process in order to increase possibilities of sales. Although the attitude of progressive dealers, museums, and collectors has changed enormously in the past few years, there are still many

whose attitude is that of the dealer who sorrowfully said of Daumier that ". . . his lithographs would sell much better if they were etchings!"

The possibilities of sales, however, were not entirely the determining factor in preventing the American artist from producing lithographs. Many were attracted to the beautiful surface of the stone, and the wide range of tone and texture that could be achieved with crayon and ink. But when the drawing was completed the problem of securing satisfactory proofs had still to be met. An etcher or engraver works at an old and accepted trade. There are well-established printers who can produce proofs of his work; or if the artist chooses, he can have his own small press in the corner of his studio for use whenever he cares to pull a proof of work in progress. But to emphasize the comparative newness of the acceptance of lithography as a legitimate medium for the production of fine prints, consider that only one printer in New York City produces the bulk of all the privately printed lithographs,* and that there is still no art supply dealer who realizes that a small portable litho proving press could be sold to enough artists to warrant its manufacture and sale.

Early in the century a few artist experimenters, impressed by the work of lithographers abroad, began to produce prints and were forced either to send their stones to Europe or to become their own printers. Many important lithographers developed in spite of these difficulties, but their contributions, with few exceptions, were limited to work in one stone. The added problem of color lithography, which requires the use of successive printing from two or more stones, was a step which was not to be taken by any large group of artists until the second year of the existence of the WPA Federal Art Project.

It should be remembered that Bolton Brown and Joseph Pennell both spent many years furthering the use of the lithographic process among creative artists. Bolton Brown, especially, delved deeply into the wide range of possibilities of the medium and encouraged some of America's finest artists to make use of his knowledge. Pennell, who never had a complete understanding of the process, was led astray on the easier path of transferring his crayon drawings from paper to stone. Nevertheless he too encouraged artists to use the lithographic medium.

Today, the greatest stimulus to the artist in America for completely realizing the possibilities of stone and crayon is the graphic division of the WPA/FAP. In New York City, the artist is fortunate in having a workshop where four competent printers, developed by the Project, are engaged in proofing his stones.

Color lithography, especially, has been encouraged as never before in this country. Until recently only a few dozen color prints from stone by a handful of creative artists had been produced. During the past year more than fifty artists have produced over one hundred and twenty-five lithographs in color.

With an opportunity to work unhampered by the demands of unprogressive private patronage, and with the time and equipment necessary for real research and experiment, the graphic artists of America may yet develop an idiom that will enrich the culture of this country and lay the cornerstone of a great tradition.

Jacob Kainen. *Drought*. Lithograph, New York City Project, c. 1935. (AAA)

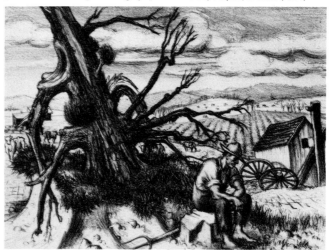

*This would be George C. Miller.

Eulogy on the Woodblock

FRITZ EICHENBERG

Of late, "Democratic" has become an often-abused term. It should be bestowed only upon an achievement beneficial to the greatest number of people, designed to enlighten the masses, to open new vistas to them, to improve their mental and physical well-being.

Since its origin the woodblock has been the most democratic medium of art. Whatever its social, political, or religious significance may have been, it has always been the carrier of a message.

From its earliest traceable beginning in China, half a century before the birth of Christ, the blockprint has served mainly as a missionary. By reproducing prayers and illustrating the stories of saints and sages, it made the spiritual message of religion graphically intelligible. When the "magic" process of printing from wooden plates became known to medieval Europe, it was soon recognized as an important factor in influencing and molding the minds of men.

It was a medium so simple in its technique and so easy to execute for everyone with a little skill and a vivid imagination that with the help of a knife and a piece of wood even the village artisan was able to cut and print biblical scenes or a picture of the patron saint of his community.

In Germany, until the days of Martin Luther, the word of God in its printed form, because it was in Latin, had been accessible only to the learned. The common people had to depend on their preachers for an interpretation of the Scriptures. To see their biblical characters come to life, people went on pil-

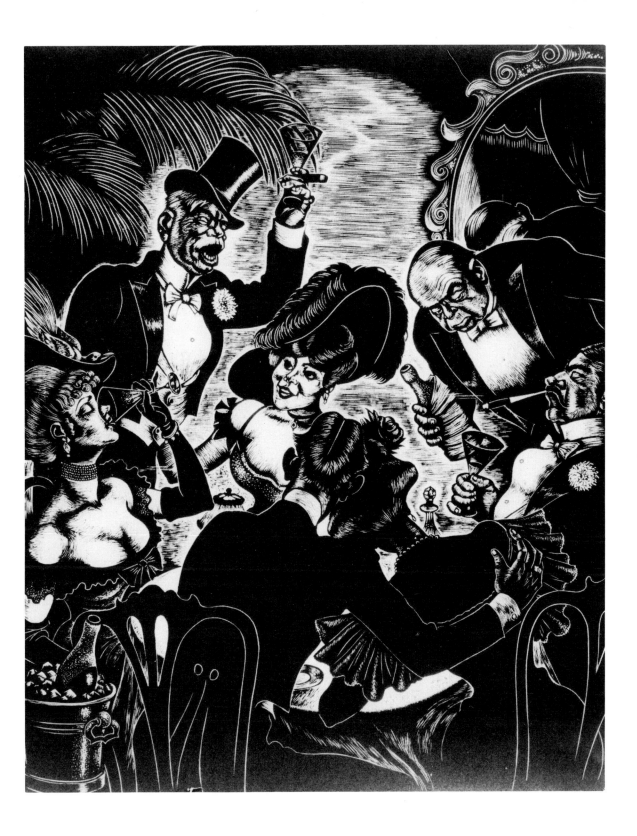

Fritz Eichenberg. *A.D. 1904*. Woodcut, New York City Project,
c. 1937. (AAA)

grimages to churches and chapels which displayed paintings, altarpieces, and sculptures by more or less famous artists.

Then the blockprint entered the home of the humble man. He could buy it for a few pennies from a street vendor and gaze at it reverently at his leisure within his own four walls.

It was only natural that leaders with ears to hear and eyes to see seized upon this first method of large-scale production to carry into the homes of the uneducated new and often revolutionary social and religious ideas. Their efforts to grasp the truth were aided by Luther's translation of the Bible into simple German.

In those days the political cartoon was born. Luther used it for the first time in mass production in his fight against the papacy. He recognized the striking effect of a simple picture on the minds of simple people who could read only slightly or not at all, but who could always understand the meaning of pictorial symbols. He secured the help of Holbein and other sympathetically-minded contemporary artists to illustrate his biting comments and crusading slogans. The work of these artists helped to bring Luther's struggle to victory.

This was the first time artist and writer-priest combined their forces and wits successfully to form and influence public opinion. It was the twilight of art for the few and the dawn of art for the many.

During the following five hundred years very little has been changed in the methods used by Luther and others to bring a printed message to the people. Instead of a woodblock printed on a handpress, we have today a zinc plate printed by an electrically driven printing press.

But the woodblock still has its attraction for the artist. Its smooth surface still invites knife and graver to cut their furrows into it. It still seems miraculously simple, even in the days of the triumphant monster machine with its speed and cold efficiency, that an artist can lock himself up with a piece of wood, a knife, some paper and ink, and a spoon for a burnisher, to create art and reproduce it.

In my opinion it is the simplicity of the woodblock, the direct contact of wood with the artist's graver, and the creative struggle it involves that produces something alluringly fresh and immediate in the way of reproduction which no mechanical process can achieve. Even in a world where everything is driven by machine, there is still a place for the ruggedly individualistic artist if he cares to fight for it. And he can compete with the machine if he dares to!

Religion having relinquished its role as a constructive social philosophy, as a vitalizing force in the lives of men, the artist was compelled by circumstances to give up his position as a messenger of spiritual values. Like the world around him, the artist of our time had lost faith. His work has consequently been deprived of an essential life-giving quality. Technique alone will not suffice. Wood without an inspiring conviction is dead.

But how can the artist of today regain what he has lost? Certainly not by retiring to his studio. Certainly not by devoting all his time and energy to comic-strip and magazine illustration or cheap political cartoons. Certainly not by living in an artists' colony and painting idyllic country scenes while the world is in turmoil.

To become again a messenger of "spiritual forces," to help again to enlighten the masses and heal the wounds the world inflicts on them, the artist of today must go out and live among his people. He must, in order to diagnose its ailments and find a cure for them. He must be a prophet, a preacher, and a physician.

The woodblock makes an artist practically independent of publisher and printer. But to find an outlet for his work the artist must pay a high price. He must face unpopularity, ingratitude, and privation and must suffer as much as any prophet ever has. He must work on himself incessantly to prepare himself for his task. He must find a philosophy that will support him, a faith that will be the driving power of his art.

Satire in Art

MABEL DWIGHT

Satire implies the presence of disease in the social organism; it can exist only in an unhealthy society. Utopia would have no place for it. A militant satirist sees a sick world and tries to operate on it with his rapier. Injustice, cruelty, and absurdity are deformities; his passion for life resents them with vigorous contempt; his art isolates and dramatizes them—holds them up to scorn and laughter. His healthy satire is intellectual, but the fire of his emotion forges its weapons.

Satire is itself, at times, tainted with disease; sardonic and fatalistic, it pictures the inevitable defects inherent in life and shows the hopelessness of man's attempts to fight against his fate. Possibly the artists who created the "danse macabre" pictures of the Middle Ages might belong to this class. Again, satire may play lightly with man's foibles—in kindly, ironic vein portray him as not such a bad fellow after all, though at times a rather absurd one.

The artist who attempts to be a satirist may get into trouble with his god. For art, like Jehovah, is a jealous god. Art demands that the parts of a picture be so organized that beauty and a feeling of inevitability of design result. Ideas often resist stubbornly the artist's imperative need to be an artist first while satirizing or propagandizing. A few men have been magnificently successful in uniting satire and art. They were robust masters; art flowed in their veins and they immortalized an idea without suffering esthetic conflicts. Because Goya's tragic satires are noble art, their bitter comment is perennially effective.

There are always certain artists who cannot be satisfied with the credo of art for art's sake. They must tell stories, express opinions, and "take sides." Some of them suffered from inferiority complexes during the late reign of modern art with its too-great subservience to abstract theories and story-telling taboos. But that is past and they are now telling hair-raising stories about a mad world.

The academician in art seems able to live through art movements, war, pestilence, and depressions, safely entombed in his orthodoxy. Ideas sweep past him and find expression on the canvases of more responsive artists—experimentalists, fine fools in art who may turn out to be wise men: men who sometimes father dynasties in art without knowing it. These movements have their humorous as well as their distressing side. As the dealers and purveyors of culture just about get the public trained as to what is art, there is an overthrow of artistic government, and culture feels like a turtle on its back. Years ago only old masters were respectable in this country. For a long time the academicians and Beaux-Arts disciples held sway; then the European modern art movement was imported—and culture kicked over the traces. It was an exhilarating, liberating period for art and artists. But the public turned ribald and talked out loud in the sacred temples of art. It was uphill work trying to educate people. To a certain extent the feat was accomplished; then the pendulum swung the other way again. In this country many modern artists gradually revolted against the Ecole de Paris; they discovered America; they began to see the people

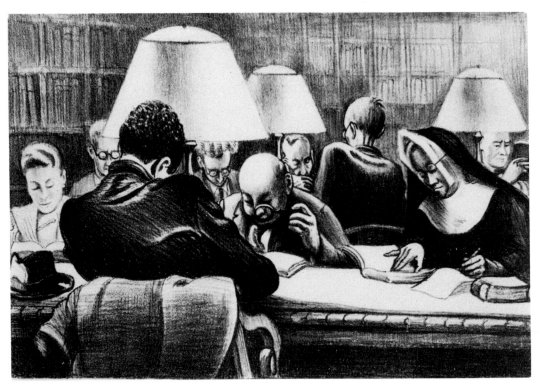

Mabel Dwight. *Silence*. Lithograph, New York City Project, c. 1940. (AAA)

about them as subject matter for art. Moreover, the depression had deprived them of patrons.

The state of financial depression has always been the habitat of artists. They know the geography of that state. But with gaunt specters of war, depression, and oppression stalking the world, they began to realize that, like other workers, they must stand together to save themselves. Art has turned militant. It forms unions, carries banners, sits down uninvited, and gets underfoot. Social justice is its battle cry. War, dictators, labor troubles, housing problems all appear on canvas and paper. Inevitably, propaganda and satire are popular forms of expression.

Let no one fool himself into thinking that artists cannot draw useful conclusions as well as pictures. The real artist sees with clarity and coordinates his thoughts with precision—that is part of his training as an artist. Seeing where things are "out of drawing" is part of his business. The present state of the world should produce great satirists. But all the satirical work that has lived was fine art. Newspaper cartoons may be clever in drawing and in idea, but few survive as works of art. They are hastily constructed and generally express merely local or topical values. However, some of them are very able and embody universal conceptions, and as life changes her dress

often but her disposition seldom, the point in a cartoon of one day is often found to be equally sharp at a later day. Certainly many of Daumier's newspaper drawings might have issued from this morning's press, as far as the freshness of their ideas is concerned.

I have the temerity to say that I do not think all of Daumier's newspaper work was great art. But his best work sheds enough radiance to light up everything he ever touched. He never copied nature; never drew from life. He looked at it with his mind's eye and abstracted meanings. He constantly trained his hand to obey his mind until his ideas flowed through his fingertips onto stone with unconscious fluency, as if conceiving an idea and drawing it were one single gesture.

If the artist-satirist makes use of distortion and exaggeration in his drawing, it is generally for the purpose of stressing a point or calling attention to a weak or absurd characteristic in an individual. After all, he is dealing with art and ideas; any method that helps to clarify the thought or enrich the design is legitimate. An artist must follow his inner necessity. But the work of the great social satirists contains little arbitrary distortion. The figures in Hogarth's "Rake's Progress" and other series are free from it.

Goya's "Disasters of War," "Caprichos," etc., are natural in proportion except where he introduced grotesque giants or fabulous forms. Forain practically never distorted. Rowlandson's rollicking old squires and their dames were true to their period and perhaps seem more exaggerated than they really were. Daumier used distortion in his political caricatures. He sometimes drew men with huge heads and small bodies. This was rather a fashion of the day. Perhaps he wished to reveal the motives of the men behind their facial masks and felt that the exaggeration focused attention on telltale characteristics. He was not concerned with their bodies. However, the body is just as revealing as the face. I feel that when Daumier was most truly the artist and revealer of character, his work was most free from deliberate distortion. His long series of "Palais de Justice" types is an instance.

Too much distortion would seem to be an immature resource—a noisy show rather than a subtle suggestion. Some of the young, class-conscious artists are too arrogantly vehement in their portrayals of vulgarity, ugliness, injustice, etc., and one is conscious of their agonized effort to twist the whole into a pattern of art. The result leaves the spectator indifferent. Propaganda and satire in art require a keener legerdemain.

Some artists who are active and radical workers for social justice choose to keep their art entirely free from human problems. They may belong to the abstract or surrealist schools. This is fortunate. Not every artist with a social conscience is a potential Daumier. Artists are too prone to follow movements. Why should they all join the present back-to-life movement unless aesthetic as well as social conscience impels them.

When I was a very young woman and an art student in San Francisco, some fellow students introduced me to socialism. The encounter was similar to "getting religion." My fervor shocked and alarmed my parents to such an extent that I was forced to go "underground" with my social ideas. This of course made the heat whiter. Art, too, I thought, must be an

Leroy Flint. *Distraction*. Etching, Ohio Project, c. 1937. (AAA)

heroic comrade. This period of my life at least gave a definite bent to my later thought, and the reading done then directed my natural impulses. I was born with a hatred for the duality of poverty and riches. An early faith in a world without underdogs is a healthy experience, even if later experiences point to a world gone to the dogs. But whatever ups and downs of political or social faith I may have passed through, I have been true to the fundamental conviction that poverty is the great evil—a form of black plague inexcusable in a scientific age.

Some artists turn everything they touch into still life—landscapes, people, even children and animals. People are merely compositional problems to them. They demand the "immobility of an apple" from flesh and blood. They may produce beautiful art and overcome technical difficulties, but the artist who is as much interested in the motivation of a gesture as in the gesture itself has a different problem to solve. It is the quality of life in people that fascinates him. Possibly he has no definite thought of satire or propaganda, but unconsciously he makes comments and reveals his inner philosophy. An honest painter of this kind may become something of a satirist or propagandist without intending to. If certain aspects of life raise the pulse of his resentment, his intention

may become clarified and take the definite form of satire. In that event he concerns himself with the discrepancies between the real and the ideal; he moves his flashlight about and spots a wrong at its most absurd or ignoble moment. He is interested more in the motives of people than in their pictorial aspects, but he must never let the satirist browbeat the artist.

Many of the young artists are depicting the more strident and garish aspects of modern America, but not all of them are trying to tell how awful they think it all is. They frankly enjoy painting Coney Island, gasoline stations, hot-dog stands, cheap main streets, frame houses with jig-saw bands—all the Topsy-like growth of our cities. The subject matter is rich in humor, drama, and magnificent pattern. These artists are portraying at least a phase of their period, as men like Renoir and Degas portrayed theirs. Naturally there seems to be some quality of satire in their work because the things represented are travesties upon architecture, pleasure, living—life itself. Artists have an uncanny faculty for seeing beauty in ugly and unsanitary places; in fact a true artist can find it anywhere. Perhaps it might be better to say he spins beauty from himself as a spider spins its web from its own body. This ability enables him to transmute any phase of life into art. If he keeps a cool head and a warm heart and paints life with understanding, his creation will be a living influence in the world. There is no reason for his caricaturing people—for he could never hope to rival nature, who herself has created beings so out of all reasonable proportion, so ludicrous and horrible, that one might wonder if it is satire she is aiming at. The artist has only to look at these people with sympathy and translate them into art to be just as tragic or humorous as he may wish.

A Graphic Medium Grows Up

ANTHONY VELONIS

A print, if it is an etching, insofar as the artist himself has worked on the copper plate, is valued as an original. A print, if it is a lithograph, insofar as the artist himself has worked on the stone, is valued as an original. And rightly so, for no cold mechanical process has come between the artist and the print. It is not that a drawing is merely reproduced. The original sketch itself is only a step in the production of the print. For between the sketch and the print comes the vitalizing discipline and character of the graphic medium itself. It is impossible to conceive of an etching or a lithograph without taking the very idiom of the medium—the bitten line, the soft plate tone, the crayon and tusche on stone.

However, when you do try to reproduce a painting, for instance, by even the finest and most sensitive of processes, the reproduction always falls far short of the original, because the artist had conceived a painting and not a reproduction. The painting might have a certain heavy and monumental luminosity which no tint-like reproduction, however good, can achieve. And what is more painfully artificial than the printed shadows of brushstrokes? Efforts to emboss prints in imitation of the building up on the original painting simply amount to supreme bad taste. Nothing will substitute for a good layer of pigment.

Yet considerations of this sort are practically non-

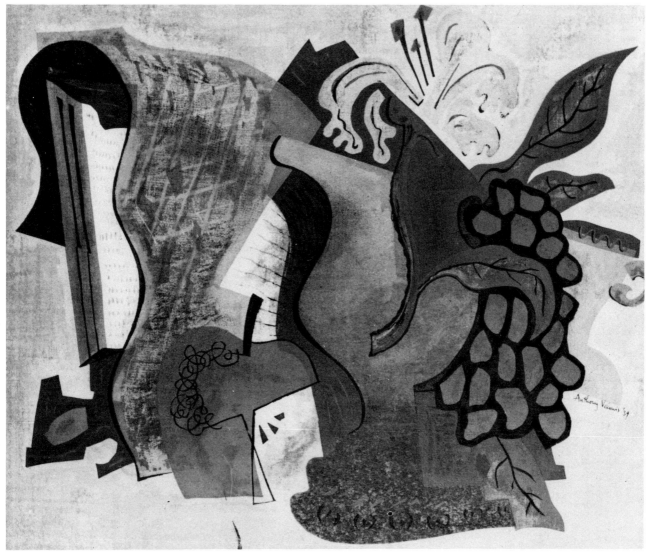

Anthony Velonis. *Abstraction*. Serigraph, New York City Project, c. 1939. (AAA)

existent when the artist himself uses a graphic medium directly, for then his purpose is not reproduction. He uses the medium as his brush and palette. He is conscious of its powers and limitations and the print then becomes the final and correct product of his vision.

The reason the writer develops these rather obvious critical nuances is to prepare a fitting introduction for a rather remarkable new medium. A real artist's tool. A graphic medium with all the aesthetic virtues. A medium with such scope and variety that it is difficult to define its limits. It is facile and flexible. Yet it definitely shapes and disciplines the direction of the artist's design.

It uses color from the grayest tone to the most brilliant hue on the palette, and from the thinnest transparency to a palette-knife opacity. A print in this new medium may have the richness of an oil painting with its luminous, thick pigment quality. It may have the mat, yet vivid surface of a tempera. It may have

the thinness of a watercolor. It may have the crispness of a woodcut, the softness of a lithograph, the accidental blendings of a monotype. A print may be made on paper, wood, glass, gesso, cloth, canvas.

What, then, is this amazing new medium? It is based on the principle of a simple stencil and it is called silk screen process.

You have heard of it, of course; so, as a matter of fact, it is not new at all. It has been used commercially for the last thirty years. Even some fine artists have occasionally dabbled with it. But now it really appears that the screen process is going to play a big role in the future of American art. A decade ago, color lithography was considered commercial and unworthy of the fine artist and, until very recently, silk screen process was generally looked upon as a very limited commercial medium. They said only flat simple areas could be printed—posters and things. Not much use to the fine artist.

It took the WPA/FAP to prepare the conditions for a real development of silk screen process as a fine-art medium. The writer proposed it to the Project through the helpful agency of the Public Use of Arts Committee, a public-spirited and far-sighted volunteer organization.

Since the introduction of screen process in the graphic division of the WPA/FAP, the writer, with other artists, has been conducting an investigation into its fine-art possibilities. The prints which we have already produced are highly satisfactory and have aroused the enthusiasm of all the artists who have happened to see them. Each print is so different and so sensitively individual that one can hardly believe all the prints were products of the same process.

The WPA/FAP was the logical place for all this to be initiated and developed. For nowhere else is there such a crosscurrent of varied technical experience and such an opportunity to practice, mixed with a bold, imaginative, and creative spirit. Artists bring in work with quiet humility and remarkable lack of fanfare. Much of this contains elements of importance for the vitality and growth of American art.

A cumulative movement is slowly evolving which, if continued, promises to make a firm independent tread out of the toddling walk taught us by the French school. In this background, the development by the Project of silk screen process is significant, insofar as the most successful prints were those which adhered to the direct and fresh approach of contemporary styles.

There are stories that the silk screen process started in China a thousand years ago. The Japanese cut intricate decorative stencils, the "centers" and "peninsulas" tied in place with a web of hair. Silk screen process is based on just that principle.

A piece of gauze-like silk or organdy stretched on a wooden frame. A thin delicate stencil held by the web of the silk. Paint is "squeegeed" and the paint flows only through the part of the mesh that is not obstructed by the stencil, depositing itself on the paper underneath. The first color is printed. It is permitted to dry. The next color is "squeegeed" through another stencil, and then the next, and so on until the print is finished. That is a bird's-eye view of the process, but in and out of the basic steps of production, experience and resourcefulness supply a thousand little ingenious gems of technique.

None of this, however, requires any costly or cumbersome machinery. The artist may print even in his own studio. Depending on his space and facilities and his willingness to sweat, he may print from ten to ten hundred prints. He may print with special inks, with oils, or with watercolor.

Many artists have, in fact, already begun to set up silk screen equipment in their studios. Silk screen prints will soon be emerging in numbers. The writer predicts that in the next year or so, Fifty-Seventh Street will be headlining these prints. Madison Avenue will be putting big gold frames on them. The walls of homes, new housing projects, and collectors' dens will be graced with paintings done by screen process. And all "for the price of a good book."

Here in the making, then, is another of the many contributions to the richness and beauty and color of America from the WPA/FAP.

Street of Forgotten Men

ELI JACOBI

In childhood one's fancy turns to all the arts. The urge for play and self-expression is uppermost. As the artist matures and meets an age of steel and economic struggle, he feels lucky to survive with a single one of the arts, and clings desperately to his solitary ivory tower—a haven for his dignity and self-defense. With the advent of a "depression," even that protective refuge collapses, and the artist finds himself lost in the mass of foundering humanity.

Thus it came to pass that I set about making my series of linoleum cuts for "The Street of Forgotten Men." My reasons for doing this can be summarized somewhat as follows: first, because of my personal experience and the desire to escape from it through the safety-valve of expression; second, to test out the poet's definition of truth and beauty, and how far one can go toward marrying truth—ugly truth—to beauty; third, to epitomize the present world's dilemma: man's inhumanity to man.

Although I love painting and share an equal affection for various media of the graphic arts, I find linoleum the most suitable medium for my present subject matter. It responds more readily to spontaneity in execution and, at the same time, offers a stimulus for experimentation.

I daresay that, with the pampered private connoisseur in mind, such groping freedom in point of technique and content would have been scarcely possible. Under government patronage, however, and directed with unexampled wisdom and toler-ance, the artist's psychosis of uncertainty is now disappearing.

With the artist about to take his rightful role in society, America will have made its bow with a modern Renaissance, and the world will have come to witness the birth of the happy equilibrium—spirit transcending matter. There will be no need then for ivory towers, no desire for evoking bitter truth with beauty.

Truth will be synonymous with beauty in proclaiming a better and more realized life.

Eli Jacobi. *Maxies' Moose*. Linoleum cut, New York City Project, c. 1936. (AAA)

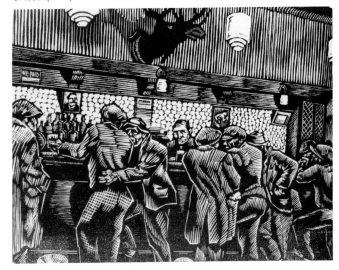

Changing New York*

BERENICE ABBOTT

"To photograph New York City" is the definition of this sub-project of the WPA/FAP. The original plan stated that the purpose of such a photographic enterprise would be "to preserve for the future an accurate and faithful chronicle in photographs of the changing aspect of the world's greatest metropolis." In this mood the project has been carried out since it was approved in August 1935.

"To photograph New York City," I stated more fully in the plan, "means to seek to catch in the sensitive photographic emulsion the spirit of the metropolis, while remaining true to its essential fact, its hurrying tempo, its congested streets, the past jostling the present. The concern is not with the architectural rendering of detail, the buildings of 1935 overshadowing all else, but with a synthesis which shows the skyscraper in relation to the less colossal edifices which preceded it: city vistas, waterways, highways, and means of transportation: areas where peculiarly urban aspects of human living can be observed: city squares where the trees die for lack of sun and air: narrow and dark canyons where visibility fails because there is no light: litter blowing along a waterfront slip: relics of the age of General Grant and Queen Victoria where these have survived the onward march of the steam shovel—all these things and many more comprise New York City in 1935. And it is these aspects that should be photographed."

It was a firm conviction I held about this idea, because it was an idea nurtured a long time. In March 1929, I had come to New York from Paris, where I had made my home for almost ten years and where I had been doing portrait photography for several years with considerable success. The trip was to be just a short visit. But when I saw New York again, I felt that here was the thing I had been wanting to do all my life, photograph New York City. That was the birth of the idea of the project "Changing New York."

So back to Paris, to wind up my affairs there. And back again to the United States with feverish excitement. But 1929 was not a year for anyone to start new enterprises. Financial backing for anything went out of fashion when the fat boom years ended, and the lean years of Depression came. I had from the beginning sought to interest various people and institutions in the plan to photograph New York City. The first person I saw was I. N. Phelps Stokes, the distinguished iconographer of Manhattan Island.** He has always been unfailingly cooperative and interested in the idea. In 1930 I sent a long plan both to the Museum of the City of New York and to the New-York Historical Society. Both were sympathetic. But private patrons had other uses for their funds then, as I discovered in 1932 when I sent out several hundred letters asking for subscriptions. One contribution for $50 was received.

*This essay incorporates the texts of two separate drafts.

**Isaac Newton Phelps Stokes. *Iconography of Manhattan Island: 1498 to 1909*. 6 vols. New York: R. H. Dodd, 1915-1928.

Berenice Abbott. *Rockefeller Center with Collegiate Church of St. Nicholas in foreground*. Photograph from the "Changing New York" series, New York City Project, 1936. (NCFA:Cahill) →

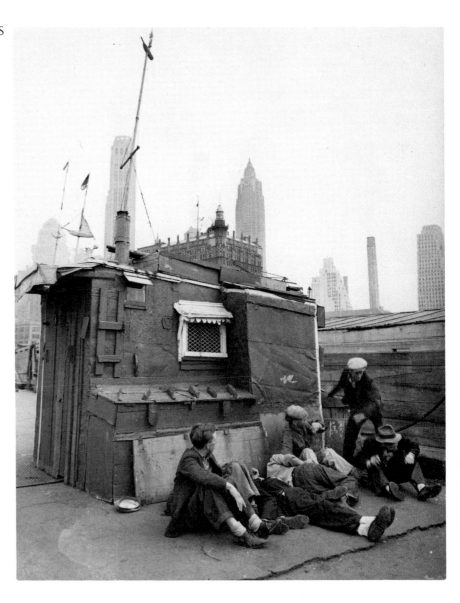

The years went on, and the fantastic passion for New York continued to obsess me. As far as time and finances permitted, I photographed the city on my own, building up the "chronicle in photographs" which I was always hoping could be carried out on a larger and more complete scale. Early in October 1934, a selection of these photographs was shown at the Museum of the City of New York and proved of such great interest to the public that the exhibition was held over several months after its original month was ended. Previously my New York photographs had been exhibited at the opening of the Museum's new building in 1932, several times at the Julien Levy Gallery, and in Paris, San Francisco, Boston, Hartford, Springfield, etc., where the response was enthusiastic.

It was plain from these exhibitions that there is a real popular demand for such a photographic record.

But the Depression continued. And art patrons continued in hiding. The enterprise could go on only in partial and very limited terms, because photography costs money, for supplies, for equipment, for the living expenses of the photographer. Moreover to carry out this idea in the most efficient and intelligent way, technical help was needed, both in the field and in the darkroom, as was further explained in the project's original prospectus. Moreover a tremendous amount of collateral research should be done in order that the photographs might achieve the fullest possible documentary value. The aesthetic factor depended, of course, on the artist;

Berenice Abbott. *Shelter on the Waterfront.*
Photograph from "Changing New York" series,
New York City Project, 1938. (NCFA:Cahill)

PHOTOGRAPHY 161

but the historical needed further factual data.

Such is the background of the project to photograph New York City. It is important to recite this current history because the experience is typical of many of the enterprises now being carried on by the Federal Art Project. Many creative workers have gone through the same cycle of hope, delay, and frustration, because there was no practical social support for their work. And many have found in government patronage the aid they needed to continue their creative development. Thus, since the photographic sub-project, "Changing New York," got under way, in September 1935, I have had the experience which is a healthy part of every artist's growth: the more you do, the more you realize how much there is to do, what a vast subject the metropolis is, and how the work of photographing it could go on forever.

The capturing of the vanishing instant cannot be hurried. The work must be done deliberately, in order that the artist actually will set down in the sensitive and delicate photographic emulsion the soul of the city. Haste is always damaging to the creative process; and particularly in photographing a great city where the photographer must set up the camera in crowded streets or on dangerously precipitous rooftops, rickety fire-escapes with broken steps, streets where there is tremendous vibration of trucks elevators, subways, streets where the winds blow with fury down the narrow canyons, sometimes toppling over the camera. Here sufficient time must be taken to produce an expressive result in which moving details must coincide with balance of design and significance of subject.

For over three years the "Changing New York" project has been at work. The field is by no means exhausted, and never can be as long as the city continues to be and to change. However, the many public uses to which the photographs have been put (besides the use originally defined, namely, to be a part of the permanent collections of the Museum of the City of New York and similar historical depositories) proves the immediate as well as the ultimate value of the documentary photographic record.

The Federal Art Project has exhibited them in the demonstration galleries of the South; in New York City, in a comprehensive one-man show at the Museum of the City of New York in 1938, in "New Horizons in American Art" at the Museum of Modern Art in 1936, in the First International Photographic Exposition in 1938, in "Photography: 1839-1937" at the Museum of Modern Art, in the section "Seven American Photographers" in the Museum of Modern Art's exhibition "Art in Our Time" held in 1939, at numerous community centers in the five boroughs; at the New York State Museum in Albany, etc.

A great variety of publications have used the photographs, from *Life, House and Garden, Town and Country*, to publications of social work and religious organizations. Newspaper rotogravure sections have availed themselves of this pictorial material; and government publications, such as the New York Guidebook, have also made use of it.

In the spring of 1939, E. P. Dutton & Co. published *Changing New York*, a selection of ninety-seven photographs from the series, with documentary text by Elizabeth McCausland. Almost the full size of the original eight-by-ten prints, these reproductions ensure that a permanent record of the series will be preserved for the future, even if disaster should befall the negatives. The value of such double protection against time and its vicissitudes is illustrated by the case of the Brady documentation of the Civil War, many of whose negatives have been lost, but some of whose best work survives in the *Pictorial History*. Planned with sincere interest by the publisher, *Changing New York* is printed on good paper, a plate on each right-hand page, with facing text. Although printer's ink and paper are not guaranteed to last a thousand years, this book should last longer than most.

A growing public demand for the photographs is to be seen in the allocations. Prints have already been allocated to the Evander Childs, Roosevelt, and Commercial High Schools in New York City, and to

the University of Wisconsin. A set is to be deposited with the New York State Museum in Albany. This convinces me that there is real need in America, for those who have a real love of America, to preserve such records of the evolution of our cities, which symbolize the growth of the nation, as yet uncrystallized and unformed.

The experience of the "Changing New York" project suggests how this can be done. It is possible to expand this conception and have groups of photographers working together cooperatively on one assignment, not only in New York but wherever in America there is important photographic material—which means, indeed, in all the forty-eight states.

The good work done by members of the photographic division of the New York WPA/FAP, as evidenced in the documentary study for *One Third of a Nation* and in the generally excellent showing made by the younger photographers in exhibitions such as the modern section of the 1939 International of the Pictorial Photographers of America, the housing exhibition of photographs at the Museum of the City of New York, and in the Photo League's exhibition "Photographing New York City" held at the New School for Social Research, makes it more than ever certain that such a broadening of the horizons of documentary photography would be of inestimable service to American life.

Part II
THE PRACTICAL ARTS

Anton Refregier. Mural panel (destroyed), oil on canvas, symbolizing the Index of American Design, in the WPA Building at the New York World's Fair, 1939. (AAA)

What Is American Design?

CONSTANCE ROURKE

American design has many ancestries, but this circumstance does not exclude the possibility of a distinctive character. All art is in some measure derivative; and for us, relationships with European design have been obvious and inevitable because of our origins and because of the many interchanges with Europe which have belonged to our history from its inception.

These ancestral ties have perhaps received undue emphasis in the field of design; and the forthright adaptations, changes, and fresh inventions showing themselves on American soil have on the whole been neglected. The impact of life on the frontier—on our many frontiers—through successive generations has continually produced simplifications even until a recent date, as local craftsmen have worked in new country, often without models, for impatient customers anxious to obtain objects for immediate use.

A definite turn toward functionalism inevitably took place under these conditions. The highboy, useful in the compact frontier home because of its convenient and ample storage space, became a typical and widely spread form, which perhaps had its influence—again in conjunction with need—in inducing the selection of other pieces of furniture which were capacious, simple, and strong enough to stand many removals by ox-cart or covered wagon. Functionalism reached a peak in the craft of the Shaker communities in the last century, where every object was fluently given the form demanded by the uses to which it was to be put, where chests, for example, never followed a few stereotypes, but appeared in literally dozens of forms. We are accustomed to think of the Shaker crafts as limited and special in influence, but the communities were widely distributed, reaching even into the early West; Shakerism had a long and sturdy history, and its crafts were constantly received into "the world" as Shaker wares were sold through channels of trade.

Thus these little-known crafts represent a definite native impulse in American design.

Need, combined with thrift, produced the hooked rug and the patchwork quilt and the multitude of stoneware jugs, of many fine sculptural forms, made from local clays on our frontiers; and the great variations in these homely products suggest a further strong element which tended to enter, even to crowd into American design from an early date—pleasure in individual taste or idiosyncrasy. This individualistic expression was not universal; often the craftsman lacked time for it. It does not appear in Shaker design at all, where the consciousness of the community was always uppermost, where the individual lost himself in the sense of the whole, and where in consequence an abstract or generic quality in design is strikingly apparent.

But elsewhere, individual assertions often appeared with great energy. The scrimshaw of American sailors on whaling ships is a prime example. Though the tooling on bone or shell often followed well-known classical patterns, the modeling of small and beautiful crimping-wheels almost consistently reveals vigorous, free individual outlines that range from naturalism to abstraction. On a larger scale, figureheads of Atlantic sailing ships showed similar broad variations, including sculptures which were severely classical, others that were definitely Gothic, still others that developed realistic portraiture of native American types or even individuals. The aesthetic impulse which produced them was positive, generous, and widespread; it reappeared in the familiar cigar-store Indians and the many related figures which adorned stores or taverns and were often amazingly fine in plastic and decorative values. These often followed a type or a stereotype, yet a wide swing toward individualism often appeared in the handling of posture, costume, color, and, more broadly, form.

An unmistakable richness becomes clear as the arts of design in this country are surveyed with anything more than a cursory glance. Their strong diversity is further indicated by two major classifications, the folk arts, and what, because of their origins, may be called the aristocratic forms. The latter obviously include the work of such distinguished craftsmen as Duncan Phyfe and the fine groups of furniture workers who flourished in seaboard cities from Boston to New Orleans in the first half of the nineteenth century. On the other hand, the folk arts run all the way from homespuns and simple furniture and ironwork to the distinctive creative forms of the Pennsylvania German and those of the old Spanish Southwest in painting or sculpture.

Whether dominant and recurrent strains have been created which can be called distinctively American is a question that cannot be easily settled. We do not know enough. Whether in essentials such strains have survived the development of the machine, or have been lost, is another significant problem. In our haste to conquer a continent, many examples and even whole phases of design have been covered over or neglected. It is the object of the WPA Index of American Design to document as many of these as possible. The Index presents the decorative and utilitarian arts of this country broadly by the vivid means of pictorial rendering, in a large series of portfolios. As a result, if this work is carried to full completion, the questions "What is American design?" or "Have we an American design?" may answer themselves, possibly with some surprises, certainly with a wealth of fresh materials. In any event, these many-sided and many-colored evidences will represent basic traditions in design which, as a people, in the past, we have chosen as our own.

Recording American Design

C. ADOLPH GLASSGOLD

At no time in the history of our country had there been undertaken a comprehensive survey of American design comparable to those publications in Europe with which students are so familiar.* This was in part due to our relative unconcern with our own cultural traditions, and in part to the vastness of the undertaking. But within recent years that indifference toward our artistic background gave place to an avid interest. It became generally felt and variously expressed that we had too long neglected that phase of our cultural heritage which had evidenced itself in the humbler arts and crafts, and that the picture of our plastic tradition would be incomplete if limited to the so-called fine arts.

Although many scholarly studies on special aspects of America's decorative and practical arts have appeared during the past thirty years, those desiring a panoramic view of American design have not found these publications completely satisfying. Not only would one have to spend much time tracing articles in scattered periodicals, or consulting unrelated volumes, but they would be found, by and large, inadequately illustrated, and vast areas, such as the folk arts, or the handicrafts, or religious communities, sparsely treated. There was a growing belief that a comprehensive collection of illustrations in colored drawing and photograph, depicting the history of American design in the applied and decorative arts, was a need that the WPA/FAP alone could fill, since the magnitude of such a task was beyond the resources of all but the Federal Government.

So it was that in the fall of 1935 the WPA/FAP as part of its broader national program, set up the Index of American Design, which was to be a series of portfolios consisting of plates in color and in black and white, pictorially and graphically recording the history of American decorative and utilitarian design from the earliest days of colonization until the late nineteenth century.

Under trained supervision and with the assistance of research workers, the four to five hundred artists variously employed on the Index throughout the country make colored drawings or paintings of selected objects in public and private collections. It is no exaggeration to say that many of the plates done by the Index artists are without parallel in the field of illustration by reason of their high fidelity to the original object, their accuracy of color and draftsmanship, their sense of material and texture.

A diversity of objects, such as glassware, ceramics,

*For example, the famous *L'ornement polychrome* edited by Albert Charles Auguste Racinet, Paris: Firmin Didot, 1869-73; English translation, London: H. Sotheran & Co., 1873.

Elizabeth Moutal. *Figure of Liberty*. Watercolor rendering of carved and painted wood statue made by Eliodoro Patete in Anawalt, West Virginia, sometime after 1863. Massachusetts Project. (NCFA:Cahill; Index of American Design, National Gallery of Art, Washington, D.C.)

costumes, textiles, metalwork, toys, furniture, and all the other "lares and penates" that were characteristic of the varied American modes of life, are being recorded. Particular attention is given to material which has not been studied or illustrated elsewhere, and emphasis is placed upon those examples which may be considered typical.

It is, of course, too much to expect this first project for an Index of American Design to do an encyclopaedic work. That would be too ambitious a program for any department other than one operating on a permanent basis. It is possible, however, to do the preliminary spadework, to produce a number of selected, beautifully colored portfolios which can be made accessible to scholars, teachers, artists, de-

signers, and to the general public interested in the arts as exemplifying cultural traditions. A dozen portfolios have already been definitely outlined and others are well under way.

All material collected by the Index of American Design units in the various states will finally be edited and correlated by a central planning committee composed of the administrative staff and a body of specialists in the various fields of the decorative and useful arts.

Of particular interest is the work being carried on in the more obscure fields of American Design. The Pennsylvania unit, for example, is doing an exhaustive piece of work on the Pennsylvania-German culture; Northern California is busily engaged in re-

constructing the era of mining and the riotous expansion of the seventies; Minnesota is specializing in the early contributions made to American design by the Swedish immigrant; Louisiana has produced more than a hundred plates of the exquisite costumes typical of ante-bellum New Orleans; Utah is recording the applied arts of the Mormons; New England, with contributions from Ohio and Kentucky, is making what will probably be the first definitive compilation in color of the practical arts of the Shaker Colonies; and here and there, the little known and less appreciated folk arts, such as ships' figureheads, tavern and storefront figures, the nautical arts of scrimshaw and bone carving, are being recorded.

The question, "Will not the accumulation of traditional material inevitably lead to imitation?" quite naturally comes to mind when considering this project. It would be futile to argue that this is not a possibility. Yet to contest, on this account, that the Index should not be compiled would be equally absurd. Imitation, even slavish copying, has always existed, and for those who practice it, models are never lacking. Only by destroying every last vestige of our tangible heritage can the dubious pursuit of "compliment by imitation" be eradicated. On the other hand the eventuality, equally possible, of the Index's serving as a fertilizing influence more than compensates for courting the danger of imitation.

Were it not for the Index of American Design, the superb costumes, saddle trappings, furniture, and "santos" from the old Spanish Southwest might never have been recorded. As it is, units in New Mexico, Colorado, and Southern California are making plates which when published will come as a pleasant surprise to many. Along with this factual task, Southern California is performing another valuable service. There, in the old mission, the Index workers, removing layer on layer of whitewash from the walls, are disclosing painted ornamentation hidden for decades. These they then record with the utmost fidelity of drawing and color.

Exhibitions of Index plates throughout the country

have already done much to stimulate interest in our design heritage. About twenty exhibitions have been held in large department stores, including Marshall Field of Chicago, R. H. Macy of New York, Stix Baer & Fuller of St. Louis, Hutzler Bros. of Baltimore, Bullocks of Los Angeles, and Rike Kumler of Dayton. Outstanding museums that have displayed the Index are the Cleveland Museum, the Art Institute of Chicago, the Detroit Art Institute, the Museum of Modern Art, the California Palace of the Legion of Honor, the Dallas Museum, the Milwaukee Art Institute, the San Diego Fine Arts Museum, the Cincinnati Museum, and the Worcester Museum. The material has been shown in about thirty Federal Art Centers and by a large number of cultural organizations, such as the University of Pittsburgh, the University of California, and Yale University. A vast number of hitherto disregarded or little-known collections and individual items of Americana have been brought to light as a result of these shows.

We must also mention the constantly growing body of research material which constitutes a background for the drawings and photographs. Exhaustive lists of craftsmen, biographical sketches of artisans and designers, stories of historical interest about the original owners and the manufacturers, and sidelights on the vicissitudes of the objects themselves are forming a vast reservoir of illuminating information about the material gathered by the Index. Fresh knowledge about American design and designers is continually being unearthed by Index research workers who study the yellowed files of old journals, newspapers and documentary records in museums, historical societies, and libraries. As a result, attributions become clearer and the snarled history of America's design heritage is slowly but surely being untangled.

The varied character and forms of American design stand at last in the way of being presented as a comprehensible whole. What it may mean to the cultural future of America one cannot at this time prophesy, but that its meaning is more than mere antiquarianism is self-evident.

The New York Index

CHARLES CORNELIUS

The chief preoccupation of the New York unit of the Index of American Design, as of all other units, is the recording of objects of American decorative art in pictorial form. To this end, a special supervisor has been assigned to each of the principal fields of the decorative arts—furniture, glass and pottery, silver, pewter and other metalwork, textiles, costume, etc.—to direct the work into constructive channels.

Through exhibitions, or reproductions in current publications, the public is more or less familiar with the type of rendering that is being produced by our artists. Less known to the public is the work which is going on behind the scenes, so to speak, that of assembling and coordinating the documentary information connected with the subjects depicted by the drawings. In this part of the work, due to the enthusiasm of the workers, a spirit of discovery has evidenced itself. A few examples of accomplishment may illustrate the point.

In the Historic Gardens Unit of the New York Index the plans of old gardens are being studied. One of the workers in this unit discovered the Blackwell survey of upper Manhattan Island, a part of the city once occupied by large country estates. Blackwell was the official topographical surveyor of the city between 1860 and 1864. On the backs of the sheets of this official survey were careful drawings of gardens then in existence, some of them dating back to Colonial days. On the basis of these drawings, hitherto unknown, the Index is making renderings for publication.

The textile division gives an illustration of a new approach to an old subject. Bed quilts have usually been considered only from the point of view of their design and color, just as they are now represented in the Index drawings. In addition, however, to this approach, a study is being made of the actual materials used in the quilts, appliqué or patchwork, which often are of great variety. Family documents are consulted and patterns and dyes help in the authentication. A set of early manufacturers' swatchbooks containing dye formulae has been brought to light, which should aid, in conjunction with an intensive study of materials and patterns, in identifying American-made textiles.

As for costumes, in addition to the regular drawings for publication, scale drawings of patterns of models typical of each period are being made. An experienced pattern-maker cuts a full-sized pattern in muslin, sews it up and puts it on a form for comparison with the original. When this full-sized pattern is perfected, it is taken apart and careful

NEW YORK STATE

Locations of Glass Factories

1. BERNARDS BAY, OSWEGO CO. 1852-19th Cen.
2. BINGHAMTON, BROOME CO. 1880-?
3. BRISTOL, ULSTER CO. c.1810-?
4. BUFFALO, ERIE CO. Late 19th Cen.
5. CLEVELAND, OSWEGO CO. 1840-1899
6. CLYDE, WAYNE CO. 1820-1880
7. CORNING, STEUBEN CO. 1868-Present
8. DUNBARTON, ONEIDA CO. 1802- 19th Cen.
9. DURHAMVILLE, ONEIDA CO. 1845- 19th Cen.
10. ELLENVILLE, ULSTER CO. 1836 19th Cen.
11. GENEVA, ONTARIO CO. 1810 Late 1850.
12. GREENPOINT, KINGS CO. 1860- c.1867
13. GUILDERLAND T'SHIP, ALBANY CO. 1785-1815
14. HARRISBURG, JEFFERSON CO. 1841-c.1843

15. LANCASTER, ERIE CO. 1849-1907
16. LOCKPORT, NIAGARA CO. 1840 19th Cen.
17. MT. MORRIS, LIVINGSTON CO. 1841-1848
18. NEWBURGH, ORANGE CO. Mid. 19th Cen.
19. NEW LEBANON, COLUMBIA CO. 1873-1876
20. NEW WINDSOR, ORANGE CO. 1753-1785
21. NEW YORK CITY, N.Y. CO. 1698 19th Cen.
22. PETERBORO, MADISON CO. 1804-1830
23. REDFORD, CLINTON CO. 1831-c.1852
24. REDWOOD, JEFFERSON CO. 1833-1860
25. SANDLAKE T'SHIP, RENSSELAER CO. 1806-1853
26. SARATOGA, SARATOGA CO. 1844-1890
27. UTICA, ONEIDA CO. c.1809-1822
28. VERNON, ONEIDA CO. c.1809-1843

(?) Ewing. *Map of New York State Showing Locations of Glass Factories.* Watercolor, New York Project. (Index of American Design, National Gallery of Art, Washington, D.C.)

drawings to a smaller scale are made. Such a pattern is not only of real value as a record but has its practical uses.

In silver, the New York Unit is concentrating, so far as possible, on the work of New York silversmiths, about whom comparatively little has been published. A chart of forms and ornaments of early silver has been made, and a series of New York spoons, showing changes in shape and decoration during the period circa 1700 to 1825, has been made. A study is under way of silver medals made by early silversmiths for presentation as tokens of amity by colonial officials to Indian chiefs.

A special study of stoneware, hitherto but slightly touched in the literature of American ceramics, is a major activity of the division of ceramics. A map has been made showing the location of early glass and ceramic manufacture in New York State.

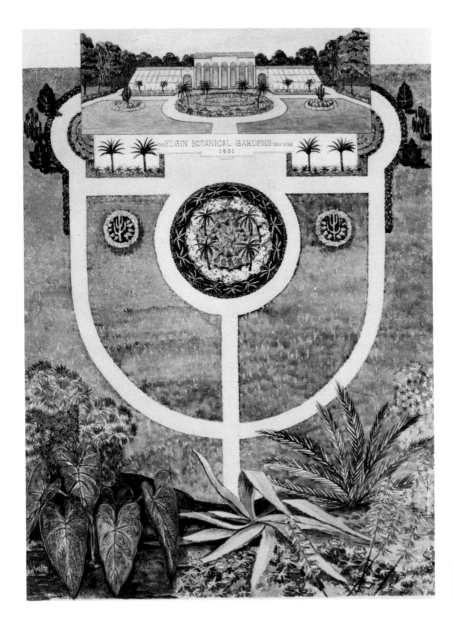

T. Hosier. *Elgin Botanical Gardens*. Watercolor, New York Project, 1936. (Index of American Design, National Gallery of Art, Washington, D.C.)

Since every rendering is accompanied by a data sheet, giving as full a history as possible of the pieces represented, general research has been found necessary to put certain information at the service of the staff. This includes a complete annotated bibliography of books and articles on American decorative art. No such general bibliography is at present elsewhere available. A list of New York craftsmen has also been compiled, as reference for names and dates. This list shows, in every field, more craftsmen than are published in similar lists appearing in the literature. A glossary of furniture terms, with special emphasis on terms used in America, and a dictionary of costume, beginning with the seventeenth century, are other activities of the research group of the New York Unit.

A small group of workers is searching through early newspaper files for information on craftsmen, for fashion notes, and for general items concerning the decorative arts, to be placed at the disposal of our workers.

These specific points may give an idea of the freedom of approach to the usually cut-and-dried matter of research. Unexpected items, often amusing as well as informative, which are turned up, help to round out the picture of social life in this region.

The Shaker Arts and Crafts

GORDON M. SMITH

The search for a native American tradition in the arts and crafts is fraught with pitfalls. On the verge of labeling an object definitely American and of definitely American inspiration, we go deeper into its background and discover it to be merely an outgrowth of some earlier European form, changed, it is true, by adaptations to the American idiom, by different materials, by different needs, by a different state of mind. This is illustrated vividly by the art productions of New England, so closely linked throughout much of their history with those of old England.

As long as the ships traveled between Europe ports and America, bringing materials, patterns, books, even craftsmen, we were constantly in contact with the more sophisticated art of Europe, and although we did not always slavishly imitate, we were rarely entirely free from its influence. Consequently, when the Index of American Design was first established to make and preserve a record of our native arts and crafts, it was essential to choose among its first endeavors an art which we could call our own without reservations. The Shakers were chosen because they came closest to this ideal. They represent in their art and in their lives a good many of the qualities which we have come to associate with our definition of Americanism — simplicity, economy, reliability, durability, solid good sense, and, finally, complete freedom from frills.

Quite as important for the purposes of the Index was the fact that the very unity and single-mindedness of the entire artistic expression of the Shakers made it possible to study their art as an entity. Few if any of the standard reference works on American decorative arts have considered the Shakers seriously, either because they do not fit into the chosen scheme, or because they were considered a quaint and folksy offshoot of an art capable of producing Philadelphia Chippendale furniture or the Federal mansions of Salem.

The recent interest in modern architecture and in functionalism, in plain surfaces and in simplicity, has given the study of the Shaker arts an impetus, and those who once considered it beneath their notice are beginning to claim it proudly as one of their most, if not their most, individual native art traditions.

That very interest in so-called primitive art, the growing desire to have an art tradition to call their own, the gradual turning away from Europe as the source of everything of artistic value, makes the Index study of the Shakers especially timely and

especially important. Perhaps the most immediate reason for choosing the Shakers is the fact that Shaker colonies are gradually disappearing; they have dwindled to five from the original eighteen, and only a small part of their work remains.

The Shaker Society, or United Society of Believers in Christ's Second Appearing, was established in this country by Mother Ann Lee and eight followers, who came to this country from Manchester, England, in 1774. Mother Ann's oft-quoted "Hearts to God and Hands to Work" perhaps expresses best the purposes and ideals of the Shakers. Not only their hearts but their property were consecrated to God. They lived apart in isolated communities, separated themselves from the world with its evil vanity, and pursued their agricultural and industrial pursuits methodically and efficiently.

There is practically no phase of the Shakers' philosophy that is not illustrated vividly by the products of their hands. One would scarcely need the books or Shaker manifestos in order to discern their ideals and principles, for these are preserved in the architecture, the minor arts, the inventions.

When one comes upon a typical Shaker village, one cannot help but be impressed by the system of planning, the orderliness, the neatness and efficiency of the whole, and still more by the air of calm distinction and dignity. The buildings are simple,

Orville A. Carroll. *Shakertown Bonnet.*
Watercolor, Kentucky Project, 1938. (Index of
American Design, National Gallery of Art,
Washington, D.C.)

INDEX OF AMERICAN DESIGN 175

without useless ornamentation, excellently proportioned, and adapted for a purpose.

The meetinghouse at New Lebanon, New York, built in 1824, with its unusual elliptical barrel-vaulted roof and separate hooded doorways for brethren, sisters, and Ministry, is one of the most beautiful surviving examples of Shaker architecture.

Another distinguished Shaker building is the round barn at Hancock, Massachusetts, with its severe simplicity, its fine proportions, graceful, sweeping lines, and ingenious construction.

The Index has recorded a number of the extant examples of Shaker buildings in interior and exterior views, as well as detailed studies of interesting architectural features. These should provide a definite and worthwhile contribution to the study of American architecture.

Interiors are even more simple than exteriors: the walls are plain, of whitewashed plaster or painted in the famous Shaker blue. Built for utility, but providing a pleasing accent and tying the room together in an indestructible unity, are the familiar pegboards found in every Shaker room. Built-in drawers and cupboards are another important feature of the interiors. Solely utilitarian in purpose, they lend accents to the rooms and break up the expanses of plain wall surface. There are drawers and cupboards by the hundred, lining entire walls of storerooms, and indicating that there was a place for everything, and that neatness and order were preeminent.

Furniture was entirely in keeping with the interiors; one can scarcely imagine a Shaker room without Shaker furniture or vice versa. The same ideals of simplicity and utility persist. Furniture was constructed for strength and durability. An object was made to serve a purpose, a chair to sit on, so why elaborate graceful curving legs or backs in the shapes of lyres or anything of the sort? They were very practical about it all, and because utility and simplicity were their chief concerns, they succeeded admirably in creating something aesthetically significant.

The Index of American Design has recorded in watercolor plates practically every type of Shaker furniture that survives today. A study of these indicates the many types, the pieces adapted to every need, the ingenious devices employed. Most important and certainly the most familiar to the layman are the Shaker chairs, which were sold widely outside the colonies. Some of these were equipped with an unusual ball and socket device at the termination of the rear posts whereby it was possible to tilt the chair without slipping. Seats were covered with multicolored textiles woven by the sisters.

The Index has recorded a number of the many varieties of tables—the long trestle type for dining; those used for ironing and sewing; the tailoress's counter, used for cutting, piecing, and sewing of garments; the drafting table with slanting top; the numerous drop-leaf tables. There are the chests of drawers, often with cupboards above, with never a deviation from the straight front and knobs of the simplest type.

Textiles also have been studied by the Index, these reproduced with the most meticulous accuracy to show clearly colors, materials, and weaves. For the cloth, flax and wool were raised in the communities, cotton imported from the South. The sisters spun the yarn, dyed it, and wove and tailored the cloth for their own garments, for rugs, for the tapes and braids used in chair seats, for blankets, and for tow or garden sheets for the gathering of herbs, for chair mats, spreads, and toweling.

The Index has recorded characteristic costumes and costume accessories, the kerchiefs, caps and bonnets, aprons, cloaks, and capes of the sisters, the fur and wool hats, the stocks, dress and everyday suits, and the knitted mittens of the brethren, thus forming a rather complete picture of Shaker dress.

Although the Index has quite naturally not been able to record every invention and every tool in use in the Shaker colonies, photographs have been taken of outstanding examples. They lead to the conclusion that in this branch of their work as in every other their hands and hearts were in it, and their minds were working overtime to make as perfect as possible their small civilization.

Public-health posters. Silkscreen, New York City
Project, c. 1938. (AAA)

Posters

RICHARD FLOETHE

When in 1935 the Government, through its WPA/FAP, formed Poster Divisions to employ jobless commercial artists, the Government unwittingly launched a movement to improve the commercial poster and raise it to a true art form.

Poster designing has for years been considered by artists and the public an occupation for the inferior and commercial-minded designer. This attitude is based on the traditional misconception concerning the function of the artist in his relation to the public, according to which many artists considered it below their dignity to accept orders used for mercenary purposes.

The development of the poster as we know it is comparatively new. The poster is the direct result of our steadily increasing industrialization. It has become an important factor in sales promotion, ceasing to be a mere announcement. Its potentiality as a silent salesman has been recognized and utilized.

The poster at the turn of the last century was a rather simple affair. To illustrate the printed message, an artist was asked to draw or paint a subject outlined to him—a letterer would design the copy, and the whole was put together, printed, and displayed.

In principle the average poster has changed but little, except in the use of better and faster printing methods. So-called successful posters are still copied in style and wording by competitors who hopefully anticipate the same result. Design and idea patterns have been developed which are considered the recipe for successful advertisement. Artists who had seen in posters the great possibility for an artistic form and were eager to try their skill were forced to capitulate before the conservatism and ignorance of the advertising experts.

The advertisers are not entirely to blame in their reluctance to work in close collaboration with the designer. The commercial artist himself, for too long, has been perfectly satisfied with the part he has played as long as the remuneration was adequate. He has been content to disregard artistic integrity as long as his customer was satisfied.

Of recent years poster designing has become a profession. This is due to the combination of the new literature on modern poster designing, samples from abroad, and chiefly through the modern art schools. A student may now avail himself of specialized training in design. He is being taught the fundamental knowledge of design, lettering, the use of color, and the manifold possibilities and limitations of the various printing methods. He is being taught how to artistically collaborate with the advertiser.

The drawback now confronting the artist is the general lack of understanding of his new approach. Decline in employment makes it still harder to secure positions. The Project has absorbed many young artists of background from the relief roll in its poster divisions. These artists have found, to their delight, that not only are they allowed to design posters as they have been taught, and feel posters should look, but are also encouraged to experiment.

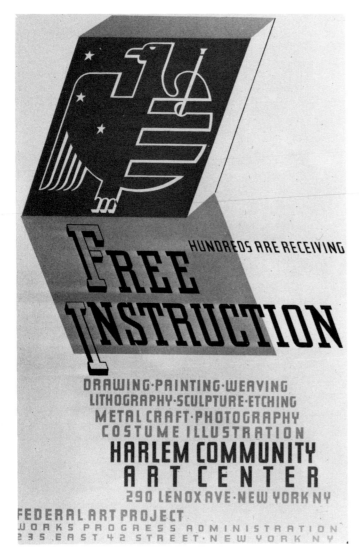

Typical WPA/FAP silkscreen poster. New York
City Project, c. 1938. (AAA)

The result is astounding. Private industry, which had looked skeptically at our new concept, took notice—visited our shops and even asked technical advice on silk screen process—a process which most of the Project's Poster Divisions used as a reproduction method. The press visited our exhibition and gave us recognition and encouragement. Among other publications, *Signs of the Times*, a trade paper, in its issue of April 1938 features an article by Sydney Kellner about the New York City Poster Division. Mr. Kellner (formerly with the Detroit Institute of Art) wrote, and I quote in part:

Sheer numerical production may sound impressive, as it surely does in this case, but if it were not for the amazing design quality invested in these posters, which has raised them to the status of a true art form, there might be no particular interest in them. The professional scorn, entertained generally by the "fine" artist for the work of his brother, the "commercial" artist, seems to have been swept away completely by the constant barrage of good posters turned out by the WPA Federal Art Project. . . . Proof of the esteem accorded these posters lies in the enthusiastic comments of professional artists, the press and the general public. . . . The community value of these posters is inestimable, and the standard of taste, to say nothing of the requirements in poster design and printing, have been praised by both public and artist.

The New York City Poster Division up to this date has printed nearly six hundred thousand posters for Federal, State, and Municipal departments to the satisfaction of their clients. Schools have used our posters for teaching purposes in their art courses. Libraries and even museums have secured samples of our designs.

The aim of the WPA/FAP to preserve the skill of the unemployed artist not only accomplishes its purpose, but those returning to private industry do so with more knowledge in their profession and greater confidence in themselves.

The Poster in Chicago

RALPH GRAHAM

The Poster Division in Chicago began slowly in the early stages of the WPA/FAP by turning out handmade charts and posters, each man doing his specific assignment, such as tracing or filling in a certain area with a certain color. This was like an assembly line in a factory and not very conducive to latent creative impulse.

Later a silk screen department was set up and made available to the poster designers to reproduce their work in quantity. Of necessity, the designs used at this time were composed of the simplest basic elements to permit of reasonably accurate reproductions by little-trained or unskilled workers.

Slowly but surely the designers became more confident, and this confidence was reflected in their work. Importance of design was and continues to be stressed, for without this element a poster fails in its purpose—which is to startle the passerby into looking at it, and, having looked, into retaining its message.

As a whole, the European poster artist has run the gamut of changing styles and techniques, but has clung, more or less, to this fundamental tenet, whereas in America the poster's development has been retarded somewhat because the artist has overlooked this important factor and become interested in magnification of detail. This may be due to the fact that in many advertising campaigns the posters are merely enlargements from the magazine page, or it may be due to the fact of the advertiser's insistence upon the use, subjectively, in the poster of a rosy-cheeked maiden with a paralyzed smile inviting the spectator to invest in his product, no matter whether it is trucks or toothpaste.

Both American and European printers have progressed remarkably and in most cases reproduce the original poster faithfully. Although zinc plates, halftones and rubber plates are used, perhaps the majority of posters here and abroad are reproduced by offset lithography. Transparent inks are used to simulate the opaque tones of an original poster.

Lithography enables the printing of subtle tones

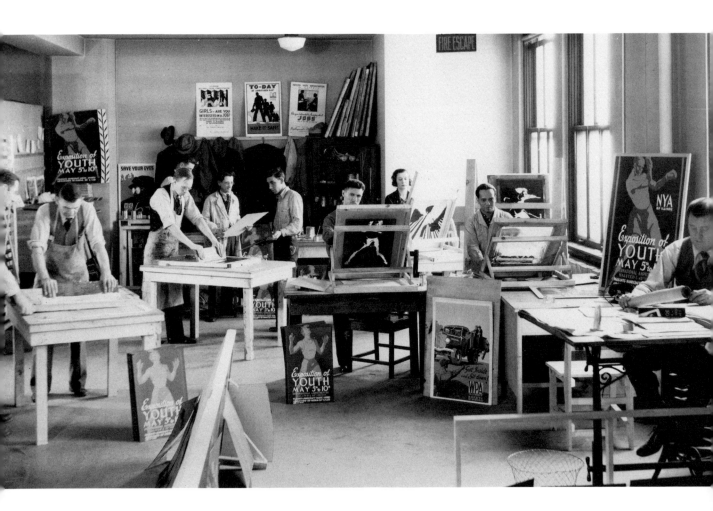

Poster workshop. Chicago, Illinois Project. (NCFA:Cahill)

and blends of color such as may be achieved through the use of an airbrush. This may be a virtue in some phases of printing, but when used in poster printing, it reduces the strength and starkness of the poster. In any case, these attributes should not be sacrificed, as has been pointed out, at the expense of simplicity, just for the sake of a lovely tone or a subtle nuance of color.

In silk screen printing, oil paints are used, and while we can cut them to a transparency, in almost all instances we retain their body so that they dry

with a complete opacity and a mat finish that is identical in character to the tempera color used in painting the poster. Screens are blocked directly from the poster, and in some cases the artist does this work himself so that very little is lost in the transfer. Thus it can be seen that the simple silk screen printing method has its advantages over the less direct and much more expensive and elaborate processes of other systems.

The fact that there are physical limitations in silk screen reproduction is a boon to the poster artist, because these limitations impose the necessary primary rules required in designing a poster. Our artists realized this and used it to their distinct advantage. As a result the posters done here are comparable to any, as regards technique, either in America or in Europe and are superior in design to the majority of commercial posters of either, thanks to our roster of artists.

Public institutions and agencies in Chicago and Illinois realized the benefits to be derived from the Project and took advantage of the opportunity to avail themselves of posters at such low cost. The types of sponsors we have served and hope to continue to serve are the City, State, and Federal Health Departments, U.S. Post Office Department, small-town post offices, Chicago Park District, State Parks, Department of Conservation, Department of the Interior, Department of Labor, Department of Agriculture, Chicago Zoological Park, Libraries, Art Institute, Community Art Centers, Settlement Houses, Schools, Civic Groups, National Youth Administration, and various agencies within the WPA.

While quantity production should never be achieved at the expense of quality, which it has not in our case, it is interesting to look at our accomplishments in terms of figures. During the twelve months of 1936, our production was slightly over 50,000 posters and book covers; in 1937 we showed an increase of 48 per cent over the previous year. The 1938 total was an increase of 111 per cent over 1937 and 159 per cent over 1936. The figures of last year, 1939, reveal that we had an increase of 19 per cent over 1938 and 178 per cent over 1936, and this in spite of the fact that we had a reduction in personnel in 1939.

In the four years since 1936, we have printed a total of 601,783 pieces, or an average of 611 finished posters per working day. When it is remembered that from three to eight colors are used on a poster, these figures become more significant.

Also more significant, and very gratifying, is the fact that this tremendous growth points to one conclusion, and that is the public need of and demand for the work of the artist as an integral part of the community. The artist has occupied a place aside, not from his own volition entirely, but because he was thought to be a little different from the throng. Through the efforts of the WPA/FAP the artist and the public have come to know each other and to realize the definite need of each for the other.

The poster has been responsible in large part for this phase of common understanding, because it has reached so many people. It would be impossible to estimate the exact number, but when one considers the fields covered it would undoubtedly run into the millions. The motor coaches carry our posters on the front and sides at least six months of the year; the "L," interurbans, railroads and stations, art museums throughout the country, grade schools, high schools, libraries, settlement houses, community centers, and traveling exhibits all display our posters from time to time. The various neighborhoods of the city are reached by means of the local merchant, who donates space in his window to show our posters.

The poster, serving the public, is readily understandable to the man on the street. While it may go through phases in its healthy growth, it is free from the many isms that infest the allied arts. The public is benefited by being informed through the medium of the poster of means to help itself materially and culturally, means to enjoy itself, and means to improve itself. The poster performs the same service as the newspaper, the radio, and the movies, and is as powerful an organ of information, at the same time providing an enjoyable visual experience.

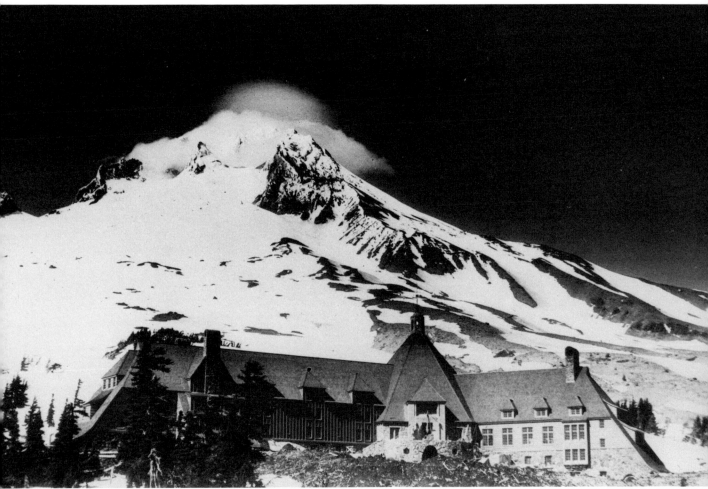

Timberline Lodge at Mount Hood, Oregon. (NA)

The Builders of Timberline Lodge

FEDERAL WRITERS' PROJECT

In Mount Hood Timberline Lodge the mystic strength that lives in the hills has been captured in wood and stone, and in the hands of laborer and craftsman, has been presented as man's effort at approximating an ideal in which society, through concern for the individual, surpasses the standard it has unconsciously set for itself.

This recreational project, the construction of which involved a larger variety of labor than any other in Oregon, cannot be matched in any other state. All classes, from the most elementary hand labor, through the various degrees of skill to the technically trained were employed. Pick and shovel wielders, stone-cutters, plumbers, carpenters, steam-fitters, painters, wood-carvers, cabinet-makers, metal workers, leather-toolers, seamstresses, weavers, architects, authors, artists, actors, musicians, and landscape planners, each contributed to the project, and each, in his way, was conscious of the ideal toward which all bent their energies. Debating the

possibility of environmental influence in this case would serve no purpose. It must be recognized that there was an element, a quality, a purposeful something, evident in all the work centered in Mount Hood Timberline Lodge.

Commonplace knowledge recognizes that the unskilled, the unfortunate, and the unadjusted must take their places in the lowest bracket of labor, making their muscles serve as the medium for earning bread. Among these it is not usual to discover a full appreciation of the sound significance of their endeavor. Even a partial understanding was considered so remarkable that one of the Portland newspapers commented editorially:

Recently cars seeking to ascend a new road to the 6000-foot elevation on the south slope of Mount Hood encountered trucks being loaded with heavy stones. Politely, one of the men explained why the way was not instantly cleared for official visitors.

"We are," he said, "working every daylight hour, even Sundays, to get rock in place as abutments against winter for the new Timberline hotel."

It was an enthusiasm not commonly credited to the Works Progress Administration. Yet, Timberline Lodge is a WPA project, to be administered, upon completion, directly by the United States Forest Service. And the progress on the lodge also demonstrates a construction energy fit to silence critics.

The man who "politely" explained the work was one of several hundred who spent the spring and summer of 1936 toiling on the heights, often under conditions which would ordinarily have prohibited all outdoor activity. Wind of blizzard proportions buffeted them in early spring, and twice their sturdy camp was battered by shot-snow, which, after its assault, rolled down the slope and settled to rest, completely filling the newly cleared road.

Melting snows and rain at times made the earth a sticky, resistant mass. Still the steam shovel and the bulldozer, trailed by the willing pick and shovel crew, pushed on.

"But with every discouragement the construction army has gone back to work with more energy than before," the *Oregon Journal* declared in reporting these incidents. The reason for this enthusiasm might have been found in the fact that many of the men who were employed were those who, a few months previously, opened listless and discouraged eyes each morning, to confront a cheerless and foodless day. Repeatedly the men showed a devotion to their job and a consideration of their fellow workers that transfigured them; but the actors themselves in these little dramas on a stormswept mountainside accepted such deeds of heroism as all in the day's work. As an example, in January of 1937, a sudden and violent blizzard hit Mount Hood. The landscape was blotted out in a driving snow with the wind blowing over 70 miles per hour and the temperature subzero. A gang of workers was caught on the road below the Lodge. Ice caked on their faces, and it was only by holding on to a rope and with the greatest difficulty that they found their way up to the Lodge. Then it was discovered that two of their number were missing. The foreman, himself half frozen, went back in search of them. He found one man nearly buried in drifts and, lifting him to his shoulder, carried him up the steep slope. Then he returned and assisted the second man to safety.

When the building of Timberline Lodge started, workmen were sent from Portland and other localities at some distance from the site of the work. To care for this large number of men, it was necessary to create a camp where they could be housed and fed, since no existing accommodation near the site of the work could be found. Walled and floored tents, a kitchen, mess hall, and quartermaster's store were erected, and showers with an ample supply of hot and cold water provided, as well as a complete infirmary with a male nurse in charge.

In return for physical security supplied by a powerful social agency they gave the best that was in them, cheerfully, with an eye to the finished project, realizing in the satisfaction of their work, though all unconsciously, that they were a part of something bigger than themselves.

Natural developments occur unobtrusively. They do not proclaim their awareness by obvious steps. Similarly, true advancement through the exercise of manual skill is a gradual process, one in which the laborer may scarcely recognize his increasing dexterity. At first he may be capable only of shifting stones from one place to another. Then he learns to shape them, to lay them in position, eventually to build a wall.

A striking example of this progression was found among the stone workers. At first the foreman selected each stone and personally directed its placing. The workmen began to be interested in selecting the colored stones, then to regard their placement with a practiced eye. They became careful of arrangement, critical of the color and texture of the rock, then conscious of their own development as craftsmen; some of them, comparing

their late with their earlier work, wanted to do it over again. Fully as important a consideration was the fact that the stonework they were doing was something new in masonry, and, incidentally, something originated and being perfected in the Cascade area.

Each workman on Timberline Lodge gained proficiency in manual arts. He was a better workman, a better citizen, progressing by infinitely slow steps to the degree above him. Perhaps he never reached it. Yet the unconscious but concerted effort of several hundred men to advance meant something, even if they failed. Its social values could not be estimated in monetary return for toil, nor man-hours of labor completed.

Very definitely, among those who could be classed as helpers to skilled workmen, there was an inspiring increase in aptitude. Whether or not this was a purposeful development, or was the facility acquired by repetition, the helpers pressed closer and closer to the borderline of skill. Someday a confidence and capacity earned in working on Timberline Lodge may erase the line of demarcation between them and the journeymen of their guild, and they may become their masters' peers.

A blacksmith, accustomed to working at the forge, but with no knowledge of the technique and artistry required in making ornamental wrought iron, enrolled at the foundry on Boise street where the hardware and decorative iron for Timberline Lodge were made. Encouraged by the foreman over a period of months, this blacksmith developed into an accomplished worker. He discovered in himself an artistic inclination he had not known he possessed. Then he was entrusted with carrying out the design prepared for the dining room grille gates at the Lodge, painstaking and intricate work, for which he forged every piece.

Another matter of interest as relating to the unskilled workmen at Timberline Lodge was the fact that its construction provided a suitable outlet for many whose intelligence quotient restricted them to the lower order of manual work. Yet even among these were found examples which heartened social

workers. An illiterate Italian, whose family had been a problem to Multnomah County, for the first time in years earned enough to support his children.

Among these naturals, however, was found an affinity for the earth and a deep respect for the awe-ful qualities of the glacier-flanked peak. They were as quick to pay homage to the spirit of the mountain as the highly sensitized and cultured oriental visitors who ascended to the timberline, and according to an editorial appearing in the *Hood River News*:

. . . kneeling in the forest duff—joined in prayer. Above them towered—our own Mount Hood—and from the solitude of their niche in the forest, broken only by the occasional roar of an avalanche, the three devout men had a magnificent prospect of the great white sentinel and the heavens above and beyond. "Almost unconsciously," declared the writer, "our own battered felt hat came off, and we stopped in our tracks to listen to the appeals of these three to O-Kami-sama to make them better men and worthy to live in a world in which there is so much beauty for those who are willing to see. . . .

The necessity for revealing this beauty was evident in the beginning to those who planned the lodge and its decoration. That the finished building and the whole recreational project expresses natural beauty and provides accommodation for all the arts, including music and the theatre, is not an accident. Qualified research writers assembled a bibliography of pictorial material associated with the Mount Hood region. An outline, based on this material, was prepared for the use of architects and artists planning the lodge, and the bibliographies themselves were made available to them. Later the writers served in an entirely different manner, publicizing the project by writing booklets descriptive of it for public distribution.

Steam-fitters, carpenters, painters, wood carvers, and cabinet workers, identified with the skilled trades, many of whom were forced out of their craft through no responsibility of their own, discovered

that government accepted this responsibility, and in accepting it was willing to prepare a place for them in the construction of Timberline Lodge.

Mechanized production with its emphasis on speed, which characterizes present-day industry, places a serious handicap on age. The middle-aged and elderly men, though masters of their crafts and skilled in proportion to their years of practice, find their muscles unequal to the tempo required. They lag behind. They are dismissed.

Rather than rewarding them for wisdom gained in years of work, our industrial scheme has penalized them. They have been left with but one asset—skill, and skill appears to be a drug on a mechanized market. Timberline Lodge, with its opportunity for the revival of dormant crafts and arts, offered employment to many men in this classifiication, and in their successful absorption suggested the possibility of a permanent program designed to perpetuate handicrafts and to make them serve a social need.

A seventy-six-year-old wood-carver found that age and speed had outmoded him. He had even found it necessary to close the little shop where for years he had carried on his chosen art. When he applied for work he was enrolled on the Timberline Lodge project and assigned to carving the arched panels to be placed over the doors. Curiously enough, there worked beside him, in happy coordination, a man whom he formerly employed.

Like others in the shop they found a use for trained hands. Mallets drove chisels into clean-grained wood. Chips flew and the Thunderbird emerged from the pine, perpetuating not only the memory of a forgotten race, but the skill of earnest workers. This skill, which they had come to regard as almost worthless, was presented to them again as something valuable, something to be cherished and redeemed. They found it of dual concern: it was made to contribute to fulfillment of the social need for a recreational center, and in this fulfillment objectified the necessity for preserving the products of an active brain and a skillful hand. Old values these, and almost forgotten in the quickening tempo of the ma-

chine age. Old values, dear to the intimate soul of man, which respects the human body and the honest toil it may be made to perform.

For a sum total of what Timberline Lodge signified to laborer and craftsman, add the possibility that in their subsequent industrial and economic adjustment, they will find two paths open to them—the pursuit of their own trades as hired workmen, or the opening of their own shops.

The workmen already discussed were all those who made the roads, constructed the building, prepared the Lodge itself for the highly skilled artisans, artists, and technicians who ornamented and furnished it and made it completely habitable.

Following the dictates of a pattern, they fashioned native timber and stone into an object, which, even in an unfinished state, revealed the spirit of the commonwealth. Their contribution, primitive as it appeared, nevertheless made evident to the dullest observer the beauty and utility of Ponderosa pine from Eastern Oregon, Port Orford cedar from the southwest coast, and stone, both from the Cascades and the Santiam valley.

The crudity of evolving form, symbolic perhaps of the changing social order in which this recreational project has had a part, is evident not only in the exterior of Mount Hood Timberline Lodge, with its projecting and rudely carved beams, its sturdy basaltic foundation, and its stalwart battens and shakes, but may be found in all the interior details. The only permanency, change, is exemplified in stone and wood. Cruel or beautiful, nature is shown in exquisite expressions of a universal power.

This sense of power, experienced by every person who visits the Mount Hood recreational area, is the keynote of all construction and decoration. It is a realization of belonging to a vast freedom, of being fleetingly identified with natural force, with gigantic invisible form which is constantly varying in its manifestations.

Skiers know it well and express it, not in words or in design, but by sweeping curves describe- in mid-air, in swift patterns on precipitous snow. Horsemen

glimpse it in rough-barked trees along the bridle paths, in chiseled rock-patterns on glacial moraine. Climbers recognize its nameless kinship in the challenge of the peak, in the sharp splintering of ice, in cruel shard and unyielding basalt.

Ornamentation and furnishing have contributed to a purposeful attempt at stimulating within the visitor the fleeting and inspired sense of belonging to all that is Western—to the mountains serrated with hemlock and pine, to the valleys fragrant with apples and roses, to the restless and urgent sea, to the calm and ribbon-colored uplands.

Consequently, decoration is characterized by strength rather than by grace. It is identified by masses and substance and permits no confusing superfluity of line and color. A new and indigenous style was developed, a style that is more than a product of the forces that made Mount Hood and the American ranges. It is the mountains themselves, this new Cascadian art. Artists have found their best expressions, not in the perfection of polished woods, but in the hewn strength and swift chiseling of natural figures. In murals, painters depicted the exaggerated comedy of the fisherman's lie, the bravado of the woodsman, and the paradox of the hunter washing grease-mottled dishes. Though amusing in theme, their spirit was drawn from the strength of the hills, a source that artists and craftsmen alike tapped and diverted to social and individual advancement.

Of special significance in this unique development was the fact that working singly and in isolation, none of the artists who were employed appeared capable of approximating this particular style. They could not discern the true Western spirit, could not alone discard the old technique, the old and hardy forms. Brought together under WPA with intelligent direction, they worked out in combination something bigger than any of them individually. Each, in acquiring a new skill, a new ideal, and a new technique, opened the way for subsequent individual participation in an American renaissance.

Special reference to various art forms will illustrate the social and personal implications of participation

Detail of timber construction at Timberline Lodge, Oregon. (NA)

in the construction of Mount Hood Timberline Lodge.

A young man was employed on the Timberline Lodge project to carve the newel posts on the massive stairway. Each post represents a bird or animal characteristic of the Mount Hood region. To be in keeping with the rough-hewn logs of the balustrades and the iron-bound steps, the designs required sturdiness and swift modeling. Convention-bound by the technique he had learned under a different social order, the wood carver struggled with his old tools, his old methods. In despair he sought help from the source of his material. He learned the relation of the wood to the mountain upon which it grew, discovered the adventure and romance of Mount Hood's past, and found at last a technique suitable for expressing the spirit of the place.

It was a new technique, bold in line and mass, and requiring specially made tools for its execution.

These tools, made according to specifications, were forged at the WPA shop.

A painter whose hobby is photography made a pictorial record of construction during his employment on the project. He had over 200 pictures to tell of his participation in building the recreational center. His real story, however, could best be told by officials of the United States Forest Service, who were so pleased with the specially mixed paint which he originated for the Lodge, that they made the formula standard, not only for the northwest, but for the mid-mountain region as well. This paint, which simulates frost, is remarkable not only for its realism, but for its economy of cost.

The wood-carver's tools and the painter's formula were minor developments, yet each is indicative of Timberline Lodge's contribution to American progress in the arts.

What these men will be able to do with their new knowledge, their precious spark of originality, is a matter for conjecture. It is certain, however, that they have gained in skill, in confidence, in value to society. The personal advantages will depend upon their adaptability in a competitive world.

For years Mount Hood has furnished definite values to hundreds and thousands through offering them a release from daily monotony. Energy stored or left over from other tasks has here found a constructive outlet, one that develops the individual physically, and, by association with grandeur and beauty, gives him a spiritual relevance to universal ideals, which often he does not recognize, and could not name.

The cabinetmakers who were employed on the project to execute the furniture designs prepared by the artists profited not only by cumulative skill acquired by practice, but by fashioning new models from materials frequently despised because they were commonplace.

This disrespect for the ordinary has long eaten at the core of all American arts and, reflected in home decoration and domestic values, has, with alarmingly increasing pressure, set a false standard in American life. Radio, newspaper, and magazine advertising blare the advantages of the bizarre, the fantastic, the expensive, until the person of ordinary intelligence finds himself so bewildered he accepts what is thrust at him as valid.

Machine-made furnishings of doubtful taste and artificially boosted price are coveted and yearned over by many a housewife, who, had she the vision to see it, has had in her hands the power to possess beautiful things. In these blind ones, who were employed on Timberline Lodge as seamstresses and weavers, the project found its most far-reaching social opportunity.

Obviously no patterns could be employed for curtains, draperies, counterpanes, and the like which are used in the lodge, except those which conform to simplicity and forthrightness. Colors had to be those discovered in earth, in stone, in glaciers, in tree, and sky. Materials had to be sturdy, enduring, devoted to the irregularity and diversity found in individual patterning rather than in the similitude of perfection found in machine-made goods.

Accordingly, hand weaving, employing Oregon flax and Oregon wool as warp and woof, and appliqué, an art distinguished by its capacity for utilizing scraps of material, were chosen as the media employed by seamstresses.

In this instance the value of the work as a means of focusing attention on a common interest and an ideal was far overshadowed by the personal training in the simplicity of good taste. The women employed as weavers may be presumed to have become sufficiently interested in the craft to carry home a memory of the pattern and the flax and wool used in looming it. It is but a step to the building of a simple loom and the fashioning of a similar design for house furnishing or decoration. Having seen how the homely materials work up into something surpassingly beautiful, a woman may not only become inspired to copy them for her own home, but may even search and find a commercial market for her work.

The use of native materials, flax and wool, is of

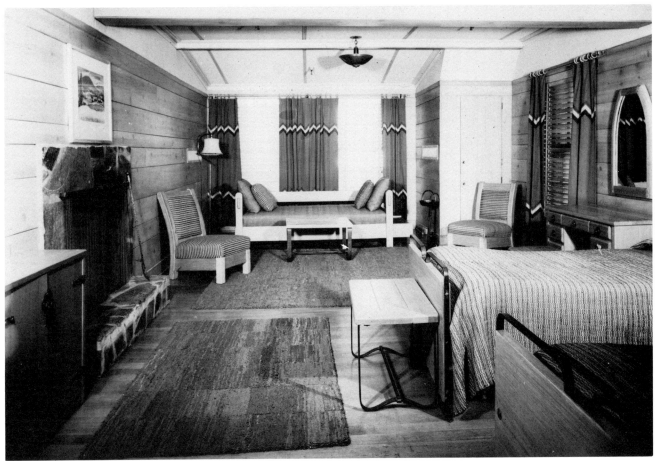

View of typical room in Timberline Lodge showing furniture and fabrics made by WPA artisans. (NCFA:Cahill)

particular interest in this respect, since anything that stimulates local consumption will be of marked influence on the production of these commodities.

The seamstress, whipping her needle in applying scraps of cloth in orderly progression, discovered that the pieces, which under ordinary conditions would be discarded as useless, here assumed importance to the design. It was a dull woman who could not carry over this thought to her own home. Like the man on the carving project who became so pleased with shop designs he spent his leisure reproducing one of them for his own house, the women carried away a respect for commonplace materials. They became interesting, then desirable for home decoration.

Its challenge may be the chiefest of all the values evoked by Timberline Lodge. Like the mountain upon which it is built, Timberline Lodge is symbolic of many things not seen in the timber and stone which make it. As the winding road leading to it represented progress by laborers, not the least of whose rewards was the daily inspiration of the enlarged and expanding view of mountain tops, so the building itself exemplifies a progressive social program which has revived dormant arts and pointed the way for their perpetuation. It presents concretely the evidence that men still aspire to the dream, often secret but always universal, of becoming greater than themselves through association with others in a common purpose.

The Materials of Art

RUTHERFORD J. GETTENS

In any treatment of the different phases of modern art some consideration must be given to the materials with which things of art are made. The production of paintings, drawings, and frescoes that are expected to endure for generations requires careful and intelligent selection of materials for supports, grounds, vehicles, and pigments. Especially in the construction of an oil painting where a wide variety of materials is used in some detailed knowledge of the properties, limitations, and possibilities of those materials required. It is as essential that the artist use materials of the highest quality for the making of a masterpiece in art as it is for the architect to use the best of materials in the construction of a really fine building.

The great paintings of the past are examples not only of skill in draftsmanship, modeling, and use of color but also of superb craftsmanship and technical knowledge of materials. This knowledge the artist learned during his long training as an apprentice under a master for whom he ground paints and prepared walls, panels, and canvases to receive the paint. He learned from actual handling and intimate association the properties, uses, and limitations of each component of that complicated physical structure, a painting.

Today the artist buys his materials ready-made over a store counter; his paints are put up in tubes and his canvas is already primed and stretched. As he squeezes his paint on his palette, he gives too little thought to its chemical composition. Our art schools, with few exceptions, do not give the artist a good grounding in the properties of materials used nor do they train him to be critical in purchasing. There are, even today, only limited opportunities for those who wish to acquire technical knowledge of materials.

When the WPA/FAP was first established in 1935, it set out to provide the artists it employed with the necessary materials. Purchasing was done by the state offices through the Procurement Division of the United States Government. The supervisors naturally wanted to supply the artists with first-grade materials, but purchasing agents knew very little about artists' materials and hence could not buy them critically. Confusion of trade names, lack of any kind of standard of quality, lack of uniformity in packaging, all made purchasing a most haphazard procedure. As already indicated, artists themselves were untaught in these matters and had no strong convictions about quality and sources of materials, or if they did their opinions differed widely. They would

frequently ask for paints having most fugitive and undesirable pigments. The difficulties of purchase were greatly increased when the state projects received orders to buy artists' supplies, on the basis of sealed bids, from the lowest bidder. The purchasing agent could no longer place his order with an established and reputable house. It was found that the materials supplied on low bids were cheap substitutes that masqueraded under names ordinarily used for better grade paints. This resulted in complaints from artists and grief for the purchasing agent.

The difficulty in buying artists' supplies of satisfactory quality under government procedure eventually led, in the spring of 1937, to the establishment in Boston of the Paint Testing and Research Laboratory of the Massachusetts WPA/FAP. The laboratory now occupies two large rooms, including library and office, and is equipped with a chemical balance, microscope and accessories, centrifuge, drying oven, metal lathe, apparatus for physical testing of paints, files for thousands of test specimens, exposure racks, humidity and temperature controlled room, and numerous other items. Some special equipment and several of the testing devices were designed and built in the laboratory. The personel now consists of a technical director, a technical adviser, supervisor, secretary, two chemists, twelve artist-technicians, and three skilled workers.

The activities of the laboratory, so far, have been confined chiefly to the testing of artists' oil paints. Samples of paints from both domestic and foreign sources were purchased on the open market. The methods of test applied to them may be divided into three general classes: physical, chemical, and microscopic. The physical tests determine those characteristics of paints which are of immediate interest to the painter, like consistency, tinting strength, and drying rate, and give some indication of that quality which is of such great interest to the patron of art, namely, permanency.

Some of these properties are determined during the process of painting out of specimens of the paint on small (three-by-five-inch) test panels which are kept for purposes of long-range testing, comparison, or even exhibition purposes. During painting out, estimates of such properties as consistency, brushing quality, evenness of grind, and behavior under the palette knife are recorded on suitable forms by the artist-technician. Certain tests, however, are made with special instruments. The *consistency* of a paste paint as it comes from the tube is gauged by applying a two-kilogram weight to a two-cubic-centimeter volume of the paint contained between two glass plates and observing how far from the center (as marked by concentric rings on the lower plate), the paint spreads after it stops flowing. *Tinting strength* is measured and compared by mixing a standard volume of the colored paint with a standard volume of zinc white oil paste. *Surface drying rate* is determined by means of a sanding device which allows sand to fall on the surface at an angle of forty-five degrees at regular intervals. *Body drying rate* is indicated by the imprint of a sharp-edged ring applied at intervals to a standard thickness of paint. Testing of drying rate is done in a temperature- and humidity-controlled room. The *light fastness* of pigments is estimated by exposing painted out specimens in glass-covered exposure racks on the roof. Film hardness, toughness, and elasticity are physical qualities which have a bearing on film durability, and estimation of them is worthwhile. Data on all these characteristics are recorded on standard forms in, so far as is possible, simple numerical terms.

Chemical examination is usually limited to the identification of pigments in the paint to see if they correspond to those indicated by the labels. A fair idea of pigment composition and quality can be gained from the color and character of the ash residue left on burning in a crucible a small sample of the paint. Many confirmatory tests for metallic and non-metallic constitutents may also be applied to the ash. Separation of pigment from vehicle by centrifugal methods is necessary when pigments that

would be destroyed by burning are to be examined, or if the vehicle itself is to be investigated. In special instances quantitative methods are applied to determine the proportion or percentage of a certain pigment or the proportion of pigment to vehicle, etc., but quantitative methods that are time-consuming and laborious must of necessity be avoided.

The microscope is very useful in examining paints. Many of the pigments have optical characteristics by which they are recognized as easily, if not more easily, than by straight chemical methods. Fillers, adulterants, and toners frequently show up quite clearly under the microscope. As a matter of routine a specimen of each paint taken for examination is kept permanently mounted on a microscope slide for ready reference.

A mass of very important data on modern artists' materials, particularly oil paints, has resulted from the work carried on by the laboratory for the past two years. The experience and knowledge gained by those who have had a part in it have convinced them that some sort of nationwide standardization of names, composition, quality, methods of packaging, and labeling of artists' paints would result in benefit not only to the consumer, but to the dealer and manufacturer as well.

The question that arose soon after laboratory work got under way was how all this accumulated information on artists' materials could be put to use and how best standards could be set up and put into effect. It was hoped that the results of the work would benefit not only artists on the Project but would eventually be made available to all artists in the country. After inquiry and investigation it was decided that standards for artists' paints could best be formulated and promulgated through the Division of Trade Standards of the National Bureau of Standards. That Bureau was already organized to do such work, and it had trained personnel with much experience in setting up standards for numerous industries. Commercial standards formulated by the Bureau of Standards are voluntary standards agreed upon by producer and consumer groups. They are

not arbitrary standards, like Federal specifications set up for the purchase of goods for the Army and Navy, but are mutual agreements among manufacturers to bring the standard of goods up to or above a certain level of quality.

A Tentative Commercial Standard (75-2649) governing artists' oil paints has already been prepared by the Paint Testing and Research Laboratory. In Boston, in April of 1939, a meeting was held which may be an important event in the history of American art. It was a meeting of several of the manufacturers of artists' materials in the United States to discuss and debate this proposed standard. Several members of the laboratory staff were invited to attend the meeting and to take part in the discussion. The proposed standard has yet to come up for final acceptance at a general meeting of manufacturers, dealers, and consumers of artists' materials to be held in the fall. It will go into effect only after it is accepted by manufacturers representing 65 per cent of the volume of U.S. business in the commodity under consideration.

In this standard, certain rigid requirements are set up, methods of test are provided, and terms are defined. The standard includes a list of terms to be used in designating artists' oil paints. This nomenclature is based mainly upon the chemical composition of the principal pigment the paint contains. Regulations governing the packaging, labeling, and certification of quality of oil paints are also included. The establishment of trade standards to cover other classes of artists' materials are planned. These classes will include watercolors, dry colors, oil vehicles, diluents, brushes, drawing papers, illustration boards, canvases, and many other items.

When these trade standards go into effect, they will immediately govern the purchase of all artists' materials by the WPA/FAP. The artists on the Project will eventually be supplied only with materials that bear certification of their conformity to a certain commercial standard. In this way a large number of artists throughout the United States will become well acquainted with the protection offered by purchas-

ing under this new system. It is hoped that they will pass the information along to the many thousands of children and adults whom they instruct. It is expected also that manufacturers and dealers will choose to certify that the goods they sell over the counter to the general public are made in accordance with the commercial standards. It is further hoped that artists all over the country will stimulate the establishment and use of standards by insisting upon goods that are the best in quality and conform at least to a certain minimum standard.

The Massachusetts Art Project Laboratory looks forward to a broadening of its activities. It plans to go far beyond the mere routine testing of materials, the setting up of standards, and the checking of manufacturers' goods. The directors hope to attack some of the fundamental technical problems of art. Such a program will include the experimental use of new materials; an examination of the faults of present day painting methods and techniques; inquiry into the lasting qualities of specific materials, and the development of new methods for testing. It is planned to issue, from time to time, bulletins or technical statements of interest to artists.

It is felt that the new generation of artists is taking a more direct interest in matters technical than those of the older generation. Formerly, in the eyes of many of the more romantic artists, such things as techniques, mechanics, chemistry of materials, and even fine craftsmanship were held in a certain contempt. But that attitude is fast disappearing, and we have a younger generation that wants to know about chemistry of pigments, mechanics of supports, and physics of color. The trouble is that these matters have not been organized for the artists' assimilation and made available for their ready use. Laurie, Eibner, and Doerner have made notable contributions in this field, but their works are only a starting point for attack upon the many technical problems of the modern artist.

Part III
ART EDUCATION

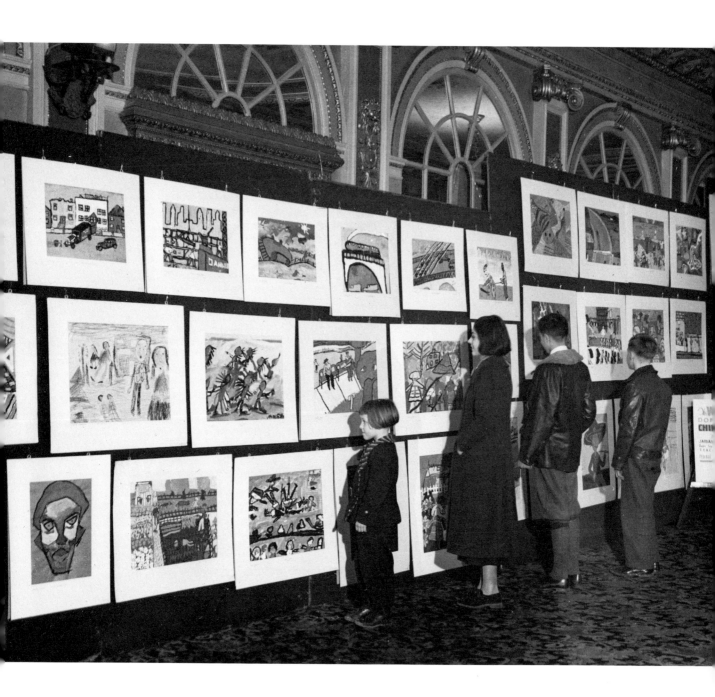

An exhibition of works created by children in the free art classes of the Jamaica, New York, public schools under the supervision of teachers from the WPA/FAP, 1937. (AAA)

The Artist as a Social Worker

IRVING J. MARANTZ

"I was a regular guy," they used to say. Never too well dressed, in no way superior to the other "guys." I played handball, boxed, and argued with them. This activity netted my art class the attendance of one of the toughest boys on the block, named "Red" McQuire, aged twelve. With him came at least a dozen others. These boys of the toughest type, many already with police records, came in and actually put in time away from the anti-social training of the streets.

Ragged, undernourished, and in many cases extremely brilliant lads were in a short while handling paintbrushes as deftly as they threw stones, or stole apples from the peddler, or penknives from the "5 and 10." With personal contact, individual encouragement, and almost complete freedom, they found themselves proficient and liking what they once scornfully regarded as "sissy."

Numerous case histories can be cited of the success of our art class, which grew from a small group in the damp cellar of a neighborhood political club to the art department of the Community Boys' Club, which now has four art classes in drawing, painting, sculpture, and block printing. These lads, Negro and White, Gentile and Jewish, had hearts that were hungry for the personal contact and encouragement that was lacking in their lives.

There was, for example, Abe Levine, who had been sent to numerous psychiatric wards by the school authorities, because of his undisciplined behavior. He was regarded as uncontrollable—a problem child. He began to attend the art classes after school.

Conference with the grade-school authorities and with his mother indicated a complete change of attitude. His mother was delighted. I took sick for three weeks, and Abe stopped attending the class. During this short period he returned to his old gang, and was arrested and sent to Hawthorne, a school for delinquents. The case of Johnny Lang is no less revealing. He came from a family of ten, one of whom was already in a state penitentiary. He himself was on parole when he was induced to enter my class. Johnny bullied, stole, and was generally disruptive except when he was busy carving wood. Then he was so quiet that I was not conscious of his presence. It so happened that at that time our tools and supplies were limited. When our materials had been exhausted and none were forthcoming due to financial limitations, Johnny stated, "I won't come any more. There's nuttin' ta do." He arrived every day and asked if we had gotten the tools or wood. Upon hearing a denial, he ran out again. Johnny is now institutionalized.

The hanging of the outdoor exhibit of the paintings by these boys was the first time in the history of the neighborhood that there had been a display of creative work. The boys stood proudly by and guarded the exhibition from any vandals from other neighborhoods. This was the beginning of a large movement and a sharp change in the attitude of the entire neighborhood toward the Community Boys' Club and toward art.

It is a source of personal satisfaction to me and to the other teachers that the artistic merit of the pro-

duction of our art classes has been widely recognized and often publicly praised. But far more significant is the social value of this work in terms of human rehabilitation. Experience has clearly demonstrated that the Abe Levines and Johnny Langs are what they are because their family surroundings and social environment have made them so—and that art is a great therapy which can in many cases turn them into useful social beings, often into sound craftsmen, and even sometimes into distinguished artists. With sufficient funds and adequate cooperation, the Federal Art Project's teaching work can become a vital and indispensable factor in the life of the community. It is to the benefit of society that these activities initiated by the Project be extended to reach every American community where they can be of service.

The New Orleans WPA/FAP

LAWRENCE A. JONES

My efforts to secure an art education have taken me, in the capacity of a waiter, to many American cities large and small, where I have had ample opportunity to watch the cultural progress of my people. Both as an artist and as a citizen, therefore, I feel that I can speak with knowledge on the subject of the Negro artist and what Uncle Sam is doing for him and his community.

As a high school student in Lynchburg, Virginia (1930-34), I found it impossible to secure an art education. The public schools did not offer this important course, nor did the college for Negroes. I did, however, receive criticism and encouragement from sympathetic white artists of my community. At that time there was no art program in Lynchburg giving classes to the public, so my friends advised me to pack up and go elsewhere.

My train fare to Chicago was generously contributed by appreciative Negro citizens of Lynchburg and Mrs. Bessie Lamb Woolfolk of the United Char-

ities. In Chicago, Jane Addams gave me a job as a waiter at Hull House, and there I earned enough money to keep me going. A scholarship at the Art Institute gave me the education I had set out to get at any cost. After four years of study in Chicago, I came to Dillard University in New Orleans to serve as assistant in the Department of Fine Arts. I took some academic work at the same time toward my degree. In my second year at Dillard I won second prize in a national exhibition of Negro art. When my work at Dillard came to an end, I sought and found employment on the WPA Federal Art Project in Louisiana.

This new connection gave me a vivid realization of my social responsibility toward the underprivileged, and in New Orleans I have since followed the example of many of my race who in the North have been taking an active part in WPA/FAP art work for many years. Believing as I do that the appreciation of art cultivates in man a sincere regard for the contributions of his fellow men, regardless of race or

creed, I am trying through my own painting and art teaching to create a more democratic America.

On the New Orleans art project we teach art to poor children whose undirected energy might otherwise lead to delinquency. This energy I try to divert into creative work through finger painting and simple crafts; I have been very successful with maladjusted children and general rowdies. On our project there are four artists who serve the community in specific sections of New Orleans. My colleagues are Harold Pierce, Myron Lechay, Leonard Scott, and Joseph Williams. We all feel that we have a dual duty as creative artists and as teachers. Our art classes are held in all the poorer sections of the city—for adults at night and for children on Saturdays. They have brought an enthusiastic response from the children especially, who come with lunches, prepared to wear out the teacher completely. Among our adult students are many public-school teachers.

My colleagues and I know that our work is essential both for our own development and for that of the community. We think that the country as a whole may well use New Orleans as an example of what the WPA/FAP can do for the cultural advancement of the Negro.

Puppetry as a Teacher

HILDA LANIER OGBURN

"Why are you so interested in puppets?" The question has frequently been asked the children of our Puppet Guild.

"They're so much fun!" Always the same enthusiastic reply is made.

"But do you learn anything from them?"

This question does not produce a ready answer. It does not seem to occur to children that any element other than fun enters into the making of puppets and the production of puppet plays. For them the play spirit dominates this activity. Eventually other answers do come: "We learn to model heads." "We learn about dressing the characters." "We learn about using our voices." "This training will help us if we study dramatics in high school." "We make a lot of friends."

Perhaps one should not expect a child to realize all of the advantages he gains through working with puppets. The instant he timidly touches the clay from which he, with growing confidence, creates a puppet head which assumes real personality, he has opened for himself, as if by magic, the door to a new and entrancing world. In this new world of make-believe where a creative spirit reigns, work turns into play and in this play appears an inexhaustible variety of educational values. It does not occur to the child that he is learning.

The Puppet Guild of the WPA Art Gallery at Greenville, North Carolina, works with hand puppets rather than marionettes, because the former are more satisfactorily constructed and manipulated by younger children. It is with astonishing rapidity that the Guild member makes the acquaintance of this little image, consisting simply of a small garment to which is attached a head and sometimes hands. The child is thrilled as he slips the puppet on his hand like a glove and learns by simple movements of the hand and fingers to make it obey each impulse of his mind—to bow, nod, embrace, sit down, dance, or fight.

The children at the Greenville Gallery learn the papier-mâché method in making the puppets. Given fundamental suggestions for the construction of heads, and encouraged to use their limitless imagination and ingenuity, to experiment and investigate, they spend many happy hours creating these characters. They thus unconsciously learn to think creatively about construction and the observation of the typical features of the models, real or imagined, of their puppet characters. They learn about color in painting the puppets. They learn a process which is applicable to many uses other than puppetry. Then, too, they feel the joy of possession in the ownership of their creations and still greater happiness in finding use for them in puppet-play roles.

Upon reaching the step of costuming the puppets, the members find new problems arising in making choices and decisions concerning combinations and uses of materials, costume design and types of clothing suitable for the puppet characters. The possibilities of this phase of puppetry are limitless. Study and research in costume design, experience in using discarded scraps of every conceivable material donated by mothers or interested citizens contribute to the young puppeteer's valuable experience.

A more completely related project than the one undertaken by the Greenville Puppet Guild would be hard to visualize. Into the realm of interior decoration and historical research the child is introduced through the combination and adaptability of material in building suitable stage settings in which the puppet characters play. The introduction of appropriate music opens another channel of interest. Joseph Haydn was inspired to compose an opera, "The Lame Devil," especially for hand puppets and, among other musicians, Gounod and Tschaikowsky created puppet music. The production of original musical compositions adaptable to puppetry offers fascinating possibilities to children. However, with all the music of the universe from which to choose, it is evident that a wealth of educational material may be brought to light through the careful selection of music for use in puppetry. Children are thus taught to adapt many types of music, such as the carol, the lullaby, the dirge, the jig, to the various moods of the puppets. The ever-widening scope of creative experience in puppetry includes the writing of original plays and skits. Once in a Greenville Puppet Guild play, Simple Simon brought a number of Mother Goose characters to a local country fair. More recently the Guild produced a play written by one of the members especially for puppet characters which had previously been created.

The fun experienced by the members in puppet-making gains momentum as it develops. At every step of the process interest is kept at great height. The peak of enjoyment comes in giving a performance. During rehearsals the young puppeteers learn about personal conduct, social customs, and character portrayals through the action and conversation which they transmit to their puppets. The release of dramatic impulse, the employment of voice inflection, distinct enunciation, emotional variety, cooperation among the puppeteers, the assumption of individual responsibilities, the sacrifice of personal feelings in order to make the show a success, all contribute to the educational value of puppetry instruction for children. Hidden talents and powers of the child are thus brought out, timidity surmounted, and self-confidence built up. Three months ago in a puppet performance, one of the Guild members timidly repeated a couple of sentences for a puppet character. Last month he "brought down the house" with his successful portrayal of two characters.

The packed houses before which the Greenville Puppet Guild plays contain people of various ages and walks of life. In this way friendships are formed and greater interest in the gallery is created throughout the community. This response is a source of gratification to the Guild members. Imagine the exhilaration one puppeteer enjoyed when he said, "I'm afraid some of you little fellows out there in the audience are not eating your spinach like good little children," and a half-frightened, guilty little voice

from the audience piped out, "You mean me?" At the conclusion of another performance, so real had the puppeteers made the characters seem to the audience, a little tot visiting "back stage" and seeing the puppets lying lifeless on the table, looks alarmed and asked, "Why don't they talk now?"

So valuable is puppetry instruction for children in teaching them about the arts and crafts and allied subjects that this activity is encouraged in many of the WPA art centers throughout the country.

Probably one of the most outstanding achievements in the marionette field has been attained by the Community Art Center in Sioux City, Iowa. Interesting work in puppetry is also being done in the Florida centers; Oklahoma City; Phoenix, Arizona; Salem, Oregon; the Children's Art Gallery in Washington, D.C.; the Delta Art Center in Greenville, Mississippi; and the Spokane, Washington, Art Center.

The Therapy of Art*

ALEXANDER R. STAVENITZ

The beginnings of government support to artists in the early 1930s found few of them prepared to apply their knowledge and technical skills as teachers. The overwhelming majority were practicing painters, sculptors, graphic artists, and craftsmen. From the very beginning, the Project administration stressed the importance of suitable contemporary instruction in the arts as a necessary factor in the future development of a progressive movement in American art.

Artists were assigned to teach classes in settlement houses, churches, YMCA's, YMHA's, hospitals, boys' clubs, institutions for the blind, for the crippled, public schools, orphanages, and similar public agencies. The early difficulties included finding adequate space, equipment, and materials. In some instances the director of the institution had first to be convinced of the desirability of having such classes.

In one house the first classes could be held only on a stair-landing as no other space was available. Subsequently the arts program in that house justified itself to such an extent as to obtain an entire new building for the arts and crafts classes. This is but one dramatic example of a general growth that took place as the art activities won wider interest and attendance and assumed an increasingly important role in the life of the institution.

The professional artist began to learn the art of teaching as his experience in the teaching situation grew. The informal studio atmosphere prevailed, but problems of discipline and techniques soon challenged the teacher and were met with resource-

*This essay was accompanied by a number of case histories, which have been omitted.

fulness.

In some of the "tough" districts, the early problems of discipline required the teacher to actually defend himself against gang attacks. In neighborhoods such as Hell's Kitchen and Brooklyn Navy Yard, for example, the instructor had to contend with a traditional contempt on the part of the boys for any kind of art activity. These boys, however, were gradually won over by the instructor's resourcefulness in presenting a challenge to them. They began to use their group habits, learned as a gang, in new and constructive ways, such as the collective painting of a mural. Competition was developed between groups trying to achieve the finest mural and possibly win a coveted prize. Juvenile delinquency began to drop sharply as this kind of activity came into the neighborhood.

Another set of values has been developed in connection with the Teaching Division's program in hospital and special institutions. Here the instructor serves a particular kind of incapacitated student, as, for example, in the Hospital for Joint Diseases in Far Rockaway, Long Island, where painting and clay modeling classes have brought beneficial activities to bedridden patients. In many instances doctors have reported a remarkable increase in facility in the use of hands and arm muscles as a result of the manipulation required in painting and clay modeling. A patient might begin by tying the paintbrush to his arm and in several months achieve sufficient control of the fingers to hold the brush firmly with them. Also, in institutions for the blind and for the crippled, the handicapped are being provided with a means of physical and mental therapy. At the New York Association for the Blind, interesting work is being achieved in pottery and sculpture. One might think that the latter medium would involve too great difficulties for the blind to overcome, but remarkably vigorous and imaginative pieces of sculpture have been achieved in this class.

The most widely known of the Teaching Division's work in hospitals is in the Observation Wards of Bellevue Psychiatric Hospital in New York. In 1934 an art teacher was assigned on an experimental basis to work under the supervision of Dr. Lauretta Bender, senior psychiatrist in charge of the Children's Ward.

It has long been known that a child's drawing of the human figure may be used as a fairly accurate criterion of intelligence (as formulated and standardized in the Florence Goodenough test). It has also been well recognized that art expression is closely related to the personality and mental life of the artist. Studies by individuals in Europe and this country have indicated that art expression may serve as a valuable diagnostic and therapeutic aid in the treatment of mental patients. Further development and application of these previous experiments proved so valuable that these techniques have been incorporated into the Hospital's regular ward routine and extended to the Adolescent and Adult Wards, with six instructors instead of the original one. In many cases the art production of an inhibited child may serve as the main or sole clue to the child's disturbances. Fear or unwillingness to relate the facts verbally, or inability to do so, is frequently overcome by means of art expression. The disturbed child tends to preoccupy himself with his problem and express it symbolically in a drawing or painting, unaware of the special meanings inherent in his art work. Much of what has been learned in the Observation Wards at Bellevue Hospital has been informally and broadly applied in general practice by our teachers in most of our classes. The average child attains satisfactions symbolically though art production. Frequently the child utilizes art activity to vent aggressive impulses in the form of paintings of fights, explosions, shootings, stabbings, gang warfare, etc. This symbolical aggression has been found very useful as a substitute for actual acts of violence by the child, constituting a sort of "blowing off of steam."

The general practice of our teachers is based upon working through the student's interest. We do not believe in imposing a rigidly formulated curriculum with standardized steps and processes, precisely because children's interests vary greatly and we know that they will work best and develop more

rapidly by dealing with things which interest them. A boy may not care about copying flowers but will attack with relish the depiction of a prizefight or an airplane. Once he begins work on the prizefight he encounters technical problems—anatomy, space representation, color, perspective, etc. The solution of these problems is facilitated by the boy's eagerness to achieve *his* wishes rather than the instructor's. The instructor's role here is more or less one of a friendly aid. The boy sets his own goal and does most of the work toward achieving it.

The instructor tries to understand the work in terms of the child's own capabilities and technical level. As far as the child is concerned, his creation is good and satisfactory to him. He knows exactly what the drawing or painting means. The ability of the instructor to understand this communication is extremely important. It immediately sets up a bond with the student. This special understanding be-tween student and instructor begets mutual confidence and sympathy. It also flatters the child to know his achievement is valued by someone else, particularly an adult. These underlying principles are, of course, utilized in each situation with special reference to the requirements of the situation.

Perhaps the most important single new factor introduced by the WPA/FAP nationally has been the establishment of community art centers. I do not attempt to describe them here—Miss Gwendolyn Bennett's article on the Harlem Art Center does so in detail—but I do want to say that I believe these centers may become as important for art education as the public libraries are for general education. They have brought art training and art experience to large numbers of people for the first time, including the opportunity to see exhibitions of contemporary American art. They have made the cultural value of participation in the arts available to young and old.

Art Within Reach

THADDEUS CLAPP

A work of art exists for man. This simple truth, which must be the basis of any democratic esthetic, too often has been lost in a welter of finespun rationalizations as to the value of art. Also lost is the simple fact that art is of value to man and to society because of the intense delight it offers. Art for expression, art for uplift, art for art's sake, all the reasons, conscious and unconscious, that are given to justify the artist or to make morally acceptable an interest in art only becloud the basic value of art.

Works of art and an appreciation of art were part of the normal environment of the citizens of Greece. In the Middle Ages works of art were perhaps closer to the lives of the people as a whole than they were even in Greece, for the people came in contact with them under the favorable conditions. Painting and sculpture were used to adorn the interiors of churches into which people withdrew from the activity of the world for short periods. In these quiet interiors they had the opportunity to look at objects of art while there for purposes of devotion or instruction.

It is neither possible nor desirable to return to the past. It is possible, however, once more to bring art to the vast population of our country, and by so doing to straighten out the confusion caused by the widespread feeling that the appreciation of art is the expression of a superior culture which, combined with the time taken to acquire it, becomes a manifestation of conspicuous consumption. Schoolrooms, auditoriums, libraries, and settlement houses can take the place once held by the churches as repositories for works of art and can reach a broader public than can be reached by the churches today, some of which have doctrinal objections to the use of painting and sculpture in their edifices

Museums through their galleries and extension activities reach a wide public, but they are limited in scope by geographical considerations. Whole sections of the country have no museums or galleries, and it must be remembered that there are thousands of people in each of our large cities who live too far from the museums and galleries to be able to walk to them and who cannot afford the carfare to ride to them. No matter how important lectures on art and demonstrations of technique may be, an understanding of art is impossible without close contact with original objects. It has been our experience that only too often lectures merely cause people to look at works of art with their ears instead of their eyes. On the other hand, pictures placed in rooms where people gather either for social purposes or for study or for meetings gradually attract attention and are really looked at. The paintings,

sculptures, and craft objects produced under the patronage of the government and belonging to the people of this country and not to any group or institution have an advantage for widespread exhibition purposes over objects owned by museums. These works of art are out of the market and hence have no price value. It is obvious that a museum cannot place an original painting for which it has paid thousands of dollars, from either public or private funds, in schoolrooms, libraries, or settlement houses. Government-owned pictures, often painted by men represented in contemporary museum collections, can be widely exhibited without risk of tremendous monetary loss, because the investment involved is only the cost of the labor and the materials used. The very fact that these pictures do not have dramatic monetary value should in itself help to make people realize that "Art has no relation to age, rarity, or price," but rather that a work of art has its own intrinsic value that lies in the delight that if offers man.

For an understanding and appreciation of art, next in importance to the easy availability of art is instruction in its practical problems. Much of the pseudo-mysticism surrounding "Art" disappears the minute a person learns through experience that the pirmary concern of a painter or sculptor, as of any manual worker, must be with the technical problems involved in the work. The prudent man soon learns not to worry about individual expression or profundity in the practice of art. These two elements, which raise workmanship to the level of art, depend entirely on the personality of the worker. His job is to find articulate expression for these qualities, which means that he must be able to handle his tools and materials with ease and sureness. The art classes conducted by the Art Projects reach thousands of people, who, having faced the technical problems involved in painting or sculpture, study original works of art with a new and healthy interest and deriverelaxation and pleasure from participation in art studies. This does not mean, however, that people who have no inclination to work in the techniques of

art are barred from art appreciation, any more than people are barred from an interest in music or in sports because they are not active participants.

If the thesis that art exists for man is true, then it is man's right to enjoy it. In any program attempting to restore that right to the millions of people in this country, there can be no condescension. Art cannot be taken to the people, nor can such a program be carried out in the spirit of social uplift or social service work. There are thousands of publicly owned works of art in this country; there are millions of people to see and enjoy these works of art. The whole problem of making works of art available is one of distribution.

An art project is one of the instruments that can be used in solving the problem of the distribution of works of art. The state headquarters of a project serves a manifold purpose, and an understanding of the operation of an art project in relation to the public can be gained by visiting one. The operation of such a project can be made clear by comparing it to two types of manufacturing enterprise. If the project headquarters is large, it will have, in addition to the administrative offices, storage rooms where paintings, sculpture, and handicrafts are kept available for allocation or exhibitions, as well as studios or workshops in which carpenters, cabinetmakers, mural painters, photographers, woodcarvers, sculptors, and stone cutters produce goods for distribution. Here works of art can be seen in process of production under a system that must resemble that of the factories which existed in the Middle Ages in the cities of Northern Europe for the production of altar pieces and images, or the great decorating houses or stained-glass studios of the present day. Apart from the work done under this system of group production, a great deal of work is produced in the studios of the individual artists or (in the case of mural painters) in the place of ultimate destination, in much the same way that manufacturing was done under the cottage system in the early development of the textile, shoe, and garment industries in this country. In the light of the romantic theories only

too often applied to the production of works of art, it is very amusing to find in the New England Art Projects an exact parallel to the two types of manyfacturing which prevailed in Massachusetts and Rhode Island in the textile industry of the late eighteenth and early nineteenth centuries.

The works of art, or (for the sake of the comparison) the goods produced by the workers on the projects, are shipped out to institutions that have ordered them, or in the case of work that has not been contracted for, are put on display in a small gallery or showroom. Here the works may be seen not only by other artists on the Project, but by scores of school teachers, town officials, and members of organizations which are interested in raising money to turn over to towns or to tax-supported institutions for the purchase of works of art. Backing up the display and allocation of works of art is the usual machinery involved in business transactions. Apart from offices where invoices, bills of lading, and collection bills and accounts are made out, the project headquarters must have a supply room from which the artists draw the raw materials to be turned into finished products. Information services, ranging from material on early Americana (which is being studied and recorded by the Index of American Design), through the technical behavior of artists' materials or the feasibility of restoring or cleaning old paintings, to help in selecting pictures for given locations or advice to prospective students on where to study almost any phase of practical art, are also to be found at Project headquarters. Meetings of the faculty of the teaching division, meetings of supervisors to determine policy, tours and discussion groups, as well as a constant procession of workers and members of the general public who come to the Project headquarters for one reason or another, add to the daily bustle and excitement in the midst of which thousands of works of art are produced and distributed throughout each state, and from one state to another throughout the nation.

By means of our activities the Art Projects have been able to reach the millions. We have reached a vast public that knows nothing about art in terms of dinner-table conversation. We have found through experience that the quickest response to widely varying types of painting, ranging from the most conservative to the most modern, comes from people who have not been limited by the arbitrary preconceptions of what makes good painting which are too often exacted as a sort of price paid for a more polite cultural background. It is encouraging indeed to see a farmer who has never before seen an oil painting become so excited by a picture in an exhibition that he goes out and brings in all his friends to look at it; or to have a group of people in a settlement house "discover" an artist several months before the critics recognize the artist's work. For the artist this has meant increased dignity in the social structure. He is no longer an exotic, but an individual functioning freely within a society that has a place for him, no longer in an ivory tower, but in contact with his time and his people.

Boy painting at Phoenix, Arizona, Community Art Center. NCFA:Cahill)

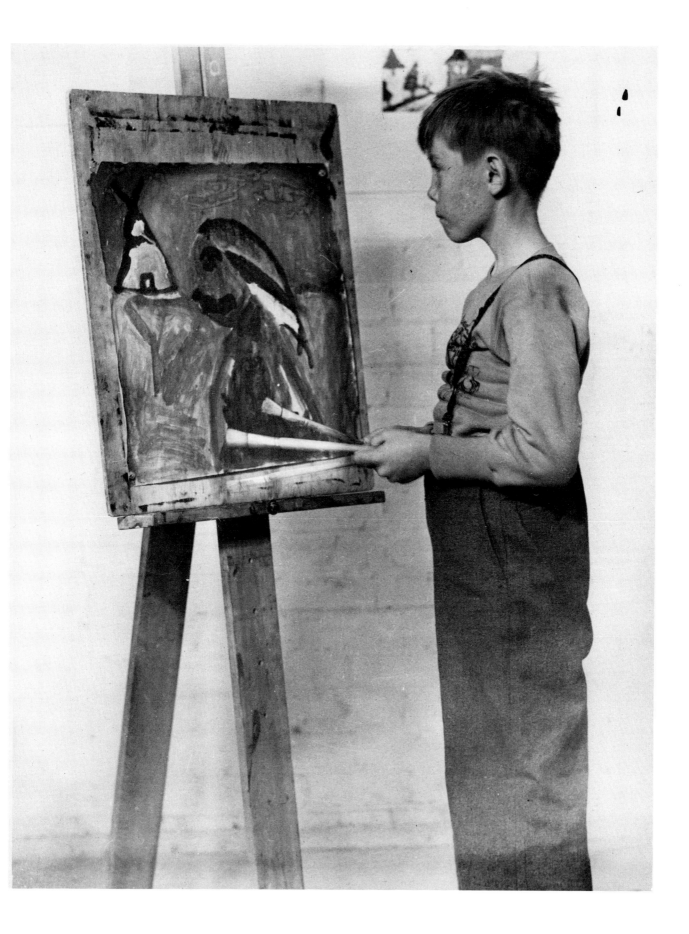

Birth of an Art Center

ELZY J. BIRD

Part I — August 11, 1939

If you will look on the map of Utah, you will find, very near Price, the little town of Helper—stomping grounds of the once-notorious Butch Cassidy Gang that haunted Robbers' Roost. It is approximately one hundred and twenty miles south and east of Salt Lake City, consists of thirty-six hundred people, and is a coal mining and railroad town. Named Helper because engines have to be hooked to the D&RG trains to get them over the hill into Utah Valley.

Lynn Fausett told me that the people might be interested in some sort of art activity, so Wednesday noon I wandered into a meat market owned by Barney Hyde. He is not only a guiding light, but is part of the City Council, a distinguished member of the Kiwanis Club, and, incidentally, the town butcher. After telling him who I am, we engaged in a long talk about meat and coal prices, artistic wrappers on hams, and about what the WPA/FAP could do for the City of Helper.

They have recently completed a very large building—a sort of community auditorium-gymnasium, which also has public library, meeting rooms for the Kiwanis Club, and can be put to sundry other uses. On the first floor, right beneath the auditorium-gymnasium, there is a space of approximately seven thousand square feet, well lighted and quite presentable. However, it is cluttered up with chromium and leather furniture—divans, chairs, end tables, humidors, etc. Here railroad men's wives while away the hours with conversation, bridge, and dominoes. It struck me that this would be just the place for an art center, and I asked Barney if it would be possible for me to attend one of the City Council meetings.

"Sure," said Barney, "I'd like to have you as my guest at the Kiwanis dinner tonight. Right after, there'll be a Council meeting, and you can put it up to the boys about an art center."

"Swell," I said, and deposited Barney back in his meat shop, while I grabbed some paper and planted myself in the space beneath the auditorium-gymnasium to do some figuring. At seven o'clock I was seated beside my friend at the Kiwanis dinner. There was roast beef, scalloped potatoes, and a lettuce and tomato salad, interrupted by much clanging of the Kiwanis bell and patriotic songs from their songbook.

The speeches went something like this: "My friends," said Barney, jumping to his feet, "congratulations are in order for Brother Fatz. In a ball game with Magna, he got a home run on a bunt." Much wild laughing and clapping, and the bell clanged.

Finally, the chairman called the gang to order and announced that Barney Hyde had a guest who would take five minutes of their time telling about art. He introduced me as the United States Supervisor of the WPA/FAP. I cleared my throat and was red in the face, but managed to thank them for the lovely dinner and to say something about art centers. Right in the middle of my so-called speech, the chairman clanged the gong again. I felt like an amateur on Major Bowes' program. He said, "Everyone on the City Council is excused," so taking this as my cue I thanked them for the dinner all over again and excused myself by saying that I had a date with the City Council too.

Well . . . we all dragged over to the City Hall, and my friend Barney banged on the table and said (again!), "Gentlemen, we have with us this evening the United States Supervisor of the Art Program. He is going to make us a proposition." I gathered together my papers and told them how we could re-model their room and make it an art center, that the operating expenses and transportation charges on

exhibitions would amount to $25.00 per month, and that $225.00 would take care of construction costs. The acting Mayor then said, "Is there any reason why the City of Helper cannot afford this sum for the expenditure toward *culture* for the ensuing year?" There were no comments. My friend Barney (he always pops up at the right time) jumped to his feet and said, "Mr. Mayor, I would like to put this in the form of a motion. I move that the City of Helper appropriate the sum of $225.00 plus $25.00 per month for the building and maintenance of a community art center." The Mayor said, "All those in favor, say Aye." The room resounded with "Ayes," and consequently, I claim the record for the fastest-sold art center in the history of the WPA Art Program.

Part II—January 2, 1940

I would like to give an account of the opening of the art center at Helper. It seems that Barney Hyde—you will remember he is the town butcher—who is, by the way, the new mayor, is selling art to the natives by the pound, like choice beef. He sort of gets them in a corner and ties them up in butcher's paper. I heard him tell one guy, "And just think! They bring it in from all over the country. We might even get to see some paintings from New York." Anyway, he's enthusiastic, and it's been my experience that enthusiasm is cheap but catching.

I went down and personally arranged the show, which, by the way, is one of the best things we have had in Utah yet. It's a combination of the works of Lynn and Dean Fausett and looks very swell in the large room. Gail Martin made the opening speech—with gestures.

I don't know yet whether the town will appreciate what we have done for them (or to them), as just before the opening, some guy, testing his strength, punched a hole through the top of a pedestal with his fist. Somebody else ruined a screen by seeing if the alcohol in a bottle of whiskey would take the stain off.

Part III—January 25, 1940

Do you remember the piece I wrote you on the Helper Gallery that you wanted to include in "Art For The Millions"? You can change that chapter to "Art for 3,017." Helper, with its miserable population of twenty-seven hundred, turned out to the tune of the above figure for its exhibition covering a period of three weeks. Of course we couldn't brand or earmark them as they came in, but I'm almost certain that a few sneaked in from Price, which is eight miles up the river. The payoff came when Lynn Fausett wrote me on January 18 as follows: "I was told tonight that a large delegation from the women's clubs were going to the City Council meeting Monday night to demand an art center for Price. Maybe you're interested. I've been asked to go."

Well, I was interested enough to show up at the Council meeting, arriving at eight o'clock, equipped with my photographer, Bob Jones, Mrs. Bird, and Lynn Fausett. They prowled around looking at Lynn's murals in the upper floors, and I was called in to the meeting. Seated in a semicircle around the Council table were ten excited and determined women. These gals had a spokesman by the name of Mrs. Barker, who, in a cool and collected voice, stated that "the competition next door had beat them to the draw on a great movement for culture." She also stated that no one was jealous of Helper's good fortune, and that they only had thirty hundred and seventeen persons to the first exhibition, and that Price, which was a much larger town, should be able to support an art movement on a much larger scale and in grander style. Well, the City Commission didn't have a chance. Mayor J. Brackson Lee turned to me and asked if my proposition for $150.00 to cover remodeling and $25.00 a month for expenses still held good. I said my bargain would just last out the week, and what with the foreign wars, etc., it might go up at any minute. Some guy jumped to his feet and said, in no flowery terms, to accept the whole business. Before I could get my photographer lined up for the killing, it was all over.

The Negro Artist Today

VERTIS HAYES

The late Henry O. Tanner enjoyed a wider reputation than perhaps any other Negro artist, especially in the South. Since his time, a younger group of Negro artists has come upon the scene. Among the few elder members of this group is Augusta Savage, sculptress, a native of Florida who some years ago won a scholarship to study abroad and later conducted an art school in Harlem where many of the younger artists came under her influence. She was an active member of a group of citizens who, keenly feeling the need for broader art activities, embarked upon the idea of an art center.

This was finally achieved when, through the WPA/FAP, the Harlem Community Art Center was established. The Center, under the direction of Miss Savage, and more recently Miss Gwendolyn Bennett, together with a capable staff of assistants and instructors, has become an active cultural force filling a long neglected need in Harlem. The Center stands as a tribute to the Federal Art Project and a service to the community without which it would be a great deal poorer. Miss Savage recently opened an art gallery in Harlem. Her most recent work was a commissioned assignment for the New York World's Fair, a piece of sculpture entitled "The Harp." No other Negro artist received work on any of the many projects for the Fair.

Aaron Douglas, who painted murals for Fisk University in Nashville, among other mural paintings, displays in some of his easel paintings a richness of texture, combined with a somber palette and a reserved rendering that reflects the maturity of the painter.

Hale Woodruff of Atlanta, Georgia, studied abroad and lived in New York for a short time before returning to teach art at Atlanta University. Woodruff stands alone in that he was among the first of the Negro artists to enter the Deep South with a more progressive art philosophy than is even today accepted by the majority of the communities in the South. One of Woodruff's most recent works is a mural painting for Talladega College.

A still younger group of Negro artists bids fair to carry the banner of art by Negroes to a higher point of development than has heretofore been achieved. This is due in no small measure to the program of the WPA/FAP for with it came at long last recognition of the Negro as being as capable in plastic art expression as he has long since proved to be in others of the fine arts.

Among this group is Ronald Joseph, who in early youth showed promise of a brilliant career. He studied at Pratt Institute. Comment of leading critics of two of his paintings shown in the Harlem Artists Guild exhibit at the American Artists School in 1937, titled "Madonna and Child" and "Bus Interior" is the best indication of how he has lived up to an early prophecy. There is also Norman Lewis, a vigorous painter who studied with Vytlacil and is now one of the capable instructors of the Harlem Art Center. Lewis, like Ronald Joseph, Ernie Critchlow, Sarah Murrell, Jacob Lawrence, Rex Goreleigh, and

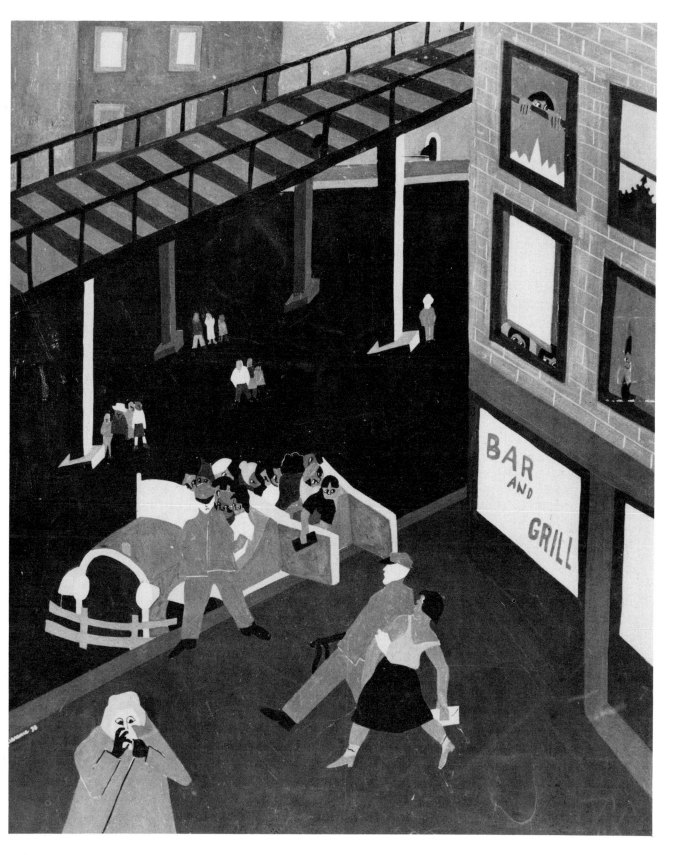

Jacob Lawrence. *Night*. Gouache, New York City Project, c. 1938. (AAA)

Georgette Seabrook, belongs to a group indeed young, as maturity among artists goes. They have nevertheless shown in their work a progressive approach and healthy vigor which, to say the least, is a happy departure from the affected, pretty, and often over-sentimental approach that characterized much of the work done by Negroes in the past.

Other evidence of the progress being made by young Negro artists is to be seen in some of the mural paintings executed in Harlem and in other sections of New York City. Dr. Alain Locke, Professor of Philosophy at Howard University and author of a number of books on art, commenting on the mural paintings done in Harlem says:

"Harlem projects which have already attracted favorable attention are the series of murals on 'Negro Achievement,' the last work of the late Earle W. Richardson; the sculptural friezes on motifs from 'Green Pastures' by Richmond Barthé for the auditorium of the Harlem River Housing Project, and an elaborate series of murals for the Harlem Hospital by a group of younger artists among which is a very outstanding epic of Negro life, a series called 'The Pursuit of Happiness.'"

One of the problems of the Negro artist is reaching his audience, as it is with all the artists. Too often he is forced to leave his own community for lack of facilities in art training or any art opportunities. He concentrates in a few of the large cities and thus the smaller communities are systematically deprived of their local talent. At the same time the metropolitan areas are overrun with artists who in turn must have jobs aside from their problem of social readjustment.

The area around Fifth Avenue, Madison Avenue, and 57th Street is the locale of most of the art galleries in New York City. Fifty-seventh Street alone perhaps has more galleries than any other three cities combined. There are more Negro artists living in New York than in any other city, yet most of the art galleries exclude work done by Negroes from any of their exhibitions. Hence the Negro artists' lack of adequate participation in the progressive art movement on the one hand and the ever-widening breach of understanding among his own people (artist and layman) on the other. To appreciate any art one must be aware of its development, approach and philosophy. This latter problem is largely due to the lack of opportunity for visual participation for Negroes in many sections while many of these same communities have museums and galleries maintained and supported by tax-created funds.

To the WPA/FAP must go the credit for having taken the initiative in bringing art opportunities to a great number of people, for in many communities throughout the country where representative numbers of people have indicated cognizance of the need for art training and education by willingness to support such enterprises, art centers have been established. It has been the policy of the Project to set up centers in the crowded areas where no art activities existed. A number of such centers have been started in Negro communities. One of the outstanding examples of the effect that these art centers have had is to be seen in the LeMoyne Federal Art Center in Memphis, Tennessee. Like LeMoyne College on whose campus the Art Center is located, and indeed like the city of Memphis, the Art Center might justly be called an outpost strategically situated. It serves well the neighboring communities of Arkansas and Mississippi, as well as the smaller towns in Tennessee. In a recent annual report by the LeMoyne Federal Art Center to the LeMoyne Art Association, its sponsoring organization, the record showed an attendance at exhibitions of 12,593 visitors, 1,943 at gallery talks, 1,278 at lectures, 776 at special activities, 4,895 at painting classes and 755 adults at the senior classes. Other such centers are to be found in Jacksonville, Fla., and Oklahoma City, Oklahoma, and of course there is the large Harlem Community Art Center. So for the first time in history many more thousands are sharing in a broad cultural program that may eventually become more national in scope, and in which, in the final analysis, the cultural standard of this country as a nation will be determined.

The Harlem Community Art Center

GWENDOLYN BENNETT

Cumulative reports are most enlightening things! They are almost more enlightening to those who prepare them than to those who read them. Not until such a report on the Harlem Community Art Center was being compiled, covering the period from its beginning, November, 1937, to March 31st, 1939, was I able to realize the full import of its work. One goes about in the community saying many things fervently and trustfully; but it is not until a comprehensive report on the job has been made that it is possible to know for certain whether the things we have said and believed are actually true.

I have been talking and thinking about the Harlem Community Art Center for about four years. It was a dream when Negro artists forming the Harlem Artists' Guild met to pool their experiences in a discussion of ways to bring about the establishment of a permanent art center for Harlem. The individual experiences of several artists had led this group to believe that there was a real necessity for such a center. Augusta Savage had been holding art classes for years; first Lessene Welles, then Charles Alston and Henry W. Bannarn had cooperated with the 135th Street Branch of the New York Public Library in the program of the Harlem Workshop; and many other artists in smaller ways had been at work in the fulfillment of a community need for a place where those who wished to learn might study free of cost, and where instruction in the use of creative materials might be made available to a wide public. And so in

a dream motivated by the urgency of fact many of the precepts governing the program of the Harlem Community Art Center were laid down.

When classes were organized by the WPA/FAP, first in a renovated garage known as the Uptown Art Laboratory, and later in the Music-Art Center, this dream began to take shape. Working closely with Augusta Savage, who was in charge of both of these ventures, I began to see an ideal acquire bone and sinew. The establishment of the Harlem Community Art Center in a large empty loft at the corner of 125th Street and Lenox Avenue began to symbolize the growth and maturity of this ideal. The coming of eager children to register in the classes, the formation of a sponsoring committee, the long line of visitors from Harlem and from the rest of the country, and the growing enthusiasm among the people who worked in the Center acted like a strong tonic on the entire community.

In January, 1938, when I became acting director of the Center, and later when I was made the director, I found that I had brought to the task a whole set of ideals and ideas born in the minds of many people and deriving from many sources. So impelling were these ideals and so important was the work at hand that individuals willingly identified themselves with the collective will of the many. Many minds became one. As a result, the Harlem Community Art Center is becoming not only a cultural force in its particular locale, but a symbol in the culture of a race.

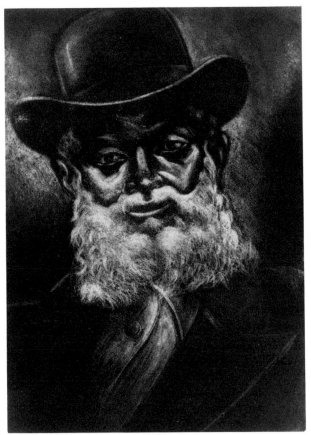

Dox Thrash. *Whiskers*. Carborundum print,
Pennsylvania Project. (NCFA:Cahill)

Thoughts like these are heady and appear to grow glib on the tongue as one goes about talking, almost preaching, the virtues of the Harlem Community Art Center. It is not until these beliefs are checked against the facts contained in a comprehensive report that one knows them to be true and begins to realize their full significance.

What did the Center's cumulative report show?

First, and possibly the most important fact: 70,592 people by actual count had attended the Center's activities during the sixteen months it had been in operation. Apologies for saying and believing that the Center meets a community need are no longer necessary when facts prove that it has reached an average of more than 4,000 people a month.

And who are these people who have been reached by the Center? Exactly 2,467 children and adults have registered in the art classes. More than 23,989 people have participated in the Center's extension activities, lectures, and demonstrations. Thousands of others come to the Center regularly to see the exhibitions and to attend other special events.

These visitors have come to the Center from every part of the United States and from England, Scotland, the British West Indies, China, Japan, France, the Netherlands, Palestine, and Germany. Teachers, students, writers, social engineers, and people from every walk of life have come to the Center and have sent their friends. Impelled by curiosity at first, most of the Center's visitors have ended up by signing our guest book with humility and expressions of profound respect.

Forming a sponsors' group and drawing to it distinguished citizens from all walks of our national life to which the Negro has made a significant contribution, has been a challenging and often thrilling task. An equally effective bulwark of support and encouragement has come from the parents of children who attend the Center's classes and from large groups belonging to the community's large working class. Within this rank-and-file sponsorship there exists a genuine consciousness of what the Center means as a necessary stimulant to the development of Negro culture in America.

The events of major importance that have taken place at the Center are too numerous to itemize. Certainly the gracious visit of Mrs. Franklin D. Roosevelt on December 20, 1937, the Center's official opening day, is one of the most memorable of these. The exhibition, "Art and Psychopathology," jointly sponsored by the WPA/FAP and Bellevue Hospital, which drew to the Center so many eminent psychologists and psychiatrists, is another significant event. Nor will we soon forget the visits of Albert Einstein, the famous scientist, and Paul Robeson, the internationally recognized singer and actor.

Equally exciting has been the experience of watching delinquent and maladjusted children sent to the Center from psychiatric wards of the city hospitals become stable material with which to build future citizens. Gratifying too has been watching Robert Blackburn, one of our students, develop his talents and win recognition last year by being awarded two first prizes in a nationally conducted high-school art competition, and this year receive,

Samuel J. Brown. *Mrs. Simmons*. Watercolor,
Pennsylvania Project, c. 1936. (NCFA:Cahill;
National Collection of Fine Arts, Smithsonian
Institution, Washington, D.C.)

upon his graduation from school, a year's scholarship
to study at the Art Students' League.

More important than all of these things has been
the developing philosophy and understanding
behind the work of the Center. In each person at
work in the Center there has grown a new selflessness
and dignity in the performance of the smallest task.
A new understanding of the value and meaning of art
teaching in the cultural scheme of things has been
engraved on the consciousness of every person
associated with the Center. We who are part of the
Harlem Community Art Center feel the way the
editor-in-chief of a well-known Paris newspaper did
when he wrote in our guest book: "One goes many
places, seeing many things but being little im-
pressed; but here, indeed, one sees a true expression
of a New World." With real conviction we add, a new
and better world!

High Noon in Art

HARRY H. SUTTON, JR.

High Noon—Friday, May 29, 1936. Heat waves licking hungry tongues, devouring the few refreshing breezes.

High Noon—dry, sultry, hot. Plans for the Negro Unit, Jacksonville Federal Galleries, were outlined; plans to establish a Negro Art Gallery in Jacksonville, Florida, a city where art was practically unknown among the 65,000 Negroes. To establish an art center where only about 10 per cent of the population had ever visited an art gallery anywhere. Where less than 50 per cent had ever seen an original painting. An art school for persons who were never exposed to art in any form; not that these people would not want the exposure, but because they never had the opportunity. To give lectures; to teach art and art appreciation. Was this to be a job or a miracle?

Mid-afternoon. Same day. Heat, glare.

Three rooms! Three rooms, two 12′ x 15′, one 12′ x 21′, and a corridor 9′ x 12′, donated by Miss Eartha M. M. White, president of the Eartha White Settlement House, chairman of our Citizens' Sponsoring Committee. Three rooms on the second floor of a Mission building located in the heart of a vice-infested Negro section of Jacksonville.

A Center of Culture. To the right: bars, poolrooms, dingy restaurants, cheap hotels . . . soda pop fronts.

In the front: Chinese laundry, bars, poolrooms, dingy restaurants, cheap hotels . . . soda pop fronts. To the left: a music store where "hot" recorded music blared forth all day, barber shop, public high school. Below: a Mission where kind-hearted religious Negroes gathered each morning to sing praises to their Maker. In the midst of this was to be our gallery.

Afternoon, May 30th. Afternoon, June 21st. Renovating. Borrowing paintings for exhibitions from the seven Negro artists in Florida. Establishing classes. Selling art and art appreciation to 50,000 people.

June 22nd, 1936. Gallery opened. Opened with a greater success than we had anticipated. An eventful day in this city where art was practically unknown to a particuular race of people. Accepting the unknown in the most impressive manner, accepting it with enthusiastic appreciation.

May, 1939. In three years we have directly contacted over 40,000 persons. Over 35,000 of these were Negroes, over one half of the city's Negro population and one third of the city's total population. From the very beginning our classes have been crowded. Negro children, adults—drawing, painting in their own manner, painting in a definite Negro manner, rhythmical, colorful,

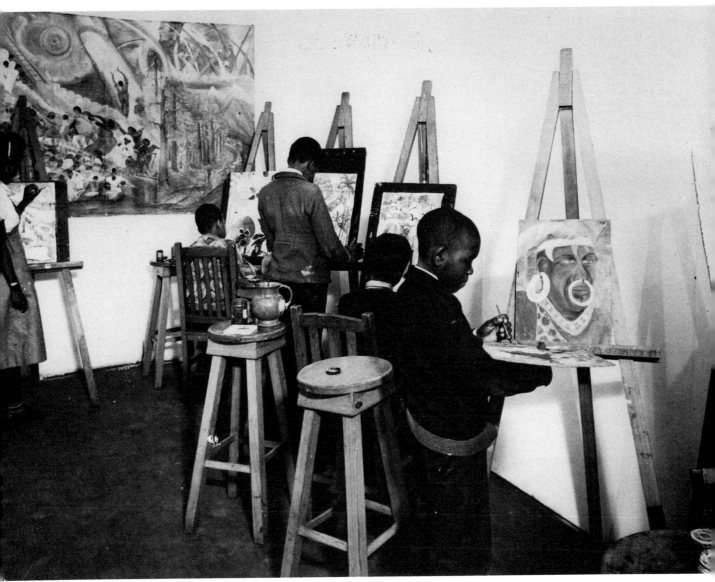

Art class at WPA/FAP Negro Art Gallery, Jacksonville, Florida. (NCFA:Cahill)

definite; relying upon their emotions, creating Negro music in their art.

Classes in three years, 1,749. Class attendance, 15,654. Student exhibitions, 56. State exhibitions, 14. Federal exhibitions, 20. Total gallery attendance at exhibitions, 16,748. Special services. Posters. Instruction, Public services. The public in this section looks to us for the cultural side of Jacksonville. These people have learned to depend upon us for their foundation of cultural achievements. Their programs founded on our programs; their cultural aim based upon our aim; their problems our problems.

Plans for the future: a State Negro Museum and Art Gallery. Through the efforts of our Local and State Sponsoring Committee, plans for a two-story stone and steel fireproof structure for housing museum galleries, offices, studios, and auditorium are being definitely formulated.

Towards accomplishing this end, the site for the building has been given by the Eartha White Settlement House; some material has been obtained. Citizens, local and state organizations, schools, the City of Jacksonville, Duval County, State of Florida, and the WPA have pledged moral and financial support for this structure.

Jacksonville Negro Federal Gallery. . . . The pioneer among Negro Art Centers!

The Spokane WPA Community Art Center

CARL MORRIS

On arriving in the virgin territory of Spokane, Washington, one of the first questions people asked was whether I would miss the pleasures and associations, the new and vital developments of the art world to which I was accustomed in the East. Contrary to the expected reply, I answered that nothing could be more stimulating and more important to my development than to be part of an educational institution whose purpose was the entrenchment of creative expression in a growing community. Bringing to the community the opportunities and benefits of the arts, heretofore limited to the larger cities, is one of the primary purposs of the WPA/FAP.

Spokane was prepared for an art center but, like other developing cities, it presented its own problems and potentialities. This relatively new city, located in one of the greatest wheat and mining sections of the United States, was not far removed from frontier problems. Long after the establishment of the Metropolitan Museum of Art in New York, the Art Institute of Chicago, and other art institutions throughout the East, the hardy citizens of Spokane were still digging gold and silver from the mountains, fishing the beautiful lakes and streams, and clearing the timber from the mountainsides. It is small wonder that these people found little time for art.

In 1871 Spokane boasted a total of four citizens— occupied for the most part as fishermen camped along the banks of the Spokane River. The population today is approximately 130,000.

When the WPA Community Art Center program was presented to this community, an art association already existed which sponsored and displayed a limited number of exhibitions in a small museum located in the residential section. There was also the Associated Art Teachers, which did good work in providing classes in creative expression for talented children. Starting with one class for 15 children, it grew to thirty classes attended by 600.

To these groups the possibility of the Federal Art Center meant a wider realization of their ideas, and through their efforts came the necessary local

sponsorship. Members of the Art Association, public-school teachers, and leading businessmen were among those who recognized the potentialities of the art center program. This group accepted the responsibility of raising $2,500. Businessmen's service clubs, the Junior League, women's organizations, and public-school children cooperated in the drive, which exceeded its goal by $1,000.

After funds were raised, renovation of the chosen location in the downtown district began. Carpenters, electricians, painters, and helpers were selected from the WPA relief rolls. The date for the opening of the center had been set much too soon to allow for the necessary building changes. Rather than postpone the date, workers ignored pay periods and time sheets. The general attitude of these men was: "Since we cannot contribute in cash, we can certainly give our labor."

So the art center opened its doors to the public on October 29, 1939. The galleries were filled with people from all walks of life.

One month after the opening of the galleries, our studio workshop program was scheduled to begin. There was only one instructor available from the State Federal Art Project for our teaching staff. We needed a minimum of five! Volunteers assisted with registration. Seven hundred students were registered for scheduled classes, and the waiting list mounted to a thousand. Still no instructors. Our SOS went from the State office to the National office. Subsequently, the New York Project was prevailed upon and our problem presented to artists of the New York production unit. Volunteers were asked to leave whatever work was at hand, to leave their families, and assist with a project entirely new in a part of the country heretofore without any art activities.

Soon four people boarded the train in New York for Spokane. The last of the group arrived two days before the opening of the school. At that time we had twenty people employed on the Project, including instructors, office help, and gallery attendants—all embarking on an uncharted course, but with the determination of pioneers.

From the beginning, gallery attendants and office workers have been required to attend at least one class per week. To date, one person has worked his way to a permanent position on our teaching staff. All the others have benefited in some way by the efficiency of our program.

While members of the general staff became a part of the educational program, the teaching staff was required to continue with production. Through such production work, a greater and more imaginative approach to teaching developed. With the tremendous demands made upon the teaching staff, it would be very easy for members to become "just another teacher," with all creative instinct stifled, and the work of their students consequently repressed and lacking in inspiration. It is therefore necessary that all instructors retain the time and energy necessary to create and produce in a measure comparable to artists on the production units.

Unlike an art school or museum, the purpose of an art center is not to serve only those people primarily interested in art, but all people, including students and hobbyists. Whether or not time is limited, the art center program must be flexible enough to include all people.

The problem, therefore, was to provide instruction and contact with the arts for varied interests and through various sources. For those interested as students of art, classes in life drawing, painting, and sculpture are provided. These classes, however, are flexible enough for those who simply want to understand and appreciate art through actual working contact. Many to whom class attendance is difficult fill their need through demonstrations and exhibitions. Lectures, too, touch many and varied subjects. For the home designer there are talks on decoration, fabric, color design, and arrangement. For those interested in the history of art, there is a series on the development of art from ancient times to the present day. And for many others there are discussions on innumerable special subjects.

Through the classes, lectures, and exhibitions, we are able to reach those in the community desirous of

learning. The types of people benefiting are as various as our approaches: business men and women, clerks, salespeople, nurses, physicians, housewives, laborers, railroad employees, school children, the unemployed—all find relaxation in one or more of the thirty weekly classes. Here they may gain a constructive occupation and an understanding of the art fields which have hitherto been unavailable to them, although especially necessary for their well-rounded development. Here they may find vocational activity, an opportunity for an education previously denied, and in many cases a chance for physical and emotional adjustment.

One student, who had to return home to work on the farm, managed to continue with her plastic sculpture by making a workshop in the busy farm kitchen. When her week's work was done, she rode in with the sculpture proudly displayed in the back of a truck. There is the nurse who changed her working hours to the night so that she could study most of the day; the girl whose home is 70 miles away and who scrubs floors for room and board so that she may attend classes in the afternoons and evenings; the woman, past 50, who knew of our insufficient funds for materials and who came to us "simply to break the raw clay and make it ready for others to use." These are only a few of the many persons in the local community who are constantly manifesting interest in the art classes of our center.

The problem of art centers today is comparable to that of libraries 50 years ago. Like the library the art center is working to integrate its program in the actual development of educational and social problems. Unlimited in its possibilities, the art center can and will become important in every phase of educational, industrial, and social constructive growth. It is our task to prove that a casual acquaintance with the arts through occasional lectures or exhibits is insufficient and that only through direct application and participation can the arts have practical use rather than merely provide culture.

Our students are learning the value of participation as a means to better appreciation, self expression, and education. Through their own efforts they are experiencing a real sense of enjoyment rather than a superficial form of entertainment.

Since the purpose of the art center is to make the citizens conscious not only of their own resources as individuals, but also of the artistic resources and possibilities of the community, our art center is focusing civic attention along those lines and trying to cooperate in city planning. A group of prominent citizens has organized into a civic arts committee. In cooperation with the Park Board, various projects are planned to improve the appearance of the city, especially along the highway approaches and riverbanks.

By means of extension work, the art center is fostering interest throughout the state, trying to reach with traveling exhibitions the rural districts where there is an absolute dearth of artistic opportunity. In addition to exhibitions sent to rural communities, our program is being expanded to send exhibits and instructors to hospitals and children's homes where the benefits of creative work have never before been offered.

Our center is less than one year old. Within this short time, however, our 4,000 monthly visitors prove that the community is learning to use the facilities of the center as a testing ground and as a laboratory for civic problems, as well as a place of enjoyment.

The Phoenix Art Center

PHILIP C. CURTIS

To say that the gallery, the workshops, and the patio of the Phoenix Federal Art Center were packed on the opening night of July 15, 1937, would certainly not be in itself significant. But when it is said that the temperature that night was 120 degrees and unbearably hot in the gallery, the workshops, and the patio, this fact then becomes tremendously important. Activities, particularly those of a cultural nature, are suspended during the summer months in Phoenix, Arizona, and there was a great deal of serious objection to an opening of the Art Center at that time.

There were also objections to having such things as classes, but when one week later the art supply stores had nearly run out of paint, charcoal, and paper, these objections did not seem well founded.

Parents brought their children from the desert, children were sent in from the surrounding small towns, and adults of all ages eagerly enrolled in the classes at the Phoenix Federal Art Center. This urge to express oneself in the plastic arts did burst forth, and the staff was completely unprepared to handle such response.

A community art center must meet the needs of the community. What are the needs? It would be wrong to say that all these people merely wanted a place to paint, and pictures to look at. Although Arizona is thought of as still being a frontier terrified by Indians, it is not; and Phoenix is not very unlike any other American City of sixty thousand. It might be said on the other hand, that the art frontier lies

within all towns of this country outside of the metropolitan areas.

In Phoenix, art interests have been confined to a very few. There is no museum of art; there is none within reach. There is a seasonal influx of metropolitan artists, but they take no part in local activities, and their time is taken up with the winter visitor and the spectacular "color" of the surrounding landscape. There have been organizations of local artists but they have lacked the facilities to reach the community at large. There are, however, several Indian museums throughout the State, and no doubt because of this, there is an awareness of an Indian art, but it has no defined relationship to contemporary life. All of this means that the average citizen of Phoenix is not aware of his cultural resources or what they can mean to him.

The need is obvious to discover our untouched cultural resources. When we mention that only a few hundred of our sixty thousand people are capable of responding to color, line, and form, or capable of making a worthwhile expression of these elements it is at once ridiculous. An observation of any group of children who are allowed to do their own creative painting dispels any notion that talent in plastic arts is confined to a rare few.

What can exhibitions do for this problem? The financial limitations made it necessary for the Art Center to preoccupy itself generally with the work of living artists. This immediately produced the necessity of showing this untutored group such things as a distorted nude, and paintings of smoky, unwholesome cities—these, they said at once, were not "beautiful." They have taken for granted that the Italian Renaissance developed art with a finality. It was found that this same group took for granted that Art meant only an easel painting, which must conform to their naturalistic pattern. On the other hand, art forms that they were not accustomed to seeing, such as mural painting, sculpture, tapestry, or a piece of fine jewelry, could be accepted in spite of a distortion or contemporary subject matter. This meant that the characteristic showing of oils and watercolors could not be the gallery technique. Showmanship, or new ways of exhibiting and arranging the exhibitions in the gallery, must be devised to make them as forceful and pointed as possible. There must be attractive and·easily read explanations. An emphasis on techniques and a full development of the various crafts are important. Each exhibition must be explained to the gallery visitor through his everyday experiences until there is a relationship established between art and himself; thus art may become, in its various uses, a necessary part of his own daily life.

Now, what about the classes? How does this phase meet this particular need? The most important thing in any community is the children, and children receive the greatest attention in the structure of the creative workshop of the Phoenix Federal Art Center. We feel that we can develop the cultural resources of the community most surely with this emphasis.

We have built a separate gallery—a children's gallery—one that is delightful to see and scaled to their vision. Exhibitions shown here will not necessarily be of their work, but exhibitions directed to them. Every Saturday morning the children come to the Art Center, and at nine o'clock they meet in their gallery for a carefully planned children's hour and the activities of the Junior Artists Club. These small children under the age of twelve elect in their club a hanging committee, and thus they actually take part by arranging shows. At this writing they are hanging a fine show of children's work from Mexico City.

The Junior Artists Club also has a radio membership. Each Friday afternoon a children's hour is given over the radio, at which time the lives and art of artists from all eras are discussed in such a manner as to appeal to children and to develop in them a fine understanding of art. Sculptured plaques and figurines are given them for membership and attendance, or for writing to the radio station. The same material is discussed Saturday morning in the gallery, and full-sized color reproductions are used to illustrate the work of the particular artist. Following the children's hour in the gallery on Saturday

morning, they all go to the workshop where they make their very bold and joyous paintings and little pieces of sculpture. They are allowed the utmost freedom, and we have found it necessary to have the best possible materials on hand. There are plenty of large brushes, rich, brilliant watercolors, finger paint, three or four sizes of paper from which they may choose, and a large pile of wet clay. These materials are furnished to them free, and they are all ready to be used when the children scramble in.

Besides the activities in the Center, we have established a circuit of exhibitions in the various county and city schools. Every two weeks each school on our list gets a new exhibition. The exhibitions are prepared around a theme and directed to the interest of the child. Each exhibition includes adult work as well as work of children, and each print or painting has an individual explanation from the child's point of view. This way we reach practically all the children of the county directly every two weeks, and we feel that through our choice of material and experimenting with explanations we are definitely arousing their interest.

The interest of the adults, on the other hand, noticeably grows from the intensity of our program with the children. The excitement and the little scrapbooks that the children take home each week are definitely reflected in the parents' attitude to our activities.

While our program with the adults is not as extensive, we have aroused a tremendous amount of interest in them through our classes. We emphasize the importance of doing work in the arts to have a great appreciation, and as often as every week, members of the staff lecture to them on art, using slides, reproductions, and the current exhibitions as illustrative material

Art in Action

DANIEL S. DEFENBACHER

The Walker Art Center in Minneapolis demonstrates art in action through public exhibitions, through workshops where people may pursue art avocationally and professionally, and through general educational and recreational events. In such ways the Center will bring art to more and more people.

The average man does not believe that art is important to him, in spite of the fact that he uses art every day of his life. He knows vaguely that man has had art since the dawn of history, when his prehistoric ancestor painted a bison on the wall of a cave. He also knows that there is such a thing as art today although, to him, it may mean only a painting in a museum. He is willing to admit that a painting may have definite uses, but he will not admit that these uses are particularly necessary to his existence.

His attitude, of course, is mainly a product of a misconception of where and how art functions in relation to his personal environment. The misunderstanding creates an unfortunate situation, but not an irremediable one. The average man is not too proud to admit his vagueness about art. He is willing to learn. He may not be exactly eager to know all of the intricate details, but he will listen to a few fundamentals. Like a man learning to drive a car, he feels that he can get along without knowing the physics of internal combustion if he knows enough to make the car perform its duties effectively. It is knowing the use of the car that counts. It is also knowing the use of art that will alter his attitude toward the part that art plays in his life.

It is true that at times this association of art and

man becomes obscured. Today we are passing through a period of rapid change. The carved butter-mold has been discarded for the machine-stamped wrapper. Thousands of women wear the same dress made by the same machine instead of a dress made by their own hands or by their own seamstress—the old wire dress dummy is in the attic. We accept readymade apartments rather than building houses. The movie has displaced the sewing circle. These things have taken art away from the hands that once made their own butter-molds, their own houses, and their own entertainment. The machine-stamped package is today's art, but it is of a different kind than the history books illustrate; the same art exists today as before, but the pattern looks so unfamiliar that the average man fails to recognize it. Art works in new surroundings and on newly created things.

We sometimes hear statements to the effect that "Art lives only in museums." The phrase does not belittle the museum or its importance. It merely implies that, to most of us, museum art is all of art, and most important, that art seems to be nothing more than a series of objects, suspended in time and space with no apparent connection to the hands that wrought them or to the lives of the people that were enriched by them. We are apt to forget entirely that these objects were put to use in the daily work of their ancient owners.

It is not strange, then, that today there is a separation in our minds between a useful object and one that is artistic. If we do not comprehend that a pottery jug was used for carrying water by the Persians rather than being merely a manifestation of art in a glass case, we cannot understand that our own milk bottles are potential art objects. Therefore, we do not bother to consciously design the bottles in an artistic fashion. If we do endeavor to give ourselves aesthetic pleasure by surrounding ourselves with beautiful things, we go to the museum where art is supposed to reside exclusively, and borrow our patterns from the past. We do not label as art the things which are built or manufactured today for our

daily use. We live in a colonial house designed by century-old ideas and yesterday's knowledge. We fill the house with yesterday's objects. New knowledge, new materials, and new conditions mean nothing to us in spite of the enrichment they could bring to our lives. If we consider the house and its properties as art at all, they must be objects rubber-stamped by a vintage. Art in our houses is established by date, not by design or form. We will buy a lamp-base stamped out by a machine, but it must be a duplicate of a Greek column which was originally carved by hand. The lamp-base, if it carries an ancient form, is regarded as art; if it carries a new form dictated by new processes it is only a utensil. This separation of museum art and art in use deprives us needlessly of many opportunities for aesthetic enjoyment.

The aesthetic experience put in motion by the object of art is the same aesthetic experience that in varying degree pervades a broad range of human activity. As medicine influences our diet, our clothes, and our habits, so art influences our dress, our conduct, and our environment. It is difficult for the average person to understand that the art object has a bearing upon these latter things. Dress, conduct, and environment are totally different from painting and music, for example, and are produced by widely differing skills. Actually all spring from the same creative process of molding something from the stuff at hand. As music can be made from notes, our environment can be molded from the opportunities around us. The application of art is totally different, but basically, the same quality of art exists in all. It is simpler, perhaps, to see art labeled as such only in a museum and to remain unaware of its actual use in the pattern of daily life.

The art of the past—museum art—is important and useful to man in a very practical sense. It gives him pleasure, provides an opportunity to exercise his aesthetic sense, and gives him a basis for comparisons and evaluations of art as he uses it. In this sense the object of art, present as well as past, is an active force useful to every man. Museum art in action is

generally recognized and in some measure fostered in our communities. It is the other phases of art in action that are obscured and forgotten.

A small minority of men and women use art as a profession. They form the vanguard of all artistic development. The professional is the standard bearer whose product will be used by time to mark our state of culture. In the obscured relationship of man and art we are apt to forget that the artist labels our civilization indelibly in the story of mankind. Ask the average man to name three famous people who mark the history of the Renaissance. He will name one and probably two artists—Leonardo da Vinci and Michelangelo. He will probably not name one politician, doctor, or athlete, and very likely he will be unaware that Leonardo, although known as an artist, actually was more an architect and engineer. It is well for us to remember that the artist in our time, the man who uses art as a means of livelihood, will mark our time as surely as Leonardo marked his. It is also well for us to recall that Leonardo's work is, in reality, only a selected example of the work produced by thousands of nameless artists of his period. If the thousands had not been working, there probably would have been no work by Leonardo. So, in our time, there must be many artists, mature and immature, who live art and whose action in the community is to produce the objects of art.

A growing number of people use art as an avocation. These form a link between the professional and the layman. Their action is one of direct leadership. They speak the language of artist and layman and act as guide from one to the other. It may be said that art functions in the community through these people. As often as not they are the spearheads of art movements. Every community art association or club abounds in them. They paint, they write, they landscape, they collect, they build. To them art in action is an integral part of their existence.

An even greater number of people use art as entertainment. Art to them is a spectacle to be observed. Some are constructively critical, others dabble for fun, and still others merely pass the time in pleasant spectatorship. Their function is one of broadening the scope of art in the community. In the relationship of art to man they give encouragement and support and form a fertile field of material from which new leaders and new artists may eventually arise.

As a consumer every man uses art. Art in action for him is art in every phase of his existence—the selection of clothes, houses, actions, tools, and utensils. He uses aesthetics much as the artist does, although in less concentrated form. His medium he obtains from stores, manufacturers, and builders. His composition is his environment. As he collects and arranges objects for his use he makes a visual pattern of his life. The way he arranges his house and the way he equips his community make a picture so fundamentally art that it has always been the really great subject for the painter's canvas and the musician's score. To the consumer, art is a daily action involving the most fundamental human needs.

Every merchant and manufacturer uses art by selling or making objects which, potentially at least, are objects of art. The perfume vial of the ancient Egyptians preserved and displayed by our museums has its counterpart today in Woolworth's or Tiffany's. Unfortunately the manufacturer uses art, not as such, but as a form of sensationalism. He knows that the appearance of his product is often more important in selling than the functional quality. He not only seeks to find the mean level of consumer ideas on art, but he seeks to exploit it and exaggerate it. For example, much inexpensive glass tableware is decorated with a bursting profusion of embossed leaves and rosebuds. The garlands are not necessary and are certainly not highly artistic. However, the manufacturer knows that the consumer will buy plates with garlands. Therefore he not only applies the garlands in liberal quantity but he also makes the plates a garish green to exaggerate the effect. By smothering the consumer with mediocrity in art, he tends to retard art development. In some cases, of course, the

manufacturer and merchant exert a constructive force, but on the whole they follow the consumer rather than lead him. Nevertheless, they are men using art, and their use of it must be understood as a phase of art in action.

Man uses art in constructing his community. The planning of housing, parks, streets, industrial areas, and residential areas embraces the qualities of harmony and aesthetic perception which define art. Community planning, of course, is a result of function and art indivisibly integrated with each other. The functional element is the use which man makes of the community; the art element is the appearance of the community and the effect which this appearance may have on man's development. Here is art woven inextricably with man's daily life. The layman uses this form of art as constantly as the artist uses paint.

These are the uses of art in life—as an object for aesthetic enjoyment and guidance; and as an action for the professional, the avocationalist, the spectator, the consumer, the industrialist, and the citizen. They are uses that exist through all ages in changing appearances but not in varying degree. In our time these uses have been obscured by a curtain of misconception—a curtain woven of social and economic change. The threads of the curtain are mass production, machines, new frontiers, and revolutionary scientific discoveries. Behind this curtain art is recognized only on a pedestal. If man is to use art constructively and well, this misconception must be dissolved. Art must be seen for what it is and for what it does in community life. We must know that it

can be used as an influence in the development of civilization; that the professional can work to raise the level of our artistry in objects; that the consumer can strive to make his environment harmonious and beautiful as well as functional; and that most men can get personal pleasure, at least, from conducting their lives with some degree of aesthetic sensitivity.

The recognition of the uses of art must, of course, be guided and demonstrated. There is, therefore, a need for leadership through a community workshop where demonstrations of art in action may be presented and where people may refocus their use of art by doing as well as by seeing. We have established this community leadership for health, social welfare, and science; we must follow the same course for art.

In the recent past the museum has been generally understood to be the leader and demonstrator of art in life. Actually, the traditional museum has dealt only in the collection, preservation, and presentation of objects belonging mostly to the past. It has generally forgotten present-day professionalism, avocationalism, consumer art, and such things as industrial design. In reality the traditional museum has done its work in one phase of art but has ignored the broadest phases, those directly touching the greatest numbers of people. Often this onesidedness is used as a mark for derision. It is a point badly taken. The traditional museum job is as necessary as any other and may well occupy the entire time of one institution.

In every community, however, there is a need for an institution of public character, such as the Walker Art Center, which will show the average man a synthesis of all of the phases and uses of art.

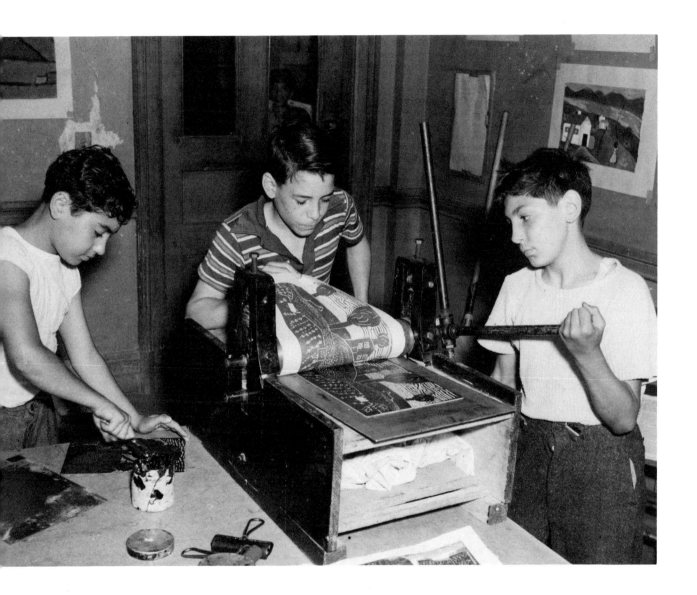

Children's art class at the University Settlement House, New York City, c. 1940. (AAA)

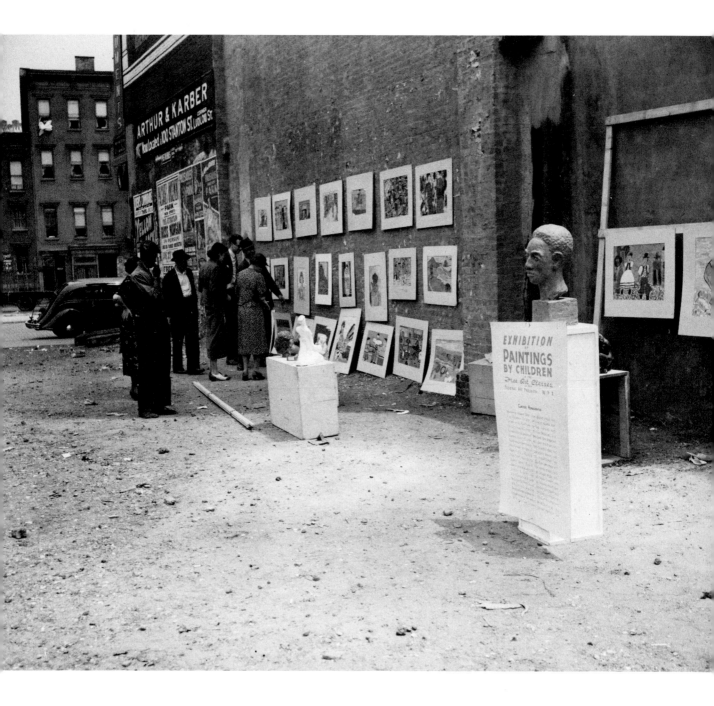

Art exhibit in an alley, New York City, c. 1938. (AAA)

The Exhibition Program of the WPA/FAP

MARY MORSELL

The exhibitions of the WPA/FAP have sought to bring a wider experience of art to the entire country and to give artists a healthy contact with large audiences. In the past, a few attempts were made by various museums to break through this impasse. Inevitably, these so-called "national exhibitions" were thin and pitiful in their gleanings, because there had been no true cultivation of our artistic soil. The idea that art could flourish only on the Atlantic Seaboard was a fallacy, but it was difficult to dispel. Yet this tendency towards a single, dominant art center was based on expediency, rather than logic. It starved both the artist and the public and tended to create false standards and false values in American art.

A simple principle has governed the selection of Project exhibitions, whether large or small. They are a means of revealing the new impulses towards a free and sincere expression that have developed in this country under government patronage. Artists who have worked in their home environment, undisturbed by the conflicting currents of prevalent fashions, come together in Project displays as in a symposium that is essentially American. Through the healthy community contacts and true regionalism which have been the living spirit of the movement, freshness and vigor of accent and expression have appeared in sections of the country formerly thought barren. These are the "New Horizons" which the displays reveal. To the young men and women who have come to maturity during the depression, the exhibitions have given healthy democratic opportunities for recognition and growth through criticism. To older artists, who under former conditions were in danger of either discouragement or acceptance of prevailing formulae, they have given stimulation and a fresh set of values.

A new America, more robust than any hitherto discovered in contemporary art, appears without self-consciousness in Project displays. In addition to the fresh impetus in mural painting, easel painting, and graphic art apparent in the work from New York City, the full energy and imagination of the Middle West is apparent for the first time. New England finds release from its inhibitions in works which range from forceful figure painting to watercolors of the Maine coast. The picturesque exuberance of the Far West and the Southwest comes to closer grips with reality in art that expresses the reality of sky and mountains rather than their mere outward beauty. The South escapes from prettiness into a true exploration of the pictorial significance of land, people, and cities.

For the general public, Project exhibitions have sought to build up a new and more enduring relationship with the artist. Both the circuit exhibitions sent out to the Community Art Centers in the South and the large invitation displays held in museums throughout the country have presented a cross section of achievement, as varied as our own landscape, psychology, and racial interminglings. A typ-

229

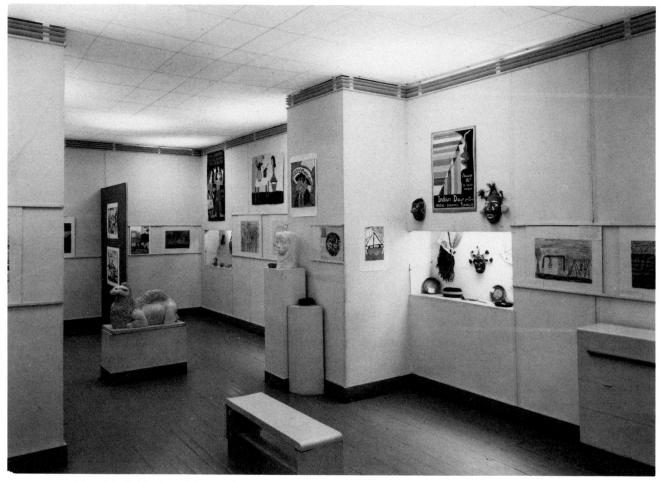

View of the Children's Art Gallery, Washington, D.C. The camel is by Eugenie Gershoy of New York. (NCFA:Cahill)

ical exhibition may include a painting of a Negro graveyard in New Orleans; a mural sketch with symbols drawn from the machine; Middle Western farmyards seen in a mood of poetic fantasy; and a piece of mystical folk sculpture, almost Romanesque in its intensity of feeling and simplicity of form. All these are elements of the panorama of the art of the American future. Like a slow journey from New York to San Francisco, they give a vivid sense of all that may be ours, if cultural riches be given one half the encouragement that has brought triumph in the mechanical and industrial world.

In the assembling of each exhibition, whether small or large, care is taken to choose pictures which will present this cross section. In addition to unfold-

ing this fresh panorama of American art, displays are marked by a sound and democratic mingling of known and unknown talents. An artist who has won many prizes is hung on equal terms with a newcomer. Conservative and experimental talents also have their logical place, provided only that technique be sound and expression sincere. Since the quality of the work done during the past year has won showing for the Project in leading museums, the work of hitherto unknown artists has come before discerning critics, patrons, and dealers, eager to support something new and vital in our art.

In several sections of the country, and especially in the South, the exhibitions of the Project have created an active, popular interest in contemporary

art for the first time. Here people have learned to read the language of painting, to realize that art is not an experience for the few, but an extension of experience, possible to all. In general, the people who have thronged to Project exhibitions during the past year have obviously been responsive to the sincerity and spirit of the displays. They show a new approach towards painting, marked by the genuine eagerness that is given to, new books or plays or music. Lively discussions, instead of the borrowed aestheticism of fashionable displays, is the general rule in Project exhibits. Friendly and well-informed docents in both the Art Centers and Project Galleries answer questions and adopt a simple and human approach to visitors with a possible inferiority complex about art. Usually, however, such explanations are unnecessary. Gallery visitors feel that the works before them are alive. They respond accordingly.

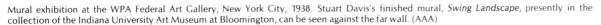

Mural exhibition at the WPA Federal Art Gallery, New York City, 1938. Stuart Davis's finished mural, *Swing Landscape,* presently in the collection of the Indiana University Art Museum at Bloomington, can be seen against the far wall. (AAA)

Art Comes to the People

EUGENE LUDINS

One of the problems with which the WPA/FAP has concerned itself is that of reaching people in the rural communities and bringing to them some of the cultural experiences available to those who live in the big cities. Because large areas existed in ignorance of the Project's many services, a twofold plan was developed in New York State designed to create interest in the arts and encourage local participation.

A chain of small art teaching and exhibition units throughout the state was established, with the cooperation of local groups and school authorities, to be serviced and advised from a central headquarters. Communities have been encouraged to start local art collections by subscribing in advance to a series of exhibitions of art works furnished by the New York State Art Project, from which they may select paintings, prints, etc., for permanent allocation.

A motorized Art Caravan was equipped to carry a complete outdoor exhibition, and tours were lined up for visits to a series of communities within easy driving distance of each other. The exhibitions were set up in a prominent location, such as the town square or the lawn in front of the local school or library, and remained on view during the day. The public responded unconsciously to the charm of an outdoor setting, and much time was spent studying the paintings and sculpture. In the evening an indoor lecture and discussion was usually held. The Caravan would then move on to the next town.

Many practical difficulties needed to be solved before this program could be realized, not the least of which was the necessity for keeping costs to a minimum. However, an old army ambulance was obtained, the body of the truck rebuilt, and the interior redesigned for its new purpose. By extremely careful planning and by the utilization of every inch of space, it was found possible to carry and display a wide range of art works. The equipment included six

large folding standards on which to hang oil paintings, a number of folding screens for prints, watercolors, and Index of American Design plates, six boxes for packing sculpture, which were also used as stands for its display, a number of folding easels, and other necessary paraphernalia. All of this equipment was made by members of the New York State Art Project. Results were extremely gratifying, for besides looking well and showing the paintings and prints to the best possible advantage, the equipment was very strong and yet light enought to be handled by one man. The entire exhibition could be unloaded from the truck and set up in little more than an hour.

The Project was fortunate in obtaining the services of Mr. Judson Smith, and later as his successor Mr. Kaj Klitgaard, to supervise and travel with the Art Caravan. Both of these men had had wide experience as artists and lecturers. It was their duty to make advance arrangements for the exhibitions, to give informal "gallery talks" to visitors, and deliver lectures in the evenings in any hall available. A driver was employed, whose duties, besides driving and servicing the Caravan, consisted of assembling and placing the various standards and hanging the exhibition. At evening lectures he operated a moving picture projector and lantern for slides, which were also part of the Caravan equipment.

In order to judge the interest of visitors to these informal exhibitions, a ballot box was provided and paper ballots distributed. Besides voting for the work they liked best, people were asked whether or not they would be interested in the establishment of a community art center or in obtaining any of the other services of the Project. In every case the vote was overwhelmingly in favor of the initiation of some art activity in the vicinity. The Art Caravan usually found a friendly and curious public during its visit, and some local person with organizing ability, such as the art teacher from the high school, would form a citizen's committee to develop plans for participating in some phase of the Project's programs.

As an example of the effectiveness of this method

of approach, some excerpts from one of the regular monthly reports to Washington may be quoted:

The exhibition at Ellenville, New York, started a movement for an extension gallery. Suitable quarters have been found and the necessary funds for renovating the building and for co-sponsoring an exhibition program have been pledged.

Radburn, New Jersey, is definitely interested in starting a teaching center and exhibition gallery.

At Atlantic City the president of the Contemporary Art Association, after seeing the Art Caravan, offered to sponsor a WPA art exhibition on the famous Steel Pier for the duration of the summer.

At Allentown, Pennsylvania, we received a request from the Consolidated Schools for the allocation of three paintings, several prints, and a mural decoration.

At Stroudsburg, Pennsylvania, a request for a mural for the local high school was received.

Although the Caravan has been in use for a short time, it has already demonstrated its great value, judging from the response of the thousands of people who saw it. It proved over and over again that the very people who "know nothing about art" are the most easily interested when it is presented to them informally and they are encouraged to express their opinions. Significant exhibitions have been brought to places that had never before seen an art exhibition of any description. It has made an entirely new public aware of the WPA/FAP as a functioning cultural influence available even to the smallest village or township.

If this experiment could be expanded and the technique improved through further experience, the Art Caravan would become a powerful medium for the introduction of new and vital interests into the lives of thousands of children and adults who are isolated from the big cities but who nevertheless make up the great majority of the people of this country.

Part IV
ARTISTS' ORGANIZATIONS

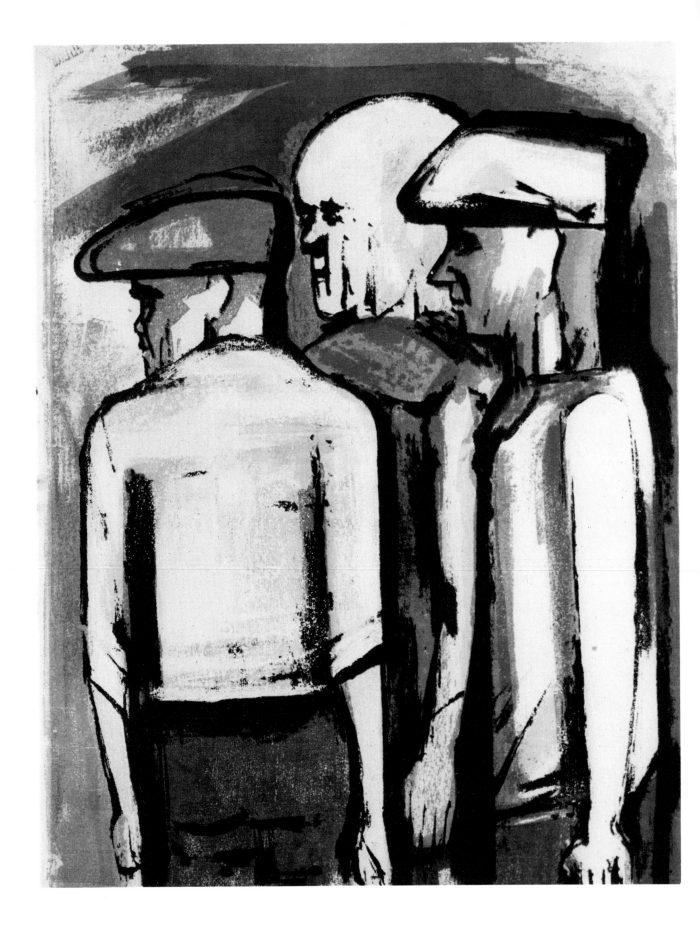

The Artists' Union of America

CHET LA MORE

Four years ago there was no union or unity among the plastic and graphic artists in America. Today there is a firmly established organization touching the larger centers of our country from Cape Cod to the Bay of San Francisco. In this short period our artists have not only built a Union but have created a tradition for organization which makes clear for the first time a new path for the future development of culture in the United States. To understand the significance of the Artists' Union it is necessary to understand the economic, cultural, and social soil from which it has grown.

The history of the past decade is the story of the great crisis and its effect upon various strata of the population. To the artists, 1929 does not represent an abrupt change, but merely a point of intensification in the process which has slowly been forcing them downward in the economic scale. The majority of the younger artists and a tremendous section of those who were well established reached the rock bottom of home relief and welcomed it as an improvement over their previous situation. The first renaissance of American art was at an end. The art market, as well as the stock market, had collapsed. Private patronage had failed in the function it must perform to have validity as an instrument for sustaining a vital development of contemporary art. This failure was based upon its utter inadequacy as a means of distributing contemporary art to a suffi-

ciently large section of the population to insure an audience for that art and consequently stable financial support upon which basis the movement could develop. It is from the finality of this failure that the history of a new movement was begun.

It must be understood that no culture can be built without an economic base of sufficient strength and stability to allow the artist his right to life and the chance to work in his craft. The art market failed because it was predicated upon the exclusive support of the top-flight economic groups and relied upon upper-class philanthropy to bring art to the people as a whole.

The artist quite correctly refused to accept this failure as meaning the end of contemporary art. From his vantage point at the bottom of the economic pile, he was able for the first time to realize the necessity for support from the entire population. The first Artists' Unions demanded and won Government support and sponsorship for art through the PWAP. The importance of government support is that it constitutes support for art by the people as a whole. Culturally such support is important in that it demands a growth within the art movement itself toward the entire people. The face of American art at last was turned toward the entire population through economic and cultural necessity. The WPA/FAP is the historical beginning of a new and democratic movement of art in America.

The growth and expansion of the Artists' Unions nationally marks the spread of this new art move-

Chet La More. *Unemployed*. Color lithograph, New York City Project, c. 1941. (AAA)

ment among the artists as a social group. The continual broadening of the program of the Artists' Unions, which has evolved from the curt demand for Government support and sponsorship of art to a complete exposition of the social and cultural necessity for democratic direction within the art field upon the basis of Government support, indicates the deepened understanding of the implications of our basic program among the artists. Our steadily increasing influence among other sections of the population establishes our growth as the only cultural organization which is taking its place in the forefront of the progressive movement to better the life of everyday America.

It is because we, as artists, understand these steps in our evolution as an important social group that we are able today to project our program for the establishment of a Federal Bureau of Fine Arts as the agency for perpetuating and carrying on permanent Government support for the arts in America. We bring forward this program not merely in order to solve our economic problem. We regard it as the only solution for the permanent incorporation of the arts into the life of every American citizen. Behind this program lies the logic of our national historical development as a democracy, which resulted in the establishment of our free and public system of education over one hundred years ago. Through it, our common cultural weal may be expanded to encompass the entire scope of our national life.

From their first breath the Artists' Unions have been the center of the movement for Government sponsorship of the arts and the prime stimulant for a democratic direction in the growth of our national culture. Through our Public Use of Art Committees we have built and instrumented a far-flung program for the increased use of art among the people and also in connection with many special fields such as education, psychiatry, physical therapy. The Artists' Unions have given the artists of America a new perspective for growth through which they will be able, in collaboration with all other American citizens, to build an art in our country predicated upon our historical ideals of democracy.*

*In an essay written for *Art for the Millions* by Mildred Rackley, called "The United American Artists: A Trade Union for Artists," which has not been included in this volume, the following pertinent information is given: "The New York Artists' Union became the United American Artists, Local 60, United Office and Professional Workers of America, CIO, in December, 1937. Any member who is in good standing may put the union label under the signature on his painting or sculpture. Many have done so. Local 60, whose president is Rockwell Kent, brought into itself the membership of three organizations: the Artists' Union of New York, the Commercial Artists' and Designers' Union, which had been a federal local of the American Federation of Labor, and the Cartoonists' Guild, a national independent organization. The United Office and Professional Workers of America subsequently chartered local unions of artists in other cities: they are established in every section of the country and have a total membership of 2,500. The work of these locals is co-ordinated by the National Advisory Committee for Organization of Artists."

Chicago and the Artists' Union

ROBERT JAY WOLFF

At the time of the formation of the Artists' Union in 1935, the dominant factors in Chicago's art world, the Art Institute, the wealthy art patrons, and the artists themselves, formed a community which could be broadly classified as progressive where matters of art were concerned. The two annual exhibitions of American art at the Art Institute over a period of years had awarded prizes to a long list of progressive painters and sculptors. Collectors such as Eddy and Ryerson had made the Art Institute internationally known for its great collection of modern art. The great Armory Show of 1913 was the impetus behind twenty-five years of development on the part of Chicago artists during which time they definitely established themselves in the sphere of contemporary art trends. However, when a group of artists banded together and called itself a trade union, this community was outraged. Ironically it was the artists themselves, along with the two local critics, whose wrath was the most righteous. The Art Institute, to its credit, though it disapproved at first, at no time failed to recognize the Artists' Union and before long cooperated with its cultural program.

The facts behind the formation of the Union are closely linked with the character of the art community. For the first time painters and sculptors were being offered regular employment within the bounds of their own profession. The establishment of the WPA/FAP accomplished this historic and unprecedented step. One would assume offhand that this farsighted attempt to find for the artist a useful and gainful place in society would have been accepted with wonder and enthusiasm by the whole community. This was not so.

The fact is that this community, not excluding the artists, was comparatively progressive only insofar as works of art were concerned. When it came to considering the artist, the community's ideas about him were as old-fashioned as those of "La Bohème." The artist was a talented misfit. Since the monetary

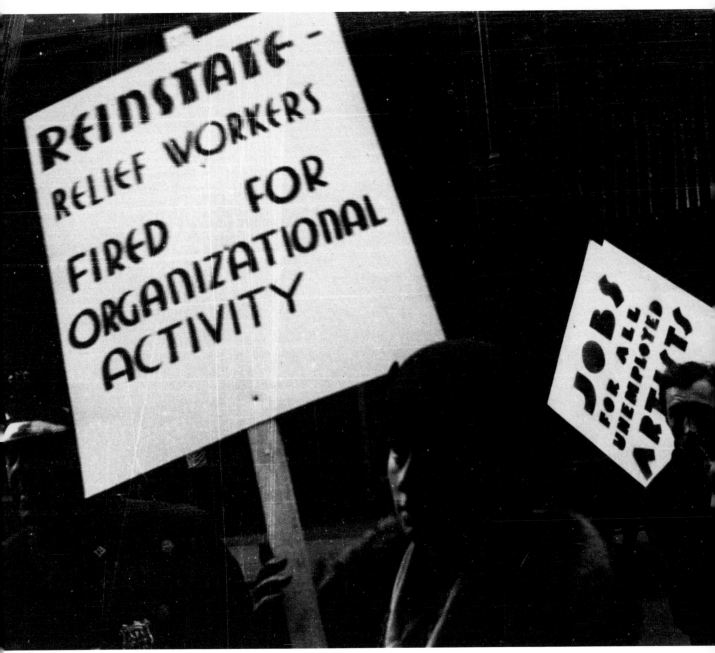

Artists and picket signs. (Photo: Irving Marantz)

value of his wares could not be judged safely during his lifetime, he could not be considered a respectable economic member of society. He required charity. This point of view engendered a kind of abstract paternalism. In this way the patron was able to place a self-beatifying interpretation on speculation in highly marketable French contemporary art, while he managed to ignore his Chicago charities.

The artists, on the other hand, struggled with a hopeless situation, living the traditional precarious existence. Still, by and large, they too clung to the Bohemian legend that gave to their poverty and their isolation a kind of precious freedom and exemption from the humbling process of identifying their efforts with the efforts of others. It is safe to say that not a few of them at the beginning of the Project were prepared to be ashamed of their employment.

The formation of the Artists' Union two years after

the creation of the Project was the inevitable result of the community's inability to see the artist as anything but an object of charity or benevolent patronage. The Project was set up in Chicago by people who could think in no other terms, and their minds were further closed to the real issue by the nature of the new agency, which was officially identified with work-relief and general unemployment. The relief station had taken the place of the garret, and the benevolent patron had become a government official.

To the artists, the idea of organizing for the purpose of economic security was new and strange. Their experience in organization was limited to the fields of exhibitions and the segregation of aesthetic ideologies. Chicago has seen many art societies and groups come and go, some of them successful insofar as they brought to their members a modicum of local publicity. Until the appearance of the Artists' Union no organization had had the forthright courage frankly to acknowledge and face the fact that the artist was a hopelessly maladjusted member of society. It was as though by means of one exhibition after another the long string of art societies had hoped to throw a smoke screen of aesthetic and professional activity around the shameful fact that the community wished to escape. The new group wisely chose the word "union." By calling itself a union the organization identified itself with the underprivileged. This shattered the old illusion of the lofty position of the artist and publicly put him in the ranks of the unemployed. The community deeply resented being jolted out of its comfortable evasion of the bitter truth. Formation of a new artists' organization would have been an ordinary event. That it should call itself the Artists' Union was to most a display of bad taste.

It was in this way that the WPA/FAP and the Artists' Union found themselves in a completely hostile environment. Applying the old conception that able men will always find employment and that the incompetent will always be unemployed, the community washed its hands of the Project. So long

as the artists on the Project did not ask to be taken seriously, the Project was tolerated, as were other work-relief agencies, as a kind of unpleasant but inevitable result of economic depression. The appearance of the Artists' Union changed matters. It was a challenge to the community to admit that an honored profession existed in its midst and was being starved out of existence. If it were to accept the Project as a legitimate enterprise, it would have to reveal its own essential indifference to the fate of native art or subscribe to a principle of federal help which bordered on socialism. Instead of subscribing to this principle, the community used it as a weapon to discredit both the Project and the Union. The red herring was dragged across the face of both.

The original constitution of the Union was as uncompromisingly democratic as the Bill of Rights. It guaranteed the right of any artist to membership in the Union. The organization in its early days had to undergo the relentless persecution of violent reaction. The fact that the only artists to understand the significance of these first steps in social readjustment were those who had not closed their eyes to history and were consequently known as "reds and radicals," and the fact that these constituted the majority of the charter members were used by the community to distort the basic democracy of the organization into a kind of revolutionary plot. It was an easy matter to play the Union against the Project and to use one to discredit the other. In this way word went the rounds that the unemployed incompetents on the Project sought to perpetuate their employment by forming a union. Similarly, that the "reds" of the Union were using a government charity for propaganda purposes. It took some courage in those days to join the Artists' Union, and the atmosphere on the Project was tense and bitter. In spite of this, the best painters and sculptors in Chicago were managing to turn out work that soon was to create the nationwide impression that Chicago was an increasingly important center of American art. Ironically, the artistic reputation of this community was being enhanced by those very

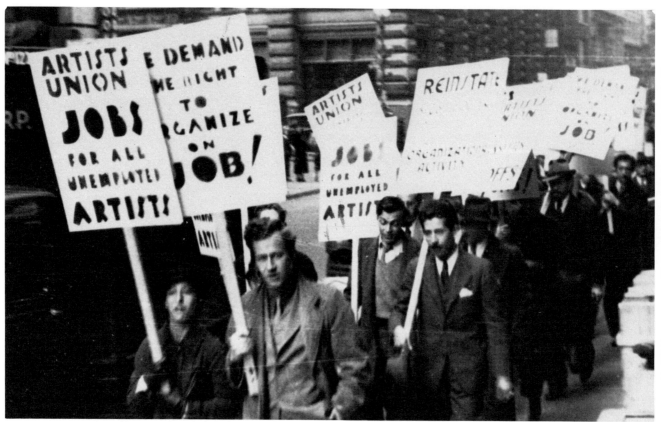

Artists' Union picket line. (Photo: Irving Marantz)

artists whom it denounced and vilified. It took Chicago three years to realize that Artists' Union members were being recognized by museums and foundations all over the country. Today the WPA/FAP is accepted almost as a civic institution, and Union membership is a commonplace.

The Union began working in the direction of community support, and an attempt was made to end its position of isolation. It leased a gallery where the work of Union members was exhibited and offered for sale. Traveling exhibitions of an international character were brought to Chicago by the gallery. A series of lectures on art subjects was instituted. The Union interested itself in broadening the scope of local exhibitions and was instrumental in initiating the huge Navy Pier annuals. As the field of the Union's activity grew, it made new friends. Financially, it barely made ends meet. Dues were kept as low as possible, and it was difficult to be strict about their collection, considering the incomes of the members. In spite of this the organization remains solvent and is indebted to no one but its members for its existence. No one, officers or

members, has ever received payment of any kind for services. In 1937 the Union affiliated with the American Federation of Labor. This affiliation was terminated in 1939, and the organization became a local affiliate of the United Office and Professional Workers, Congress of Industrial Organizations. The name was changed to United American Artists, and the group became a unit of a national organization of artists.

Over a period of four years the Project has enlarged what was once a small professional art community to include the thousands of lay citizens whose schools, libraries, and hospitals contain the work of local artists. These thousands constitute a new patronage whose enthusiastic acceptance of the Project's work has given to the artist what the old, isolated art community could never give: vital encouragement and a respected and useful place in the scheme of things. The Union, which in the beginning was the voice of artists demanding the chance to work, is finally becoming the collective voice of this new and fruitful patronage.

The Minnesota Artists' Union

EINAR HEIBERG

The spring of 1935 witnessed the formation of a new and progressive association composed of the leading artists of Minnesota. Faced by an ever-increasing economic crisis and tiring of their traditional isolation and non-participation in the affairs and questions pertaining to their very existence as a cultural force, they banded together, hoping that by their united efforts and through direct contacts with the public, they could change the old stereotype of the artist: an obscure person with long, unkempt hair cascading over his shoulders, living in an attic, wearing a beret and black string tie, and having an utter disregard for convention. His was a labor of love. He produced pictures merely because he liked to paint, then sent them to the dealer who made the profit.

Artists throughout the country were beginning to realize that modern life demanded a relinquishment of their traditional aloofness from everyday affairs and trends. They decided to do something about it. They realized that an individual artist who might have the temerity to vocalize his objections to being kept in obscurity through the failure of the public to gauge has value in the cultural world would have little chance of being heard.

They realized that to work for a greater understanding between artists and the public, to further the cultural development of the state, to promote a better spirit of cooperation between the artists of Minnesota and the artists elsewhere in matters of mutual interest and benefit, to work for an economic adjustment between artist and employer, a united voice was needed—a voice strong enough in numbers to be heard, a voice backed by an organization determined to be heard.

A group of well-known Minnesota artists met one evening in June 1935 to discuss and to plan. Among them were Charles Wells, Cameron Booth, Erle Loran, LeRoy Turner, Mac LeSueur, Sydney Fossum, Stanford Fenelle, Elmer Harmes, Samuel Sabean, Frederic Johannes, Wilhelm Bodine, and several others. Enthusiasm ran high among them, and they left that meeting with high resolve. By July 1935, the

Association was completely organized and the first regular meeting was called for the 10th.

Charles Wells was President, Elmer Harmes, Vice-President, LeRoy Turner, Secretary, and Wilhelm Bodine, Treasurer. On July 23, 1935, they adopted the name of Minnesota Artists' Union and immediately began a drive for members.

They experienced an instant and most gratifying success and soon had a membership of well over one hundred members.

The organization immediately became active and made its presence felt in the community by actively working for the improvement and enlargement of the Treasury Section which was then in operation, but not representing a very great number. They helped guide the Section in channels that were designed to promote a better understanding in the matter of public works of art and in the education of the public to the great cultural benefit of the establishment of a WPA/FAP.

Working ceaselessly on this idea, the Union made strong contacts with artists' organizations in New York, Chicago, Cincinnati, and many other points, which led to an interchange of ideas and to the strengthening of the spirit within the young Minnesota group.

In October 1935, the Project, under the WPA was announced to the Union. A detailed report of this action was read to its members. Much of the future success of this project was due directly to the active part the Union played in its formation. A realization of the advantages of united action became apparent at once, since the Project gave a measure of security to nearly one hundred Minnesota artists.

In December 1935, the Union first participated in a movement of national scope when the Rental Policy in the exhibition of the works of artists throughout the country was laid before it for discussion and consideration. This policy at once became a highly controversial issue throughout the country between the museums and the exhibiting artists. The idea that an artist should be paid a definite sum for the exhibition of his work was preposterous in the minds of the museum directors. It had never been done! They were furnishing a place where the artist could exhibit his work, gain prestige and an occasional prize; they felt that a demand for a rental fee was outrageous.

The Union, however, took a different viewpoint and called attention to the unreasonableness of the objections. Should a group of musicians play without recompense, for instance, simply because a hall had been provided? Should a singer give a program without remuneration simply because of the donation of a stage and possibly an accompanist? The artists felt there was no logic in the protests of the museum directors, and felt there was as much value in a given work of art as there might be in an orchestration, or a song, or a dental extraction. Prestige acquired from the hanging of a picture might bring the artist a lot of pretty words and some encouragement, but very few groceries. The artist had made up his mind once and for all to make an attempt at moving from the attic to at least the second floor, and to eat more regularly—in short, to make an attempt to better his economic position and his value to society. To earn a steady income and be enabled to hold his head up would be recognition enough.

The first success in applying the Rental Policy came in September 1936, when the Minnesota State Fair agreed to pay a rental fee instead of making the usual distribution of prizes. On the other hand, the Minneapolis Institute of Arts refused to comply with the requests of the Union, even refusing to meet with a committee of artists to discuss the matter. The March 1936 spring salon of the Minneapolis Women's Club was cancelled because of disagreement with a committee of artists in a discussion of the Rental Policy. The reason for the cancellation obviously was because the Women's Club realized the majority of the exhibiting artists were members of the Union and that an exhibition would not be representative were these artists to withdraw their entries.

The refusal of the Institute to discuss the Rental Policy with the Union precipitated immediate ac-

tion. The Executive Committee of the Union decided on three measures: to picket the Institute during the time it was receiving entries to the October 1936 show; all Union members to boycott the 1936 Twin City show; a brochure to be prepared, presenting the Rental Policy, to be distributed on the steps of the Institute on the opening night of the show. This program was placed before the Union membership and approved. The Institute was notified and at once agreed to a meeting with a committee from the Union. Assured of a meeting, the Union called off the picketing. The museum director, Mr. Russell Plimpton, explained that the prize money for the show was donated by individuals for a specific purpose and that he had no authority to change the old order namely, giving a cash prize for the pictures which, in the minds of an appointed jury of selection, merited such a prize.

Boycott of the show and the distribution of brochures on opening night were carried out by the Union. As a result of so many of the leading exhibitors' withholding their entries, the show of October 1936 was far below its usual standard, and was, of course, not representative of the work of artists in the Twin Cities.

The Rental Policy, it was found—as is experienced with practically all new movements—would have to depend not on sudden and intensive drives, but on a program of education and enlightenment not only of the museums, but also of the public. The Union at last decided upon such a course as the wisest and a motion was passed in a general meeting to adhere to such a policy.

In order to acquaint the public with the work of individual artists, exhibitions were arranged by the Union. The first show was held at the Main Public Library March 2-20, 1936. Great interest was shown, not only by the members of the Union and their friends, but by the general public as well. Subsequent shows have been held at the St. Paul Public Library, the Women's Club Galleries, the Little Gallery of the University of Minnesota, Hamline College, and St. Olaf's College in Northfield, Minnesota, and have

been repeated at different times. Several one-man shows have also been put on by Union members in private galleries.

During this time of activity, the men who had sponsored the organization and had knit it into a militant functioning group of men and women who knew what they were doing and where they were going felt that their labor had not been wasted. Meetings were instructive and entertaining. The artists at last had a voice in the exhibition and distribution of their work; they had a voice in shaping the policies of the Federal Art Project, and under a unified program of cooperation, had begun to interest the public in the value of community participation in the art life of the Twin Cities and the state. They were advocating the inauguration of art centers where everyone could come and share, not only in viewing works of art but in actually producing art for themselves. This movement was to result in gains throughout the country that were far beyond anything hoped for.

In April 1936, the New York Artists' Union gave warning of a threatened discontinuance of the cultural projects by the WPA. Immediate action was taken by the Union. Aligned with other artists' organizations and unions throughout the country, a flood of telegrams and letters were poured out upon our Senators and Representatives in Congress and upon Administration officials. Sponsors of all the cultural projects were contacted and did their bit with private wires and protests. The result of the intensive protest was that the initial attack of the so-called "economy bloc" in Congress died out. Later, more serious attempts on the life of the cultural projects were made.

At this time the members of the Union began to realize and appreciate the value of an organized resistance, of the power and force of closely-knit groups acting in national unity.

On June 5, 1936, a conference of midwest artists' unions was held in Chicago. This conference had as its chief point of discussion a bill, drafted by the New York Artists' Union, called the Federal Arts Bill. This

bill embodied the principle of the development of a mass cultural movement and the ultimate establishment of a Bureau of Fine Arts, covering the field of the graphic and plastic arts. In August 1937, Congressman Coffee of Washington introduced a revised bill which included art, literature, music, and the theatre, and as its final development the absorption of the existing WPA/FAP. In the Senate this bill was supported by Senator Pepper of Florida and became known as the Coffee-Pepper Bill. Through constructive criticism by interested individuals and groups, the bill was revised in January 1938. The resulting bill was heartily endorsed and was submitted to Congress. Bitter opposition was experienced at once, coming from the same sources that mount most of the opposition to progressive movements not originating within a political party. The foregoing statement may seem vague, but the reader will understand it, through his or her own knowledge of measures designed for the public benefit which have again and again been defeated in the halls of Congress in cloakroom caucuses. In June, 1938, on the last day of the session, the bill came out on the floor for discussion, but was subjected to such ridicule that its sponsors, rather than suffer a direct defeat, moved to have it tabled. Concerted action by all artists' associations coupled with the support of the entire labor movement will, in the near future, present another Arts Bill, and in its presentation the experience acquired in the first attempt will be carefully taken into account.

In the meantime the cultural projects had become the focal point for political activity in Washington. The so-called Economy Bloc was determined to cripple these projects by cuts in quotas, mass layoffs, and periodic "scares" of complete emasculation; the artists' unions throughout the country were working furiously to gain public support for the continuation of the projects. Sponsors were again contacted, publicity committees were organized, the radio was used in appeals to the public, and personal calls on influential citizens were made. In New York, powerful demonstrations of protest were used, in-cluding huge parades, floats, and speaking campaigns. The Minnesota Artists' Union struggled valiantly beside their affiliated unions elsewhere. Many artists were laid off; however, the unions, through their grievance committees, succeeded in getting laid-off members placed on other white-collar projects. The Minnesota Artists' Union was recognized by the state WPA Administration as being the bargaining agency for Project workers.

During this struggle it was inevitable that some internal friction would occur, and although at times this friction threatened total disruption of the Union, nevertheless, these difficulties were adjusted. It is to the everlasting credit of the membership as a whole, entirely unused to militant action in their own behalf, that they did adjust themselves to function cooperatively and hold their ranks together.

The protests of the Minnesota Artists' Union were at all times conducted in a firm but businesslike manner. Conferences were arranged with Administration officials at the state office, where an attempt was made to get the quota raised, laid-off workers back on the project, etc. Much of the credit for the calm procedure of the Minnesota Artists' Union must be given to the Executive Committee of the Union and to the State Director of the WPA/FAP, Mr. Clement Haupers, who was courteous at all times, received the various committees in a friendly manner, and showed complete understanding of their grievances.

With the resolution presented to Congress in May 1938 by Congressman Bell, Chairman of the Ways and Means Committee, calling for the elimination of all projects whose annual cost per man exceeded $1,000, the Minnesota Artists' Union, realizing the critical period ahead, began discussions aimed at affiliation with the AFL or the CIO. However, the threatened elimination of the cultural projects did not materialize. The Bell resolution was rescinded, but as a substitute measure, certain wage cuts were proposed.

The Union at once began working to limit the wage cuts and to secure a larger quota on the Proj-

ect. The union membership was by now a seasoned group of determined men and women, willing and eager to do all in their power to hold onto the jobs they had fought so hard for. Determined to publicize and educate the public to the fallacy of a program of petty economy at the expense of culture, the Union aimed to awaken the masses of people to the fact that daily contact with the beauties around them is not a luxury but is necessary in their everyday life, and that the right to engage in the bringing forth of beauty is theirs and should be guarded jealously.

The achievements of the New York Artists' Union after its affiliation with the Office and Professional Workers Union of the CIO had a large influence on the final decision of the Minnesota Artists' Union when, on September 27, 1938, it voted to affiliate with that organization. This action was approved by a two thirds majority of the members present.

The Minnesota artist has abandoned completely his ivory tower complex and has learned that beside his love for his brushes and his palette there is a joy in participating and being part of the general movement of the masses of the people to find expression in a common search for a more abundant life.

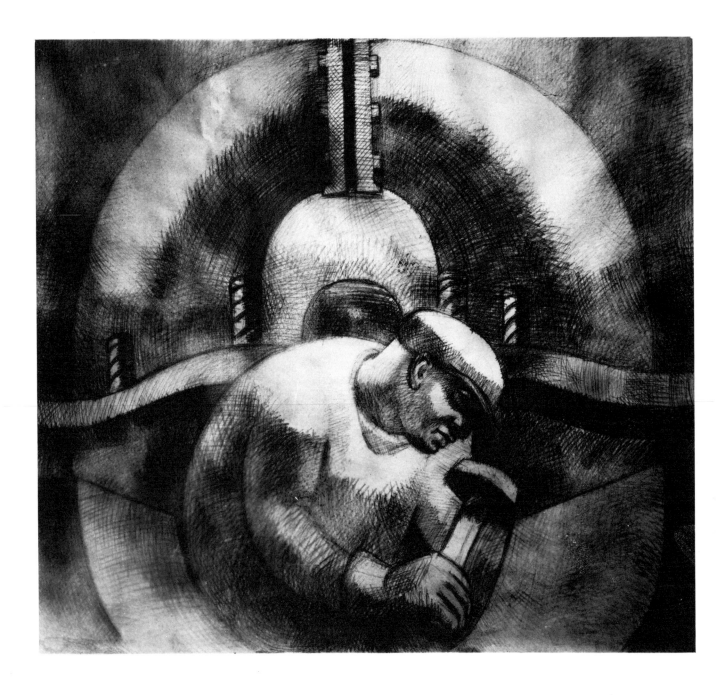

Abraham Lishinsky. Cartoon for mural titled *Major Influences in Civilization* in Samuel Tilden High School, New York City. (AAA)

American Artists' Congress

STUART DAVIS

The experience of the American artist during the last half dozen years has done much to increase his social consciousness and open his eyes to the importance of his art as an essential public service. This experience is divided into two parts, the pre-government-project period and the post-government-project period. In the first period the artist saw his world crumble and experienced disillusionment and despair, and in the second period he found a new orientation and a new hope and purpose based on a new sense of social responsibility.

In the first period the artist found himself deserted by private patron and dealer, who under the impact of the depression, gave up their patronage. It could not have been otherwise since the wealthy art patron, the endowed museum and its trustees, and the private commercial dealer (who was dependent on the wealthy patron and museum), all regarded art patronage as financial investment or speculation, or as a hobby to be indulged in as a luxury. Exceptions to this rule were, precisely, exceptions.

In the second period, which started with the establishment of government sponsored art patronage, the education of the artist and the public began. They slowly realized a new significance in art. From a commodity for speculation or a costly trifle, it became a necessary part of the cultural wealth of the nation, and its preservation in time of threatened destruction became an obligation of the government in its fight against the depression. Art, as essential cultural wealth, had to be conserved, just as our banks, industries, agriculture, sciences, and educational system needed government support to protect them against destruction.

Full credit must be given to a Federal administration which included in its program of reconstruction the cultural as well as the economic assets of the nation. And credit must be given to the spirit in which the largest of the painting and sculpture projects, the WPA/FAP, has been administered, taking the words of its administrator, Holger Cahill, as the ideal of that administration. He has said, "The organization of the project has proceeded on the

principle that it is not the solitary genius but a sound general movement which maintains art as a vital, functioning part of any cultural scheme. . . . In a genuine art movement a great reservoir of art is created in many forms both major and minor."

But it would be a great mistake to conclude that the new orientation in art is solely the result of a beneficent government. In the final analysis it is the producers of art, the artists, who have made the government art projects possible. And it is their wisdom which has consistently pointed the path these projects must follow if the art culture of the American people is to be preserved and developed. This course has been arrived at through hard struggle, and the struggle is still on. In this struggle for adequate government support of art the Artists' Unions all over the country have taken the leading role. Through the courage and foresight of these organizations of workers on the art projects, other artists have learned the need for a new type of artists' organization to meet new conditions in the field of art. The American Artists' Congress was formed to meet this need and includes among its members hundreds of the best-known artists all over the United States. They support the program of the Artists' Unions for the permanent establishment of the government art projects on a scale adequate to guarantee the soundness of conditions under which a genuine American art can develop. They also work through symposia, publications, and special exhibitions, to clarify the position of the artist in contemporary society.

The artists of America do not look upon the art projects as a temporary stopgap in an emergency situation, but see in them the beginning of a new and better day for art in this country. This viewpoint is given ample support by the quality of the work already produced, which has been acclaimed by all unprejudiced and competent critics. In addition to the high quality achieved, the work of the artist has been brought to new sections of our population through traveling exhibitions and the establishment of permanent museums and art centers. Already the work produced has become part of the cultural wealth of our nation, and every progressive person must recognize the need for its conservation and development. Such conservation can continue only with the support of a government administration that will regard the arts, along with proper housing, playgrounds, health service, social security legislation, and educational facilities for all, as part of the basic obligations of a democratic government of all the people toward the welfare of its citizens.

The American Artists' Congress

LINCOLN ROTHSCHILD

Evidence of the growing desire of artists today to reject the ivory tower and come to grips with the practical problems of their existence is found in the formation of the American Artists' Congress in February 1936.

The always-difficult lot of the artist had grown severely worse with the onset of the Depression. The stock-market crash convinced him that the problem was not one of the art world alone. In the summer of 1935 a few of those most aware of the nature of their

personal difficulties issued and circulated widely a call to their fellows to join together for the purpose of studying the precise nature of the artist's situation in relation to the broad problems shaking the basis of contemporary society and steps which he might take according to the democratic tradition of self-government, self-protection, and self-respect. Unity was needed, since it was all too evident that the force of an individual alone was ineffective in modern industrial society.

Tremendous enthusiasm went into the new and exciting experience of formulating a program, the need for which each artist, in his isolation, had to some degree felt. After months of spirited discussion and planning, the first American Artists' Congress was held on February 14, 15, and 16, 1936. New York's Town Hall was filled for a thrilling public session chaired by Lewis Mumford, at which Heywood Broun, Rockwell Kent, Margaret Bourke-White, Aaron Douglas, J. C. Orozco, and others spoke. A series of closed discussions on artists' problems during the following two days culminated in the formation of a permanent organization that has grown to a national membership of over nine hundred artists of prominence in their communities. A series of papers was read under the general topics of "The Artist in Society," "Problems of the American Artist," and "Economic Problems of the Artist." The entire proceeding was published as a book, *The First American Artists' Congress, 1936.*

Maintaining a national office in New York City, the Congress also conducts its activities through organized branches in Chicago, Baltimore, Cleveland, Los Angeles, San Francisco, New Orleans, St. Louis, Salt Lake City, Santa Fe, Washington, D.C., and Portland, Oregon. Annual congresses have been held for the purpose of further discussion, reports, and re-direction of the program and election of a national executive board, which at present includes: Stuart Davis, national chairman; Arthur Emptage, national executive secretary; Lincoln Rothschild, treasurer; Max Weber, honorary national chairman; vice-chairmen, Margaret Bourke-White, Rockwell Kent,

Yasuo Kuniyoshi, Paul Manship, Lewis Mumford; national executive committee—New York: Herman Baron, Gwendolyn Bennett, Lucian Bernhard, George Biddle, Henry Billings, Arnold Blanch, Peter Blume, Paul Burlin, John Cunningham, Aaron Douglas, Philip Evergood, Hugo Gellert, H. Glintenkamp, Aaron Goodelman, Harry Gottlieb, William Gropper, Minna Harkavy, Carl Holty, Joe Jones, Mervin Jules, Jerome Klein, Frederick Knight, Louis Lozowick, Ralph Pearson, George Picken, Ruth Reeves, Anton Refregier, Katherine Schmidt, Niles Spencer, Raphael Soyer, Alexander Stavenitz, N. Tschacbasov, Lynd Ward, William Zorach; Baltimore: Walter Bohanan; Cedar Rapids, Iowa: Robert F. White; Chicago: Aaron Bohrod, Mitchell Siporin, Morris Topchevsky; Cleveland: Milton Fox; Detroit: Walter Speck; Los Angeles: Grace Clements, Fletcher Martin; Milwaukee: Alfred Sessler; New Orleans: Myron Lechay; Philadelphia: E. M. Benson, Benton Spruance, Herbert Jennings; Provincetown, Massachusetts: Karl Knaths; St. Louis: James B. Turnbull; Salt Lake City: Mabel Frazer; San Francisco: Beniamino Bufano, John L. Howard; Terre Haute, Indiana: Gilbert Wilson; Washington, D.C.: Nicolai Cikovsky.

"For Peace, Democracy, and Cultural Progress" is the slogan expressing the aims of the organization's activities. Almost at the outset an exhibition of prints past and present, "Against War and Fascism," was held in New York and circulated throughout the country for over a year. Several subsequent shows of work by members, around basic social themes, have attracted wide attention.

To dramatize the potentialities of the graphic media for reaching wide audiences, an exhibition of one hundred selected prints called "America Today" was arranged, with thirty copies of each shown simultaneously in thirty centers throughout the country. Later the same group was exhibited in London and Mexico City, and was published in book form by Equinox Press with introductory articles on the printing media and their place in current cultural developments.

Besides the many discussions on professional and cultural problems of the art world at local membership meetings and private sessions of national congresses, a number of symposia for the general public have been held on topics of immediate interest. One of the most successful of these was held in connection with the first exhibition of "Abstract Art" at the Museum of Modern Art, and the series included the presentation of the great Spanish artist Luis Quintanilla, and a discussion of Picasso's "Guernica," the showing of which in America was sponsored by the Artists' Congress.

On behalf of its members, the central executive committee constantly studies national, international, and professional problems and takes suitable action from the standpoint of the progressive artist. Questions of museum policy in relation to the interests of living American artists and the general public have been the basis of discussion and action. Cultural and economic problems related to government sponsorship of the arts under the WPA and the Treasury Department have been followed and action taken to protect and further these vital programs.

With a considered belief in the fundamental interrelations of broad political and economic problems with the welfare of professional artists, the Congress has studied all vital public issues, taking action, for example, in support of the Spanish and Chinese people in their fight against aggression, in support of exiled art and artists, in favor of truly protective neutrality legislation, of free speech and democratic rights for labor, as well as protection of individual artists from bureaucratic suppression of their works.

In many of these actions the American Artists' Congress has cooperated with other artists' organizations in New York City through the Artists' Coordination Committee, of which it has been one of the leading supporters. The notable victory of this group in obtaining a professionally-controlled exhibition of contemporary art at the World's Fair was an achievement of outstanding importance in the development of democratic culture in America.

During the past year the American Artists' Congress has given active support to the nascent Artists' Conference of the Americas, in an attempt to carry out President Roosevelt's Good Neighbor Policy on a cultural plane by establishing channels for a discussion of cultural democracy with our neighbors to the North and South.

The organization is composed of artists having recognized professional standing in their communities who subscribe to the progressive program of the organization. Recently the basis of membership has been expanded to include laymen who are interested in supporting the program of the Congress and participating in its cultural activities as associate or sustaining members.

Contacts have been made with artists in other countries; a similar organization already exists in Great Britain. The New York branch has been instrumental in starting an organization of art students and younger artists known as the Young American Artists.

By all these means great strides have been made to bring the artist face to face with the true nature of the problems he encounters and in opening up to him means of action for the betterment of his condition. The hope is to achieve a high level of practical consciousness and effective expression among artists, so that they may become a force in the political and economic world of which they are a part, and thus fortify the growing trend toward recognition of the cultural needs of a great democracy and develop the means for their fulfillment.

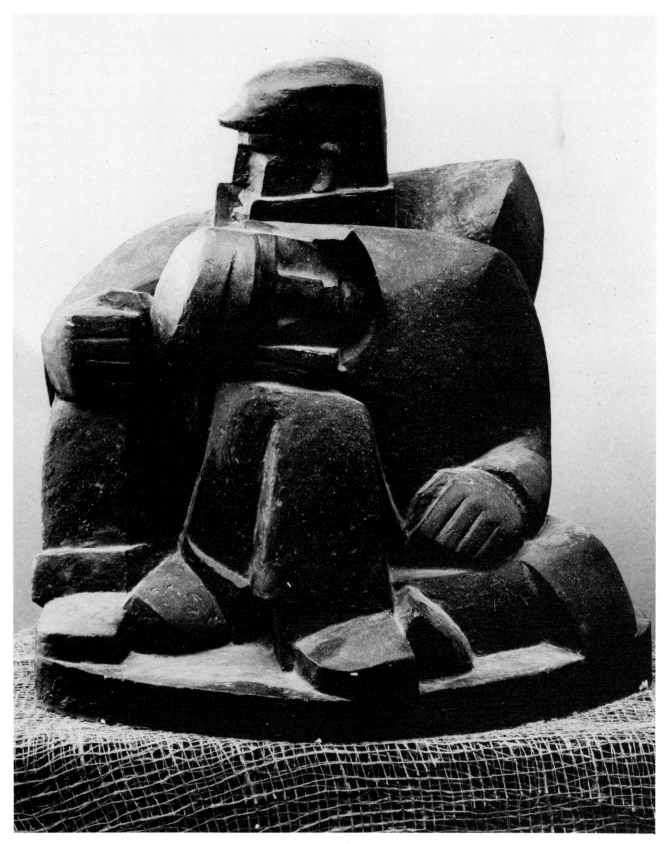

Aaron Goodelman. *Homeless*. Plaster, New York City Project, c. 1936. (AAA)

Artists' Coordination Committee

HUGO GELLERT

The Artists' Coordination Committee embodies the first serious, sustained effort on behalf of artists' societies to work together toward their common objectives. The Artists' Coordination Committee represents ten artists' societies, each of which has three delegates serving on the committee. The societies are as follows:

American Artists' Congress
An American Group, Inc.
American Society of Painters, Sculptors & Gravers
Harlem Artists' Guild
Mural Artists' Guild of the United Scenic Artists
National Association of Women Painters & Sculptors
National Society of Mural Painters
New York Society of Women Artists
Sculptors' Guild, Inc.
United American Artists

The total membership of the artists' societies is above four thousand.

Of these, the American Society of Painters, Sculptors and Gravers, the National Association of Women Painters and Sculptors, and the National Society of Mural Painters are national in character. The American Artists' Congress is not only a national society, but it has active branches scattered throughout the country. The Harlem Artists' Guild is the only Negro artists' society in the United States. The Mural Artists' Guild of the United Scenic Artists is an affiliate of the AFL and the United American Artists is affiliated with the CIO.

The Artists' Coordination Committee was organized by Frederic Knight, its first secretary, in January 1936. Undemocratic rulings announced by the new Municipal Art Galleries of New York City prior to the opening of the galleries presented the incentive for organization. According to the rulings, only United States citizens were eligible to exhibit, and the Municipal Art Committee had the right to exercise censorship over all works submitted for exhibition. The storm of protest following the announcement brought about the rescinding of these rulings. The artists, however, realizing that greater cooperation among their groups was necessary if they were to succeed in protecting and promoting their common interests, formed the Artists' Coordination Committee.

The Committee serves to exchange and disseminate information on issues that confront all or individual member artists' societies. It aids and directs action on recommendations that have been approved by the member societies. It has the power, as an immediate measure, to protest publicly in the name of all the societies on matters of discrimination affecting artists.

The Committee has been successful in securing jobs for the unemployed. Through its efforts in having the Treasury Relief Art Project reopened for employment, about fifty jobs were obtained for artists during the year 1936. When it became known that the termination of TRAP was planned and over three hundred artists in the various sections of the country were faced with the prospect of losing their livelihood, the Artists' Coordination Committee was instrumental in the transference of TRAP artists to

255

the WPA/FAP. According to our information, the local administration of the Project gave employment to about ninety TRAP artists in 1937.

During the summer of 1937, Harry L. Hopkins, who was at that time the Administrator of the WPA, announced that all workers on the Project were to be paid the prevailing wage as established in the community for various classes of work. It was the contention of the local administration of the WPA that since no prevailing wage for artists existed in private industry and since WPA is the greatest employer of artists, the wage paid on the Project might be considered as the prevailing rate of wages. In New York City this amounted to about one dollar per hour. This issue was of the greatest importance to artists, because the establishment of a low rate of wages on the WPA/FAP would have meant a low wage scale for privately commissioned work as well

The Artists' Coordination Committee was recognized by the WPA as the agency best qualified to represent the artists of the community. Based on wages paid in private industry for work such as painting, decorating, designing, etc., the Committee decided upon a minimum of two dollars per hour as a reasonable scale of wages for artists. But the conditions on the WPA/FAP and the existing executive order establishing the monthly security wages made a compromise necessary. The Artists' Coordination Committee came to an agreement with Colonel Brehon Somervell, WPA Administrator for New York City, and Mrs. Audrey McMahon, Director of the New York WPA/FAP, by having the wages of artists increased to one dollar and sixty cents per hour. The Committee agreed to this figure with the understanding that acceptance of it was only a compromise and that as soon as conditions permitted, two dollars per hour would be requested.

The activities of the Artists' Coordination Committee in popularizing the Project and defending it against vicious, reactionary attacks would take too much space to enumerate. Protecting the freedom of expression of artists—their right to choose the form and content of their art—was an important part of the work of the Committee. The attempted removal of Philip Evergood's mural in the library at Woodside, Long Island; the attempted obliteration of writing contained in Rockwell Kent's mural in the Post Office Building in Washington, D.C.; and the destruction of the sculpture of Abraham Lincoln by Louis Slobodkin in the United States Government Building at the New York World's Fair, are outstanding instances. In each case the censorship was prevented. (The destroyed sculpture by Slobodkin was replaced by a half-sized model.)

Sometime in 1936, the Artists' Coordination Committee began its work for an Exhibition of Contemporary American Art at the New York World's Fair of 1939. It was made clear from the outset that if the exhibition was to be a valuable cultural contribution to the Fair, authority to select and arrange the exhibition must be vested in the artists themselves. The Board of Design of the New York World's Fair, the agency the artists had to deal with, had not shown much enthusiasm for the proposed exhibition. Indeed, it can definitely be said that had it not been for the energetic efforts of the Committee, there would never have been an exhibition of contemporary American art at the fair. It would be a mistake to believe, however, that the Artists' Coordination Committee could have secured the exhibition alone, without the aid and cooperation of all the important artists' societies of New York. The Artists' Coordination Committee *was* instrumental in gaining the support of art critics, of well-known writers, museum directors, and other outstanding individuals who made public statements in favor of the proposed exhibition. But the concerted action of all the artists' societies of New York won the support of Mayor La Guardia. He in turn influenced Mr. Grover Whalen and other directors of the New York World's Fair to grant space and the means for the exhibition. The Artists' Coordination Committee consisted of seven member societies at the start of this work; during the struggle to win the exhibition, it grew to include ten societies.

The high artistic standards of this nationally repre-

sentative exhibition were attained through a procedure of selection which is, in our opinion, the most democratic ever devised by artists. It might well serve as a pattern for future exhibitions of similar scope. More than eighty committees of selection were set up in all sections of the country. Each committee was composed of artists representing the various art tendencies and was headed by a nonvoting chairman, usually a museum director or official of an art organization. We believe that the real significance of the exhibition lies in the fact that it served to unite all the artists' societies. Thus the exhibition is a symbol of artists' unity. We hope that this exhibition, significant as it may be, is but the beginning of a series of important achievements of artists' cooperation.

That artists' cooperation has not terminated with this exhibition is indicated by the joint appeal sent to President Roosevelt by the presidents of New York Artists' Societies, requesting that in transferring the

WPA/FAP to state sponsorship, as required by Act of Congress, its administration should not be affected. The signers of the appeal include the presidents of the National Academy and the National Sculpture Society. Replying on behalf of the White House as well as himself, Commissioner of Work Projects F. C. Harrington said: "I appreciate the necessity of adequate technical direction and proper safeguards to the integrity of these projects, and I assure you that these will be maintained."

Now, more than ever, there is great need for artists' cooperation. Everything possible should be done to perpetuate the good work of the Project, one of the most important sources of cultural influence in the history of the nation.*

*This essay is dated about 1939. An earlier version in the manuscript of Art for the Millions, dated 1936, was written by Frederick Knight.

The Organization of Supervisors of the WPA/FAP

E. HERNDON SMITH*

There was art and there were artists and there was Government, but the bonds between them were slight and loose before 1935, when with dramatic swiftness the creation of the WPA/FAP demanded coordinators. These were to become known as "supervisors." Putting aside their creative careers in studios, artists embarked upon the utterly new, absorbing, and revitalizing experience of supervising other artists employed in large numbers by the Federal Government for the first time in our history.

There has not been before and there can never be again a period quite like the first three months of the

WPA/FAP. To have helped launch this great venture will remain one of the outstanding experiences of those men and women who first struggled with the responsibilities of guiding it. Federal sponsorship was a challenge—new horizons opened, a new pioneer appeared.

In New York City nearly 3,000 artists went to work. An excited, hard-pressed staff coped with the dynamic situation often by sheer determination.

*Mr. Smith signed his manuscript, "for the Art Shop of Local 100 of the United Federal Workers of America, CIO."

Unheard-of problems arose, the individual did his best. There was no precedent, no one with a similar experience to turn to for advice. Things had to be done and were done. The project had abounding life, energy.

After six months, something happened that has no counterpart in American art. The Supervisors Association of the WPA/FAP of New York City came into existence.

The organization of supervisors continued under this name until July 1938, when the United Federal Workers of America, affiliated with the CIO, granted a charter to Local 100, to include supervisors of Federal Project #1—that is, the supervisors of the Arts Projects of New York City, which include Art, Music, Theatre, Writers, and Historical Records Survey. In New York City, WPA supervisors have also organized in Local 96 for the education projects, and in Local 109 for the research project, under the regular state administration.

Before this time, a rather loose federation had been set up with other supervisory organizations in the arts projects, largely on the basis of consultation among wholly autonomous groups. The later arrangement had the value of strength and experience gained by joining a nationwide group of unions in all fields of work.

In general the program of the union has had a twofold character. Its primary function is to protect the jobs and working conditions of its members. Its second function, which has been keenly felt by the supervisors, is the responsibility of suggesting administrative improvements and long-term perspectives in the development of the project.

The first point of the union program is carried out by adjustment committees on the various projects, which consider grievances of supervisors and present them to the administration at regular meetings. A committee, representing the entire membership of the Local, functions in respect to the office of the local administrator of all the Arts Projects. Many complaints of supervisors against their immediate divisions are adjusted by the union committees and

never go to the administration. On the other hand, workers who have been upset by ill-considered rulings or discrimination can be represented by their experienced and informed fellows. The ready and assured opportunity for a hearing permits adjustment or explanation, whereby the faith in the administration and the goodwill and general morale of the worker are maintained.

Since joining the United Federal Workers of America, supervisors have subscribed to the limitations on militant action outlined in a letter by President Roosevelt and accepted as the policy of the national organization. In the main, this eliminates strikes, work stoppages, picketing, and militant demonstrations of a similar sort for government workers.

One of the outstanding accomplishments of the supervisors of the WPA/FAP, of New York City was the publication by the old Supervisors Association in August 1937 of the brochure "Art as a Function of Government."

This pamphlet has run through two editions and has become widely known throughout educational circles as a pioneer research effort in presenting a picture of governmental sponsorship of the arts in the United States and other leading countries.

This attempt to provide a background for consideration of a program which at first was considered merely as relief, but which the future might regard as a legitimate, long overdue, and permanent function of government in an expanding democracy, has pointed the way to a thorough study of the subject.

For the worker on the project and for the project as a whole, the organization of the supervisors of the WPA/FAP has been extremely profitable in developing the program on the one hand, and in preserving goodwill and self-respect on the other. An *esprit de corps* has been one of its notable accomplishments.

These have unquestionably been the results in respect to labor relations on the WPA/FAP.

The WPA/FAP and the Organized Artist

AUDREY McMAHON

The relationship of the WPA/FAP to the artist is a very complex one and plays an important role both in the production of his work and in the adjustment of his problems. In this article I am concerned primarily with the methods that have developed for handling the problems which are brought before the administration by organized artists as well as by individuals.

The unemployed sections of organized groups are, of course, interested in expanding employment. Their major protest is against our inability, due to limitation of funds, to give employment to all needy artists. In line with this grievance is another against relief requirements under which many of them, though needy, cannot secure WPA employment. They further protest any apparent discrimination either against their group in favor of unorganized artists or against their group in favor of other organized groups. It is, of course, the policy of the administration to show no discrimination or preference toward any group or individual.

The employed organized groups, while embracing and endorsing the demands of the unemployed, are primarily concerned with their own immediate problems. Among the criticisms of national policy placed before us are the refusal of the administration to grant sick leave with pay and the requirement that time lost because of federal and state holidays be made up. Under the heading of local policy come all issues resulting from rulings originating either in the office of the State Administrator or in the local

project headquarters. These in turn are subdivided into technical and administrative issues. Under the former heading are discussed such grievances as rejections of work, unsatisfactory assignments, and incompatible assistants or supervisors. The local administrative problems are, of course, legion. They range from protests against decisions made by the State Administrator's office to objections to lack of janitor service on a job location. They include discussion of local policy in the matter of receiving delegations, hearing complaints, and making adjustments. In short, the grievances of the artists are brought to the doorstep of the project administration, where they belong. This method serves to clear the atmosphere of misunderstanding, straighten out procedures, and remedy injustices.

This varied array of problems is presented by the artists either as individuals on their own behalf or as representatives of organized groups. The project administration, in its determination to deal fairly with each artist, does not differentiate between individual and group presentation. The procedure is the same in both cases. The individual may either present his grievance himself or have it presented for him. He may be present or absent during the hearing, in accordance with his preference. The problem is heard by the person he requests to have present, with the addition of the personnel manager, the artist's immediate superior, and any other person who may have a contributory interest in the question. A problem may be reheard as often as seems necessary.

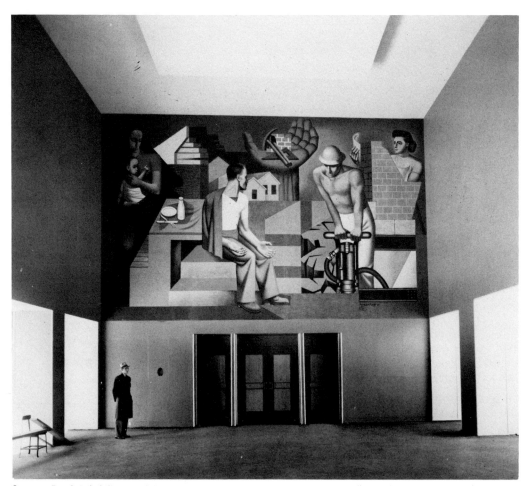

Seymour Fogel. *Rehabilitation of the People*. Mural (destroyed), oil on canvas, in the WPA Building at the New York World's Fair, 1939. (AAA)

The project does not discriminate in any way against organized groups in these hearings, but imposes only such limitations as have been agreed upon administratively. Thus, it has been decided that delegations of twelve are received on appointment. It is required that agenda be furnished in advance so that the persons involved may be invited to the hearing. They are encouraged to group their business under two headings—old business and new business, the old business to be disposed of as soon as possible and the new business to be referred for investigation. They exercise freely the privilege of collective bargaining and are restricted only when they seek to bargain for a group outside their province. They may not represent anyone who does not desire to be represented and in presenting petitions are required to have the signatures of those supporting them. This insures the unorganized artist his individual rights.

There is no question but that group representation can be beneficial to the project. By this method the problems of the weaker and less articulate artists are presented by persons who are experienced in the handling of grievances, and difficulties which might otherwise be overlooked are brought to our attention and corrected. The organized artist groups are still young and often overenthusiastic or injudicious in their decisions. But with the sympathetic reception which the Federal Art Project accords them and with their own organizational maturing, these faults may soon be eliminated.

It is a profoundly important factor in the understanding between the artist as an individual or as a member of an organized group and the administrative personnel of the Federal Art Project that all have the same goal—permanency of government subvention of the artist.

PART V
AFTERWORD

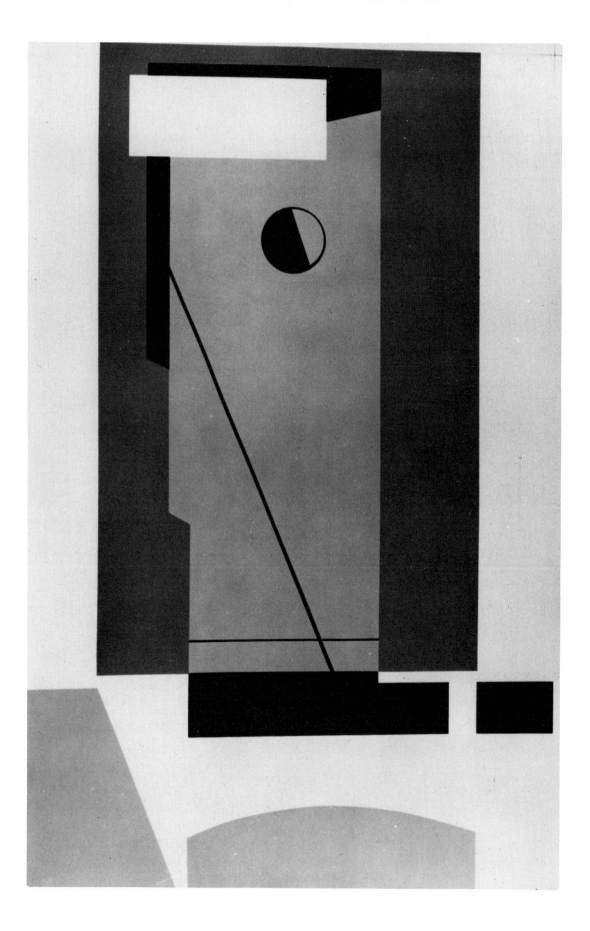

Society and the Modern Artist

BALCOMB GREENE

The problem of the artist giving his best to society is more time-worn and time-ornamented than many theorists indicate. Yet today the problem of every citizen contributing to the national and the general human good is matched in importance, dramatically as never before, by the individual's problem of subsistence. The creative imagination should not drive a truck. The degenerate must not guide the nation. Better that the ruler of Germany, and now of Austria, had kept on hanging paper—or, failing that, had continued painting his trivial landscapes and had them hung on public walls.

Any form of art, to develop far, requires about all a man can give it. The extent to which an artist's specialty and energy permit whatever direct political activity his economic status and cultural consciousness require, may be left to him to solve. He may join a union, function on committees, picket the strongholds of reactionism; but the line between these maneuvers and his canvas is for himself to draw. When his painting activity is not enough, there is immediately a more difficult line to draw—the distinction between progressive movements with which he is professionally affiliated and spurious political machines which can only misuse him. It is safe to say that in present-day Germany, and in other totalitarian states, the artist cooperates with the totalitarian machinery to his own detriment. One questions, if this is so, what purpose is served by his supporting a would-be totalitarian movement which operates within a democracy.

It is sometimes observed, and with good cause, that the painter and sculptor read less, both of imaginative and "serious" books, than other professional men. The artist's studio has traditionally a half dozen volumes. It is as though the artist, who surely is no piker as a revolutionist, had drawn his opinions and his inspiration from the people he has met, from the situation of himself as a semi-outcast, and from his very personal stroking of paint upon canvas. The energy such a schooling has summoned up and seeks to direct is fair game for the adroit propagandist.

If one were to say that the artist, when concentrating upon his historical mission of leading his fellow men, becomes giddy with the immenseness of it and is apt to assume the gestures of other characters—when we say this we are promptly charged with defending a "precious" man, just too too good, in his ivory tower. But when we say that no artist has the moral right to go around signing protests and petitions until he has studied the contexts—that makes sense. Unless he perceives the likeness in these two warnings, any artist who ventures from his studio drags his Muse with him by her neck.

Balcomb Greene. *Abstraction*. Oil on canvas, New York City Project, c. 1937. (AAA)

263

The further question as to whether brush and chisel are implements with which to paint or carve out a new society, is the "art question" of most concern to us. The documentary painter and the satirist (and certain romanticists who think themselves documentary or satirical) often claim their work qualified to move people, to make them reflect, and to stimulate their humanitarian or so-called "class" emotions by the significant presentation of everyday data. The abstractionist who works with non-representational form and color (as well as many other plastic artists not abstractionists) makes more modest assertions—and is generally disposed to allow the photography of the film and the daily papers this direct approach. Indeed the whole modern art movement, from Cézanne and Van Gogh on, with its dual insistence upon plastic quality and upon the individualist's expression, has led to an art the qualities of which finally absorb the object.

Because of his development and traditions the modern artist is placed on the defensive in our period of political uncertainty, but least of all on the defensive against the orthodox Marxist critic. Like most formal criticism Marxism has only aborted a reactionary art, mouthing the fine phrases of revolution for an instant, then taking a quick dive into the much publicized midwestern grave which Benton and Curry have dug for it—in a word, into nationalism, without benefit of music. The modern artist defends himself, if at all, against the international regimentation which demands easy thinking and comforting sentiments. His obstacle is Mr. Public, unable to look at virile pictures because afraid even to look squarely at life.

Most persistent of all criticisms against modern painting is the objection that it woos people away from reality. The truth is that modern art was originated because the public, and the artists, got to looking at the output of canvases without being enticed anywhere. When we look at a picture, we see it or we don't; and if we don't we can keep on brooding about Aunt Emma's will or this afternoon's headlines in our newspaper. If we do see it, then a journey begins. It is a mental and emotional journey, we can't just pay our fare and talk about it afterwards. The journey is conducted by the artist. It may be exciting or mostly peaceful; we may get all worn out by it, we may never want to go again. This is where what we call "artistry" enters. Artistry is not in the gaudy folders with which the travel-bureau Marxist or the cracker-barrel politician sells us a ticket to familiar places.

The excuse for all artistry is the simple product which we lift, hold to the light, hang on a wall. The thing is. A healthy mind has made it, or an unhealthy mind did; we can hope in advance for a positive correlation between health and intelligibility. During the years that this painting hangs on our wall it has an integrity peculiar to canvas and paint. The globules of ivory black and cadmium red will never line up to vote on Hitler versus Stalin. In view of current attempts to simplify the world conflict, this ought to encourage us.

We have said that the problem of every citizen contributing his energy to the national and general human good is matched in importance only by the individual's problem of subsistence. Now, it was essential with modern social thought, in its need for using the methods of science, that it stress the maximum good to the greatest numbers; even as it has been necessary for the class-theorist to speak, with an even greater use of scientific terms, of the maximum good to the lower numbers. It is in this tradition that many progressive men would extend what appears to be a scientific premise into the realm of art, and come through with the conclusion that whatever falls from the brush should contribute directly to the happiness or the welfare of 51 per cent.

Having thus simplified our instructions to the painter, it has only been necessary to equip him with a sort of Marxian and Martian super-sense which can restrain him from a calendar art merely pleasing, while guiding him to a realistic art which pleases and also teaches almost everyone. Unluckily our general

scientific principle, applied to the matter of art production, has led back into the mustiness of the Academy.

The issue finally becomes clear.

Commodity production is of several sorts. A mousetrap can conceivably be made which pleases every man, and a house designed which pleases most, but the painting which finds this easy acceptance is probably turned out the way mousetraps are. The view is enforced by history that the function of art at its most progressive point has been *profound* rather than *extensive*. Regardless of the painter's aims, the vigor has at first been communicated by an articulation able to affect the very few. The language he used was advanced, and it came constantly as a surprise and disappointment to him how illiterate most of his fellow men were. This surprise is congenital, running always in the veins of the profession's aristocrats. Yet it is difficult to imagine a vigorous, intelligent artist setting himself in his youth at the point of progression which the current masters had attained in their youth, and then springing full-blown before the public just at the opportune moment when the old masters have died. Progress and the ceaseless piling of contempt upon the innovator are actually the most repetitious of phenomena.

It is likely that the *extensive* and spurious effort in art is best served today by the American Realists, or whatever they are at the moment called—men like Grant Wood and Curry who sweep cleanly across the American market by getting as much of our national acreage on canvas as the canvas will bear. For the maximum utilization of the aggregate of human energies of people viewing canvases (which is one of the ways we justify a WPA program) it may be necessary to have men sweeping up after the genuine creators. It would be a pity however, and an historical novelty besides, if the great figures of tomorrow were sweeping up after the sweepers of today.

Part VI
APPENDICES

APPENDIX A

Who's Who Among the Authors and Artists

EDITOR'S NOTE:
I have tried to provide in this Appendix a useful biographical sketch of each person represented in this anthology. To do this, I have emphasized basics such as life dates, education, relationship with the New Deal art projects, major works and publications, first one-man show, recent retrospective exhibitions, and current address, rather than meaningless lists of group shows and museum collections. The objective is to lead the reader to further information about the individual. In some cases, unfortunately, no information aside from WPA/FAP employment records could be found.

The often frustrating efforts to research these biographies uncovered the desperate need for a comprehensive and regularly augmented inventory of all American artists.

I want to thank Mrs. Lucy Leitzell for her assistance in preparing the first draft of this Appendix.

Berenice Abbott (1898-)

Born in Springfield, Ohio, in 1898, she studied in Europe from 1921 to 1929. She was assistant to the photographer Man Ray in Paris for two years, then opened her own studio. She made a series of portraits of avant-garde figures, notably Gide, Cocteau, Joyce, and the photographer Eugène Atget, whose work she preserved and later gave to the Museum of Modern Art. Her European work was exhibited at the first Salon des Indépendants, at the Folkwang Museum in Essen, and in Stuttgart. When she returned to New York, she worked for a time as a photographer before joining the WPA/FAP as Supervisor of the Photographic Division in 1935.

Man Ray. *Berenice Abbott*. (NCFA:Cahill)

While on the Project she photographed New York, and many of her prints were reproduced in *Changing New York* (1939) with a commentary by Elizabeth McCausland. She has made a photographic record of U.S. Route 1 from Maine to Florida and has done a series of scientific photographs illustrating physical laws. The Smithsonian Institution presented a retrospective exhibition of her work in 1969 as did the Museum of Modern Art the following year. She lives in Maine, which is the subject of her latest collection of photographs, *A Portrait of Maine* (1968).

Darrel Austin (1907-)

Born in Raymond, Washington, June 25, 1907, he was educated at the University of Oregon, the Emile Jacques School of European Art at Portland and the University of Notre Dame. He worked on the Portland PWAP and that city's WPA/FAP from 1935 to 1937 as a muralist. His first one-man show was at the Howard Putzel Gallery in Los Angeles in 1938. He moved that year to New York City, where he showed his paintings at the Perls Gallery from 1940 to 1964. In 1945 he moved to New Fairfield, Connecticut, where he lives today.

Patrocinio Barela (1908-1964)

Born in Bisbee, Arizona, in 1908, of Mexican-American parents, he came to Taos, New Mexico, with his father as a child. He had little education and remained illiterate all his life. He began to carve in 1931 after repairing an old wooden religious statue. He worked on the WPA/FAP in Taos from 1936 to 1943 as a woodcarver, under the direction of Vernon Hunter, who took an interest in his carvings and encouraged him to try relief pieces and furniture. Some of his sculptures were displayed at the New York World's Fair in 1939. Most of the pieces he did

for the WPA are now in the Harwood Foundation of the University of New Mexico at Taos. He died in a fire in his workshop in Cañon, New Mexico, October 24, 1964.

Donald Jeffries Bear (1905-1952)

Born in Seymour, Indiana, on February 5, 1905, he studied painting with John E. Thompson, Henry McCarter, and at art schools in Denver. He began his career in museum work in 1930 as a docent at the Denver Museum of Art, where in 1935 he became Curator of Paintings and then Director of the Museum. He was appointed WPA/FAP State Administrator for Colorado in 1935. He took a leave of absence in 1936 to spend six months in Germany and Austria studying museum techniques on a fellowship. He returned to continue as WPA State Director and Regional Adviser for Colorado, Utah, New Mexico, and Arizona through 1938, when he became Assistant Director of the "American Art Today" exhibition at the 1939 New York World's Fair. In 1940 he moved to Santa Barbara, California, to direct its new Museum of Art. He himself painted in oils and watercolors; some of his work was purchased by the Museum of Modern Art. He wrote *Contemporary American Painting* (1945) and the article on twentieth-century American painting for the 1950 Encyclopaedia Britannica. He died March 16, 1952, in Santa Monica, California.

Gwendolyn Bennett (1902-)

Born in Giddings, Texas, in 1902, she was educated at Pratt Institute, New York, and the Académie Julian, Paris. She held a Barnes Foundation fellowship in 1926 and taught at Howard University and Tennessee State College. She was employed on the PWAP in 1934 and on the WPA/FAP from 1935 to 1941. From 1937 to 1940 she directed the Project's Harlem Community Art Center.

Emanuel M. Benson (1904-1971)

Born in New York October 22, 1904, he studied at Dartmouth College and Columbia University. In 1936 he was hired as an editorial assistant in the WPA/FAP Central Office in Washington, D.C., to work on the Index of American Design. Early in 1937 he went to the Philadelphia Museum of Art as Chief of the Division of Education, while remaining a consultant to the WPA National Coordinating Projects for Art until mid-1941. It was in this capacity that he served as editor of the original manuscript of *Art for the Millions*. Following his work with the WPA, he was a contributor to such publications as *Parnassus, The Saturday Review, Creative Art,* and the *American Magazine of Art*. He also wrote monographs on John Marin and the problems of portraiture. In 1953 he left the Philadelphia Museum to become the Dean of the Philadelphia College of Art, a position he held until his retirement in 1965. He served as critic-in-residence at the Nassau, N.Y., Community College, directed the Southampton, N.Y., College summer art program, and operated the Benson Gallery at Bridgehampton, Long Island, New York, from 1965 until his death in 1971.

Elzy J. Bird

He was employed on the WPA/FAP in Salt Lake City, Utah, from 1935 to 1942 and was State Director from 1937 to 1940.

Julius Thiengen Bloch (1888-1966)

Born in Kehl, Germany, May 12, 1888, he came to the United States while still a young man and studied art at the Philadelphia Museum of Art School, the Pennsylvania Academy of Fine Arts, and the Barnes Foundation. He was employed on the PWAP in 1934 and on the WPA/FAP in Philadelphia as Project head in 1936. During the 1930s he was noted for de-

pictions of the black people of Philadelphia. In later years he taught at the same art schools in which he had studied. His paintings and lithographs are in major collections. He died in Philadelphia August 22, 1966.

Lucienne Bloch (Dimitroff) (1909-)

Born in Geneva, Switzerland, January 5, 1909, the daughter of composer Ernest Bloch, she came to the United States in 1917. She studied painting with André Lhote in Paris and worked as an apprentice, along with her future husband Stephan Dimitroff, with Diego Rivera on his murals in Detroit and New York. Employed on the WPA/FAP in New York from 1935 to 1939, she executed murals in the Women's House of Detention and the George Washington High School music room. Since the Project years she has created about twenty murals in public buildings in the United States and has worked in various other media such as glass, terra-cotta, and wood. She is also noted as an illustrator of children's books. She lives in Mill Valley, California.

Lou (Louis) Block (1895-1969)

Born July 11, 1895, in New York City, he studied art in Italy, France, and England and at the National Academy of Design and the Art Students League in New York. In 1934-35 he collaborated with Ben Shahn on a TERA mural project for Rikers Island, New York. He was employed 1935-39 on the WPA/FAP in New York and acted as Co-Director of the Mural Division with Burgoyne Diller. He also directed the Index of American Design in the New York region. After the Project he worked at various government jobs. From 1947 to 1951 he taught painting at the Brooklyn Museum Art School. From 1951 until his death in October 1969 he was on the faculties of the Art Center School and the University at Louisville, Kentucky.

Cameron Booth (1892-)

Born March 11, 1892, in Erie, Pennsylvania, he studied at the Art Institute of Chicago for five years. In 1917 he received a scholarship from that school which enabled him to study with André Lhote in Paris. Later he attended Hans Hofmann's school in Munich. He had his first one-man show in 1935 at the Paul Elder Gallery in San Francisco. He was employed on the WPA/FAP in Minneapolis as a supervisor 1936-37. He was awarded a Guggenheim Fellowship for 1940-41. He has taught drawing and painting at a number of schools, including the Art Institute of Chicago, the Art Students League of New York, and the University of California at Berkeley, and was artist-in-residence at the University of Minnesota. The American Federation of Arts circulated a retrospective exhibition of his work in 1961. He lives in Minneapolis.

Edgar Britton (1901-)

Born in Kearney, Nebraska, April 15, 1901, he was educated at the University of Iowa, 1918-20. He studied and worked with Grant Wood in Cedar Rapids, Iowa, 1920-24 and moved to Chicago in 1925. For the next decade he studied art and worked on various architectural decorations. He was employed there on the PWAP in 1934 and on the WPA/FAP mural division from 1935 to 1937 and as its technical director in 1940-41. He executed three Post Office murals and one at the Interior Department in Washington, D.C., for the Section between 1938-40. From 1942-50 he taught art in various midwest schools. Since 1950 he has devoted himself to architectural sculpture and stained glass. He lives in Littleton, Colorado.

James Brooks (1906-)

Born October 18, 1906, in St. Louis, Missouri, he studied at Southern Methodist University and came

to New York in 1926 to work with Boardman Robinson and Kimon Nicolaides at the Art Students League. He joined the WPA/FAP in 1935. His murals received wide acclaim, particularly the huge "Flight" done for the rotunda of the International Marine Terminal Building at La Guardia Airport, which occupied him for two and a half years. He left the Project in 1942 and, after service as a combat artist in the Middle East, returned to New York. He had his first one-man show, at the Peridot Gallery, in 1949. He was a leading figure in the Abstract Expressionist movement, and his work has been widely exhibited and is in the collections of major museums here and abroad. He lives in New York City.

Samuel Joseph Brown (1907-)

Born in Wilmington, North Carolina, April 16, 1907, he graduated from the Pennsylvania Museum School of Industrial Art in 1930. His first one-man show was at the Philadelphia College of Art in 1935. He worked on the Philadelphia PWAP and the Easel Division of the WPA/FAP from 1935 to 1938, when he joined the Philadelphia Public School system as an art teacher—a position he held until his retirement in 1971. He lives in Philadelphia.

Beniamino Benvenuto Bufano (1898-1970)

Born in San Fele, Italy, in November of 1898, he was brought by his parents to New York as an infant. He was apprenticed to a woodcarver while still a child and later won a scholarship to the New York Academy of Fine Arts. He worked with James Earle Fraser in designing the famous buffalo nickel, for which he won a $500 prize. A lifelong partisan of peace movements, in 1917 he chopped off a finger and mailed it to President Wilson as his "contribution to the war effort." After this incident he set off on a series of adventures, including a stay in China during the 1920

Revolution, where Dr. Sun Yat-sen befriended him. After studying with Paul Manship in Paris, he joined the WPA/FAP in San Francisco in 1935. He stayed on the Project until 1940, working as Assistant Supervisor the last year. Most of his major works—many crafted in both stone and metal—are in San Francisco, and include statues of Dr. Sun Yat-sen, St. Francis, and the "Peace" at the International Airport. His statue of a black cat is the symbol of the San Francisco Press Club. He died in his adopted city on August 18, 1970.

Holger Cahill (1887-1960)

Born in Iceland, January 13, 1887, son of Björn Bjarnarson and Vigdis Bjarnadóttir, his given name was Sveinn Kristjan Bjarnarson. Self-educated, he studied intermittently at Columbia University and with Thorstein Veblen at the New School for Social Research, New York. From 1918 he wrote extensively on American art for magazines, newspapers, and exhibition catalogues. On the staff of the Newark Museum under John Cotton Dana, 1922-29, he selected much of its collection of contemporary American painting and sculpture. After Dana's death in 1929 he organized for the Newark Museum in 1930 and 1931 the first major exhibitions of American folk painting and sculpture, searching out this then-obscure material in New England, New York, and Pennsylvania. In 1932-33 as Director of Exhibitions at the Museum of Modern Art, New York, during a leave of absence of its director, Alfred Barr, he produced memorable exhibitions and catalogue texts: *American Painting and Sculpture 1862-1932*, *American Folk Art* (the collection of Abby Aldrich Rockefeller which he had helped form), and *American Sources of Modern Art* (Mayan, Aztec, Incan), the first of that Museum's great series on "primitive" art. He organized New York's *First Municipal Art Exhibition*, sponsored by Mayor La Guardia and Rockefeller Center in 1934,

and in 1939 the exhibition *American Art Today* at the New York World's Fair. From 1935 to 1943 he served as National Director of the WPA/FAP. Author of three novels and three biographies, including *Max Weber* (1930), he also wrote introductions to many publications, among which *New Horizons in American Art* (1936), and *The Index of American Design* (1950) deal with the WPA/FAP. From 1943 on, he devoted much of his time to creative writing, for which he was awarded a Guggenheim Fellowship in 1957. In 1938 he married Dorothy Canning Miller. He died at Stockbridge, Massachusetts, July 8, 1960.

Samuel Cashwan (1900-)

Born in Cherkassi, Kiev, Russia, December 26, 1900, he studied at the City College in Detroit, the New York Architectural League, and under Bourdelle, Milles, and Maillol in Paris. He was employed on the WPA/FAP in Detroit from 1936 to 1942 and served during that period as state supervisor for sculpture, ceramics, and allied arts. He taught sculpture and was head of the sculpture department at the Detroit Society of Arts and Crafts. During the 1950s he worked as a sculptor-designer for General Motors and showed his work locally.

Thaddeus Clapp

He was a state supervisor for the Massachusetts WPA/FAP.

Charles Over Cornelius (1890-1937)

Born in Sewickley, Pennsylvania, September 9, 1890, he obtained his A.B. from Princeton in 1913 and a B.S. in architecture from M.I.T. in 1916. He began his career as an architect in New York. In 1917 he became Associate Curator for the Department of Decorative Arts at the Metropolitan Museum of Art and was named Associate Curator of the Collections of American Art in 1925. He returned to practice as an architect in 1931, specializing in the restoration of old buildings in various parts of the country. He joined the WPA/FAP in New York in February 1936 as the Senior Project Supervisor of the Index of American Design and was named Managing Supervisor in August, one month before he resigned. He was the author of *Furniture Masterpieces of Duncan Phyfe* (1922), *The American Wing of the Metropolitan Museum of Art,* with R. T. H. Halsey (1924), *Early American Furniture* (1926), and from 1916 on was a contributor to periodicals on architecture and the decorative arts. He died July 14, 1937.

Martin Craig (1906-)

Born in Paterson, New Jersey, November 2, 1906, he earned a B.S. from the City College of New York but was largely self-instructed as a sculptor. He taught art on the PWAP and joined the WPA/FAP in August, 1935, where he stayed until 1940. While on the Project, he executed a variety of works, ranging from portrait heads to abstract constructions. Some of his pieces were exhibited at the New York World's Fair 1939. He won a prize from the Museum of Modern Art in 1940. After the war he lived in France, where his first one-man show was presented at the Galerie du Siècle, Paris, in 1949. He has taught sculpture at Sarah Lawrence College, Cooper Union, Brooklyn College, N.Y.U., and Pratt Institute. He is presently teaching at the New School for Social Research and lives in New York City.

Francis Criss (1901)

Born April 26, 1901, in London, he studied at the Pennsylvania Academy of Fine Arts and the Art Students League of New York. His first one-man show was held at the Contemporary Arts Gallery in the early 1930s. He was employed on the PWAP. In 1934

he held a Guggenheim fellowship. He was an art teacher and muralist on the New York City WPA/FAP from 1935 to 1939. He later taught at the Brooklyn Museum Art School, the Albright Art School, and the Art Students League. He lives in New York City.

Philip Curtis (1907-)

Born in Jackson, Michigan, in 1907, he took his A.B. at Albion College in 1930 and began to study law at the University of Michigan. He turned to art about the age of 25 and studied at the Yale School of Fine Arts from 1932 to 1935, when he joined the New York City WPA/FAP as assistant supervisor of the mural division. In 1936 he was sent to Phoenix, Arizona, to start a WPA Community Art Center and to Des Moines, Iowa, in 1939 on a similar mission. After serving in the OSS during the war, he returned to Arizona to paint. He had his first one-man show at the San Francisco Museum of Art in 1949 and a 20-year retrospective at Northern Arizona University in 1967. He lives in Scottsdale, Arizona.

Joseph A. Danysh (1906-)

Born July 15, 1906 in San Antonio, Texas, he was educated in New York City, taking a degree from Columbia College in the early 1930s. From 1933 to 1935 he operated the Adams-Danysh Gallery with the photographer Ansel Adams in San Francisco. He was employed on the San Francisco WPA/FAP 1935-39 and was Regional Director for eleven western states during that period. In 1940 he directed the "American Art Today" exhibition at the New York World's Fair. He worked in private industry as a personnel and labor relations executive 1941-56. He was administrator and president of the Oakland, California, College of Arts and Crafts 1956-59. From about 1960 he has turned to interior design and writing. He lives in Monterey, California.

Stuart Davis (1894-1964)

Born December 7, 1894 at Philadelphia, Pennsylvania, he studied with Robert Henri from 1909 to 1913. He exhibited with the Independents and at the Armory Show. Before the war he did covers and drawings for *The Masses* and *Harper's Weekly*. His first one-man show was at the Sheridan Square Gallery, New York, in 1917. He worked in Paris from 1928 to 1929. During 1931-32 he taught at the Art Students League, New York. In 1932 he was commissioned to do a mural for Radio City Music Hall. He was on the PWAP in 1934 and on the WPA/FAP from 1935 to 1939, creating abstract murals and prints. During this period he was active in the American Artists' Congress and as an editor of the Artists' Union publication *Art Front*. He taught at the New School for Social Research from 1940 to 1950. He had retrospective exhibitions at the Museum of Modern Art in 1945 and at the Walker Art Center, Minneapolis, in 1957. He died in New York on June 25, 1964.

Daniel S. Defenbacher (1906-)

Born in Dover, Ohio, May 22, 1906, he studied art and architecture at the University of Indiana and at the Carnegie Institute. In 1935 as State Director of the WPA/FAP for North Carolina, he developed the first Community Art Centers. He became Assistant to the National Director in charge of Community Art Centers in 1936. He conducted an investigation of the art habits and needs of the average citizen, applying his findings to helping communities establish useful art center programs. He resigned his WPA job in 1939 to accept the Directorship of the Walker Art Center in Minneapolis, where he remained until 1951. From 1951 to 1954 he was Director of the Fort Worth, Texas, Art Center. He was named President of the California College of Arts and Crafts at Oakland in 1954, leaving that position in 1958 to become a management consultant in design.

In 1959 he was named Director of Communications of the Raychem Corp. of California. He is the editor of *American Watercolorists and Winslow Homer* (1945), *Jades* (1946), and has written on a wide range of topics for journals. He lives in Redwood City, California.

Burgoyne Andrew Diller (1906-1965)

Born in New York City January 13, 1906, he began to paint at the age of 14. He studied at Michigan State College, the Art Students League of New York, and with Hans Hofmann. In 1934 he was on the PWAP. He headed the Mural Division of the WPA/FAP in 1935 and held other administrative jobs on the New York Project through 1943. He exhibited regularly with American Abstract Artists from its founding in 1936, and played a leading role in encouraging abstract murals on the Project. His first one-man show took place in 1941 at the Pinacotheca Gallery, New York. He was Associate Professor of Design at Brooklyn College from 1945 to 1961. He had a retrospective exhibition at the Galerie Chalette, New York, in 1961 and was a consultant in fine arts to the Monmouth Museum, New Jersey, at the time of his death in New York January 30, 1965.

Mabel Dwight (1876-1955)

Born in Cincinnati, Ohio, January 29, 1876, she grew up in New Orleans. She studied art in San Francisco at the Hopkins Art School before the turn of the century and in Paris during the early 1920s. Her interest in lithography developed late, after travels in Europe and Asia; on returning to the U.S., she produced a series of lithographs that earned her international recognition and representation in leading museums. By 1929 she had turned out more than 100 prints of New York City personalities. She worked on the WPA/FAP in New York from 1935 to 1939, doing lithographs and some watercolors. She had her first major show in 1938 at the Weyhe Gallery, New York. She lived in Pipersville, Pennsylvania, for many years and died in Sellersville, Pennsylvania, on September 4, 1955.

Emmett Edwards (1906-)

Born in Mount Pleasant, Iowa, October 11, 1906, he studied painting at the Art Institute of Chicago and under Edward Geisbert and John Norton. He worked on the WPA/FAP in Ulster Country, New York, from 1935 to 1939. His work was exhibited in the "New Horizons in American Art" show at the Museum of Modern Art and also at the New York World's Fair in 1939. He has held grants from the Solomon R. Guggenheim Foundation, and lives in Woodstock, New York.

Fritz Eichenberg (1901-)

Born in Cologne, Germany, October 24, 1901, he studied at the State Academy of Graphic Arts, Leipzig, and with H. Steiner-Prag. He worked on the WPA/FAP in New York from December, 1935, to July, 1937, teaching at the New School for Social Research at the same time. He had his first one-man show of prints at the New York Public Library in 1949. The Associated American Artists presented a one-man retrospective of his work in 1967. He is a successful illustrator of books for adults, winning many prizes for his work, including awards from the Library of Congress and a medal from the Pennsylvania Academy of Fine Arts. He has lectured on book illustration and graphic arts, particularly woodcuts, is the editor of *Artist's Proof*, and has been Chairman of the Department of Graphic Art, Pratt Institute, 1956-63; Founder and Director Emeritus of the Pratt Graphic Art Center, 1964-65; and Chairman of the Art Department of the University of Rhode Island since 1966. He lives in Peace Dale, Rhode Island.

Philip Howard Francis Dixon Evergood (1901-)

Born in New York October 26, 1901, son of the Polish painter Meyer Evergood Blashki, he was sent to his mother's home in England for his education. After a try at Eton and Cambridge, he studied art at the Slade School in London, the Académie Julian in Paris, and the Art Students League of New York under George Luks and William von Schlegel. His first one-man show was at the Dudensing Gallery, New York, in 1927. He joined the WPA/FAP in 1935 after working on the PWAP and was managing supervisor of the Easel Division before leaving the Project in 1939. In 1940 he won a commission from the Section for a mural in Jackson, Georgia. He has taught art at Kalamazoo College, Muhlenberg College, and in New York. He was awarded gold medals by the Pennsylvania Academy of Fine Arts in 1950 and 1958 and had a retrospective exhibition at the Whitney Museum in 1960. He lives in Bridgewater, Connecticut.

Leroy W. Flint (1909-)

Born in Ashtabula, Ohio, January 29, 1909, he studied at the Cleveland Art Institute, Cleveland College, Western Reserve University, and the University of Minnesota. He worked on the WPA/FAP in Cleveland from 1936 to 1941, executing a number of murals, notably for the Cleveland Metropolitan Housing Authority, Cleveland Heights Public School, Akron Public Library, and Innes School. He began exhibiting his graphics and easel paintings at the Cleveland Museum of Art in 1936, winning prizes almost every year from the Cleveland Institute of Art. After teaching in the education department of the Cleveland Museum of Art, in 1950 he became an instructor in the Akron Art Institute School of Design, where he stayed for six years, also serving as its Director. He is presently an associate professor and gallery director at Kent State University and lives in Cuyahoga Falls, Ohio.

Richard Floethe (1901-)

Born in Essen, Germany, September 2, 1901, he studied at Dortmund and Munich, learned graphics from Willie Geiger and Edward Ege, design from Klee, and color theory from Kandinsky. He executed a large mural for the International Exposition at Cologne in 1928. He came to the U.S. the same year, eventually becoming a citizen. He worked as a commercial artist, illustrating both children's and adult books, several of which were prize winners. He was head of the WPA/FAP Poster Studio in New York from 1936 to 1943. He continued to do illustrations while on the Project and had a one-man show at Pynson Printers, New York, in 1937. He has been an instructor of commercial design at the Cooper Union School of Art and has taught at the Ringling School of Art in Sarasota, Florida, where he now lives.

Seymour Fogel (1911-)

Born in New York, August 25, 1911, he studied art at the National Academy of Design. He was on the WPA/FAP from 1935 to 1939, assigned to the Mural Division. While on the Project he did murals for the New York World's Fair 1939, the U.S. Customs Courthouse at Foley Square, the Brooklyn Hospital, and schools in the city. He won Section competitions for murals in the new Social Security Building in Washington (now HEW), for a post office in Cambridge, Minnesota, and for Federal Buildings in Safford, Arizona, and Fort Worth, Texas. From 1946 to 1954 he taught art at the University of Texas, Austin, and subsequently at Michigan State University, and the Springfield, Missouri, Art Museum. His first one-man show of easel paintings was at the Duveen-Graham Gallery, New York, in 1956; he has had over a dozen since and is still active as a muralist. A fellow of the Institute of Arts and Letters, he has written articles on art and architecture for the *American Institute of Architects Journal, Art in*

America, and other art magazines. He lives in Westport, Connecticut.

Aline Fruhauf (Vollmer) (1907-)

Born in New York City in 1907, she studied at the Parsons School of Design and the Art Students League under Kenneth Hayes Miller, Boardman Robinson, and Charles Locke. She sold her first caricature to the *New York World* in 1926. She has caricatured many outstanding personalities in the worlds of music, art, literature, and the theatre for *The New York Times, The New York Post, The New Yorker, Vanity Fair,* and *Vogue.* She worked on the graphic division of the WPA/FAP in New York from March to December 1936, creating a number of lithographs. She was asked by Emanuel M. Benson to prepare a series of caricatures of the WPA artists who were writing essays for *Art for the Millions.* Since Project days she has exhibited her paintings, drawings and prints in many shows, including a retrospective titled "Making Faces" at the Smithsonian Institution in 1966. She has been married since 1934 to Dr. Erwin P. Vollmer, has written her autobiography (unpublished), and lives in Chevy Chase, Maryland.

Hugo Gellert (1892-)

Born in Budapest, Hungary, March 3, 1892, he studied at the National Academy of Design, New York. His first one-man show was at the Kevarkian Gallery, New York, in 1923. He painted murals for the Workers' Cafeteria at Union Square in 1928, and for Rockefeller Center in 1932. In 1938 and 1939 he was employed on the New York WPA/FAP's Mural Division. He did a mural for the Communications Building of the New York World's Fair in 1939 and was chairman of the Artists Coordination Committee. He is the author of *Karl Marx's Capital in Lithographs* (1933), *Comrade Gulliver* (1934), and

Aesop Said So (1936) as well as illustrations for several books, including *Century of the Common Man* (1943). A retrospective exhibition of his work was held at the Marx-Lenin Institute in Moscow in 1967 and at the National Gallery, Budapest, in 1968. His most recent mural was executed in the Hillcrest High School, Jamaica, New York, in 1971. He lives in Freehold, New Jersey.

Eugenie Gershoy (1902-)

Born in Russia January 1, 1902, she studied with A. Stirling Calder, Boardman Robinson, and Kenneth Hayes Miller at the Art Students League of New York 1921-22. She was employed on the sculpture division of the WPA/FAP from 1935 to 1939, the year of her first one-man show at the Robinson Gallery, New York. She has taught at the American Artists School, New York, the New Orleans Art School, the San Francisco Art Institute, and in the San Francisco Public Schools. She has exhibited her sculpture and graphics widely, received numerous awards and commissions, and at present lives in New York City.

Rutherford J. Gettens (1900-)

Born in Mooers, New York, January 17, 1900, he was educated at Middlebury College and Harvard University, where he took an M.A. in Chemistry in 1929. From 1937 to 1941 he was consultant to the WPA/-FAP's Paint Testing and Research Laboratory in Boston. From 1928 to 1951 he was employed by the Conservation Department of the Fogg Art Museum and between 1948 and 1951 held the post of Lecturer in Fine Arts at Harvard. From 1951 to 1968 he worked in the Technical Laboratory of the Smithsonian's Freer Gallery of Art in Washington, holding the position of Head Curator from 1961. He has published extensively in his field since 1931, editing in various capacities *IIC Abstracts, Chemical Abstracts,* and

Studies in Conservation, and is presently Research Consultant at the Freer. He lives in Washington, D.C.

Adolph Cook Glassgold (1899-)

Born in New York City February 8, 1899, he was educated at the College of the City of New York and at Columbia, where he took an M.A. in 1923. He studied intermittently at the National Academy of Design and the Art Students League between 1920 and 1924. He taught art in New York high schools from 1922 to 1925 and traveled and painted in Europe from 1925 to 1926, having a one-man show in Paris. He was on the art faculty of CCNY 1927-29 and an editor of *The Arts* 1928-30 and *Creative Art* 1930-32. He was a curator at the Whitney Museum 1932-35 before being employed as National Coordinator of the WPA/FAP's Index of American Design from 1936 to 1940. Since 1941 he has been engaged in public housing and international relief work and is currently education director of a medical program in New York City, where he lives.

Aaron J. Goodelman (1890-)

Born in Ataki, Bessarabia, April 1, 1890, he studied at the art school in Odessa, Russia, before coming to the United States. He studied in New York at the Cooper Union Art School, the National Academy of Design, the Beaux Arts Architects, and at the Beaux-Arts in Paris. He was the student of G. T. Brewster, J. Injalbert, Gutzon Borglum, and Jo Davidson. His first one-man show was at the Dorothy Paris Gallery, New York, in 1935. He was employed on the PWAP in 1934 and on the Art Teaching and Sculpture Divisions of the WPA/FAP from 1935 to 1941. He has continued active as a sculptor, has directed the Goodelman Sculpture Workshop, and had a retrospective at the ACA Gallery, New York, in 1963. He lives in the Bronx, New York.

Jean Goodwin (Ames) (1903-)

Born in Santa Ana, California, November 5, 1903, she was educated at Pomona College, the Art Institute of Chicago, U.C.L.A., and U.S.C. She was employed on the WPA/FAP's mural division c. 1937-39. She has taught at Scripps College and from 1940 to 1969 in the graduate school of Claremont College, where she now holds the rank of Professor Emeritus. With her husband, Arthur Ames, she has created numerous ceramic and mosaic murals over the last twenty years in Southern California and has exhibited nationally. She lives in Claremont, California.

Arshile Gorky (1905-1948)

Born Vosdanig Manoog Adoian in the village Haiyotz Dzor, Armenia, in 1905, he came to the U.S. in 1920. After living in Boston and Providence, where he attended the Rhode Island School of Design, he came to New York to study and teach at the Grand Central School of Art. His early work was first exhibited at the Museum of Modern Art in 1930. He had his first one-man show at the Mellon Galleries, Philadelphia, in 1934. He joined the WPA/FAP in New York in 1935, remaining on the Project until 1941. His best-known work for the Project was the mural for Newark Airport, "Evolution of Forms Under Aerodynamic Limitations," models of which were included in the Museum of Modern Art's exhibition "New Horizons in American Art" in 1936. In 1939 he did a set of murals for the Aviation Building at the New York World's Fair. The San Francisco Museum of Art held a retrospective exhibition of his work in 1941. His most creative years followed, with annual shows at the Julien Levy Gallery in New York until 1948, the year of his suicide.

Ralph Graham

He was supervisor of applied arts on the Chicago WPA/FAP.

Balcomb Greene (1904-)

Born in Shelby, New York, May 22, 1904, he was brought up in Iowa and Colorado. After earning an A.B. in philosophy from Syracuse University, he married the artist Gertrude Glass and left for Vienna to study psychology. In 1927 he returned to New York for graduate study in English at Columbia and then taught at Dartmouth College for three years. In 1932 he had his first one-man show in Paris. Returning to New York in 1933, he worked as a writer. In 1934 he joined the PWAP and the next year the WPA/FAP. He did a mural for the Hall of Medicine at the World's Fair in 1939 and a stained glass window for a Bronx school before resigning in 1940. He was the first chairman of the American Abstract Artists (1936) and was reelected for two succeeding terms. He taught at the Carnegie Institute of Technology from 1942 to 1959. His one-man show at the Bertha Schaefer Gallery in 1950 was nominated one of the year's ten best by *Art News,* an honor he won again in 1955 and 1956. His paintings are in the collections of leading museums and have been widely exhibited. He lives at Montauk Point, L.I., New York.

Marion K. Greenwood (1909-1970)

Born in Brooklyn, N.Y., April 6, 1909, one of a family of artists, she began sketching and painting as a child. Her formal art training was at the Art Students League and the Grande Chaumière in Paris. She had her first one-man show there in. 1928. Fascinated by the murals of Orozco and Diego Rivera, she went to Mexico in 1932 with her older sister Grace, also a painter. After a year's study, she executed large fresco murals at a university in Morelia, Michoacan, and in the Rodriguez Market, Mexico City. She returned to New York in 1936 and joined the WPA/FAP as a muralist, remaining on the Project until 1940. After leaving the Project, she concentrated on figure paintings and lithographs, for which she won several awards. During World War II

she was the only woman to be accredited to the armed forces as an artist-correspondent. She was a visiting professor of art at the University of Tennessee, 1954-55, where she did a large mural, and in 1965 was artist-in-residence at the University of Syracuse. She had retrospective exhibitons of her graphics at the University of Maine, 1965, and at Long Island University, 1967. She died at Kingston, N.Y., in February 1970

Waylande Gregory (1905-1971)

Born in Baxter Springs, Kansas, June 13, 1905, he studied art in Kansas City and while still in his teens created ornamental decorations for a number of Kansas City buildings. He also studied at the Kansas State Teacher's College and the University of Chicago. He was invited to study at the studio of the sculptor Lorado Taft, where he designed and executed 35 sculptures in stone and bronze for the Chicago Theological Seminary. He was hired as Supervisor of the WPA/FAP in Newark, N.J., in 1936. He did a fountain in Roosevelt Park, N.J., while on the Project, which he left in 1938. The massive "Fountain of the Atom" at the entrance to the New York World's Fair (1939) was his work. He won a commission for an outdoor mural for the District of Columbia Municipal Building in 1939, executing it in ceramic tile. He was a pioneer in ceramic sculpture and was known for his research and innovation in materials, glazes, and processes. He exhibited terracottas and sculpture in a number of museums, won many awards as a sculptor of architectural ornament, and served as director of the Berkshire Art Center, Middlefield, Mass. He died in Elizabeth, N.J., August 18, 1971.

O. Louis Guglielmi (1906-1956)

Born in Cairo, Egypt, April 9, 1906, of Italian parents, he came to New York in 1914. He studied art at the

National Academy of Design for five years, then worked as an assistant to a mural painter and did commercial art work until 1932, when he was awarded a fellowship to paint at the MacDowell Colony in Peterborough, New Hampshire. He was employed on the WPA/FAP in New York from 1935 to 1939. He had his first one-man show at the Downtown Gallery in 1938, and his paintings were shown at the New York World's Fair in 1939 and at the Golden Gate Exposition the following year. He was included in the Museum of Modern Art's "Realists and Magic Realists" show in 1943. He served in the U.S. Army Corps of Engineers from 1943 to 1945. He won an Arts and Letters Grant in 1946, and continued to win prizes almost every year. The Louisiana State University presented a retrospective of his work in 1953. He died in Amagansett, L.I., New York, September 3, 1956.

James Meikle Guy (1909-)

Born in Middletown, Connecticut, February 11, 1909, he studied at the Hartford Art School. He had his first one-man show at the Boyer Gallery in 1939. He worked on the WPA/FAP in New York City from 1935 to 1939 as an easel painter. His work was represented at the New York World's Fair 1939. He also did murals for a school in Meriden, Connecticut. He began as a surrealist painter and evolved full circle from figuration to geometric abstraction. Before the war he did a series of semi-surreal gouache paintings of western ghost towns, "Fun in a Ghost Town." During the war he worked in a glider factory. He has taught at MacMurran College 1947-54 and at Wesleyan University, Middletown, Conn., from 1960 to the present.

Agnes L. Hart (1912-)

Born in Connecticut January 4, 1912, she studied painting at the Ringling School of Art with Lucille Blanch, Paul Burlin, and Josef Presser, whom she later married. She worked on the WPA/FAP in New York from 1938 to 1941. She had her first one-man show in New York in 1948. That year she was awarded a fellowship from the Yaddo Foundation. Since 1948 she has had five one-man shows in New York and three in Woodstock, New York, where she makes her home. She is a member and former board member of the Woodstock Art Association, and a founder of the Kaaterskill Group. She has taught painting at the Dalton Schools and the Birch Wathen School. Since 1965 she has taught at the Art Students League of New York.

Clement Bernard Haupers (1900-)

Born in St. Paul, Minnesota, March 2, 1900, he studied at the Minneapolis School of Art and in Paris from 1927 to 1929. On his return to the U.S. he began to exhibit his graphics in major exhibitions between 1929 and 1935. He was an instructor at the St. Paul School of Art from 1931 to 1935. In November 1935 he was hired by the WPA/FAP in Minneapolis, and early in 1936 he was named State Director for Minnesota. He served as Acting State Director from late 1938 through 1942 for South Dakota's WPA/FAP, and was Regional Director for District VII (Iowa, Kansas, North Dakota, South Dakota, Wisconsin, Nebraska, and Minnesota) from 1939 through 1942. After the war he resumed teaching at the St. Paul School of Art. He remains on its faculty and exhibits locally.

Vertis Hayes (1911-)

Born in 1911 at Atlanta, Georgia, he was self-taught in art. He worked on the PWAP in 1934 and on the WPA/FAP mural division in New York City from 1935 to 39. Thereafter he became director of the Community Art Center in Memphis, Tennessee.

Einar Heiberg

He worked on the WPA/FAP easel division in Minneapolis from 1935 to 1942 and was Secretary of the Minnesota Artists' Union.

Hilaire Hiler (1898-1966)

Born in St. Paul, Minnesota, July 16, 1898, his art education consisted of two years at the University of Pennsylvania, and a period of art study in Paris, where he supported himself by playing jazz. While there he became a familiar of Pound, Hemingway, Man Ray, and Joyce. He earned a reputation as a nightclub decorator for his work in the Jungle, the Grand Duke, and the Manitou. He had his first one-man show in Paris in 1923 and a second in New York two years later. He worked on the WPA/FAP in San Francisco from 1936 to 1939 as an artist, supervisor, and editor and executed murals for a public bathing pavilion in Aquatic Park. After leaving the Project he lived and painted in Santa Fe and Paris, and was active as a teacher, heading the Department of Design at the Newark Art Institute, 1958-59. He wrote *Why Abstract?* (1945) and *Why Expressionism?* (1946) and is known for his research on pigments, including *The Technique of Painting* (1955), the official British text on the subject. He died in Paris on January 21, 1966.

Donal Hord (1902-1966)

Born in Prentice, Wisconsin, February 26, 1902, he studied at the Santa Barbara School of Art under Archibald Dawson from 1926 to 1928. In 1928 he was awarded a Gould fellowship, which afforded a year's study in Mexico. He studied briefly at the Pennsylvania Academy of Fine Arts and at the Beaux Arts Institute, but taught himself direct carving in stone. Except for trips to Europe and Egypt, he made his home in San Diego, because it was close to

materials—diorite, obsidian—he preferred. His sculpture began to win awards in 1931, including the medal of the San Diego exposition (1936). He worked on the WPA/FAP in San Diego from 1936 through 1941 and was its Supervisor from 1938. After leaving the Project he won a grant from the American Academy of Arts and Letters (1942). He was a Guggenheim Fellow in 1945 and 1947 and won a grant from the National Institute of Arts and Letters in 1948. The American Institute of Architects presented him with its gold medal in 1953. In 1958 he executed a memorial at the American Military Cemetery in Henri-Chapelle, Belgium. He died in San Diego June 30, 1966.

Russell Vernon Hunter (1900-1955)

Born in Hallsville, Illinois, March 26, 1900, he came to New Mexico at the age of five. He studied at James Milliken University and the Art Institute of Chicago, then returned to paint in Santa Fe and teach art in the public schools of Los Cerrillos. From 1923 to 1927 he was in Los Angeles at the Otis Art Institute, studying with Stanton Macdonald-Wright, teaching, and designing furniture. He spent 1929-32 in New York, but left for New Mexico to accept mural commissions in Amarillo and Clovis. Under the PWAP he did a series of murals in the Fort Sumner Courthouse. In 1934 he opened a vocational school in Puerto de Luna under a state-run program to renew Spanish Colonial crafts. He served as State Director of the WPA/FAP from 1935 to its close in 1942. After war service with the USO, in 1948 he became Administrative Director of the Dallas Museum of Fine Art. In 1952 he was appointed Director of the Roswell, N.M., Museum, which had been built as a Community Art Center under his WPA/FAP administration. His own work has been exhibited nationally and is in museum collections in New Mexico and elsewhere. He wrote several books and scholarly articles on the Spanish Colonial arts. He died in New Mexico March 20, 1955.

Eli Jacobi (1898-)

Born in Russia May 1, 1898, he left home in 1910. He studied art briefly in Palestine before the war forced him to go to Greece, where he worked as a portraitist. He came to the United States about 1920, settled in New York, and studied at the National Academy and the Art Students League. By 1926 he was successful as a magazine and book illustrator. He returned to painting about 1930. The Depression reduced him to living on the Bowery. From 1935 to 1939 he was employed on the WPA/FAP as a graphic artist. He is active as a painter and printmaker and lives in New York City.

Lawrence A. Jones

He was employed on the New Orleans WPA/FAP from 1938 to 1940.

Jacob Kainen (1909-)

Jacob Kainen was born in Waterbury, Connecticut, December 7, 1909. He received his education in the 1930s at Pratt Institute, New York University, and as a printmaker on the graphic .division of the WPA/FAP in New York from 1935 to 1942. As a painter and printmaker, he has had twenty-two one-man shows, has exhibited in innumerable group shows here and abroad, and has won a number of important prizes. In the early 1940s he joined the staff of the division of graphic art of the Smithsonian's United States National Museum and for twenty years, from 1946 to 1966, held the rank of curator From 1966 to 1969 he was curator of the Department of Prints and Drawings at the Smithsonian's National Collection of Fine Arts, where he is presently a consultant. He has published innumerable books, articles, exhibition catalogues, and book forewords. Two recent books are *John Baptist Jackson: 18th*

Century Master of the Color Woodcut (1962) and *The Etchings of Canaletto* (1967), both published by the Smithsonian Institution Press. He lives in Chevy Chase, Maryland.

Albert Sumter Kelley (1909-)

Born in Slocomb, Alabama, January 12, 1909, he studied at Emory University, Atlanta, and received his art training at the Ringling Art School, Sarasota, Florida, and the Art Students League of New York. He was on the WPA/FAP in New York from September 1935 through August 1939 and during that time did murals for the children's ward of Lincoln Hospital. He worked with George Pearse Ennis on a stained-glass project in New York. After leaving the New York Project, he became exhibition director for the Jacksonville, Florida, WPA Community Art Center. He later returned to the New York area to teach art at Adelphi College, Hempstead, N.Y., where he was chairman of the Art Department. He lives in New York City.

Paul Kelpe (1902-)

Born in Minden, Germany, in 1902, he studied art in Hannover, Germany. He later earned his M.A. and Ph.D. at the University of Chicago. He worked on the WPA/FAP in New York City from 1936 until 1939. While on the Project, he completed a mural at the Williamsburg Housing Project. He was a Professor of Art at the University of Texas at Austin from 1948 to 1954, then taught at Howard University in Washington, D.C. from 1957 to 1960 before returning to Texas to teach from 1960 to 1969 at East Texas State University in Austin, where he now lives.

Albert Henry King (1900-)

Born in Kent, England, in 1900, he came to the United

States about 1910 and was educated in Los Angeles at the Canon School and that city's Art Students League. His first one-man show was at the Zeitlain Gallery in Los Angeles about 1923. He worked on the Los Angeles PWAP and was supervisor of ceramics on the WPA/FAP there from 1936 to 1939. His major Project work was the Long Beach Municipal Auditorium mosaic mural, which he executed after a preliminary design by Stanton Macdonald-Wright with the assistance of about fifty Project craftsmen. Since the early 1940s he has taught at U.C.L.A. and U.S.C. and is one of the founders of the Art Center College of Design in Los Angeles. He continues to live in that city and is still active in both painting and sculpture.

Karl Knaths (1891-1971)

Born in Eau Claire, Wisconsin, October 21, 1891, he grew up in Milwaukee and Portage and only saw his first painting when he went to Chicago at the age of twenty. He studied at the Milwaukee and Chicago Art Institutes, worked as a railroad boxcar painter for a year, and then moved to the art colony in Provincetown, Mass., which was his permanent home for the rest of his life. He worked on the WPA/FAP in Boston from 1935 to 1937 as a muralist. He was a guest teacher at the Phillips Gallery school, Andover, Mass., in the late 1930s and early 1940s and also taught at Bennington College. He was the recipient of many awards and exhibited at galleries in Boston and New York. He died in Massachusetts in March 1971.

Chet Harmon La More (1908-)

Born in Dane County, Wisconsin, July 30, 1908, he earned his A.B. and M.A. at the University of Wisconsin and also studied at Columbia University. He received his art training at the Colt School of Art, Madison, Wisconsin. He worked on the WPA/FAP in

New York City from 1937 to 1939. His work was included in the exhibition of contemporary American art at the New York World's Fair 1939. His first one-man show was at the American Contemporary Artists Gallery, New York, in 1941; he has had more than twenty one-man shows since then. He has been professor of painting in the Art Department of the University of Michigan at Ann Arbor since 1947.

Jacob Lawrence (1917-)

Born in Atlantic City, New Jersey, September 7, 1917, he was raised in Philadelphia and Easton, Pennsylvania. He began his art training in 1930 when his family moved to New York, studying with Charles Alston at the Harlem Art Workshop, where he won a scholarship to the American Artists School for 1937-39. There he did a series of paintings of scenes from the lives of Toussaint l'Ouverture, Frederick Douglass, and Harriet Tubman. He worked on the WPA/FAP from 1938 through 1939. He had his first one-man show at the Harlem YWCA (1939) and was awarded a Rosenwald Fellowship the following year. After service in the Coast Guard, he received a Guggenheim Fellowship (1946) and has since been honored by other awards and grants, including a retrospective exhibition sponsored by the Ford Foundation (1960). He shared first prize in the mural competition for the U.N. Building (1955). He has taught at Black Mountain College, Pratt Institute, Brandeis University, and the New School for Social Research. At present he is Professor of Art at the University of Washington in Seattle.

Jack Levine (1915-)

Born in Boston January 3, 1915, he began drawing while very young and attended classes at a community center. Later he went to classes at the Boston Museum and the Fogg Art Museum, where he attracted the attention of Harvard's Dr. Denman Ross,

whose encouragement had a profound influence on his development. He joined the WPA/FAP in Boston in 1935. "String Quartet," a painting done for the Project in 1937, was included in the Whitney Museum's Annual that year and was purchased by the Museum of Modern Art, effectively establishing his reputation. Noted for his "social satire," he had his first one-man show at the Downtown Gallery in 1939. He was awarded a Guggenheim Fellowship in 1946 and won a Fulbright grant in 1950. He has exhibited regularly in New York, having six one-man shows between 1953 and 1963. He has had retrospectives at the Institute of Contemporary Art, Boston (1952), the Whitney Museum (1954), and the Second Mexican Biennale (1960). He has won many awards and his work is in most major collections. He lives in New York City.

Russell T. Limbach (1904-1971)

Born in Massillon, Ohio, November 9, 1904, he studied at the Cleveland School of Art and in Paris and Vienna. He began exhibiting in the 1920s, winning the California Print Maker's silver medal in 1928, and more than fifteen awards in lithography. He worked on the Graphics Division of the WPA/FAP in New York City from 1935 to 1940. A few years after leaving the Project, he published *American Trees* (1942), for which he did both illustrations and text. A number of the color lithographs from the book were exhibited at the Smithsonian Institution in 1947. He also illustrated *But Once a Year* (1941) for the American Artists Group. He was professor of painting at Wesleyan University, Middletown, Connecticut. He died in Sherman, Connecticut, January 10, 1971.

Abraham Lishinsky (1905-)

Born in Russia in 1905, he was educated at the Educational Alliance, New York. He worked on the PWAP in 1934 and the WPA/FAP from 1935 to 1940.

He received a Section mural commission for the Woodruff, South Carolina, Post Office in 1941. Thereafter until 1955 he left art for private business. He spent 1955-57 in Spain, returning to his business interests in New York until his retirement in 1970. He has resumed painting and lives in Brooklyn, New York.

Earl Lonsbury

He was employed on the PWAP in 1934 and on the WPA/FAP from 1935 to 1942.

Louis Lozowick (1892-)

Born in Russia December 10, 1892, he received his A.B. from Ohio State University and studied art at the National Academy of Design in New York. He traveled in Europe, becoming the first American artist to exhibit in Russia since the Revolution. He worked on the WPA/FAP in New York as a graphic artist from 1935 to 1940. He has exhibited and won prizes in most of the major print shows since the early 1930s. The Newark Public Library presented a retrospective of his work in 1969. He is the author of *Modern Russian Art* and *100 American Jewish Artists*, and has contributed articles on art and the theatre to *The Nation, Theatre Arts, The New Masses, The Encyclopedia Americana,* and other publications. He lives in South Orange, New Jersey.

Eugene David Ludins (1904-)

Born in Mariupol, Russia, March 23, 1904, he came to the U.S. as a child and received his art training in New York at the Art Students League under Kenneth Hayes Miller, Allen Tucker, and Walt Kuhn. He was appointed supervisor of the WPA/FAP in Woodstock, New York, in 1936, a position he held until 1939, when he served briefly as New York State Director.

He exhibited in regional and area shows in the 1940s. From 1948 to 1969 he was professor of painting at the State University of Iowa, retaining his ties with Woodstock as a member and Chairman (1955-56) of the Woodstock Art Association. He received a grant from the American Academy of Arts and Letters in 1960. He lives in Woodstock, New York.

Stanton Macdonald-Wright (1890-)

Born in Charlottesville, Virginia, July 8, 1890, he studied at the Los Angeles Art Students League and in Paris, where he and Morgan Russell studied color theory under Tudor-Hart about 1910-11. He exhibited in Paris and in the first Synchromist exhibit in Munich in 1913. He returned to the United States in 1916 and had his first one-man show at the Photo-Secession Gallery, New York, in 1917. In 1919 he went to California to experiment with color films. He directed the Los Angeles Art Students League from 1922 until 1930. From 1935 to 1943 he was employed on the WPA/FAP as a.supervisor and later as state director for Southern California. He became interested in new techniques for architectural decoration and designed murals and mosaics in Petrachrome, a process he invented. He taught at the University of California at Los Angeles and at other universities from 1942 to 1954. He then retired from teaching after a year in Tokyo as a Fulbright exchange teacher. Since then he has continued to paint and has been the subject of a major retrospective at the Los Angeles City Museum in 1956 and another at the Smithsonian Institution in 1967. He lives in Pacific Palisades, California.

Loren MacIver (1909-)

Born in New York February 2, 1909, she began her art training at the Art Students League while still a schoolgirl. In 1929 she married the poet Lloyd Frankenberg. In 1933 she first exhibited her work in group shows at Contemporary Artists, New York. She worked on the WPA/FAP in New York from 1936 to 1940. Her first one-man show was held at the East River Gallery in 1938. After leaving the Project, she did lighting and decoration for concerts at the Museum of Modern Art, using slides for "sets." She became interested in clowns as a subject for her painting and did a series with Jimmy Savo and Emmett Kelly as models. In addition to illustrations for magazines, posters, and bookjackets and a few portraits, she did several murals for ocean liners. The Whitney Museum presented a retrospective exhibition of her work in a joint showing with the paintings of I. Rice Pereira in 1953. She lives in Paris.

Audrey McMahon

Audrey McMahon was born in New York City. She received her early education in Paris, holds a degree from the Sorbonne and has done graduate work in the fine arts and social work in the United States. During the years before her marriage to the art historian A. Philip McMahon she worked as a creative writer for a number of small publications. In the late 1920s she became director of the College Art Association and editor of *Parnassus,* as well as managing editor of the *Art Bulletin* and *Eastern Arts.* She also initiated a very large traveling exhibition program which gave many colleges and museums their first shows of original works of art. During the very early years of the Depression she got permission from John Shapley, President of the CAA, to set up a rental system and gallery for artists. Later she and Frances Pollak, who was associated with the CAA and later became editor of the Index of Twentieth Century Artists, sought and obtained municipal, state, and ultimately federal emergency relief assistance to employ artists and models. Because of her unique experience with these first work-relief programs for visual artists, her advice was sought by Harry Hopkins in the early planning stages of the WPA Federal Art Project. Inevitably, she became its

Aline Fruhauf. *Audrey McMahon.* Pen and ink, New York City Project, 1936. (NCFA:Cahill)

director for the New York region when it began in 1935 and she continued her supervisory role through to the liquidation in 1943. Since then she has worked actively in social service agencies.

Irving J. Marantz (1912-1972)

Born in Elizabeth, New Jersey, March 22, 1912, he graduated from the Newark School of Fine Arts and attended the Art Students League of New York, where he studied painting under George Grosz and lithography with Harry Sternberg. He continued to develop his painting while pursuing other work for his livelihood. In 1935 he was hired by the WPA/FAP in New York to teach art at the Community Boys' Club. He also directed the Art Teachers Institute before he left the Project in 1938. From 1938 to 1941 he worked as an antique buyer in China, where he also exhibited frequently as a member of the Hong Kong Working Artists Guild. On returning to the U.S., he began to exhibit in group shows and had his first one-man show in 1950 at the Shore Studio at

Provincetown. He has taught art at the Newark School of Fine and Industrial Art, C.C.N.Y., and the University of Iowa. He spent a year as visiting professor of·art at the University of Georgia (1965-66) and later taught at N.Y.U. (1966-69). He died June 13, 1972.

Edward Millman (1907-1964)

Born in Chicago, January 1, 1907, he studied at the Art Institute under Leon Kroll and John Norton. For a time he was a staff illustrator on the *Chicago Evening American.* In 1933 he did a series of murals at Chicago's "Century of Progress" exposition. He was employed on the PWAP in 1934. He went to Mexico to study fresco with Diego Rivera, 1934-35. In 1935 he became the first Illinois State Director of the WPA/FAP. He created a number of murals for the Project and also several Post Office murals for the Section, including a major one with Mitchell Siporin in St. Louis in 1939. He had his first one-man show at the Downtown Gallery, New York, in 1942. During the war he served as a combat artist in New Guinea and the Philippines. He received a Guggenheim Fellowship in 1946. He taught in a number of schools, including Rensselaer Polytechnic Institute from 1954-64. He died February 11, 1964, at Woodstock, New York.

Eugene Morley (1909-1953)

Born in Scranton, Pennsylvania, November 10, 1909, he studied at the Art Students League in New York. He was associated with the stage designer Norman Bel Geddes and taught drawing and lithography at the American Artists School, New York, which he helped to organize. He worked on the WPA/FAP mural and graphic divisions in New York City from 1935 to 1941 and became a project supervisor in September 1940. After the war he made his living for a time as art director of Covington Fabrics in New

York City. He continued to paint periodically, moving from social statement to abstraction, but he did not exhibit or have a dealer. He died in 1953.

Carl A. Morris (1911-)

Born in Yorba Linda, California, May 12, 1911, he began his art training in high school. After attending Fullerton Junior College 1930-31, he went to the Art Institute of Chicago to study painting for two years. He spent 1933-36 in Vienna and Paris. He had his first one-man show at the Institute of International Education in Paris. In 1936 he returned to the U.S. and worked on movie sets in Los Angeles. His first American one-man show was at the Paul Elder Gallery there in 1937. He taught at the Art Institute of Chicago 1937-38. He was hired by the WPA/FAP in 1938 to direct the Spokane, Washington, Art Center, and stayed on the Project as assistant state supervisor for Washington until 1940. In 1941 he won a section competition for a mural for the Eugene, Oregon, Post Office which he completed in 1942. After the war he resumed painting. In 1957 he taught at the University of Colorado. The American Federation of Arts circulated a retrospective exhibition of his work under a grant from the Ford Foundation in 1960. He has been married to the sculptress Hilda Grossman since 1940 and lives in Portland, Oregon.

Mary Morsell (1894-)

Born August 12, 1894, she worked on the staff of the WPA/FAP's Washington office under Holger Cahill in various capacities from 1936 to 1940.

Louise Nevelson (1900-)

Born in Kiev, Russia, in 1900, she was brought to the U.S. in 1905 and was raised in Rockland, Maine. She moved to New York in 1920 after her marriage and began to study voice. In 1929 she began to work at the Art Student's League with Kenneth Hayes Miller, and was able to go to Munich in 1931 to study with Hans Hofmann. She worked as an assistant to Diego Rivera in New York in 1932-33. From 1935 to 1939 she was employed on the WPA/FAP Easel Division in New York and also taught sculpture. She had her first one-man show of sculpture at the Nierendorf Gallery in 1941. Her first one-man show of etchings opened in 1950 at the Lotte Jacobi Gallery. In 1967 the Whitney Museum presented a retrospective of her work. Her work is in most major museum collections, and she has received many important commissions and awards. She lives in New York City.

James Michael Newell (1900-)

Born in Pittsburgh, Pennsylvania, February 21, 1900, he studied at the Art Students League and the National Academy of Design in New York. He went to France to study at the Académie Julian in 1927 and stayed to learn fresco techniques with Paul Baudouin. Later he spent three years experimenting with the medium and researching old frescoes in France and Italy. He won the Fontainebleau Hospital prize and did a fresco there in 1930. Returning to the U.S. in 1931, he did five murals for the PEPCO Building in Washington, D.C. In 1934, on the PWAP, he made mural designs for the reading room at New York University, which were chosen by Mrs. Roosevelt to be displayed in the White House. He worked for the WPA/FAP in New York from 1935 to 1942, producing murals for the library at Evander Childs High School, for which the Architectural League awarded him its annual gold medal of honor in 1936. He also did a mural series in 1939 for the Department of the Interior, in Washington, under the Section and a mural in the Dolgeville, New York, Post Office in 1940.

Geoffrey R. Norman (1899-1964)

He was born in London February 21, 1899, and educated in English private schools. During the 1920s he studied at the Académie Julian in Paris and the Art Students League, New York. He had his first one-man show in 1930. He was on the PWAP in 1934 and served in the administration of the WPA/FAP in New York and Washington, 1935-43. He painted a mural in Textile High School, New York City, and was President of the National Society of Mural Painters. During the war he served in U.S. Air Force Intelligence in India. From 1946 to 1959 he worked for the Central Intelligence Agency. He died in Washington, D.C., in September 1964.

Hilda Lanier Ogburn (1895-)

Born February 11, 1895, at Sommerfield, North Carolina, she studied art at Converse College, Spartanburg, South Carolina, 1912-15, and at the Art Students League, New York 1919-23. From 1925 to 1936 she maintained a studio in Greensboro, N.C. Her first one-man show was held there at the Art Shop in 1934. From 1936 to 1939 she was employed as an art teacher by the WPA/FAP in Greensboro, and thereafter in supervisory capacities in Greenville and Raleigh through 1942. Since the Project she has been engaged in free-lance art work in Greensboro, where she lives today.

Elizabeth Olds (1917-)

Born in Minneapolis, Minnesota, on December 10, 1917, she studied at the University of Minnesota and the Minneapolis School of Art before coming to George Luks' class at the Art Students League in New York. In 1927 she was one of the first artists to receive a Guggenheim Fellowship to study painting in France. She was hired as an artist by the WPA/FAP in New York in 1935, remaining on the Project until

1940. In those years she worked at printmaking and participated in the Silk Screen Unit of the Graphics Project with Anthony Velonis, developing serigraphy as a fine art medium. Her work of the period is often focused on social issues. She had her first one-man show at the American Contemporary Art Gallery in 1937 and has had many since then. She has written and illustrated a number of books for children, including three which have won Junior Literary Guild awards. Her work is represented in major collections of modern art. She lives on Staten Island, New York.

Uno John Palo-Kangas (1904-)

Born in Trimountain, Michigan, in 1904, he received his initial art training in Detroit at the Art League and the Detroit Art Institute, the Chalet d'Art, and under private instructors. He went to California in 1924 as a free-lance commercial sculptor. He worked on the WPA/FAP in Los Angeles from 1935 to the early 1940s and created several monumental stone sculptures.

Augustus Peck

He worked on the WPA/FAP in New York City from 1936 until 1939 and was until recently Director of the Brooklyn Museum Art School.

Irene Rice Pereira (1901-1971)

Born in Chelsea, Massachusetts, August 5, 1901, she painted on her own for several years before studying with Jan Matulka and Richard Lahey at the Art Students League in New York from 1928 to 1931. Her first one-man show was at the American Contemporary Art Gallery in 1933. She worked on the PWAP in 1934 and joined the WPA/FAP in New York in 1935 as a teacher at the Design Laboratory through 1937. Her experience there turned her painting

toward abstraction, and the climate of experimentation encouraged her to use parchment, plastic, and glass as well as the more traditional media. She worked on the Easel Division 1937-39. Sixty of her paintings were shown at the Whitney Museum in 1953 in a joint retrospective with the work of Loren MacIver. After this she began to concentrate on putting the mathematical principles and the philosophy behind her paintings into words. She wrote nine books, including *The Nature of Space* (1956) and *The Crystal of the Rose* (1959), a collection of poetry. She died in Malaga, Spain, January 11, 1971.

Girolamo Piccoli (1902-)

Born in Palermo, Sicily, May 9, 1902, he studied at the Wisconsin School of Art under Frank Vittor and Lorado Taft. His sculpture began to win awards in the early 1920s. He did sculptural decoration for the Eagle's Club Building and a fountain, "Boy with Duck," for Lake Park, in Milwaukee. He taught at the Layton School of Art in Milwaukee before joining the WPA/FAP in New York at the end of 1935. While in New York he became a member of the American Artists' Congress. In his second year on the Project, he became managing supervisor of the Sculpture Division, and continued in responsible positions until leaving the Project in March 1941. In 1942 he published a book, *Techniques of sculpture, a simple creative approach,* written in collaboration with Ruth Green Harris. He lives in Anticoli, Italy.

Charles Cecil Pollock (1902-)

Born in 1902 at Denver, Colorado, he was the first of five sons, of whom the youngest was Jackson Pollock. He studied at the Otis Art Institute in Los Angeles in the early 1920s and under Thomas Hart Benton at the Art Students League of New York from 1927 to 1930. He first exhibited in New York at the Ferargil Gallery and the New School for Social

Research. From 1935 to 1937 he worked for the Farm Resettlement Administration in Washington, D.C. He then moved to Detroit where from 1937 to 1942 he was supervisor of the Mural and Graphic Divisions of the Michigan WPA/FAP. Thereafter he taught calligraphy, typographic design, and printmaking at Michigan State University, East Lansing. Since the mid-1950s his style has changed from social realism to abstraction. In 1968, on retirement from the University, he moved to New York and later to Paris, where he lives today.

Jackson Pollock (1912-1956)

Born in Cody, Wyoming, January 28, 1912, he first studied art in Los Angeles during the late 1920s. He came to New York in 1930 and studied with the regionalist painter Thomas Hart Benton for about three years at the Art Students League. From 1935 to 1943 he was employed on the Easel Division of the WPA/FAP. His first one-man show opened at Peggy Guggenheim's Art of This Century Gallery in November 1943. He showed regularly in New York thereafter. In 1945 he married Lee Krasner and moved to East Hampton, Long Island, where he died in an automobile accident August 11, 1956. He was the leading painter of the Abstract Expressionist movement and is most famous for his "poured" paintings of the years 1947-53.

Walter Quirt (1902-1968)

Born in Iron River, Michigan, November 24, 1902, he received his early training as an artist and teacher at the Layton School of Art in Milwaukee 1921-28. In 1929 he went to New York. He was employed on the WPA/FAP from 1935 to 1943. His first one-man show was at the Julien Levy Gallery in 1936. During the early 1940s he showed at the Pinacotheca Gallery. About 1945 he left New York and eventually settled at the University of Minnesota, where he remained

until his death March 19, 1968, achieving the rank of professor in 1959. During the 1930s he was called a "social surrealist." Later he developed a deep interest in the creative process and in the teaching of art. In 1960 the Ford Foundation circulated a retrospective of his work and in 1967 funded his field experiments into the creative process in Yucatán.

Anton Refregier (1905-)

Born in Moscow, Russia, March 20, 1905, his family moved to Paris when he was fourteen and to the United States about 1920. He studied art in Paris with the sculptor Vassiliev, graduated from the Rhode Island School of Design in 1925, and studied with Hans Hofmann in 1927. In 1928 he began his career as a muralist, working in New York with architects and decorators such as Norman Bel Geddes. He contributed socially-orientated material to trade union journals. He was on the PWAP in 1934 and the WPA/FAP from 1935 to 1940, creating major murals for the Rikers Island penitentiary and the WPA Building at the New York World's Fair in 1939. He completed a mural for the Section in the Plainfield, New Jersey, Post Office in 1942. His sketches for 27 mural panels in the Rincon Annex Post Office in San Francisco were approved under the Section, though the controversial murals were not executed until after the war, in 1946-48. His first one-man show was at the ACA Gallery, New York, in 1941. He was an artist-correspondent for *Fortune* at the United Nations Organizational Conference in San Francisco in 1945. Since then he has received innumerable mural commissions. A retrospective of his paintings and graphics was held at the Hermitage in Leningrad in 1967. He is the author of *We Make Our Own Tomorrow—An Artist's Journey,* of the textbook *Natural Figure Drawing,* and of the pamphlet "Government Sponsorship of Arts." He lives in Woodstock, New York.

Hugo Robus (1885-1964)

Born in Cleveland, Ohio, May 10, 1885, he studied at the Cleveland School of Art from 1904 to 1908. He came to New York in 1910 for a year's study at the National Academy of Design. The following year he went to study and travel in Europe for three years. Back in the U.S. he made a living designing textiles and making silverware and jewelry. He stopped painting entirely in 1920 in favor of sculpture, which he first showed at the Whitney Museum in 1933. He worked for the WPA/FAP in New York 1935-39 and was a member of the jury of the show, "American Art Today," at the 1939 World's Fair. He had his first one-man show at Grand Central Galleries in 1946; two years later he was visiting artist at the Munson-Williams-Proctor Institute. He taught sculpture at Columbia University's summer sessions until 1956, and from 1950 to 1958 was sculpture instructor at Hunter College. In 1960 the Ford Foundation provided a grant for a retrospective exhibition of his work, circulated by the American Federation of Arts. He died in New York City in 1964.

Lincoln Rothschild (1902-

Lincoln Rothschild was born in New York City in 1902 and was educated at Columbia University, the Institute of Fine Arts of New York University, and the Art Students League, where he studied painting under Kenneth Hayes Miller. He started to work on the WPA/FAP in New York in 1935 and from 1937 to 1941 was director of its Index of American Design. He was also very active in the Artists' Congress. He has taught at Columbia University and City College and was chairman of the Art Department at Adelphi College from 1946 to 1950. From 1951 to 1957 he was national executive director of the Artists Equity Association. He is the author of four books, including *Sculpture Through the Ages* (1942) and *Style in Art* (1960), and innumerable articles. He also edits his own private newsletter, *The Pragmatist in Art.* He lives in Dobbs Ferry, New York.

Aline Fruhauf. *Constance Rourke.* Pen and ink, New York City Project, 1936. (NCFA:Cahill)

Constance Mayfield Rourke (1885-1941)

Born in Cleveland, Ohio, November 14, 1885, she received her A.B. from Vassar College in 1907. With a grant from the Borden Fund for Foreign Travel and Study, she was able to study at the Sorbonne in 1908-1909 and to spend the next year in independent study at the Bibliothèque Nationale in Paris and the British Museum in London. On returning to the United States, she taught English at Vassar from 1910 to 1915. As a free-lance writer, she specialized in American folklore and humor. Her article on Paul. Bunyan in the July 4, 1918, *New Republic* was the first to be published on the subject. Her best-known work is *American Humor: a study of the national character* (1931). From 1935 to 1936 she was editor of the Index of American Design for the WPA/FAP. After her work on the Index, she published *Charles Sheeler: Artist in the American Tradition* (1938). She died in Grand Rapids, Michigan, in 1941.

Mitchell Siporin (1910-)

He was born in New York May 5, 1910, but his family moved to Chicago the following year. He began his art training as a child at the Chicago Art Institute and with Todros Geller, and studied at Crane College. He worked on the WPA/FAP in Chicago from 1935 to 1940. In 1939 he and the artist Edward Millman won a $29,000 Section commission to paint a mural series in fresco for the St. Louis Post Office, which they completed in 1942. During the war he served as a war artist in Europe. In 1946 he was awarded a Guggenheim Fellowship. He has taught art at Brandeis University since 1949 and was Chairman of the Fine Arts Department from 1956 to 1962. Since his first one-man show at the Downtown Gallery in 1938, he has exhibited widely and won numerous awards for his oils and watercolors. He lives in Newton, Massachusetts.

David Smith (1906-1965)

Born at Decatur, Indiana, March 9, 1906, he studied at Ohio University in 1924 and at the Art Students League with Richard Lahey, John Sloan, and Jan Matulka from 1926 to 1932. He began to sculpt about 1931. In 1934 he was employed on the PWAP. He went to Europe in the fall of 1935, visiting London, Paris, and Greece. He returned in 1936. Between 1937 and 1939 he was employed on the WPA/FAP and the TRAP. His first one-man show of sculpture was at the East River Gallery in 1938. In 1940 he moved permanently to Bolton Landing, New York, and set up a studio-workshop there. He taught at Sarah Lawrence College and the Universities of Arkansas, Indiana, and Mississippi. He held Guggenheim awards in 1950 and 1951. In 1958 he had a one-man show at the Venice Biennale. At the time of his death in an automobile accident on May 23, 1965, he was widely acknowledged to be the most important sculptor of the New York School.

E. Herndon Smith (1891-)

Born in Mobile, Alabama, July 9, 1891, he was educated at Yale and the Art Students League of New York. His first one-man show was at the Malcom Gallery, New York, in 1921. He was employed in New York City on the PWAP in 1934 and on the WPA/FAP as an easel painter and supervisor from 1935 to 1940. From 1940 to 1943 he directed the art and museum projects of the WPA/FAP in Alabama. In 1941 he founded the Mobile Art Association. Between 1948 and 1964 he executed murals, portraits, and landscapes in the South, finally settling in the city of his birth. He was curator of the Mobile Museum 1964-66 and is presently consultant to the Mobile Public Library. A retrospective exhibition of his work was held at the Mobile Art Gallery in 1971.

Gordon Mackintosh Smith (1906-)

Born in Reading, Pennsylvania, June 21, 1906, he received an A.B. from Williams College and did graduate work at Harvard University. His career in museology began with a position as curator of the Berks County, Pennsylvania, Historical Society, in 1935. He was appointed an Assistant Regional Director of the WPA/FAP in 1936. From 1937-42 he worked as a supervisor of the Index of American Design project in Boston. From 1942 to 1946 he served as chief of the Plans and Intelligence Branch of the Armed Services. He resumed his museum work in 1946 as Director of the Currier Gallery of Art in Manchester, New Hampshire, where he remained until 1955. Since 1955 he has been director of the Albright-Knox Gallery in Buffalo, New York.

William Sommer (1867-1949)

Born in Detroit, Michigan, January 18, 1867, he began to study art at the age of eleven with Julian Melchers, father of the artist Gari Melchers. After serving a seven-year apprenticeship at the Calvert Lithography Company, he began in 1888 to work as a journeyman lithographer and poster artist in New York, Boston, and England. He returned to Cleveland in 1907, where he was a close friend of the writer Hart Crane, who dedicated *Sunday Morning Apples* to Sommer in 1922. In 1933 he joined the PWAP and did two murals in Cleveland. In 1935 he was employed as supervisor of the WPA/FAP in Cleveland, remaining on the Project until 1943, during which time he did murals in Akron and Boston, Ohio. He also did a mural for the Geneva, Ohio, Post Office for the Section in 1938. In 1946 the Akron Art Institute was appointed custodian of his works. Sommer died in Cleveland June 20, 1949. The Cleveland Museum of Art held a memorial exhibition of his work in 1950.

Isaac Soyer (1907-)

Born in Russia April 20, 1907, he came to the U.S. in 1912. His family settled in the lower East Bronx, N.Y. He studied art at the Cooper Union Art School at night until he finished high school and then attended the Educational Alliance Art School on the east side. He became an instructor in life classes there. He went to Europe to study in 1928, visiting Paris and Madrid. He worked on the PWAP in 1934 and on the WPA/FAP Graphic Division from 1936 to 1937. He taught art at the Buffalo Fine Arts Academy soon after leaving the Project, and has taught also at the Brooklyn Museum School. He has won a number of awards and has exhibited widely, most recently at the Whitney Museum of American Art in 1966 and 1969. He lives in New York City.

Max Spivak (1906-)

Born in Bregnun, Poland, on May 20, 1906, he came to New York as a child. He went to Europe to augment his earlier study at the Art Students League, working in Paris at the Grande Chaumiere. While in

Europe he became interested in the mosaics he saw in churches and ancient buildings, and on returning to the United States experimented with this medium. He was on the WPA/FAP Mural Division 1935-43. In 1948 he had his first one-man show of paintings at the Mortimer Levitt Gallery in New York. Since the early 1950s he has received a number of commissions for mosaic murals. He has taught at Bard College and at Pratt Institute, and served as first vice president of the Architectural League in 1966-68. He lives in New York City.

Alexander Raoul Stavenitz (1901-1960)

Born in Kiev, Russia, May 31, 1901, he studied art in New York at the Art Students League and attended the St. Louis School of Fine Art. He won a Guggenheim Fellowship in graphic arts in 1931. His work was included in "Fifty Prints of the Year" (1931, 1932, 1934) and in "Fine Prints of the Year" (1934). He worked on the PWAP and was employed on the WPA/FAP in 1935. He was the director of the Art Teaching Division and left the Project in 1940. He taught industrial design at Pratt Institute 1945-47, and was named Associate Professor of Art at C.C.N.Y. in 1950. He began teaching at the Museum of Modern Art in 1954, where he also was a member of the committee on art education. He died at Norwalk, Connecticut, February 12, 1960.

Cesare Stea (1893-1960)

Born in Bari, Italy, August 17, 1893, he came to the United States in 1903 and studied art in New York at the National Academy of Design, the Beaux Arts Academy, the Cooper Union Art School, and the Italian-American Art Association. He worked under such teachers as Hermon A. MacNeil, A. Stirling Calder, Victor Salvatore, Carl Heber, and Antoine Bourdelle. He won several awards for his sculpture before joining the WPA/FAP in New York. He was

employed from 1935 to 1943 as an art teacher and sculptor. Examples of his Project work are in the Community Center of the Queensbridge Housing Project, the Bowery Bay Sewage Disposal Plant, and the U.S. Military Academy at West Point. He also received Section commissions in post offices at Newcomerstown, Ohio (1939), and Wyomissing, Pennsylvania (1941). He continued active as a sculptor after the Project and had his first one-man show of paintings at the Artist's Gallery, New York, in 1950. He died in Chatham, New Jersey, February 2, 1960. A memorial exhibition of his work was held at Gallery 9, New York, in 1968.

Harry H. Sutton, Jr. (1911-)

Born in Jacksonville, Florida, in 1911, he studied painting at the Agricultural and Mechanical College in Tallahassee. He was first employed on the WPA's general Adult Education Project in Jacksonville in 1935 and was reassigned as an artist to the WPA/FAP in 1936. During 1937 he directed the Project's Negro Art Gallery in Jacksonville.

Albert Swinden (1899-1961)

Born in Birmingham, England, in 1899, he came to New York as a young man and studied art at the National Academy, the Art Students League and with Hans Hofmann. He worked on the WPA/FAP in New York from 1935 to 1942, designing a mural for the Williamsburg Housing Project. He was one of the original group of geometric-abstract painters in this country, and the early meetings of the American Abstract Artists were held in his studio in 1936 and 1937. He died in New York in 1961. A posthumous exhibition of work created between 1937 and 1955 was held at the Graham Gallery, New York, in 1962.

Rufino Tamayo (1899-)

Born in Oaxaca, Mexico, in 1899, of Zapotecan Indian parents, he was raised in Mexico City. He studied at the San Carlos Academy of Fine Art from 1915 to 1918. In 1921 he was named chief of the Mexican Museum of Anthropology's Department of Ethnographic Drawing. He had his first one-man show of oils and gouaches in a shop on the Avenida Madero in Mexico City in 1926. At the urging of a friend, composer Carlos Chavez, he took some of the paintings to New York and displayed them in a one-man show at the Weyhe Gallery later that year. He returned to Mexico City as professor of art at the Academy of Fine Art in 1928 and had a second show at the Gallery of Modern Art. In 1932 he was appointed director of the plastic arts section of the Mexican Ministry of Education. In 1936, in New York again, he worked on the WPA/FAP until mid-1937, doing a design for a mural for the Kings County Hospital, Brooklyn, which was rejected, and several easel paintings. After 1938 he taught art at the Dalton Schools, New York, and spent his summers in Mexico City. He did a mural, "Nature and the Artist," at Smith College's Hillyer Art Library in 1943. In 1953 he won a first prize at the São Paulo Biennale, and returned permanently to Mexico City, where he continues to paint.

Dox Thrash (1892-1965)

Born in Griffin, Georgia, on March 22, 1892, he studied at the Art Institute of Chicago and at the Philadelphia Graphic Sketch Club, working under H. M. Norton and Earl Horter. He worked on the WPA/FAP in Philadelphia from 1935 to 1942 and is noted for the development of the carborundum etching. His graphics were exhibited at the New York World's Fair 1939. He had a one-man show at the Philadelphia Art Alliance in 1942 and another at the Smithsonian Institution in 1948. He contributed articles to the *Magazine of Art* and the *Art Digest*. He died in Philadelphia in 1965.

Eugene Trentham (1912-)

Born in Gatlinburg, Tennessee, September 23, 1912, he was a pupil of Charles M. Kessler. He worked on the Mural and Easel Divisions of the WPA/FAP in Denver, Colorado, 1935-39. He was awarded a Guggenheim Fellowship in 1939. In 1940 he joined the faculty of the University of Texas at Austin.

Anthony Velonis (1911-)

Born in New York in 1911, he studied at the College of Fine Arts of N.Y.U. His training in silk-screen techniques came largely from experience in his brother's commercial sign-printing shop. He joined the WPA/FAP Poster Division as a designer and stencil-cutter in 1935. In September of 1938 a separate Silk-screen Unit, with Velonis at its head, was established as a branch of the Graphics Division. Through its work he was instrumental in turning silk-screen from a commercial medium into serigraphy, "the quickest, easiest, and most viable graphic medium." The artists of this Unit, notably Elizabeth Olds, Hyman Warsager, Ruth Chaney, and Harry Gottlieb, continued technical experiments in the medium under Velonis's supervision. In response to growing interest in their work, Velonis wrote a guide to serigraphy, "Technical Problems of the Artist: Technique of the silk-screen process," which was made available free to the public by the Project and was responsible for the wide dissemination of the technique among artists and amateurs. Velonis left the Project in 1939 to found a commercial studio with Hyman Warsager. He lives in Hackensack, New Jersey.

Joseph Vogel (1911-)

Born in Poland in 1911, he studied in Paris at the Grande Chaumière and with Fernand Léger, and in New York at the National Academy of Design and

the Art Students League. He worked with Ben Shahn and Lou Block on a mural for Rikers Island, New York, under the TERA, 1934-35, and was employed on the WPA/FAP's Graphic Division 1935-41. His first one-man show was at the New School for Social Research in 1938. On leaving the Project he moved to the West Coast and worked in the film industry. In 1942 he joined the Signal Corps and later served as a combat artist in the Pacific. Thereafter he taught at the University of Southern California and the Chouinard Art School and resided in Europe for a period. At present he works as a painter and printmaker in Los Angeles.

Hyman Warsager (1909-)

Born in New York City, June 23, 1909, he received his formal art training at the Pratt Institute and the American Artists School. He was employed on the Graphic Division of the WPA/FAP in New York City from 1935 to 1939. While on the Project he worked closely with Anthony Velonis on the silk-screen process. In 1939 he and Velonis went into partnership in a commercial studio for silk-screen production and experimentation. He continues to create fine prints and has recently turned to painting. His woodcuts and serigraphs have been exhibited in most of the important American print shows. He lives in Maywood, New Jersey.

Robert Jay Wolff (1905-)

Born in Chicago July 27, 1905, he took art training following study at Yale University and three years of work as a reporter, textile designer, and advertising man. He studied sculpture at the Ecole des Beaux-Arts in Paris. In 1938, he was hired as Supervisor of the Easel Painting Division of the WPA in Chicago. From 1939 to 1942 he was Dean and head of the painting and sculpture departments of Moholy-Nagy's School of Design, successor to the New Bauhaus, in Chicago. After service in the military, in 1945 he produced a portfolio exhibition, *The Elements of Design,* for the Museum of Modern Art. Wolff joined the art department of Brooklyn College in 1946, retiring as its chairman in 1964. Since his retirement, he has remained active in art education, publishing a series of children's books about color. He lives in New Preston, Connecticut.

APPENDIX B

Inventory of the Existing and Missing Manuscripts of ART FOR THE MILLIONS

This inventory of *Art for the Millions* is divided into two parts. The first lists the extant manuscripts (nos. 1-116); the second those which are lost (nos. 117-141).

One hundred and sixteen manuscripts by ninety-seven authors are extant and listed. Each has been given an inventory number. Multiple titles by the same author are listed and numbered without repeating his or her name. Untitled essays are described in brackets. A number in parentheses after a title indicates the number of drafts of the essay preserved. A date in parentheses is that given by the author. The author's state and WPA/FAP division are recorded; "administration" designates persons not employed as artists; "none," persons not employed on the Project. Dots in the appropriate columns indicate that the manuscript contains a biography or photograph of the author, correspondence from or to him concerning his contribution, whether or not his essay was included in the dummy prepared c. 1939, whether or not the essay is published or deleted, and finally, the total number of manuscript pages—

including drafts but excluding extra carbons. An inventory number in parentheses in the "Manuscript Deleted" column indicates that an excerpt from the deleted text has been published as a footnote to that essay. It should be noted that in many cases the texts have been edited by Emanuel M. Benson or Holger Cahill (with a few recent dated annotations by Mrs. Cahill—Dorothy C. Miller—indicating her husband's hand).

Twenty-five manuscripts are missing. In some cases it is known that an essay was solicited from the person indicated. In others the title appears in the dummy or other of Benson's working papers. In the hope that some of these will eventually be discovered, I am including what information I have concerning each in the manner described above.

The existing manuscripts and all related documents and photographs are preserved in the files of Federal Support for the Visual Arts: The New Deal and Now, which are deposited in the Library of the Smithsonian Institution's National Collection of Fine Arts in Washington, D.C.

Part 1
INVENTORY OF THE EXISTING MANUSCRIPTS

Inventory Number	Name	Title	State	WPA/FAP Division	Biography of Author	Photograph of Author	Correspondence about essay	Manuscript in Dummy	Manuscript Published	Manuscript Deleted	Total number of manuscript pages
1	Berenice Abbott	Changing New York (3)	N.Y.	Photography	•	•		•	•		11
2	Anonymous	Florida Galleries of the Federal Art Project—WPA	Fla.	?						•	9
3	Anonymous	What an Art Gallery Can Do for Phoenix	Ariz.	?						•	3
4	Donald J. Bear	Easel Painting: A Statement and a Prophecy (3)	Colo.	Easel					•		9
5	Gwendolyn Bennett	The Harlem Community Art Center	N.Y.	Community Art Centers (CAC)					•		4
6	Emanuel M. Benson	[Sunday Night Art Forums]	Pa.	Administration						•	1
7	Elzy J. Bird	Birth of an Art Center (2)	Utah	CAC		•			•		6
8	Julius Bloch	The People in My Pictures	Pa.	Easel		•		•	•		4
9	Lucienne Bloch	Murals for Use (2)	N.Y.	Mural				•	•		9
10	Lou Block	Murals for Use	N.Y.	Mural						(89) •	2
11	Robert Boag	Mosaic Unit	S. Cal.	Mosaic						•	2
12	Edgar Britton	A Muralist Speaks His Mind (2)	Ill.	Mural					•	(97) •	7
13		Art—1938 (2)								•	4
14		Lane Tech: Chicago								•	3
15	Douglas Brown	Subject Matter in Painting (2)	N.Y.	Easel	•					•	4
16	Helen Bruton	A Note on Mosaic as a Modern Expression (3)	Cal.	Mosaic	•		•	•		•	5
17	Beniamino Bufano	For the Present We are Busy (3)	Cal.	Sculpture	•			•	•		17
18		[Essay about Bufano's "St. Francis" for Twin Peaks]								•	7
19	Samuel Cashwan	The Sculptor's Point of View	Mich.	Sculpture				•	•		3
20	Pedro Cervantez	My Attitude Toward Painting	N.Mex.	Easel	•	•				•	1
21	Thaddeus Clapp	Art Within Reach (2)	Mass.	?		•			•		11
22	Adele Clark	Gallery Number Twenty, the Lynchburg Federal Art Gallery	Va.	Exhibits						•	2
23	Charles Cornelius	Index of American Design (3)	N.Y.	Index	•				•		8

Inventory Number	Name	Title	State	WPA/FAP Division	Biography of Author	Photograph of Author	Correspondence about essay	Manuscript in Dummy	Manuscript Published	Manuscript Deleted	Total number of manuscript pages
24	Hildegarde Crosby	The Document as Art	Ill.	Index		•				•	4
25	Philip Curtis	Art for the Millions [Phoenix Federal Art Center] (10/26/37)	Ariz.	CAC		•			•		6
26	Joseph A. Danysh	California Sculpture Project (2)	Cal.	Sculpture			•	•		•	7
27	Stuart Davis	Abstract Art Today—Democracy—and Reaction (8/11/39)	N.Y.	Mural & Graphic		•				(28) •	8
28		Abstract Painting Today (11/14/39)							•		8
29		Abstract Painting Today[1] (4/20/40)								•	10
30		The Social Education of the Artist [2]						•		••	5
31		Federal Art Projects and the Social Education of the Artist								•	3
32		American Artists Congress							•		3
33	Daniel S. Defenbacher	Art in Action	Minn.	CAC	•	•		•	•		7
34	Burgoyne Diller	The Williamsburg Housing and Newark Airport Projects	N.Y.	Mural				•	•		2
35	Mabel Dwight	How I Make a Lithograph	N.Y.	Graphic						•	4
36		Satire in Art (2)						•	•		12
37	Fritz Eichenberg	Eulogy on the Woodblock	N.Y.	Graphic					•		3
38	Gene Erwin	The Raleigh Art Center	N.C.	CAC		•				•	4
39	Philip Evergood	Murals for the People [Title edited to "Concerning My Painting"] (3)	N.Y.	Mural		•	•	•	•		19
40	Lorser Feitelson	Mural Unit	Cal.	Mural						•	2
41	Richard Floethe	WPA Made Posters	N.Y.	Posters					•		3
42	Hugo Gellert	Artists' Coordination Committee	N.Y.	Mural & Graphic					•		5
43	Eugenie Gershoy	Fantasy and Humor in Sculpture	N.Y.	Sculpture				•	•		2
44	Rutherford J. Gettens	The Materials of Art [The Boston Paint Testing and Research Laboratory] (2)	Mass.	Technical					•		14
45	C. Adolph Glassgold	Recording American Design (2)	Wash. D.C.	Index				•	•		11

Inventory Number	Name	Title	State	WPA/FAP Division	Biography of Author	Photograph of Author	Correspondence about essay	Manuscript in Dummy	Manuscript Published	Manuscript Deleted	Total number of manuscript pages
46	Jean Goodwin	California Mosaics	Cal.	Mosaic					•		5
47	Arshile Gorky	My Murals for the Newark Airport: An Interpretation (2) [3]	N.Y.	Mural				•	•		6
48	Ralph Graham	The Significance of the Poster Produced on the WPA Art Program	Ill.	Poster		•			•		6
49	Balcomb Greene	Society and the Modern Artist (4/18/38)	N.Y.	Mural					•		5
50	Waylande Gregory	Planning a Public Fountain	N.J.	Sculpture				•	•		2
51		Thoughts on Planning a Fountain of Ceramic and Concrete								•	6
52	Louis Guglielmi	After the Locusts	N.Y.	Easel		•		•	•		3
53	Clement Haupers	Minnesota Finds Her Artists	Minn.	Administration	•	•				•	3
54	Vertis Hayes	The Negro Artist Today	Tenn.	CAC		•			•		5
55	Einar Heiberg	The Minnesota Artists' Union	Minn.						•		8
56	Hilaire Hiler	An Approach to Mural Decoration (2)	Cal.	Mural		•			•		9
57	Donal Hord	Symphony in Stone	Cal.	Sculpture					•		3
58	R. Vernon Hunter	Concerning Patrocinio Barela	N. Mex.	Administration		•		•	•		6
59		An Interpretation of Patrocinio Barela (2)								•	6
60		[Research Material on Barela including transcripts of his statements]								•	17
61	Garret Hynson	Artists Teach in Massachusetts	Mass.	Art Ed.						•	4
62	Eli Jacobi	Street of Forgotten Men (2)	N.Y.	Graphic	•			•	•		4
63	Lawrence A. Jones	WPA and the Negro Artist (2)	La.	Art Education		•			•		4
64	Karl Knaths	Mural Education (2)	Mass.	Mural		•		•	•		4
65	Frederic Knight	Artists' Coordination Committee	N.Y.	Administration		•				•	4
66	Chet LaMore	The Artists' Union of America	N.Y.	Graphic				•	•		4
67	Warren W. Lemmon	Native Arts of the Southwest	Cal.	Index						•	9

Inventory Number	Name	Title	State	WPA/FAP Division	Biography of Author	Photograph of Author	Correspondence about essay	Manuscript in Dummy	Manuscript Published	Manuscript Deleted	Total number of manuscript pages
68	Jack Levine	Some Technical Aspects of Easel Painting	Mass.	Easel					•		6
68A		Street Scene						•	(68) •		2
69	Russel T. Limbach	Lithography: Stepchild of the Arts	N.Y.	Graphic				•	•		5
70	Eugene Ludins	Art Comes to the People [Art Caravan] (3)	N.Y.	Exhibits	•				•		10
71	Stanton Macdonald-Wright	Sculpture in Southern California (2)	Cal.	Administration		•			•		15
72		Architectural Decorative Trends in Southern California								•	8
73	Irving J. Marantz	The Artist as Social Worker (3)	N.Y.	Art Ed.					•		8
74	Audrey McMahon	The Federal Art Project and the Artist	N.Y.	Administration					•		3
75	Edward Millman	Symbolism in Wall Painting	Ill.	Mural		•				(97) •	5
76	Carl Morris	[Spokane Community Art Center]	Ore.	CAC	•	•			•		7
77	Mary Morsell	[Exhibition Program]	Wash. D.C.	Exhibit					•		4
78	Lloyd Moylan	Mural Opportunities	Nev.	Mural		•				•	3
79	Hester Miller Murray	Concerning Subject Matter [MS includes three drawings]	Ill.	Easel		•		•		•	2
80	James Michael Newell	The Use of Symbols in Mural Painting (2)	N.Y.	Mural	•	•		•	•		4
81		The Evolution of Western Civilization							•		3
82	Geoffrey Norman	The Development of American Mural Painting	N.Y.	Mural					•		6
83	Hilda Lanier Ogburn	Puppetry as a Teacher	N.C.	Art Ed.					•		4
84	Elizabeth Olds	Prints for Mass Production	N.Y.	Graphic					•		5
85	Uno John Palo-Kangas	Thought Forms in Red Sandstone	Cal.	Sculpture	•	•		•		•	4
86	Girolamo Piccoli	Sculpture in the Modern World (2)	N.Y.	Sculpture		•	•			•	4
87		Report to the Sculptors of the Federal Art Project								•	7
88	Frances Pollak	Art and Social Therapy [Written by Samuel Friedman, Information Department]	N.Y.	Administration						•	5

Inventory Number	Name	Title	State	WPA/FAP Division	Biography of Author	Photograph of Author	Correspondence about essay	Manuscript in Dummy	Manuscript Published	Manuscript Deleted	Total number of manuscript pages
89	Walter Quirt	On Mural Painting (2)	N.Y.	Mural	•	•		•	•		7
90		A New Attitude on Art								•	3
91	Mildred Rackley	The United American Artists: A Trade Union for Artists	N.Y.	none						(66) •	5
92	Antonio Richardson	The Social Function of Art (3)	N.Y.	?		•				•	11
93	Lincoln Rothschild	The Artist and Democracy [Artists Congress] (2)	N.Y.	Administration					•		11
94		An Introduction to the Living World of Art		Art Ed.						•	2
95	Constance Rourke	What is American Design (2)	Mich.	Index	•	•		•	•		6
96	Arthur W. Sears	The Revival of Mosaic	Cal.	Mosaic		•				•	6
97	Mitchell Siporin	Mural Art and the Midwestern Myth (2)	Ill.	Mural				•	•		6
98	Cecil Smith	[History of American Cowboy Art]	?	Index						•	4
99	David Smith	Modern Sculpture and Society	N.Y.	Sculpture					•		3
100	E. Herndon Smith	The Organization of Supervisors of the Federal Art Project	N.Y.	Administration	•	•			•		3
101	Gordon M. Smith	The Shaker Arts and Crafts (2)	Mass.	Index		•			•		10
102	William Sommer	Some of My Working Methods	Ohio	Easel	•		•		•		6
103	Walter E. Speck	Pottery Methods	Ohio	Arts & Crafts						•	4
104	Max Spivak	Murals for Children (2)	N.Y.	Mural	•	•		•	•		4
105	Alexander R. Stavenitz	The Therapy of Art [with case histories]	N.Y.	Art Ed.				•	•		24
106	Harry H. Sutton	High Noon in Art [Negro Federal Art Gallery in Jacksonville] (2)	Fla.	Exhibit	•				•		24
107	Vivian Swelander	Children's Art Classes	Cal.	Art Ed.						•	2
108	George C. Thorp	The Art of Supervising Artists (2)	Ill.	Administration						•	10
109	Eugene Trentham	Golden Colorado (3)	Col.	Easel	•			•	•		6
110	Anthony Velonis	A Graphic Medium Grows Up (2)	N.Y.	Graphic					•		8
111	Gustave von Groschwitz	Prints for the People (2)	N.Y.	Graphic	•	•				•	7
112	Hyman Warsager	Graphic Techniques in Progress (2)	N.Y.	Graphic		•			•		7

Inventory Number	Name	Title	State	WPA/FAP Division	Biography of Author	Photograph of Author	Correspondence about essay	Manuscript in Dummy	Manuscript Published	Manuscript Deleted	Total number of manuscript pages
113	Rudolph Weisenborn	Designing a Diorama for the Tennessee Valley Authority Building (2)	Ill.	Visual Models		•		•		•	6
114	Francis Robert White	Cultural Frontiers	Iowa	CAC	•					•	5
115	Robert Jay Wolff	Chicago and the Artists' Union	Ill.	Administration		•			•		5
116	Lloyd Wulf	Self-Portrait	Cal.	Graphic		•				•	3

Part 2
INVENTORY OF THE MISSING MANUSCRIPTS

Inventory Number	Name	Title	State	WPA/FAP Division	Biography of Author	Photograph of Author	Correspondence about essay	Manuscript in Dummy	Manuscript Published	Manuscript Deleted	Total number of manuscript pages
117	Emanuel M. Benson	Educating America	Pa.	Administration				•			
118	Cameron Booth	Speaking for Minnesota	Minn.	Easel				•			
119	Samuel Brown	About Myself	Pa.	Easel				•			
120	Grace Clements	Organizing the Unconscious	Cal.	?							
121	Robert Cronbach		N.Y.	Sculpture	•	•					
122	Lew Davis										
123	Elsie Driggs	The Art of Supervising Artists	N.Y.	Administration							
124	Milton Horn										
125	M. Lewis Jacobs	Photography and the Film Break New Ground	Cal.	Photography				•			
126	Benjamin Kopman	Notes on Art	N.Y.								
127	William R. Lawson	[San Francisco Artists Union]	Cal.								
128	Lucien Lebaudt	Mural Renaissance in California	Cal.	Mural				•			
129	Frances Lichten	Peoples Art of Pennsylvania [Co-author: Velma Simkins]	Pa.	Index							
130	Richard C. Morrison	Culture in New England	Mass.								
131	Eric Mose		N.Y.	Murals							

Inventory Number	Name	Title	State	WPA/FAP Division	Biography of Author	Photograph of Author	Correspondence about essay	Manuscript in Dummy	Manuscript Published	Manuscript Deleted	Total number of manuscript pages
132	Paul Parks		Cal.	Photography							
133	Harold K. Pierce				•						
134	Ruiz Rivera (Jose de Rivera)	Why Abstract Sculpture?	N.Y.	Sculpture				•			
135	Leroy Robbins	The Film as Art	Cal.	Photography							
136	Concetta Scaravaglione		N.Y.	Sculpture							
137	Leo Seltzer	[Article on photography and the film]	N.Y.	Photography							
138	Nan Sheets		Okla.		•						
139	S. L. Stolle	[Minnesota Artists' Union]	Minn.								
140	Emanuel Viviano		Ill.		•						
141	Lynd K. Ward	[Article on Prints]	N.Y.	Graphic							

NOTES TO INVENTORY

1. Published in Diane Kelder, editor, *Stuart Davis,* New York: Praeger, Documentary Monographs in Modern Art, 1971, pp. 116-21.

2. *Ibid.,* pp. 162-65. The published text is the same, with minor deletions, but is titled "Federal Art Project and the Social Education of the Artist (ca. 1938)."

3. Published in Brooks Joyner, *The Drawings of Arshile Gorky,* College Park: University of Maryland Art Gallery, 1969, p. 12.

Physical Accomplishments and Expenditures of the WPA/FAP: 1935-43

PHYSICAL ACCOMPLISHMENTS [1]

MURALS		2,566
SCULPTURES	(includes architectural and pedestal)	17,744
EASEL PAINTINGS	(includes watercolors)	108,099
FINE PRINTS	(designs for about 250,000 prints)[2]	11,285
INDEX OF AMERICAN DESIGN PLATES		22,000
POSTERS	(designs for about 2 million copies)[2]	35,000

EXPENDITURES [3]

APPROXIMATE TOTAL COST OF THE WPA/FAP: $35,000,000

1. *Final Report on WPA Program: 1935 to 1943*. Washington, D.C.: Federal Works Agency, 1946, Table XVI, p. 133.
2. "The WPA Art Program — A Summary." A mimeographed document annotated by Holger Cahill updating figures through 1943, Cahill papers, files of Federal Support for the Visual Arts: The New Deal and Now, Library, National Collection of Fine Arts, Smithsonian Institution, Washington, D.C.
3. See Francis V. O'Connor, *Federal Support for the Visual Arts: The New Deal and Now*, Greenwich, Connecticut: New York Graphic Society, 1969, pp. 53-7 for a detailed explanation of how this figure was determined.

APPENDIX D

List of Community Art Centers

Editor's Note: Date of organization is given where known. Where an already existing institution was reorganized as a **WPA/FAP** facility, the date of original founding is given first. Extension centers and galleries are listed under the parent body. I wish to gratefully acknowledge the assistance of Mrs. Mildred Baker in compiling this appendix.

ALABAMA
Mobile Art Center 1936
 Healey School Art Gallery, Birmingham 1936

ARIZONA
Phoenix Art Center 1937

DISTRICT OF COLUMBIA
Children's Art Gallery 1937

FLORIDA
Bradenton Art Center 1938
Civic Exhibition Center, St. Petersburg
Daytona Beach Art Center 1937
Jacksonville Art Center 1936
 Jacksonville Negro Art Gallery 1936
 Jacksonville Beach Art Gallery
Jordan Park Negro Exhibition Center, St. Petersburg 1941
Key West Community Art Center 1938
Miami Art Center 1936
 Coral Gables Art Center 1938
New Smyrna Beach Art Center 1941
Ocala Art Center 1936
Pensacola Art Institute 1938
 Milton Art Center 1940
Pensacola Negro Art Gallery 1939
St. Petersburg Art Center 1936
Tampa Art Center 1939
West Tampa Negro Art Gallery 1941

ILLINOIS
South Side Community Art Center, Chicago 1940

IOWA
Art Center Association of Sioux City 1914/1938
Mason City Community Art Center 1941
Ottumwa Art Center 1939

KANSAS
Topeka Art Center 1940

MINNESOTA
Walker Art Center, Minneapolis 1925/1940

MISSISSIPPI
Delta Art Center, Greenville 1939
Oxford Art Gallery—Mary Buie Museum 1939
Sunflower County Art Center, Moorhead 1941

MISSOURI
The People's Art Center, St. Louis

MONTANA
Butte Art Center 1938
Great Falls Art Center 1940

NEW MEXICO
Gallup Art Center 1939
Melrose Art Center 1938
Roswell Museum of History and Art 1937

NEW YORK
Brooklyn Community Art Center 1936
Contemporary Art Center, Manhattan 1936
Harlem Community Art Center 1937
Queensboro Community Art Center, Ridgewood 1936

NORTH CAROLINA
Greenville WPA Art Gallery 1939
Raleigh Art Center 1935
 Cary Gallery 1940
 Crosby-Garfield School
 Meedham Broughton High School
Wilmington WPA Museum of Art 1938

OKLAHOMA
Oklahoma Art Center, Oklahoma City 1936
 Bristow Art Association 1940
 Claremore Art Gallery 1937
 Clinton Art Gallery 1938
 Cushing Art Gallery 1940
 Edmond Art Gallery 1940
 Marlow Art Gallery 1940
 Okmulgee Art Center 1940
 Sapulpa Art Gallery 1940
 Shawnee Art Gallery 1940
 Skiatook Art Gallery

OREGON
Curry County Art Center, Gold Beach 1939
Grande Ronde Valley Art Center Association 1940
Salem Art Center Association 1938

PENNSYLVANIA
Somerset Art Center 1940

TENNESSEE
Peabody Art Gallery, Nashville 1936
Hamilton County Art Center, University of Chattanooga
Le Moyne Art Center, Memphis
Anderson County Art Center, Morris

UTAH
Cedar City Art Exhibit Association 1940
Utah State Art Center 1938
 Helper Community Gallery 1939
 Price Community Gallery 1940
 Provo Community Art Gallery 1939

VIRGINIA
Big Stone Gap Art Gallery 1936
Children's Art Gallery, Richmond 1939
Lynchburg Art Alliance 1936
 Alta Vista Extension Gallery
 Middlesex County Museum, Saluda 1936

WASHINGTON
Spokane Art Center 1938
 Washington State College, Pullman
 Lewis County Exhibition Center, Chalhalis

WEST VIRGINIA
Huntington Art Center 1941
Morgantown Art Center 1940
 Scott's Run Art Gallery
Parkersburg Fine Arts Center 1938

WYOMING
Evanston Art Gallery 1941
Laramie Art Center, University of Wyoming 1936
 Casper Art Gallery 1938
 Lander Art Gallery 1938
 Newcastle Art Gallery 1938
 Rawlins Art Gallery 1941
 Riverton Art Gallery 1937
 Rock Springs Art Gallery 1937
 Sheridan Art Gallery 1938
 Torrington Art Gallery 1937

Selected Bibliography

American Art Annual, vols. 32 to 36, 1935 to 1945. Valuable articles on the history and activities of the various projects, including, in volume 35, a complete listing of Section murals through 1941 and WPA Community Art Centers.

American Heritage, October 1970. "Memoirs of a WPA Painter," by Edward Laning and "A Sampler of New Deal Murals," selected by Francis V. O'Connor, pp. 38-57. Illustrated.

Art as a Function of Government. New York: Supervisors Association of Federal Art Projects, 1937.

Bruce, Edward, and Forbes Watson. *Art in Federal Buildings: An Illustrated Record of the Treasury Department's New Program in Painting and Sculpture.* Washington, D.C.: Art in Federal Buildings, Inc., 1936.

Cahill, Holger. *New Horizons in American Art.* New York: Museum of Modern Art, 1936. Illustrated.

Carr, Eleanor. "The New Deal and the Sculptor: A Study of Federal Relief to the Sculptor on the New York City Federal Art Project of the Works Progress Administration, 1935 to 1943." Unpublished Ph.D. dissertation, Institute of Fine Arts, New York University, 1969. 1969.

Collier's Yearbook, 1935 to 1943. Contains yearly articles on the New Deal art projects by Dorothy C. Miller. See "The U.S. Government Art Projects: A Brief Summary," based on these articles and published in mimeo by the Department of Circulating Exhibitions of the Museum of Modern Art, New York.

Contreras, Belisario R. "Treasury Art Programs: The New Deal and the American Artist, 1933 to 1943." Unpublished Ph.D. dissertation, American University, 1967.

McDonald, William F. *Federal Relief Administration and the Arts: The Origins and Administrative History of the Arts Projects of the Works Progress Administration.* Columbus: Ohio State University Press, 1969.

McKinzie, Richard D. "The New Deal for Artists: Federal Subsidies, 1933 to 1943." Unpublished Ph.D. dissertation, Indiana University, Bloomington, 1968.

Marling, Karal Ann. "Federal Patronage and the Woodstock Colony." Unpublished Ph.D. dissertation, Bryn Mawr College, 1971.

Monroe, Gerald M. "The Artists Union of New York." Unpublished Ed.D. dissertation, New York University, 1971.

O'Connor, Francis V. *Federal Art Patronage: 1933 to 1943.* College Park: University of Maryland Art Gallery, 1966. Illustrated.

————. *Jackson Pollock.* New York: Museum of Modern Art, 1967. See especially pp. 20-27. Illustrated.

————. "New Deal Murals in New York," *Artforum,* November 1968, pp. 41-49. Illustrated.

————. "The New Deal Art Projects in New York," *American Art Journal,* Fall 1969, pp. 58-79.

————. *Federal Support for the Visual Arts: The New Deal and Now.* Greenwich, Connecticut: New York Graphic Society, 1969. Contains comprehensive bibliography and a guide to New Deal art project documentation.

————, Editor. *The New Deal Art Projects: An Anthology of Memoirs.* Washington, D.C.: Smithsonian Institution Press, 1972.

Overmeyer, Grace. *Government and the Arts.* New York: W. W. Norton, 1939.

Purcell, Ralph. *Government and Art.* Washington, D.C.: Public Affairs Press, 1956.

Rubenstein, Erica Beckh. "Tax Payers' Murals." Unpublished Ph.D. dissertation, Harvard University, 1944.

————. "Government Art in the Roosevelt Era," *Art Journal,* Fall, 1960, pp. 2-8. Illustrated.

Index

Abbey, Edwin Austin 47, 50
Abbott, Berenice 22, 30, 158, *159, 160*-62, 269, 297
Adams, Ansel 274
Addams, Jane 42, 67, 198
Albro, Maxine 58
Alexander, John W. 50
Alston, Charles 213, 283
Altgeld, John Peter 67
Ames, Arthur 278
Ames, Mrs. Arthur (*see* Goodwin, Jean)
Angelico 47
Anthony, Susan B. 20
Anza, Juan Bautista de (as subject) 103
Atget, Eugène 269
Austin, Darrel *54,* 269

Balboa, Vasco Núñez de (as subject) 103
Bannarn, Henry W. 213
Barela, Patrocinio 20, 96—99, 269
Baron, Herman 251
Barr, Alfred H., Jr. 272
Barthé, Richmond 212
Baudouin, Paul 287
Bear, Donald J. 133-34, 136, 270, 297
Bel Geddes, Norman 286, 290
Bell, Charles Jasper 246
Bender, Dr. Lauretta 202
Bennett, Gwendolyn 20, 203, 210, 213-15, 251, 270, 297
Benson, Emanuel M. 13, 14, 15, 29, 30, 120, 121, 251, 270, 277, 297, 302
Benton, Thomas Hart 15, 22, 23, 264, 289

Bernhard, Lucian 251
Biddle, George 40, 44, 50, 251
Billings, Henry 251
Bird, Elzy J. 20, 208-209, 270, 297
Blackburn, Robert 214-15
Blanch, Arnold 251
Blashfield, Edwin 50
Blashki, Meyer Evergood 276
Bloch, Julius 115-*116,* 270, 297
Bloch, Lucienne 19, 22, 76-*77,* 81, 271, 297
Block, Lou 81, 271, 297
Blume, Peter 251
Boag, Robert 297
Bodine, Wilhelm 243, 244
Bohanan, Walter 251
Bohrod, Aaron 251
Bolotowsky, Ilya 70
Booth, Cameron 22, *130,* 243, 271, 302
Borglum, Gutzon 278
Boswell, Peyton, Jr. 44
Bothwell, Dorr 103
Bouguereau, Adolphe W. 41, 64
Bourdelle, Antoine 273, 293
Bourke-White, Margaret 251
Bowden, Harry 70
Boynton, Ray 56
Brady, Mathew B. 161
Brewster, G. T. 278
Britton, Edgar 19, 67, 271, 297
Brody, David 31
Brooks, James 20, *48,* 271
Brooks, Thomas R. 31
Brooks, Van Wyck 20
Broun, Heywood 251

311

Brown, Bolton 147
Brown, Douglas 297
Brown, John G. 122, 123
Brown, Samuel J. *215*, 272, 302
Browne, Byron 70
Bruce, Edward 17, 30
Bruegel, Pieter 67
Bruton, Esther 56
Bruton, Helen 56, 58, 297
Bufano, Beniamino 19, 20, 107, *108*, 109-10, *111*, 251, 272, 297
Burlin, Paul 251, 280
Burnham, Daniel H. 31

Cabrillo, Juan Rodrigues 106, (as subject) 103
Cahill, Holger 13, 14-15, 16-18, 20, 22, 29, 30, 32, 33-44, 249, 272, 287
Cahill, Mrs. Holger (see Miller, Dorothy Canning)
Calder, A. Stirling 277, 293
Carroll, Orville A. 174
Carter, Jean 43
Cashwan, Samuel 20, *88-89*, 273, 297
Cellini, Benvenuto 101
Cervantez, Pedro 297
Cézanne, Paul 17, 127, 146, 264
Chaney, Ruth 294
Chipp, Herschel B. 30
Christensen, Erwin O. 44
Cikovsky, Nicolai 251
Clapp, Thaddeus 204-206, 273, 297
Clark, Adele 297
Clements, Grace 251, 302
Cocteau, Jean 269
Coffee, John Main 246
Contreras, Belisario R. 29, 30, 31
Cornelius, Charles O. 170-72, 273, 297
Cox, Kenyon 50
Craig, Martin *83*, 273
Criss, Francis 69, *70*, 273
Critchlow, Ernie 210
Cronbach, Robert 29, 302
Crosby, Hildegarde 298
Crowninshield, Frederic 50
Cunningham, John 251
Currier & Ives 141, 144
Curry, John Steuart 23, 264, 265
Curtis, Philip C. 20, 221-23, 274, 298

Daley, Richard 16
Dali, Salvador 23
Dana, John Cotton 272
Danysh, Joseph 56, 274, 298
Daumier, Honoré 146, 147, 152, 153
Davidson, Jo 278
Davis, Lew 302
Davis, Stuart 14, 23, 24, 26, 27, 30, 69, 121-27, *123*, *231*, 249-50, 251, 274, 298, 303
Dawson, Archibald 281
De Brennecke, N. 84
Debs, Eugene V. 42, 67
Defenbacher, Daniel S. 223-26, 274, 298
Degas, Edgar 154
de Kooning, Willem 70
Delacroix, Eugène 47, 146
Demeny, Paul 73
Dewey, John 15, 16-17, 21, 23, 33-34, 35, 36, 37, 38-39, 41, 42, 43, 44
Diller, Burgoyne 24, 69-71, 271, 275, 298
Dimitroff, Stephan 271
Dimitroff, Mrs. Stephan (see Bloch, Lucienne)
Doerner, Max 117-19, 193
Dos Passos, John 21-22, 23
Douglas, Aaron 210, 251
Douglass, Frederick 283
Downes, Olin 52
Dreiser, Theodore 42, 67
Driggs, Elsie 302
Duci, Fortunato 84
du Von, Jay 30
Dwight, Mabel 151-54, *152*, 275, 298

Earl, Ralph 37
Eddy, Arthur J. 239
Edison, Thomas A. 94
Edwards, Emmett *124*, 275
Egbert, Donald Drew 31
Ege, Edward 276
Eibner, Alexander 193
Eichenberg, Fritz 19, 148, *149*, 150, 275, 298
Einstein, Albert 214, (as subject) 107
El Greco 117, 118
Emptage, Arthur 251
Ennis, George Pearse 282
Ernst, Morris 30
Erwin, Gene 298
Evergood, Philip 18, *46*, *47-49*, *251*, *256*, *276*, *298*

Feitelson, Lorser 298
Fausett, Dean 209
Fausett, Lynn 208, 209
Fenelle, Stanford 243
Ficini, Gino 84
Flint, LeRoy 22, 153, 276
Floethe, Richard 177-78, 276, 298
Fogel, Seymour 22, 260, 276
Forain, Jean Louis 153
Fossum, Sydney 243
Fox, Milton 251
Frankenberg, Lloyd 285
Frankenberg, Mrs. Lloyd (see MacIver, Loren) .
Fraser, James Earle 272
Frazer, Mabel 251
Freedman, Henry 120
Fruhauf, Aline 277, 286, 291

Garces, Father (as subject) 102-103
Garner, Archie 103
Gaskin, William 58
Geiger, Willie 276
Geisbert, Edward 275
Geller, Todros 291
Gellert, Hugo 251, 255-57, 277, 298
Gershoy, Eugenie 92-93, 230, 277, 298
Gettens, Rutherford J. 190-93, 277, 298
Gide, André 269
Giotto 64
Girolami, George 84
Glass, Gertrude 279
Glassgold, C. Adolph 167-69, 278, 298
Glintenkamp, H. 251
Goodelman, Aaron 22, 251, 254, 278
Goodwin, Jean 56, 58 59, 278, 299
Goreleigh, Rex 210
Gorky, Arshile 24, 30, 31, 70-71, 72-73, 278, 299, 303
Gottlieb, Harry 251, 294
Gounod, Charles 200
Goya, Francisco José de 146, 151, 153
Graham, Ralph 19, 179-81, 278, 299
Grant, Ulysses S. 84
Greenberg, Clement 31
Greene, Balcomb 14, 70, 262, 263-65, 279, 299
Greene, Mrs. Balcomb (see Glass, Gertrude)
Greenwood, Grace 279
Greenwood, Marion 22, 51, 279
Gregory, Waylande 94-95, 279, 299
Gropper, William 15, 23, 251

Grossman, Hilda 287
Grosz, George 286
Guck, Edna 84
Guggenheim, Peggy 289
Guglielmi, O. Louis 19, 22, 23, 25, 112, 113, 114, 115, 279, 299
Guston, Philip 22, 23
Guy, James 23, 136, 280

Halsey, R. T. H. 273
Harding, Chester 36
Harkavy, Minna 251
Harmes, Elmer 243, 244
Harrington, F. C. 257
Harris, Ruth Green 289
Hart, Agnes L. 22, 135, 280
Haupers, Clement 246, 280, 299
Haydn, Franz Joseph 200
Hayes, Vertis 20, 210, 212, 280, 299
Heber, Carl 293
Heiberg, Einar 28, 243-47, 281, 299
Hemingway, Ernest 281
Henri, Robert 274
Hiler, Hilaire 24, 74-75, 281, 299
Hirsh, Joseph 23
Hofmann, Hans 275, 287, 290, 293
Hogarth, William 152
Holbein, Hans 150
Holty, Carl 251
Hopkins, Harry L. 17, 256, 285
Hord, Donal 100, 101, 104, 105, 106, 281, 299
Horn, Milton 302
Horter, Earl 294
Hosier, T. 172
Howard, John L. 251
Howe, George 52
Hunt, William 50
Hunter, Vernon 96, 98-99, 269, 281, 299
Hyde, Barney 208-209
Hynson, Garret 299

Injalbert, J. 278

Jacobi, Eli 157, 282, 299
Jacobs, M. Lewis 302

Jennings, Herbert 251
Johannes, Frederic 243
Jones, Alfred Haworth 31
Jones, Bob 209
Jones, Joe 251
Jones, Lawrence A. 20, 198-99, 282, 299
Joseph, Ronald 210
Josephson, Matthew 31
Joyce, James 269, 281
Joyner, Brooks 73, 303
Jules, Mervin 251

Kainen, Jacob 22, 30, *147*, 282
Kandinsky, Wassily 276
Kelder, Diane 121, 303
Kelley, Albert Sumter 22, *55*, 282
Kellner, Sydney 178
Kelpe, Paul 69, 282
Kennedy, John F. 16
Kent, Rockwell 139, 238, 251, 256
Kessler, Charles M. 294
Kettering, Charles F. 126
King, Albert Henry 57, *282*
Klee, Paul 276
Klein, Jerome 251
Klitgaard, Kaj 233
Knaths, Karl 67-*68*, 251, 283, 299
Knight, Frederic 251, 255, 257, 299
Kopman, Benjamin 302
Krasner, Lee 289
Kroll, Leon 286
Kuhn, Walt 284
Kuniyoshi, Yasuo 251

LaFarge, John 50
LaFollette, Robert, Sr. 42, 67
La Guardia, Fiorello H. 256, 272
Lahey, Richard 288, 291
Lamb, Charles 50
La More, Chet *236*, 237-38, 283, 299
Laurie, Arthur Pillans 118-19, 193
Lawrence, Jacob 210, *211*, 283
Lawson, William R. 302
Lebaudt, Lucien 302
Lechay, Myron 199, 251
Lee, Mother Ann 174

Lee, J. Brackson 209
Léger, Fernand 127, 294
Lemmon, Warren W. 299
Leonardo da Vinci 225
Lescaze, William 52
LeSueur, Mac 243
Levine, Jack 15, 22, 23, 41, 117-20, *118*, 283, 300
Lewis, Norman 210
Lhote, André 271
Lichten, Frances 302
Limbach, Russell T. 19, *145-47*, 284, 300
Lincoln, Abraham 67; (as subject) 20, 256
Lindsay, Vachel 42, 64, 67
Lion, Henry 103
Lippi, Filippo 47
Lishinsky, Abraham *248*, 284
Locke, Dr. Alain 212
Locke, Charles 277
Lonsbury, Earl *53*, 284
Loran, Erle 243
Lozowick, Louis *141*, 251, 284
Lubetkin, Berthold 90
Ludins, Eugene 232-33, 284, 300
Luks, George 276, 288
Luther, Martin 148, 150

Macdonald-Wright, Stanton 56, 100-101, 103, 281, 283, 285
MacIver, Loren 285, 289
MacLeish, Archibald 39
MacNeil, Hermon A. 293
Magnasco, Alessandro 119
Maillol, Aristide 273
Manet, Edouard 146
Manship, Paul 251, 272
Marantz, Irving J. 20, 197-98, 240, 242, 286, 300
Marin, John 270
Marsh, Reginald 15
Martin, Fletcher 251
Martin, Gail 209
Masaccio 47, 64
Masters, Edgar Lee 64
Mathews, Jane DeHart 31
Matisse, Henri 122, 127
Matulka, Jan 69, 288, 291
McCarter, Henry 270
McCausland, Elizabeth 161, 269
McCormick, Cyrus 67
McCoy, Garnett 29, 30, 90

McDowell, Mary 42, 67
McGonagle, John F. 30
McMahon, A. Philip 285
McMahon, Audrey (Mrs. A. Philip) 28, 31, 86, 256, 259-60, 285, 300
McNeil, George 70
Meière, Hildreth 22, 50, 51
Melchers, Gari 292
Melchers, Julian 292
Michelangelo Buonarroti 90, 225
Miller, Dorothy Canning 14, 15, 29, 273
Miller, George C. *147*
Miller, Kenneth Hayes 277, 284, 287, 290
Milles, Carl 273
Millman, Edward 66, 67, 286, 291, 300
Moholy-Nagy, László 295
Monroe, Gerald M. 29, 31
Moore, Charles H. 31
Morley, Eugene 70, *140*, 286
Morris, Bertram 30
Morris, Carl A. 20, 218-20, 287, 300
Morrison, Richard C. 302
Morsell, Mary 20, 229-31, 287, 300
Mose, Eric 22, 302
Moutal, Elizabeth *168*
Moylan, Lloyd 300
Mumford, Lewis 251
Murray, Hester Miller 300
Murrell, Sarah 210

Nankivell, Frank 139
Nevelson, Louise *87*, 287
Newell, Gordon 100
Newell, James Michael 20, 60, *61, 62, 63* 287, 300
Nicolaides, Kimon 272
Norman, Geoffrey R. 50-55, 288, 300
Norton, H. M. 294
Norton, John W. 275, 286

Ogburn, Hilda Lanier 199-201, 288, 300
Olds, Elizabeth 19, 22, 142-44, *143*, 288, 294, 300
Orozco, José Clemente 47, 52, 64, 251, 279

Palo-Kangas, Uno John 20, 101-02, *103*, 288, 300

Parks, Paul 303
Pasteur, Louis (as subject) 107
Patete, Eliodoro 168
Pearson, Ralph 251
Peck, Augustus *140*, 288
Peixotto, Ernest 50
Pennell, Joseph 147
Pepper, Claude 246
Pereira, Irene Rice *125*, 285, 288
Peticolas, Sherry 103
Phidias 90
Phyfe, Duncan 166
Picasso, Pablo 126, 252
Piccoli, Girolamo 83-87, 289, 300
Picken, George 251
Pierce, Harold K. 199, 303
Pintoricchio 53
Plimpton, Russell 245
Pollak, Frances 285, 300
Pollock, Charles 22, *134*, 289
Pollock, Jackson 22, *134*, 289
Pollock, Mrs. Jackson (see Krasner, Lee)
Portolá, Gaspar de 106
Pound, Ezra 281
Presser, Josef 280
Presser, Mrs. Josef (see Hart, Agnes L.)
Puvis de Chavannes, Pierre C. 50

Quintanilla, Luis 252
Quirt, Walter 15, 23, 25, *78-79, 80-81*, 289, 301

Racinet, Albert Charles Auguste 167
Rackley, Mildred 238, 301
Ray, Man 269, 281
Reeves, Ruth 251
Refregier, Anton 22-23, 31, *49, 164*, 251, 290
Renoir, Pierre Auguste 146, 154
Richardson, Antonio 301
Richardson, Earle W. 212
Rimbaud, Arthur 24, 73
Rivera, Diego 47, 52, 271, 279, 286, 287
Rivera, José Ruiz de 303
Robbins, Leroy 303
Robeson, Paul 214
Robinson, Boardman 272, 277

Robus, Hugo 84, 290
Rockefeller, Abby Aldrich 272
Rogers, John 122, 123
Roosevelt, Eleanor 214, 287
Roosevelt, Franklin D. 27-28, 252, 257, 258
Rosalie, John 84
Rosenberg, Harold 31
Ross, Denman 283
Rothschild, Lincoln 31, 250-52, 290, 301
Rourke, Constance 165-66, 291, 301
Rowlandson, Thomas 153
Rubenstein, Erica Beckh 31
Russell, Morgan 285
Ryerson, Martin A. 239

Sabean, Samuel 243
St. Francis of Assisi (as subject) 19, 20, 107, 109, 110
Salvatore, Victor 293
Saint-Gaudens, Augustus 31
Sandburg, Carl 64
Sandler, Irving 31
Sanger, Isaac 139
Sargent, John Singer 47, 50
Savage, Augusta 210, 213
Savage, Eugene 51
Scaravaglione, Concetta 303
Schlegel, William von 276
Schmidt, Katherine 251
Scott, Leonard 199
Seabrook, Georgette 212
Sears, Arthur W. 301
Seltzer, Leo 303
Senefelder, Alois 146
Serra, Fra Junipero 106, (as subject) 103
Sessler, Alfred 251
Seurat, Georges 127
Shahn, Ben 15, 23, 271, 295
Shapley, John 285
Sheets, Nan 303
Sibelius, Jan 52
Signac, Paul 146
Siporin, Mitchell 20, 21, 41-42, 64-67, 65, 251, 286, 291, 301
Siqueiros, David Alfaro 47, 52
Sloan, John 291
Slobodkin, Louis 256
Smith, Cecil 301
Smith, David 90-92, 91, 291, 301
Smith, E. Herndon 257-58, 292, 301

Smith, Gordon M. 173-75, 292, 301
Smith, Hilda W. 43
Smith, Judson 233
Somervell, Brehon 256
Sommer, William 22, 41, 128-31, 129, 292, 301
Soyer, Isaac 15, 146, 292
Soyer, Raphael 15, 251
Speck, Walter E. 251, 301
Spencer, Niles 251
Spivak, Max 93, 292, 301
Spruance, Benton 251
Stanley, George 103
Stavenitz, Alexander R. 20, 201-203, 251, 293, 301
Stea, Cesare 22, 82, 293
Steinbeck, John 23
Steiner-Prag, H. 275
Steinmetz, Charles Proteus (as subject) 107
Sternberg, Harry 31, 286
Stokes, Isaac Newton Phelps 158
Stolle, S. L. 303
Sulmonetti, Saverio 84
Sun Yat-sen 272; (as subject) 107, 110
Swelander, Vivian 301
Sutton, Harry H. 20, 216-17, 293, 301
Swift, Florence 58
Swinden, Albert 70, 71, 293

Taft, Lorado 279, 289
Tamayo, Rufino 137, 294
Tanner, Henry O. 210
Thompson, John E. 270
Thorp, George C. 301
Thrash, Dox 214, 294
Titian 118
Topchevsky, Morris 251
Toulouse-Lautrec, Henri de 146
Toussaint l'Ouverture, Pierre-Dominique 283
Towle, Helen M. 106
Trentham, Eugene 132-33, 294, 301
Trotsky, Leon 31
Tschacbasov, Nahum 251
Tschaikowsky, Peter Ilyitch 200
Tubman, Harriet 283
Tucker, Allen 284
Tudor-Hart, Percyval 285
Turnbull, James B. 251
Turner, LeRoy 243, 244

Van Eyck, Jan and Hubert 118
Van Gogh, Vincent 127, 264
Vassiliev 290
Veblen, Thorstein 272
Velonis, Anthony 140, 154, *155*, 156, 288, 294, 295, 301
Vittor, Frank 289
Viviano, Emanuel 303
Vogel, Joseph *141*, 294
Vollmer, Mrs. Erwin P. (*see* Fruhauf, Aline)
von Groschwitz, Gustave 301
Vytlacil, Vaclav 210

Wallace, Samuel J. 30
Walsh, Bernard 84
Walters, Joseph 84
Ward, Lynd K. 251
Warsager, Hyman *138*, 139-41, 294, 295, 301
Watson, Forbes 44

Weber, Max 251, 273
Weisenborn, Rudolph 302
Welles, Lessene 213
Wells, Charles 243, 244
Whalen, Grover 256
White, Eartha M. M. 216
White, Francis Robert 302
White, Robert F. 251
Whitman, Walt 35
Williams, Joseph 199
Wilson, Gilbert 251
Winter, Ezra 51
Wolff, A. 84
Wolff, Robert Jay 28, 239-42, 295, 302
Wood, Grant 23, 265, 271
Woodruff, Hale 210
Woodward, Ellen S. 30
Woolfolk, Bessie Lamb 198
Wulf, Lloyd 302

Zorach, William 251

A BIOGRAPHICAL NOTE ON THE EDITOR

Born in Brooklyn, N.Y., Francis V. O'Connor graduated from Manhattan College in 1959, and received his M.A. and Ph.D. degrees from The Johns Hopkins University. From 1964 to 1970 he taught the history of contemporary European and American art at the University of Maryland and organized there the first comprehensive exhibition of art from New Deal projects since their cessation in 1943.

In 1968 he directed a special research project for the National Endowment for the Arts designed to evaluate the cultural and economic effectiveness of New Deal patronage, resulting in the publication of its final report, *Federal Support for the Visual Arts: The New Deal and Now, The New Deal Art Projects: An Anthology of Memoirs,* and the lost manuscript of *Art for the Millions.* He is also the author of *Jackson Pollock,* published by the Museum of Modern Art in 1967.

Senior Visiting Research Associate at the Smithsonian Institution's National Collection of Fine Arts from 1970 to 1972, he is working on a history of American art in the 1930s.